RUSSIAN DESIGN
AND THE FINE ARTS · 1750–1917

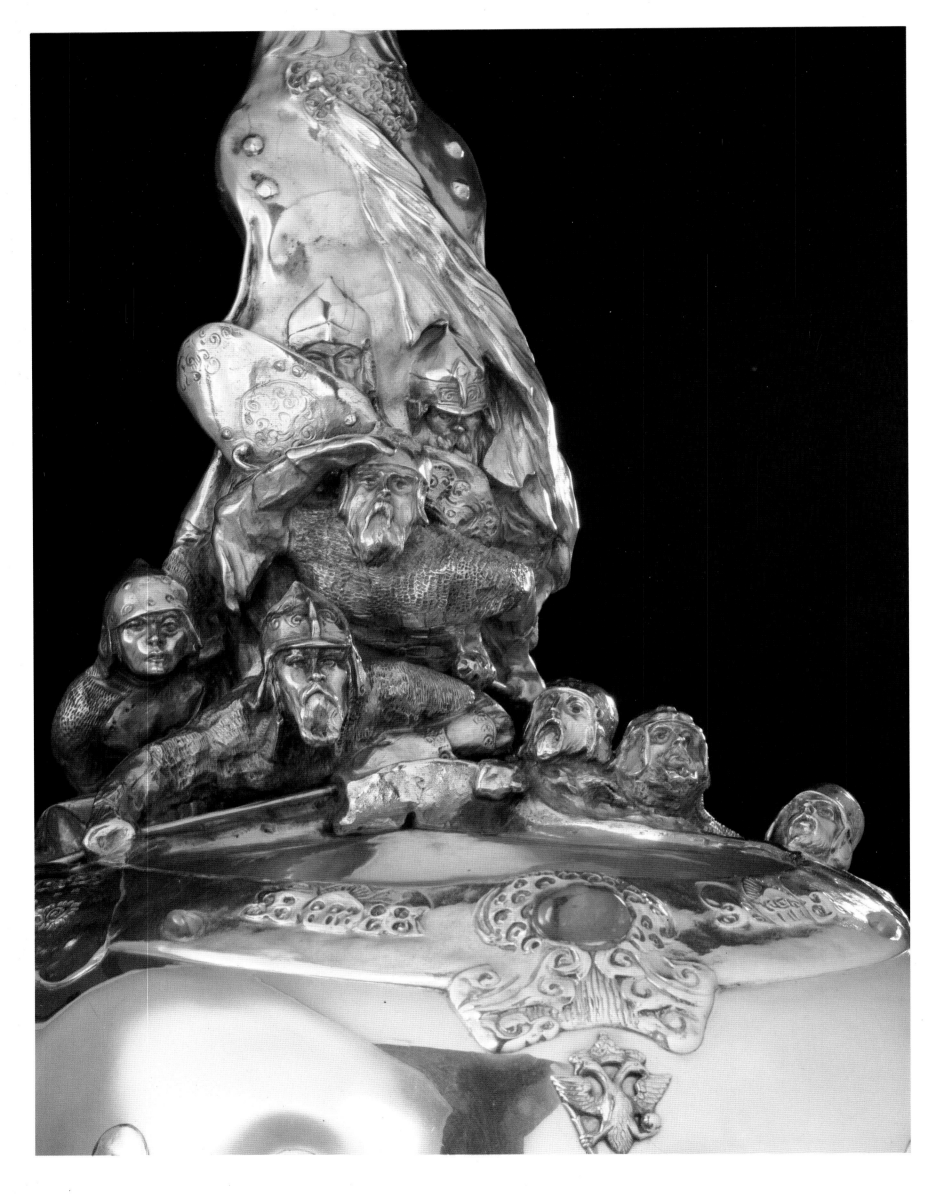

RUSSIAN DESIGN

AND THE FINE ARTS · 1750–1917

EVGENIA KIRICHENKO

COMPILED BY MIKHAIL ANIKST

HARRY N. ABRAMS, INC.
PUBLISHERS, NEW YORK

Frontispiece:
Fabergé Workshops. Detail from the *'Bogatyr' kovsh*, Moscow, 1899–1908

This book was designed and produced by
Laurence King Ltd., London

Library of Congress Cataloging-in-Publication Data
Kirichenko, Evgenia Ivanovna.
 Russian design and the fine arts, 1750–1917/Evgenia Kirichenko
 p. cm.
 ISBN 0-8109-3758-1
 1. Art, Russian. 2. Art, Modern – Russian S.F.S.R. 3. Nationalism
and art – Russian S.F.S.R. I. Title.
N6984.K57 1991 91-11101
709'.47 – dc20 CIP

Published in 1991 by Harry N. Abrams, Incorporated, New York
A Times Mirror Company

Designed by Mikhail Anikst
Translated by Dr. Arch Tait
Printed by Toppan in Singapore

CONTENTS

Chapter IV
THE NEO-RUSSIAN STYLE

FOREWORD

The neo-Russian style was born in a land infinitely remote from today's Soviet Union. The national ideals which gave it birth were replaced by an Internationale which dominated for many long decades, levelling out any suggestion of national individuality and in the process systematically destroying those buildings, monuments and works of art which were imbued with that spirit.

There is no shortage of books about Russian culture. Their number increases every year. The Western European reader will readily find many studies of the art of pre-Petrine Rus, and even more on the Russian avant-garde. The names of the Russian avant-gardists are firmly inscribed in the history of twentieth-century art.

What preceded this astonishing and extremely short-lived phenomenon in Russia? What were her art and architecture like in the second half of the nineteenth and early twentieth century? Until very recently this period of Russian culture was almost unknown to the Western reader. Those who did write about it were almost uniformly negative, interested only in emphasizing the depressed state of Russian culture before the pioneers of the avant-garde appeared to save the situation.

Professor Kirichenko's book goes a long way towards changing this view. She introduces us to a world which has long since disappeared, in which a passionate search for Russia's national artistic idiom was enacted and in which the ideals of Russian Orthodoxy were rejuvenated, without which Russian national consciousness was unthinkable. Significantly, the greatest achievements of the neo-Russian style were in church architecture. In large measure we have the architects who worked in the style to thank for what we know today of the treasures of old Russian architecture. They spent an immense amount of time studying the Russian heritage and these studies were often inseparable from their work as practising architects. It was a truly innovative period for Russian architecture. As Kirichenko states: 'Not only were the hipped-roof buildings of the sixteenth century taken as prototypes, but also the single- and five-domed churches of Moscow. For the first time since the Romantic era there was a revival of interest in the architecture of the Vladimir and Suzdal period. Finally, wooden architecture was taken as a model not only for new wooden but also, and much more frequently, for stone buildings. The architects were attracted by the individuality of wooden architecture, by its genuinely original forms which are to be found in no other culture; and, equally, by the Russian concept of what was beautiful, and a Russian treatment of form.'

This was a time, too, when collectors first became aware of the importance of ancient icons and manuscripts, a time when Diaghilev and his associates discovered the Russian portrait, a time when Russians at last became fully aware of the immense diversity of their own cultural heritage.

Professor Kirichenko's book relates the history of the evolution of a specific national style in Russia in the second half of the nineteenth and early twentieth century. This is of especial interest at the present time when the despotic reign of the international style of industrial functionalism has come to an end, leaving behind all over the planet a sorry legacy of impersonal, uniform structures which spread with the speed and ubiquitousness of a medieval plague.

The adepts of the international style placed not only regional styles, but also the notion of looking back to a national tradition under a taboo. The subject was dismissed as of interest only to chroniclers of historical style and restorers; practising architects turned away from it for several decades.

Today the leading figures of post-modernism question the absolutist notions of previous decades, and are subjecting all the stylistic tendencies of twentieth-century architecture to thorough review, scrupulously avoiding any suggestion that one style should enjoy a monopoly. Can post-modernism even be classed as a style in any traditional sense? Can you really compound an amalgam from its diverse borrowings from classicism, regional traditions and the aesthetics of high tech? We can hardly interpret what we are seeing as a romanticised yen for Gothic or the Renaissance either.

The question of how to ameliorate the environment in which we live, and of how far it should reflect a national tradition, is something which today exercises both architects and their clients. What should be taken from national tradition? Should it be merely traditional building techniques and local building materials? Or is there a need for a much deeper awareness of the forms of the national architecture, and of the spiritual values which called them into being?

All these highly topical questions were already exercising Russia's foremost architects and artists at the turn of the century. The development of the Russian style is examined by Evgenia Kirichenko not in isolation, but within the context of the international search for national styles in the second half of the nineteenth century. By adopting this approach she helps the Western European reader to recognize what was specific to the Russian attempt, and what its spiritual, social, and historical roots were. This is one of the great merits of her book. In her own words: 'Attitudes towards national tradition become increasingly ambivalent as people begin to see the task of culture as the creation of the novel and unprecedented. This is precisely what was happening in the period from romanticism to avant-garde art. Where does national tradition fit in with the new spiritual, ethical, and artistic values, which are constantly changing and being dynamically reconstituted? This leads logically to the tendency in the art of the late nineteenth century and through into the 1930s to proclaim absolute creative freedom and to declare tradition of any sort irrelevant. Fortunately this tendency remained theoretical. Had the slogan been realized in practice it could only have led to the total collapse of art. . . . As art becomes international, national cultures discover an urgent need to find their own place in the scheme of things, contrasting and differentiating themselves from others, and expressing their national uniqueness. Quite separate traditions are at work in

them, of which the ethnic is only one.'

There is another aspect of the period to which it is important to draw attention.

The era we are looking at does not represent just one more style in the history of art. It was also the artistic childhood, the milieu in which many outstanding artists grew up, who were later to become pillars of modernism, artists whose names are well known to us from exhibitions, art collections, and a never-ending flow of articles and monographs.

It is puzzling that so little scholarly attention should be paid to something as important as the spontaneous formation of an artist's first visual impressions, which can, after all, be deeper and more powerful than the impressions gained from his academic studies. Not many artists succeed in putting these impressions into words as eloquently as Kandinsky:

'Pink, lilac, white, blue, azure, pistachio, flame-red houses, churches – each like a distinct song, furiously green grass, deep humming trees, or snow singing in a thousand modes, or an allegretto of bare limbs and branches, the red, rigid, steadfast, silent circle of the Kremlin wall, and above it – overtopping everything with itself, like the solemn cry of the all-world-forgetting alleluia – the white, tall, shapely-serious line of [the bell tower] of Ivan the Great. And on its long neck, tense, drawn out in its eternal yearning towards the sky – the golden head of the cupola, representing, among the other golden, silver and multi-coloured stars of the surrounding cupolas, the Sun of Moscow.'

Kandinsky's closeness to the Russia he saw around him in his youth found expression not only in this vivid verbal panegyric to the Moscow townscape. It is also obvious in the style of many of his early works, such as 'The Golden Sail', an engraving of 1903 in the Lenbachhaus in Munich, or 'Woman at Prayer before a Rural Iconostasis', a watercolour in the Tretyakov Gallery in Moscow.

To a man, scholars classify all his early works as 'art nouveau', preferring not to notice their kinship with the Russian style. Nevertheless, one of the characteristic features of art nouveau in Russia is that in many of its most outstanding manifestations, the Convent of Saints Martha and Mary, for example, designed by Shchusev and decorated by Nesterov, or the Kandinsky studies just mentioned, the style is inseparable from the achievements and innovations of the artists and architects who strove to understand the traditional forms of Russian art at the beginning of the century.

In talking of the Russia which these artists saw around them in their formative years, I would stress that the influence is not by any means overt. Far from it. On the surface the styles are at loggerheads. The similarities lie in a deeper, genetic relatedness. One would be hard pressed to trace the pedigree of industrial design in a direct line from the creative insights of William Morris, or Viktor Vasnetsov (whose work is dealt with in detail in this book). The ground rules of industrial design were worked out considerably later. The process was painful even in the Bauhaus. In the workshops there, difficulties emerged when the attempt was made to implement the ideas of Gropius relating to industrial design's supposed independence from historical prototypes. Abandoning the heritage of the arts and crafts movement proved difficult. From where did the conviction come that the ideas of all artists have a common source, and that the relationship between 'fine art' and 'craft' is not one of hierarchical subordination but that they are two aspects of the same activity? It was born of the creative endeavours of the artists of the Russian style.

Indubitably, constructivism condemned and rejected the hand-made and the arty; and indubitably the interior decor, furniture, and everyday items produced by the best Russian art workshops were both hand-made and works of art in their own right. It was, nevertheless, within the parameters of the Russian style that pioneering work on 'construction', appreciation of the 'lucid functionality' of forms and logical evaluation of the inherent natural qualities of materials was begun. It was the protagonists of the Russian style who analyzed the construction and functionality of folk craftwork, and of the laconic forms and volumes of church architecture. I believe this is the lucidity and laconicism we find in Rodchenko's sensibility, in the articulations of his wooden constructions and his furniture. The ambition of the constructivists to design everything from textiles to teacups is close to the aims of the artists of the Russian style in their work. Wielding ruler and compasses, the later utopia superseded the earlier. The hereditary link is, however, beyond doubt.

It is now not unusual to compare the lines of Tatlin's paintings with the linear rhythms of icons, but can we really discuss the aesthetic value of Tatlin's 'bandore' or the celebrated 'Letatlin' flying machine without taking account of their hand-made quality and what might be called their 'wood' aesthetic. The study of the traditions of folk art was a practice originated by the masters of Russian style; now it was taken up and extended by the avant-garde. The artists of 'The Jack of Diamonds' group, for example, enlarged their technical vocabulary by drawing on sources in urban folk art – such items as signboards and *lubok* folk prints. Natalia Goncharova's neo-primitivism may, indeed, be seen as an intensely serious attempt to find a technical idiom for contemporary Russian painting which would incorporate both the experience of peasant art and the Russian icon's beauty of line.

Let us, however, return to Kandinsky. In 1918 the great discoverer of the abstract, having created dozens of objectless compositions and improvisations, unexpectedly developed an enthusiasm for painting on glass. He began to create odd, and at first sight compromising, resolutions of representational space. He appeared to backtrack on such immediately preceding spatial structures as 'Golden Cloud' (1918, Russian Museum).

It could be argued that there is an unbridgeable gulf between these modestly sized pictures on glass and, say, the graphic art of Bilibin. But is this really the case? I believe that underlying our excitement when we look at these pictures is the superimposition on what is recognizably the colourful, expressive, semi-objective world of Kandinsky of images redolent of his artistic childhood; images which we recognize as related to the images of the graphic artists of the Russian style. They differ from the figures of Roerich and Bilibin only in having shed a certain pedantry in the stylization of their progenitors.

To understand and feel this collision on an artistic, rather than a merely literary level, we need to know the sources of the Russian style. These are the subject of this book.

Serge Essaian
Paris, 1991

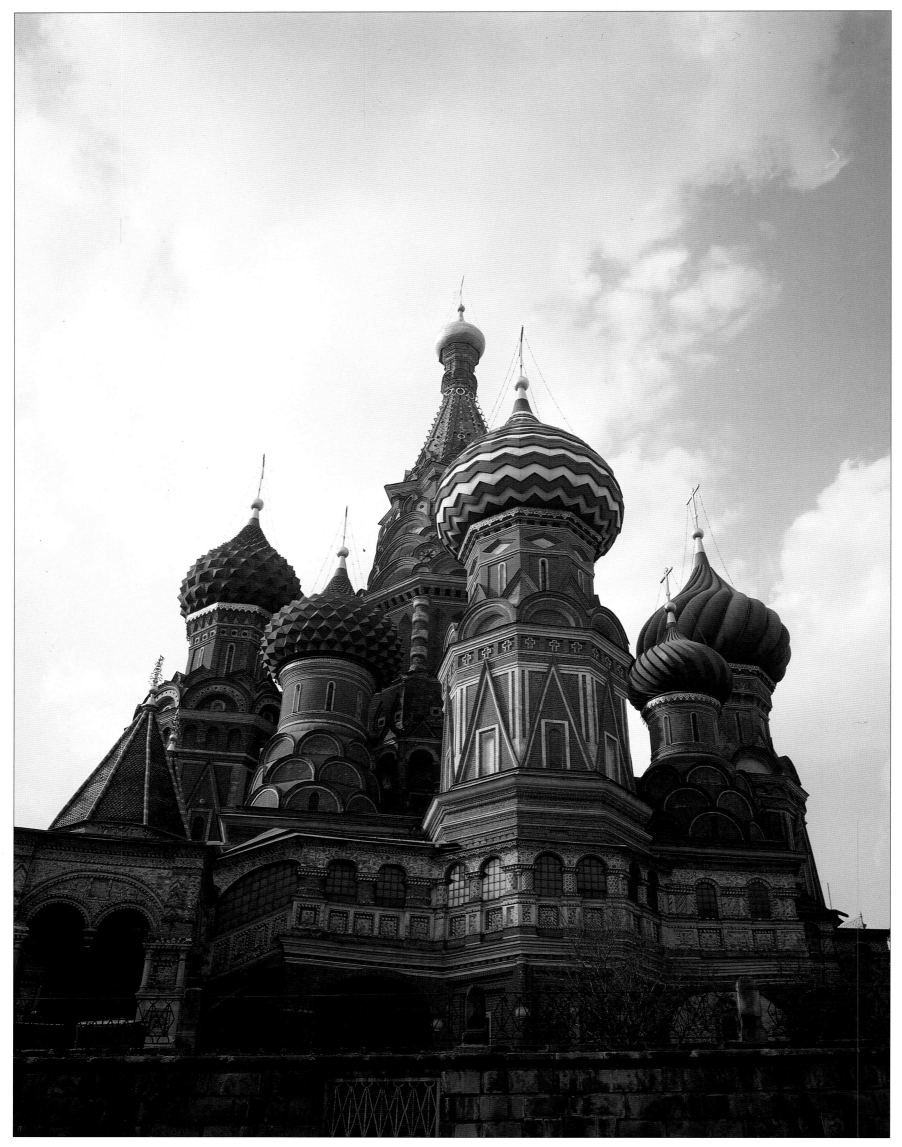

PLATE 1

INTRODUCTION

The term 'Russian style' – or *style russe* – normally refers to a style of architecture and of the applied arts which flourished in the second half of the nineteenth century and which revived the traditions of Russian folk and medieval culture. In a larger sense, however, the term may be applied to the whole movement to express the Russian character and spirit in art – a movement that began around the middle of the eighteenth century and reached the end of its development only with the October Revolution. It is this larger phenomenon that is the subject of this book.

We should make it clear that the 'Russian style' is far from being the same thing as Russian art. At any given period during the course of its evolution it was but one of the styles of the day. And, as we shall see, it assumed a multiplicity of forms. The common thread linking these forms together was the Russian people's need to give artistic voice to their identity.

Initially, in the mid-eighteenth century, the movement was associated with a relatively small number of buildings: churches that combined the Western European baroque style with a Greek, or Byzantine, structure. The movement spread, timidly and haphazardly at first but, during the 1820s and 1830s, with increasing vigour. It reached its peak in the architecture of the second half of the nineteenth century. Towards the end of the century it entered its last phase of development, known as the neo-Russian style – marked by much greater stylization and influenced by art nouveau and other avant-garde trends – which continued to flourish until the revolution and the civil war inhibited its natural development in 1917 – 21.

In order to understand the feelings that gave birth to the Russian national movement in the arts and which nurtured it for more than one and a half centuries, we must first under-stand how sweeping and how fundamental was the cultural revolution imposed on Russia by Peter the Great. This revolution was so abrupt and cataclysmic, the rift that developed between popular culture and the culture of the educated classes so deep, and the whole process implemented so ruthlessly that each succeeding generation has been obliged to return to it and to come to terms with it. A preoccupation with the national culture is common to many countries, but for Russia it became an overriding question in ways uncharacteristic of the rest of Europe.

When Peter the Great became sole ruler of Russia in 1689 the country had already begun the transition from the medieval into the modern period, and a new, secular culture, influenced by developments in Western European art, was evolving. In icon painting, for example, a trend towards a more naturalistic style was well established, while secular portraiture had emerged as an accepted genre. In architecture, features adapted from the Western baroque style were combined with old Russian forms to produce a hybrid, known as Moscow (or Naryshkin) baroque.

The radical nature of Peter's revolution lay in its forcing of a process that was already occurring naturally, as if Russia had to begin its historical development all over again. The nation was to be rebuilt from the ground up, on the model of the Western European Enlightenment, with European science, European art and a European environment in which to live. The old Russian culture and art were effectively discarded. The chosen path of Europeanization entailed a complete change of direction. The tsardom of Muscovy was transformed into an absolute monarchy along European lines: the Russian Empire.

All of this is familiar to Western readers. What may not be

PLATE 1
Barma and Postnik, St Basil's Cathedral, Moscow, 1555–1560.
Commissioned by Ivan the Terrible in commemoration of the taking of Kazan, the Cathedral consists of nine separate churches combined into one coherent whole. The building came to represent the country's heritage and was looked to by artists and architects from the eighteenth century onwards in their search for a specifically Russian identity.

PLATES 2–5

Ivan Bilibin, Four postcards with architectural drawings, 1904.

The life of the Russian peasantry, its customs and its folk art remained remarkably constant, unaffected by the imposition on other classes by Peter the Great of a Western cultural norm. The country was extremely rich in wood and her people have always had a pronounced aptitude for carpentry. These four postcards, taken from watercolours by Bilibin, reflect the inspiration that he drew from his travels in the Russian north, an area where old traditions were preserved with remarkable faithfulness. They show the way in which wood was lavishly used – whole logs were dovetailed together, and roofs constructed from thick, overlapping wooden shingles. Plate 2 shows a typical northern village, with a row of sturdy, high-roofed wooden huts and a simply constructed church with a separate belltower.

PLATE 6

Apollinary Vasnetsov, *Cathedrals of the Moscow Kremlin*, 1894.

This painting, by the gifted architectural landscape painter, shows the main ensemble of the Kremlin cathedrals: the Cathedral of the Dormition (1475–79) on the right and the Cathedral of the Annunciation (1484–89) rising behind the Kremlin wall and towers. The artist has allowed himself some degree of licence in representing the location of the buildings in order to emphasize their imposing structure. Those Russian historians such as Soloviov and Zabelin, instrumental in providing Russians with a sense of their past, have made a point of stressing that, although the builders were Italian, they were required to make a careful study of early Russian architecture, in particular the twelfth-century churches of Vladimir-Suzdal, to enable them to express the country's traditions in their work. The Cathedral of the Dormition, in particular, has echoes of earlier structures. Coronations of the Tsars took place there and it contains the most sacred relics, housing the tombs of metropolitans and patriarchs, the most precious icons, and the robe of Christ, a gift from the Persian Shah Abbas in the seventeenth century. From the mid-eighteenth century, when reviving a sense of national identity became one of the primary aims in architecture, the Kremlin's buildings provided the most obvious models for artists in their search for a sense of national tradition.

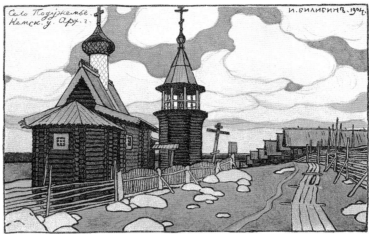

PLATE 2

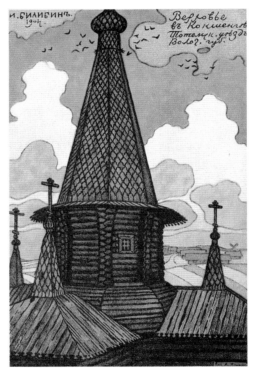

PLATE 3

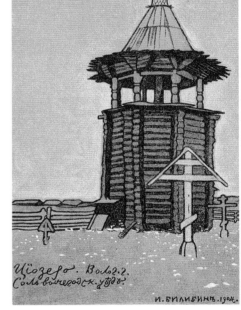

PLATE 4

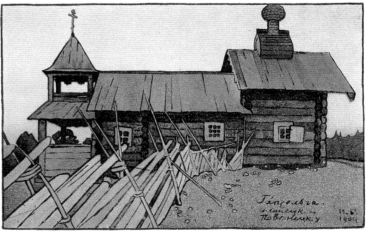

PLATE 5

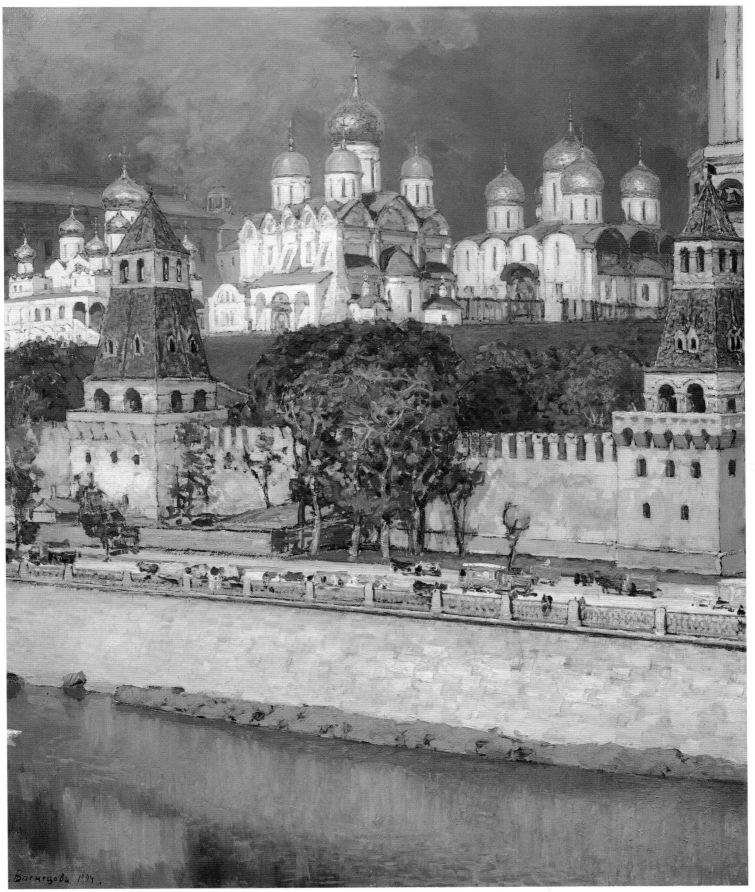

PLATE 6

familiar is that in hacking 'a window through into Europe,' Peter also drew on an age-old Russian view of Rus as the 'Third Rome'. There was a saying that went: 'The first Rome is fallen; Constantinople, the second Rome, has fallen too; Moscow is the third Rome, and there shall be no fourth.' (This belief is evident in the title Tsar, or 'Caesar'.) The concept of the Third Rome was essentially religious – part of the belief that the Russian Orthodox Church was the true embodiment of the Christian faith. In Peter's hands it received a secular reinterpretation. The Third Rome was not Moscow but Peter's new capital (from 1712), St Petersburg. Although the choice of patron saint implied a connection with Christian Rome, the city was more closely identified with ancient Rome's civic and imperial roles.

The building of St Petersburg was the most dramatic manifestation of the new policies concerning architecture and town planning. As the most widespread and visible art form, architecture was allotted a pre-eminent role as a symbol and articulator of the new values. It was the first art form to be subjected to meticulous review by the state, and it was to remain subject to this authority until well into the nineteenth century.

Systematic town planning is the branch of architecture in which the characteristic features of the Russian state's transition from the Middle Ages into the modern period is most fully expressed. The process comprised three main phases. The first, in the first half of the eighteenth century, saw the building of St Petersburg and also of new fortified cities in frontier areas of the south, east and northeast. The second phase, in the second half of the eighteenth century and the first third of the nineteenth, saw large-scale re-planning and reconstruction of old towns and the building of new towns in accordance with the principles of regularity. The third phase, in the second third of the nineteenth century, involved a massive replanning of old villages and construction of new ones, again in conformity with the approved style. The disparagement and discarding of the native culture inevitably pro-duced a reaction in support of that culture. Only a few years after Peter's death, there began a process in direct contrast to what had obtained in the sixteenth and seventeenth centuries, when old Russian culture was assimilating and integrating the techniques, forms and themes of Western European culture in accordance with its own laws. Now within Russia's high-style art, an assimilation began of elements of old Russian culture that harmonized with prevailing attitudes.

The first manifestation of this trend, as we have already noted, drew on the Byzantine, Orthodox heritage; later, the movement was to turn to folk art, both peasant and urban, and to medieval motifs and legends – the latter most evident in painting.

Just as architecture had been the foremost medium for imposing Western culture, so it was in architecture that we find the fullest expression of the national ideal. Initially the Russian trend affected the composition of façades but did not influence the internal organization or finish of buildings. It was only in the mid-1800s, nearly one hundred years after the first moves towards reviving traditional Russian architecture, that interiors, furniture and other applied-art objects began to be designed in the Russian style.

As non-representational art forms, architecture and the applied arts lent themselves most readily to the expression of abstract concepts. This makes it all the more enticing to attempt to delineate underlying similarities and to discover consistent indications of a larger unity and shared artistic and philosophical premises underpinning phenomena which, on the surface, are quite dissimilar. This is why we are going to describe the Russian style not only in relation to architecture and the applied arts but also in the context of painting and sculpture.

As we trace the emergence of the Russian style, we shall show the wealth of forms that ethnic consciousness assumed, in different art forms and genres, in respect of subject matter and treatment, examining themes and motifs that we feel most vividly express the Russian spirit in art.

PLATE 7

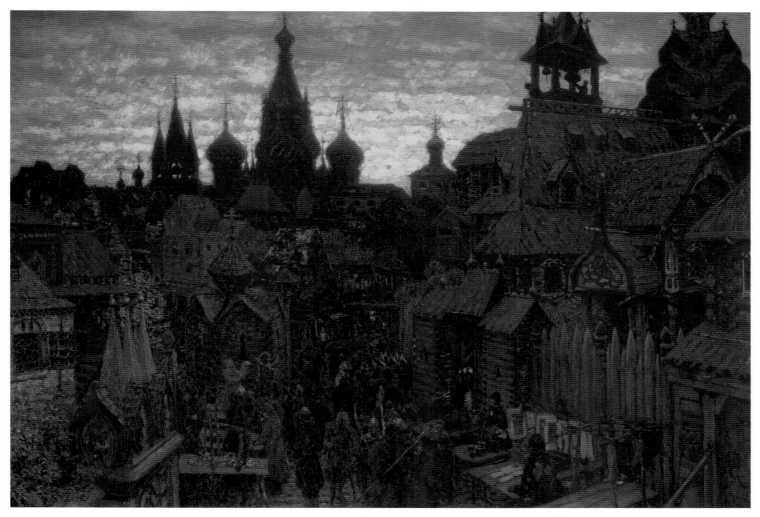

PLATE 8

PLATE 7

Nikolai Roerich, *Building a City*, 1902.
At the outset of his career, Roerich benefited
from the enthusiasm of Apollinary and Viktor
Vasnetsov, and that of their followers. But
Roerich's search took him further. An
archaeologist by profession, he had a vision of
ancient Rus, the 'land of heroes and hermits'.
Many of his paintings depict the dawn of
Russian history and the role of the Varangian
settlers in the formation of a strong Slav state.
He was drawn to the simple structures
predating the seventeenth-century
proliferation of form and full-blown
ornamentation that had fascinated the older
generation.

PLATE 8

Apollinary Vasnetsov, *Street in Kitai Gorod*,
1900.
Apollinary Vasnetsov, fascinated by the
history of the city of Moscow, executed a large
number of paintings or 'reconstructions' of its
former appearance as a wooden city. This
painting shows Kitai Gorod, the Chinatown
or trading quarter of the old city, adjoining the
Kremlin. The narrow pavements are formed of
planks, decorative gateways screen yards and
houses with, rising behind them, gilded domes
and belfries outlined along the skyline. Old
Moscow was at constant risk from fire. Only
the many churches were built from stone or
brick, to reflect their status. Apollinary and his
brother, Viktor, were the sons of a priest and
were instilled with a feeling for the beauty of
Russian religious customs which they sought to
convey through their art. Their feeling for
Russia was more concerned with her legendary
past than with the prosaic affection felt by the
generation of the 1860s.

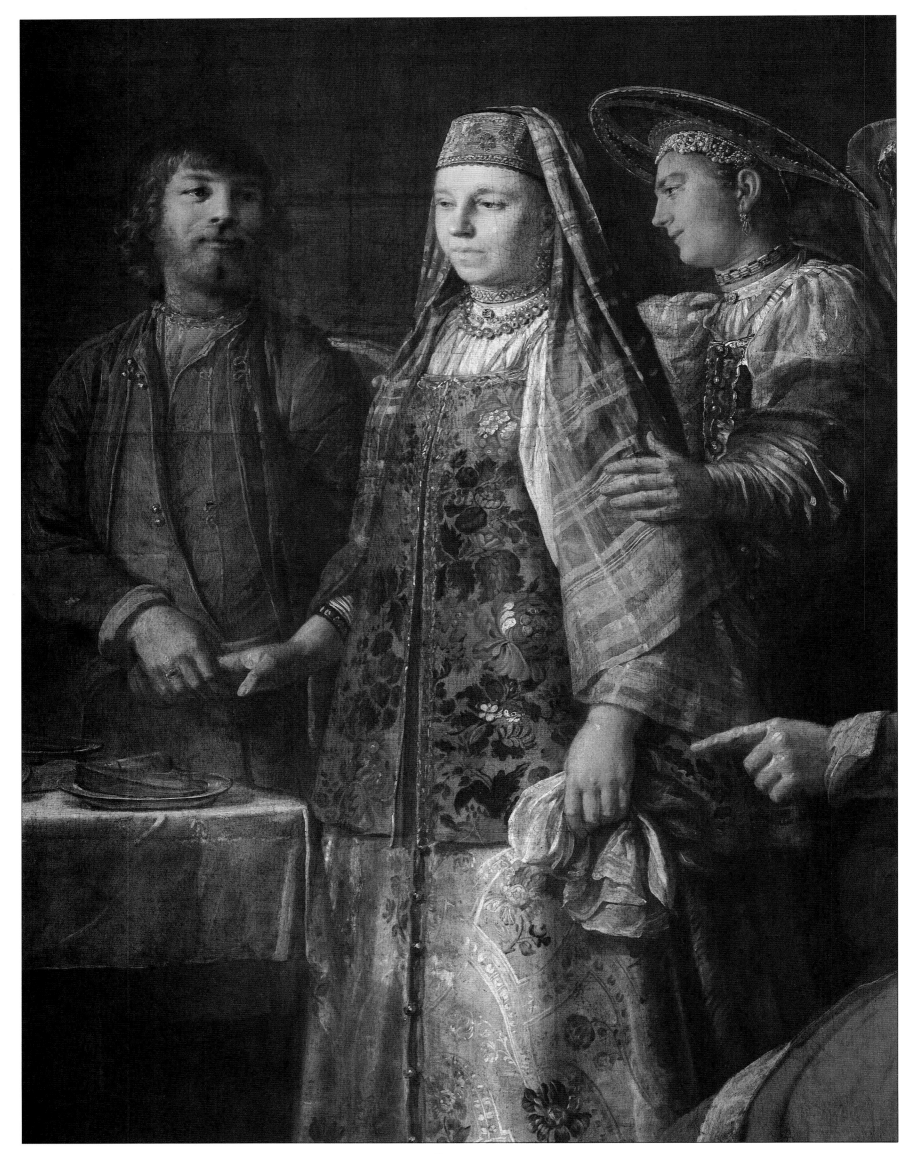

PLATE 9

FIRST ATTEMPTS TO EXPRESS NATIONAL IDENTITY 1750–1825

New Trends in Architecture

It was in architecture that the first tentative moves towards expressing the national spirit began to appear in post-Petrine Russia. These new trends, which emerged around the middle of the eighteenth century, took several forms and drew their strength from different ideologies. However, they had in common one characteristic: they appeared mainly in religious architecture – a clear indication of the crucial importance of the Orthodox faith in giving Russians a sense of their distinctive identity.

Russian baroque churches 'in the Greek manner' The first conscious return to Russian artistic tradition, within the new westernized culture imposed by Peter the Great, took place in the reign of his daughter, the Empress Elizabeth. Her accession to the throne in 1741 – sixteen years after his death – marked the end of an unsettled period spanning four reigns. From 1730 onwards this was dubbed the Bironocracy, after Ernst Johann Biron, the powerful German-born favourite of Empress Anna Ioannovna (1730–40). In November 1741 a palace revolution, supported by the Guards regiments Peter had created, deposed the Regent, Anna Leopoldovna, who was ruling Russia in the infancy of her son, Ivan VI, and placed Elizabeth on the throne in her stead.

The new European Russia Elizabeth inherited had its own, admittedly not very long, history. A new capital city had sprung up, the magnificent and beautiful St Petersburg. In this new culture the policy of actively implanting Western European values continued unabated, but it was now joined by a newly emerging, no less energetic and purposeful movement directed towards articulating the idea that Russia was different from Western Europe. The movement was initiated from above, by the Empress. It was limited in scope, amounting only to a decision to desist from Peter's practice, in St Petersburg, of constructing churches in styles alien to the Russian Orthodox tradition – specifically those with a basilical or a Latin cross plan. There was to be a return to traditional types of Russian churches, whether designed by foreigners or by Russians educated in Western Europe. In mid-eighteenth-century baroque architecture, then, Russianness is understood, quite in the spirit of the Middle Ages, as confessional or, in the Empress's own terminology, Greek (because Orthodoxy had been known in Rus as 'the Greek faith'). This was seen as a return to building in the style of the Greek faith – essentially the Byzantine style, with its characteristic square plan, inscribed with a Greek cross, its cuboid form and its five-domed roof.

Early moves towards the Greek style Despite Peter the Great's enthusiasm for baroque, he did, on one occasion, sanction the use of an old Russian style for an important building – an act that has prompted some historians to see him as the forebear of the movement in the 1740s and 1750s to revive the national tradition in architecture. In 1721 he ordered the construction of a marine cathedral in St Petersburg to commemorate Russia's gaining an outlet to the Baltic Sea. The cathedral was to be dedicated to St Nicholas the Miracle-worker and modelled on the Cathedral of the Assumption in Astrakhan, another port city, located near the Caspian Sea.

Astrakhan's Cathedral of the Assumption is one of the major buildings of early eighteenth-century Russian architecture. It is situated in a major international port near the Volga estuary with direct access to the Orient. The church's important status is indicated by its dedication to the Assumption of the Mother of God – traditionally bestowed on churches intended to symbolize the nation's might. It was natural

PLATE 9
Mikhail Shibanov, *Celebrating the Wedding Contract*, 1777 (detail).

enough, given the similarity of location and symbolic function of the new church, for Peter to choose the one at Astrakhan as a model. Even so, it marked a departure from accepted architectural tradition in St Petersburg during his reign. Unlike the basilical church, with a belfry crowned with a tall spire, typical of Petrine church architecture, the Cathedral of the Assumption in Astrakhan was a cathedral church in the old Russian tradition: cuboid, centrally oriented, having façades of equal status and crowned with five domes. It was just these attributes which came in the eighteenth century to be regarded as embodying the traditions of medieval Rus. In its time, Rus had taken this type of church from Byzantium – or, as was more commonly said at that period, from Greece.

The Cathedral of St Nicholas was ultimately realized by Savva Chevakinsky (1713–83), whose masterpiece it was. In this, as in other churches built at least partly to proclaim secular power, the imitation of the prototype was a highly stylized, largely symbolic matter. It comes down to emulation of the five-domed roof, with grouped pillars at the corners. In Chevakinsky's church the rich modelling of the columns is particularly splendid.

A major part in the evolution of the five-domed baroque cathedral church was played by Domenico Trezzini (1686–1734), an Italian working in Russia, and by one of the first architecture students sent by Peter to study abroad, Mikhail Zemstsov (1686–1743). The great masters of Russian baroque architecture – Chevakinsky, Bartolomeo Rastrelli (1700–71) and Prince Dmitri Ukhtomsky (1719–75) – achieved the highest level of distinction. Their religious buildings are a magnificent embodiment of the 'panegyric' quality which art, and architecture in particular, can convey.

The first tentative moves towards reviving the Greek style – faintly discernible in Peter's plans for the Cathedral of St Nicholas – began to take solid form in 1732, in Smolensk, a fortified city of great strategic importance on the western borders of the Empire. In that year, during the reign of the Empress Anna Ioannovna, work began in the Smolensk Kremlin on an enormous five-domed cathedral.[1]

Everything about this cathedral indicates its importance: its dedication to the Feast of the Assumption, the characteristic attributes of an old Russian cathedral church (the cuboid, compact, free-standing frame of the building, splendidly and completely visible from near and far; the five domes; the

laconic yet expressive outline). This was the first religious building to show an intelligent revival of the national tradition. In this and later cathedral churches designed by European-educated architects of the St Petersburg school, there is a curious interplay. The desire to consolidate Peter the Great's initiatives and continue the process of Europeanization is intertwined with a desire to revive the old traditions. What is of fundamental importance, however, is that revival of the national tradition takes place within the framework of a comparatively new European artistic system, baroque architecture.

The revival gains momentum The Empress Elizabeth's architectural policy developed fully the trend begun under her father and the Empress Anna: a re-interpretation of the Russian Orthodox tradition in order to glorify the state. In Elizabeth's reign it was associated principally with the churches and cathedrals of the Dormition, primarily the Cathedral of the Dormition (completed in 1479) in the Moscow Kremlin. It is a tendency that can be very clearly traced in the Empress's various decrees.

Foremost among the regiments that had helped to place Elizabeth on the throne was the Preobrazhensky Regiment; and in 1743, she commissioned the building of a regimental church in the Preobrazhensky District, 'in that place where Her Majesty assembled the Grenadier Company of the Preobrazhensky Regiment to take the oath of allegiance'.[2] The Empress required that 'the domes be made . . . as the domes found in Moscow on the Cathedral Church of the Dormition of the Most Holy Mother of God',[3] for which purpose the Moscow architect Alexei Yevlashev was instructed to draw plans of the churches of the Moscow Kremlin 'true in scale and description'.[4]

The Empress Elizabeth's policy of reviving the traditional style of church architecture did not betoken any corresponding revival of ecclesiastical power; it was not so much the state which was sanctified by religion – as had been the case before Peter – as religion which received the sanction of the state. This can be seen in the status of the palace church in the imperial country residences. Formerly a separate building, it now became merely a constituent part of the palace. The church at Peterhof, for example, had the exterior of an elegant pavilion and the interior of a grand and palatial hall. Its dome was purely decorative, the interior being roofed over with a vaulted ceiling. In order to preserve a symmetrical effect, the

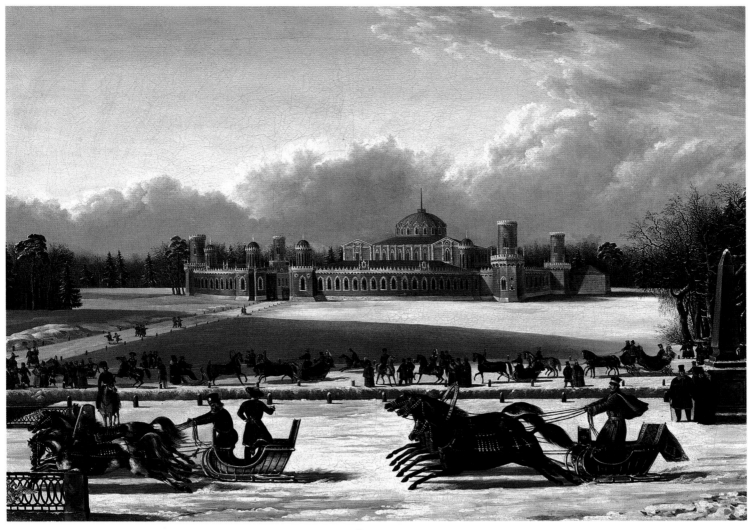

PLATE 10

pavilion opposite was surmounted by a magnificent carved state coat of arms (and thus called the Crested Pavilion). On the orders of the Empress the church of the Tsarskoe Selo Palace, originally designed with a single dome, was given five, while the symmetrically disposed orangery was endowed with a complicated roof with five pedimented crowns.

An especially magnificent Greek-baroque church was inspired by the new interpretation of the cult of St Andrew the Apostle. This had been established in the reign of Peter the Great – St Andrew being associated with his brother, St Peter. *The Russian Chronicle*, compiled by the Kievan monk Nestor in the second decade of the twelfth century, relates the legend that during a visit to Rus, St Andrew foretold a great future for this land, preached the Christian faith and set a cross on the hills of Kiev. Peter established the Order of St Andrew the First-called, the epithet emphasizing Christ's calling of Andrew before Peter, and so indicating the priority of the patron saint of Rus over the patron saint of Catholic Rome.

Work on the Church of St Andrew the First-called began in 1747, on one of the high hills of ancient Kiev. Designed by Bartolomeo Rastrelli, it is a brilliant, festive marriage of baroque and traditional Russian forms, raised on a massive podium, evoking traditional associations of urban fortification. It has the plan of a slightly elongated Greek cross and is crowned by a central dome and onion-shaped lantern,

PLATE 10
Anonymous, *Racing Sledges in Petrovsky Park*, 1840s.
The Petrovsky Palace, seen in the background of this oil painting, was designed in the 1770s by Matvey Kazakov, the leading Moscow exponent of classicism. He was the first Russian architect to draw directly on the indigenous artistic vocabulary in an attempt to emulate the Gothic revival current in Western Europe. Consequently the Petrovsky Palace is a landmark in the development of a Russian style. Borrowing from seventeenth-century architecture prepared the way for directly symbolic expressions of national ideas. It was, however, a long time before Kazakov's experiment in reviving Russian tradition bore fruit.

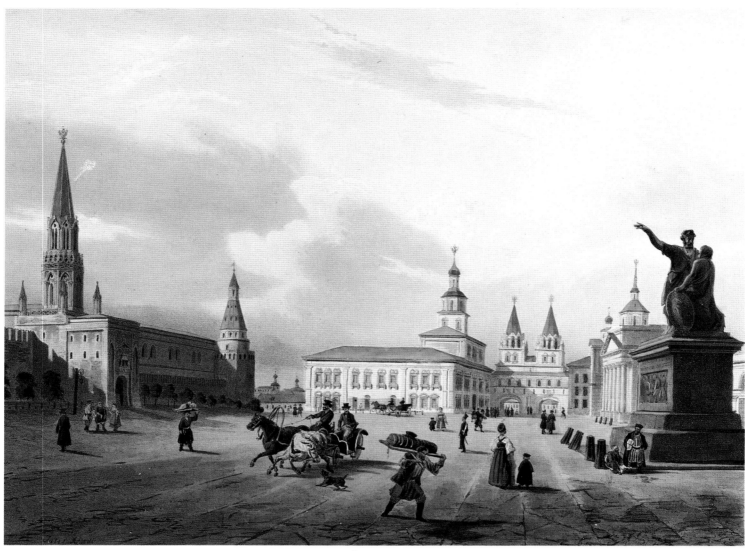

PLATE 11

flanked by four towers, each surmounted by a lantern and rising above clustered columns. Some of its features are clearly derived from the Church of the Dormition on the Pokrov in Moscow (1695–99, architect Pyotr Potapov; demolished 1930). Proof of Rastrelli's purposeful study of the old Muscovite tradition is preserved in the State Library in Warsaw, where his sketches include a plan of this church.[5]

Smolny Convent A major architectural initiative of Elizabeth's reign was the erection in St Petersburg of the great Smolny Convent. The convent's cathedral, dedicated to the Dormition, was designed by Rastrelli and shows an even more exuberantly baroque treatment of the five-domed structure than in St Andrew's, Kiev. The Empress commanded that a bell tower should be erected in the convent, similar to the Bell Tower of Ivan the Great in the Kremlin, and required that 'the cathedral church should be constructed in the likeness of the Cathedral Church of the Dormition [in Moscow], only within and without its adornment shall be that of the Greek church, and not in the manner of Rome'.[6]

St Isaac's Cathedral in St Petersburg was dedicated to Isaac of Dalmatia, the name-day saint of Peter the Great. When it was in need of repair, the Empress Elizabeth insisted that it too be reconstructed with a five-domed roof, thus reinforcing its imperial aspect.

PLATE 11
Anonymous, *View of Red Square*, mid-nineteenth-century lithograph.
Unlike most of the Kremlin towers, St Nicholas Tower (named after the icon of St Nicholas suspended over the gateway), here seen on the left, acquired its *shatyor*, or tent roof, not in the seventeenth century, but in 1780. In 1806 a decorative stone tier with open lancet arches was added, to harmonize with the other towers. The Nicholas Tower was badly damaged by an explosion during the French occupation of Moscow in 1812 and, during the intensive reconstruction work that followed their expulsion, it was further modified. The new design copied that of a tower in Potsdam as a compliment to the Prussian-born Empress, Alexandra Fyodorovna. It was decorated with delicate white stone 'Gothic' ornamentation by the architect Beauvais.

The Grand Style This was now used in St Petersburg even in the construction of parish churches. In 1762 the architect Volkov reported 'on the making of a new five-fold dome and belfry at the Church of the Nativity of the Mother of God on the Nevsky Prospekt' and that 'on the Sampsony Church [built to commemorate the Battle of Poltava, which took place on the saint's name-day] five wooden domes were made and clad with white iron in 1761'.[7] In 1732 the Church of the Dormition on the Mokrush, which had burned down, was restored following the model of the Cathedral of the Dormition in the Kremlin. In 1747 the Empress issued an edict to 'make for approval for the Cathedral Church of the Dormition of the Mother of God, presently being built, a model of a bell tower with five domes after the fashion of that in Moscow on the Cathedral of the Dormition and on other churches'[8] The building of the church was completed in the reign of Catherine the Great, who, like Elizabeth, chose to emphasize the continuity of her reign with that of Peter the Great.

In fact, all of the St Petersburg churches of the mid-eighteenth century directly or indirectly glorify Peter and the continuing viability of his works. Even in religious architecture, which is consciously striving to express indigenous values, the 'Greek' tendency is refracted through the prism of the Roman, state-oriented values. In the proud certainty of its greatness, the representatives of the New Russia saw St Petersburg as a symbol of what had been accomplished.

Moreover, they saw religion primarily as a means of magnifying the state. By employing one or two of the more significant features of the Russian heritage – the disposition of space and aspects of the overall framework of the old Russian church, its cuboid shape, its five-domed roof and its onion domes – Elizabeth's architects endowed their buildings with characteristics of Russian antiquity, while at the same time remaining within the European style, with its overtones of imperial might.

Moscow and the provinces The difference between the architecture of St Petersburg and that of provincial Russia – including the former capital, Moscow – is most strikingly evident in churches. Unlike secular buildings, which were now built in an essentially baroque style, provincial churches had retained their continuity with the past. Thus the context – baroque style – into which the 'Greek manner' was introduced in St Petersburg did not exist in Moscow and the provincial cities. In the provinces Europeanization took its course organically in traditional types of churches, through changes in the treatment of the overall structure and the gradual assimilation of the decoration and order system of Western classically inspired architecture. The most widespread type was a repetition of the parish church as it had evolved at the end of the sixteenth and first half of the seventeenth centuries, with three components consecutively placed on an east–west axis: a bell tower, a refectory or church hall (usually also serving as the winter church, being both smaller and easier to heat), and the church proper. This might follow the compositional style of Naryshkin architecture – a modified form of baroque used for the estate churches commissioned by the noble family of that name and typically consisting of an octagon superimposed on a square; or it might be cuboid.

In Moscow the tall multi-tiered bell tower, which dated from the pre-Petrine period, enjoyed a new vogue. This was the type which, in accordance with Elizabeth's edict of 1747, was to adorn the Smolny Convent complex in St Petersburg. It is difficult to say whether Elizabeth's choice reflected an idea that was in the air, suggested to her by the practice of the Moscow architects, with her command merely giving an impulse to its further dissemination, or whether it was her command that stimulated its new popularity. Whichever came first, the multi-tiered columnar belfry, whether built over an entrance gate or freestanding, with tiers of mighty colonnades, is a characteristic feature of religious architecture of the mid-eighteenth century. The great belfries over the gateways of the Novospassky and Donskoy monasteries, designed respectively by Zherebtsov and Alexei Yevlashev, are particularly striking – as also is the five-tiered bell tower of the Monastery of the Trinity and St Sergius, which became a focus for the whole monastery ensemble. The multi-tiered bell tower proved an exceptionally successful form. Corresponding to the traditional Russian enthusiasm for multiple but independent verticals and roofs, it survived until the October Revolution.

New connotations of the Greek idea The Greek-baroque style of church architecture was to survive right up to the 1830s and 1840s, when it was finally displaced by the Russo-Byzantine style. In the second half of the eighteenth century the belief that Russianness was closely related to the Greek had new life injected into it by initiatives in architecture related to the so-called 'Greek project' of Catherine the Great.

The concept of Moscow as the Third Rome had become popular in Rus after the fall of Byzantium and the occupation of Constantinople by the Turks. The wars against Turkey, begun before Peter came to the throne, and the long-term aim of liberating Constantinople and the Orthodox peoples, remained a principal strand in the country's foreign policy for almost a century. Under Catherine the Great, the idea of Russia as the successor to Constantinople enjoyed one of its periodic revivals. The Empress harboured grand designs. Constantinople was to become Russian; there were plans to transfer the capital of the Russian Empire close to its historical and cultural birthplace, Byzantium. To this end, the city of Ekaterinoslav (now Dnepropetrovsk) was founded in what is today the Ukraine and, according to the historian Markova, 'modelled on Athens'.[9] There, too, the foundations were laid for a great cathedral similar in plan to St Peter's Basilica in Rome, only bigger. Catherine's eldest grandson was portentously christened Alexander, as it was he who was destined to become emperor of Russia. His younger brother, the putative future ruler of Constantinople, was given the equally resounding name of Constantine, and was taught Greek. Near her favourite residence of Tsarskoe Selo Catherine had a new town built which complemented it in composition and appearance, and which was named Sophia. The main church of the town, like the great cathedral in Constantinople, was dedicated to St Sophia and given a number of architectural features, among them the typically Byzantine windows set into the drum of the tower, common to its prototype.

In the first third of the nineteenth century, when neoclassicism was at its height in Russia, the idea of creating a Russian national culture based on that of Ancient Greece – as opposed to Byzantium – was popular. Its champions included one of Russia's most eminent philosophers, the poet Venevitinov. The Church of Alexander Nevsky in Saratov was planned in 1814 as a memorial church to the Napoleonic War of 1812, in forms typical of the Russian Empire, with three Doric-order porticoes to the west, north and south façades, and with an apse on the eastern side surrounded by a semicircular colonnade. In the opinion of its creator, Vasily Stasov (1769–1848), one of the most significant St Petersburg architects of the period, it was built 'in emulation of the ancient cathedrals of Russia. In form it is a cube of 14 sazhens [30 metres (98 feet)], the vaults and cupola supported by four columns in the Trojan proportion'[10] As earlier, we find

that what is associated with the old Russian tradition, going back to Greek origins, is cuboid form, a free field of vision and plasticity of the free-standing shell, and also the four columns: in this case four round, relatively slim pillars modelled on the columns of the Cathedral of the Dormition in the Moscow Kremlin. Just as in baroque architecture, the neoclassical approximation to old Russian architecture is highly selective. There is no attempt to replicate the prototype in its entirety, or the unique originality of its stylistic forms and compositional techniques.

The Gothic style In the 1760s and 1770s, more or less concurrently with the building of churches 'in the Greek manner' and with the flowering of neoclassicism, a new, strikingly different architectural style began to appear in Russia. This was the neo-Gothic style – a Russian variant of the Gothic revival which was then emerging in Western Europe, notably in England. Paradoxically, this international style was to become, in Russia, another expression of the growing desire to discover and assert the special character of Russian civilization.

The first known occurrence of the term 'Gothic' is in John Evelyn's *Diary* (1641–1706; published 1818), where it is used as an antonym of 'classical'. Both terms not only denoted particular artistic traditions, but from the first also carried a connotation of value. The classical was synonymous with the perfect and beautiful, the Gothic with the opposite. Evelyn writes of 'irreproachable' classical architecture, destroyed by the 'Goths or Vandals, who introduced their wanton style, which we may call Gothick'.[11]

Notwithstanding Evelyn's confusion regarding the origins of Gothic, the very fact that the word 'Gothic', with its barbaric associations, was applied to the style indicates the low esteem in which it was held.

By the mid-eighteenth century, however, the term had to some extent lost its pejorative connotations, and the Gothic style was beginning to be admired and even to be copied, with varying degrees of inaccuracy, through parts of Europe, especially in the 'follies' built on country estates. This phenomenon was part of the Romantic movement of the time, one of whose strands was a fascination with Europe's medieval history and culture. The appeal of Gothic for the Romantic mentality lay precisely in its patent, flagrant violation of the norms of the prevailing neoclassical architecture.

In Russia the enthusiasm for the neo-Gothic style was

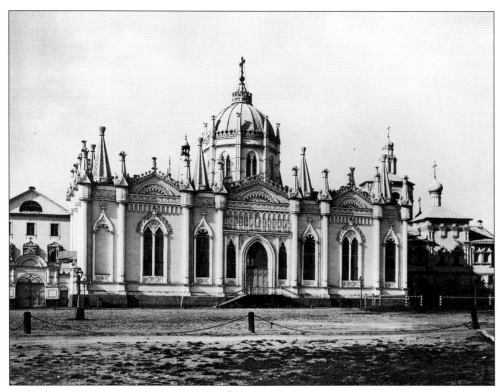

PLATE 12

PLATE 13

PLATE 12
Carlo Rossi, Church of St Catherine in the
Monastery of the Ascension, 1809–17.
In the late eighteenth and early nineteenth
centuries the practice of building or
restoration in kremlins and monasteries in the
'Gothic' style became widespread. Kazakov
designed a new Gothic portico for the
Monastery of the Miracle in the Kremlin, and
in 1798 Nikolai Lvov designed a palace in the
style for the Grand Dukes Nicholas and
Constantine, the younger sons of Emperor
Paul. The practice continued well into the new
century, even when the Kremlin was coming
to be regarded as the symbol of Russia's most
sacred inheritance. Gothic elements were
introduced in the reconstruction of the
Poteshny Palace, the residence of the
Kremlin's governor. The Church of St
Catherine, shown here, has a complex outline
and façades with lavish Gothic ornament. It
enjoyed respect as the burial place of Tsaritsas
and Grand Duchesses in pre-Petrine times. That
a country with no indigenous Gothic should
have so prolonged a flirtation with this style can
only be explained by its perception by the
educated public as the common architectural
language of Europe. Enthusiasts often had no
clear idea of what the style was – the writer
Karamzin even identifies St Basil's Cathedral as
a masterpiece of Gothic architecture.

PLATE 13
Matvey Kazakov, Church of the Nativity of
the Holy Mother of God and of St Anne.
This nineteenth-century photograph
illustrates a more classical variety of Moscow
Gothic than that of the Church of St
Catherine, seen above. Gothic was often
resorted to, in order to maintain a
homogeneity of style between buildings of
different periods thereby avoiding, in the
words of a document of the 1770s, 'buildings
which fit ill with the ancient façades'. In the
distance, on the left, the dome of Ton's
Church of Christ the Redeemer may be seen.
The rounded arches of the central drum of the
Church of the Nativity evoke the Byzantine
legacy.

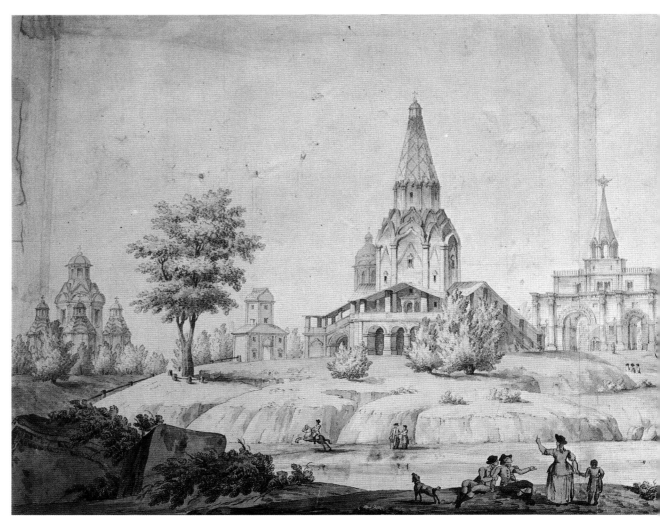

PLATE 14

infused with paradox. To begin with, true Gothic architecture was unknown in Russia – whose own rich tradition of medieval architecture developed from the Byzantine style and from such native Russian innovations as the stepped-pyramid form of church. Thus, it could be viewed as simply another cultural import – the latest architectural fashion from the West – as baroque had been in the late seventeenth century. But whereas baroque had been a new style, Gothic was rooted in the distant past and carried a rich cargo of historical and nostalgic associations. The fact that the style had nothing to do with medieval Russian architecture was beside the point; it evoked the past, and to those Russians eager to recapture their cultural identity, the mere *idea* of the Gothic held an enormous attraction. Moreover, the will to give visual expression to the national sense of identity merged naturally with the sense of being part of the larger movement of the growth of world culture and world history. In it, the national coexisted with the international, the regional with the European.

The general confusion surrounding the Gothic is apparent from the tendency in Russia at this time to apply the word to any ethnic variety of European non-classical architecture. Even the most highly educated people dubbed all pre-Petrine architecture – including for example, the sixteenth-century St Basil's Cathedral in Moscow and Tsar Alexei Mikhailovich's wooden palace in the village of Kolomenskoe, near Moscow – 'Gothic'. The architect Vasily Bazhenov (1738–99) acknowledged with admiration the 'immensity and agreeableness' of

PLATE 14
Giacomo Quarenghi, *The Palace of Kolomenskoe*, 1795.
The wooden summer palace at Kolomenskoe, remodelled and reconstructed for Tsar Alexei Mikhailovich on the site of much earlier buildings, was acclaimed by the court poet of the time, Simeon Polotsky, as an eighth wonder of the world. It was constructed by Russian carpenters using neither saws nor nails, but only axes, and was a demonstration of the high degree of skill of the native artisans. Building

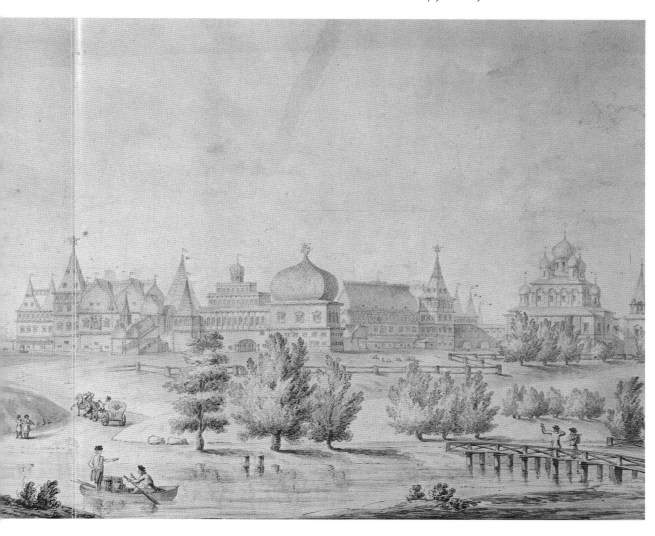

the 'Gothic' buildings of Moscow. Bazhenov was one of the Russian architects who worked occasionally in what could be called the pseudo-Gothic style, and produced some of its most striking buildings; but he never lost his preference for neoclassical architecture. Only classical buildings, he maintained, belonged to the category of the 'regular', because only they had been 'refined into perfect rules'.

The blithe disregard for historical accuracy extended naturally to the buildings that now began to be built in this pseudo-Gothic style. We must remember that at the time, the neoclassical style was dominant, in Russia as elsewhere in Europe. Because the form-building principles of Gothic architecture are so different from those of classicism, it was inevitable that the revival of the Gothic style would be even

more fragmentary and eclectic than had been the classical revival itself. The tendency was to retain the classical plan and basic structure, overlaying them with prominent, readily recognizable features of the Gothic tradition. No one was yet demanding faithful re-creation of prototypes. They were perfectly happy with odd devices and forms torn out of context – showy and easily remembered. The usual assortment was lancet tops to windows and doors, niches, arcades, small acute-angled pediments, and little spires crossed with the Russian *shatyor*, or tent roof, to produce something resembling a phial.

This eclectic approach was characteristic of neo-Gothic elsewhere in Europe. In Russian pseudo-Gothic, however, the mixture was unusually complex and sometimes eccentric,

started in 1666, and was completed within a year. The palace possessed the entire vocabulary of old Russian architectural forms – pavilions with connecting stairways and passages, and every variety of roof shape imaginable, all painted, gilded and ornamented with copper devices. It had three thousand mica windows. The ensemble was set in spacious orchards, producing a magical effect. By the time of Catherine the Great the palace, here depicted in a watercolour by one of her most distinguished

architects, the Italian Quarenghi, had become unsafe. She ordered its demolition, but also had a model made to record its charm. The forms of Kolomenskoe proved to be of great inspirational value to later architects who worked in the Russian style. On the left of this panorama is the seventeenth-century Church of the Kazan Virgin; on the right, the tent-roofed Church of the Ascension; and on the far right, a church built for Ivan the Terrible in 1554 and dedicated to John the Baptist, his patron saint.

incorporating features of old Russian, Byzantine and even Turkish architecture. For example, the picturesque church built on the estate of Chesme, near St Petersburg, in 1777–80, has a quatrefoil plan of four apses, each crowned with a cupola, a central dome, lancet windows, vaguely Gothic pinnacles and white quasi-Gothic tracery on a salmon-pink façade. Bazhenov's Figured Gate, built in the 1780s at Tsaritsyno, an uncompleted pseudo-Gothic palace near Moscow, commissioned by Catherine the Great, combines Gothic arches with *oeil de boeuf* windows, a decorative zigzag pattern around its two towers and a small colonnade of no recognizable order on top.

Building types in the pseudo-Gothic style Whereas the 'Greek manner' had been adopted only for ecclesiastical architecture, the pseudo-Gothic style was used for secular architecture also, although initially it too was employed mainly for churches. These were predominantly the churches built by the aristocracy on their estates. Indeed, the style was primarily associated with this class. They also used it for memorials of one kind or another, mainly to commemorate Russian victories – not only memorials *per se* but also other buildings endowed with this additional function, which might include entrance gateways and towers on perimeter walls. The Gothic-style castle, which was to figure prominently in nineteenth-century British and German architecture, did not become fashionable in Russia. Those country houses that were built in pseudo-Gothic style almost invariably had a classical plan, retaining symmetry in the disposition of structures, a principal axis and regularity of rhythm.

Political and historical connotations of pseudo-Gothic Many of the memorials erected by Russian royalty and nobility in the pseudo-Gothic style commemorated victories over the Turks, with whom Russia was intermittently at war during the late 1700s and early 1800s. This fact gives us another clue to the popularity of the Gothic style among the Russian ruling class: it reinforced an association they saw between themselves and the Crusaders of the Middle Ages. The wars with the Turks were seen as a struggle of Christians against Saracens. Just as the Crusaders had fought to liberate the Lord's tomb and the Holy Land from the Muslims, so now Russia was striving to liberate Greece, the Slavonic people and Orthodoxy's foremost shrine, that of Hagia Sophia in Constantinople, from the same foe. At Tsarskoe Selo, Catherine the Great built a series of monuments com-

memorating Russian victories, in a variety of styles, including a huge column supporting a miniature Gothic pavilion and some pseudo-Gothic gates. At his estate of Gatchina, her son, Paul I, built a small Gothic-style priory, intended as a copy of the headquarters of the Knights of St John, in Malta.

Near Moscow, Count Rumyantsev-Zadunaysky, a hero of battles against both the Turks and the Prussians, built an estate at Troitskoe-Kaynarca, every element of which – the layout, the names of the avenues, the appearance of the house – was intended to symbolize and celebrate his achievements. The house was in the form of a picturesque, asymmetrical medieval castle, complete with battlements and arrow slits; it was named Kagul, after one of his Turkish victories.

On a slightly more modest scale, Pyotr Panin commemorated his capture of the mighty Turkish fortress of Bendery by building a great Gothic-style gateway to the main courtyard of his estate of Mikhalkovo, near Moscow, complete with Gothic towers, fortress perimeter wall and four outbuildings, also in the Gothic taste.

The freemasonry connection The triangular battlements of the towers and outbuildings of Mikhalkovo indicate yet another element in the fascination with Gothic among the Russian aristocracy: the number three has masonic significance, and in Russia at that time almost all the educated and prominent men were enrolled in masonic lodges. In fact, freemasonry was the first unofficial intellectual movement in modern Russia; and in the late 1700s it was at the peak of its influence on Russian social, political and artistic thought. Many of the beliefs of freemasonry are derived from the practices and rituals of medieval masons. The Gothic churches that these aristocratic freemasons built on their estates thus point to a spirit more profound than simply a wish to follow the fashion.[12] No doubt their owners likened themselves to the Great Builder of the Universe, and their buildings to the world of man materialized in stone, reflecting the life of the greater world as a droplet of water reflects the sun.

The Russian Theme in the Fine Arts

Up to the end of the seventeenth century, the fine arts and architecture in Russia had developed in tandem. Now their paths diverged and their roles were reversed. We are talking here about religious fine art and religious architecture, since the fine arts simply did not exist separately from architecture and the applied arts in old Russian or any other medieval art. They

PLATE 15
The Church of the Ascension, Kolomenskoe, 1532.
Erected for the Grand Prince Vasily III, the church represents a new stage in the development of indigenous Russian architecture. Here, the tent shape, previously known only in wood, is adapted for masonry. Whereas in wooden architecture, despite the exterior height, the interior chamber always has a low ceiling and the tower is cut off from the main body of the church, here the building soars upwards over the heads of the congregation. The transition from the octagonal base towards the pyramidal tower is skilfully achieved by a series of tiered arches. This particular church had a central place in the subsequent development of Russian church architecture.

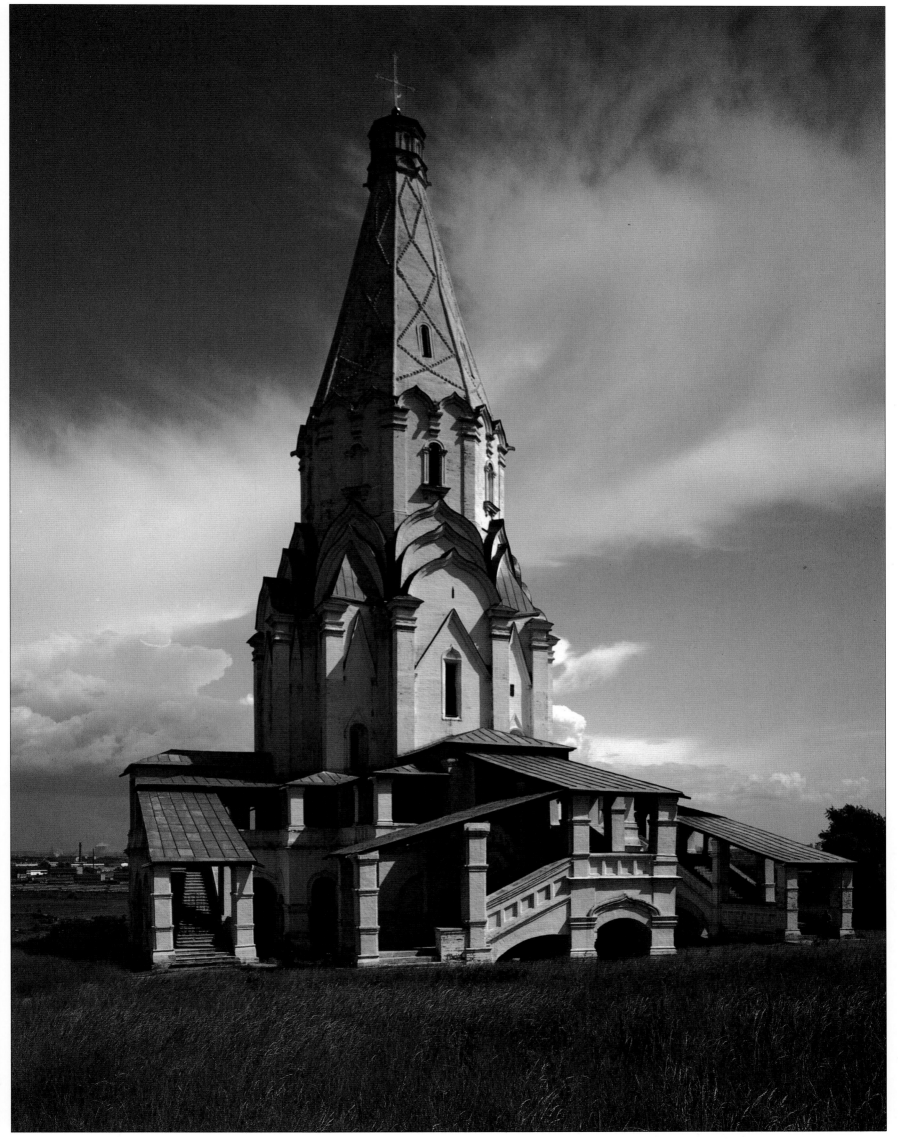

PLATE 15

diverged because architecture, including religious architecture, continued to retain its traditional style-setting role in the arts, whereas religious fine art lost this role for good – apart from a brief revival of religious art at the turn of the nineteenth and twentieth centuries. The situation reflects the declining influence of the Church after Peter the Great and the appearance of something hitherto almost unknown in Russia: secular fine art in a ready-made system of genres.

The Europeanization of Russian fine art proceeded in a materially different way from comparable developments in architecture. Whereas in architecture, old Russian elements were being introduced into Western styles by the mid-1700s, Western European painting and sculpture were adopted virtually intact and remained so until the early 1800s.

Subjects for depiction were the only contribution made by old Russian and folk art to the painting of the period between 1750 and 1850 – subjects retaining a direct link with the pre-Petrine period, such as clothing, utensils, peasant huts and domestic outbuildings, old Russian churches, and the typical Russian landscape.

The hierarchy of genres In accordance with the generally accepted hierarchy of European art, the most esteemed genre, identified with 'grand taste', was the painting of themes from mythology or national history. 'The first duty of those exerting themselves in these subtleties is to depict the history of their country and the likeness of its great personages, monarchs, conquerors and others,' declared Alexander Sumarokov, director of the St Petersburg theatre, at the opening of the Academy of Fine Arts in 1757. 'Such sights kindle the fire of heroism and love of country.' Conversely, scenes of domestic or everyday life were deemed of minor significance. This attitude was common throughout eighteenth-century Europe, but in the case of Russia it had an additional dimension. In everyday life in Russia national originality and national colour, customs, appearance and clothing survived only among the common people – mainly the peasantry. Unlike the townspeople, the peasantry were virtually untouched by Europeanization. Thus, they served as the subject matter for the first attempts to portray Russian life in painting. Only later would the life of the ordinary townsfolk become a subject for depiction.

The folk theme had appeared in Russian painting in Peter's time. These early works depicted peasant 'types', with considerable attention to the details of costume. In contemporary

Russian they were referred to by a phrase meaning, literally, 'the costume type of painting'. In the eighteenth century the theme was understood very broadly as – in the words of one of the most educated lovers and theoreticians of art, Dmitri Golitsyn – a portrayal 'of their morals, characters, fashions, customs, clothing, buildings and all that bears upon their way of life and circumstances'.[1]

An artistic concern with Russian folk life began to appear in the mid to late eighteenth century, as foreigners began increasingly to take an interest in Russia. Foreign painters were the first to depict scenes of Russian everyday life. Between 1757 and 1762 the Frenchman Jean-Baptiste Le Prince (c. 1733–81) created a cycle of engravings of the life of simple Russian folk. In these works he established the range of topics that would later become universally familiar: feast-days, sports, street trading, and representatives of various classes and trades. In 1763 the artist J.-L. Duvailly supplemented a series of drawings entitled 'Descriptions of the coronation of Catherine II' with four Moscow street scenes showing typical buildings and street characters. The paintings of Pietro Rotari (1707–62), who worked in Russia between 1756 and 1762, portray peasants and aristocrats alike in an idealized, lyrical manner.

Theatrical sources Themes drawn from peasant domestic life also appeared in eighteenth-century theatrical art forms: elaborate fireworks displays (an entire Russian village was reproduced in fireworks for one state visit by the King of Prussia), theatre décor and costumes for opera and ballet, masquerades and tragedies. The peasant and historical themes entered these art forms in mid-century, but are not recognized as something with an independent identity. They exist as one element of an environment made theatrical and organized in accordance with the rules of art of the period. The folk theme, folk characters, the unmistakable aspect of the Russian peasant or of old Russian buildings, and Russian costume make an appearance in theatrical productions otherwise remote from any affirmation of the national theme. The main point of interest to us, however, is the very fact of their inclusion.

Another source of the Russian peasant genre painting is *trompe l'oeil*. Introduced from Western Europe in the first half of the eighteenth century, cut-outs painted on wood or metal were placed at the end of an *enfilade* of rooms in palaces, and in parks, and sometimes used as part of a stage set.

PLATE 16
The Cathedral of the Dormition, Vladimir, 1189.
In the background of this photograph one can see the five golden helmet-shaped domes of the Cathedral of the Dormition in Vladimir. This is the seminal building which the Italian architects responsible for reconstructing the Kremlin in the fifteenth century were required to study. The bell tower in the foreground was built in 1818. Here the neoclassical canon has been modified with references to Gothic in an attempt to find a suitable language of form which would successfully blend with the ancient structure in the background.

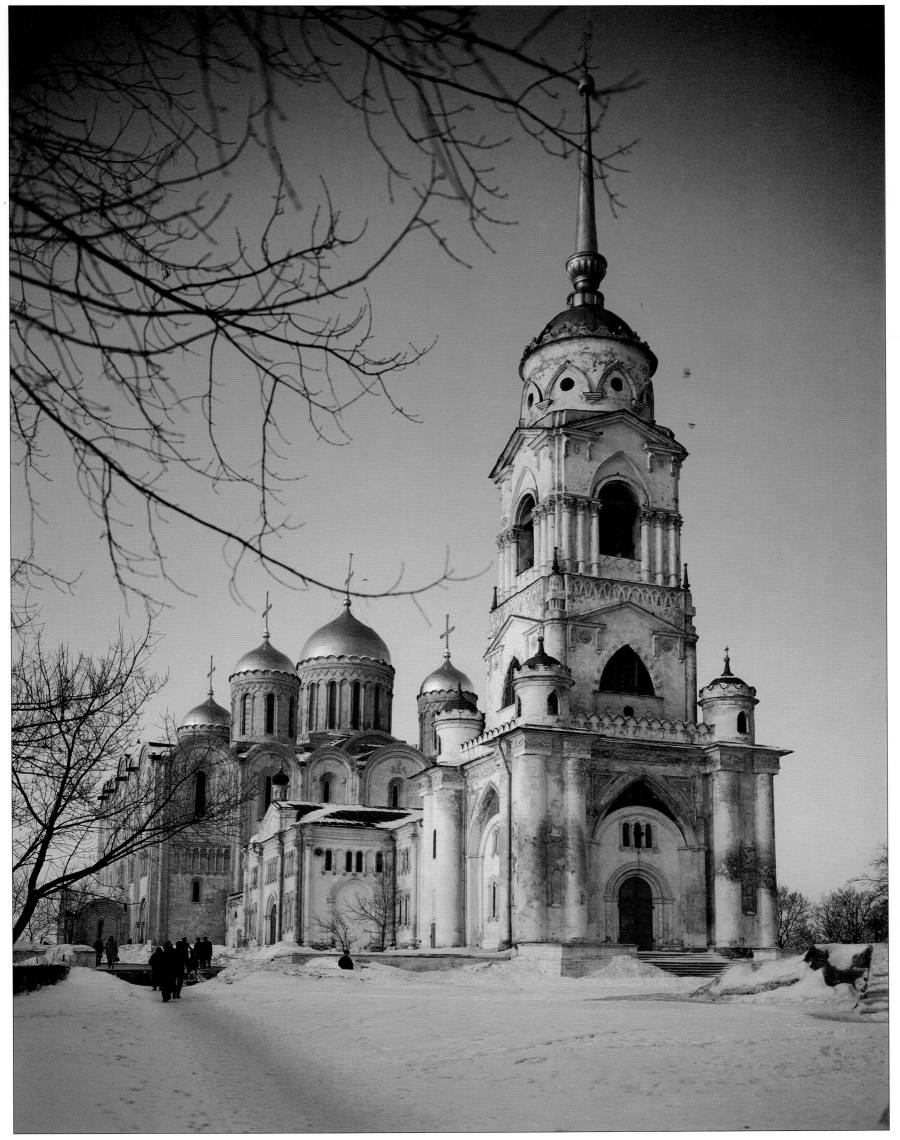

PLATE 16

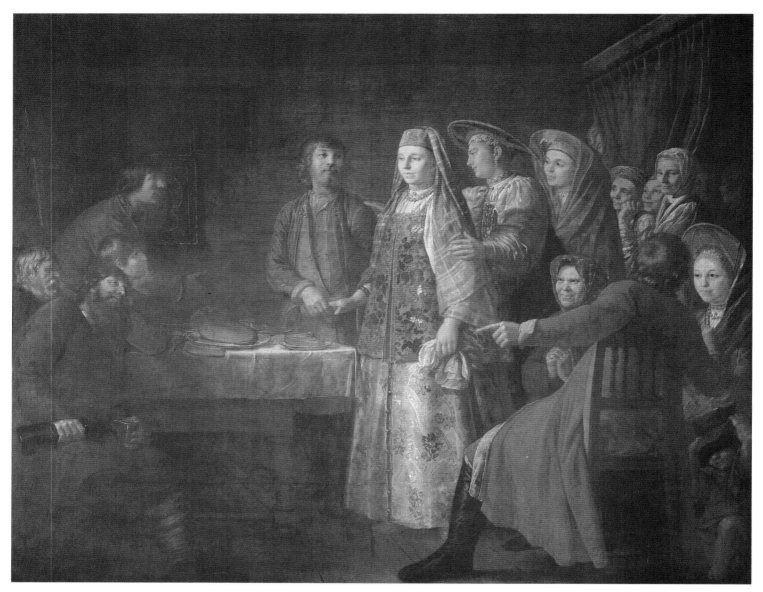

PLATE 17

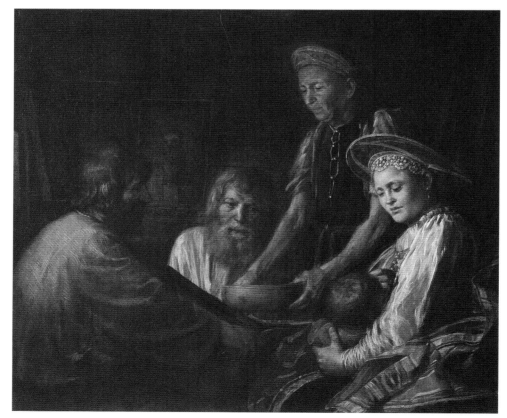

PLATE 18

Some of these *trompe-l'oeil* figures are of ladies and gentlemen; others are of peasants. A collection of them in the Hermitage shows a marked difference in the style used to depict the two classes. The ladies and their cavaliers are painted in the rococo idiom; the style is naturalistic, the poses graceful. By contrast, the figures of folk characters in the same collection – a peasant woman with her distaff, a woman with a child, a bearded peasant in a sheepskin jacket – are painted in a primitive manner – impersonally, as if they were objects in a still life. The costume and accessories are given as much attention as the face. Each figure is separate and inward-looking; even in pairs they have a statuesque, static quality. The generic character of the image and the monumental quality – enhanced by the very medium of the cut-out, with its sharp, spare, expressive outline – were to be carried over into the first Russian paintings on peasant themes.

Yet another source is the depiction of folk life in Western European art – primarily the seventeenth-century Dutch school. In the genre paintings of such masters as Adriaen van Ostade, David Teniers and Jakob Jordaens – as well as those of the Frenchman Louis Le Nain, and the portraits of the Dutch followers of Caravaggio – the life of simple country people is treated seriously and sympathetically.

Not until the 1770s, however, did the painting of Russian peasant life emerge as a distinct and respected genre. This development formed part of a more general growing interest in folk art, stimulated notably by the enthusiasm of Nikolai Lvov (1751–1803), a poet, architect and scholar, and his circle of friends. In 1787 Lvov used folk idiom and folk songs in his opera *The Postdrivers*, written jointly with the composer Yevstignei Fomin. In 1790 he published a collection of folk songs, and in 1791 and 1796 wrote *The Russian* and *Dobrynya*, folk epics using the subjects, motifs and characters of the Russian *bylina* (oral epic) and employing the principles of Russian free verse. Lvov considered that this verse form was attuned to the particular features of Russian and believed it could introduce into contemporary poetry 'more harmony, variety, and expressive movement'. Lvov was not alone in his experiments. Similar attempts were undertaken by Alexei Radishchev, who wrote the poem 'Bova' (1798–9), about a legendary *bogatyr*, and Vasily Kapnist. Nikolai Karamzin attempted stylized folk speech in his epic of the folk hero, *Ilya Muromets*. Besides being included in the comic operas of Fomin, Mikhail Matinsky and

Vasily Pashkevich, among others, adaptations of folk songs were often performed at concerts.

The 'natural man' The movement to return to the roots of Russian folk art was a manifestation of the Enlightenment's discovery – mainly through the writings of Rousseau – of the virtues of the 'natural man'. This widespread sentimental view of human nature celebrated the artlessness, moral integrity, spiritual purity and incorruptibility of the simple folk, who had escaped the baneful influence of contemporary urban culture. In Russia, it was in the city (that 'lair of tigers', as Radishchev expressed it) that the vices and debauchery of the privileged classes were most in evidence. And it was in the towns, also, that Western European culture flourished. To the Russian sentimentalists the culture of the towns, cut off from nature, meant not only aristocratic, but specifically Europeanized culture.

Thus in Russia the cult of the 'natural man' acquired a patriotic or nationalistic dimension. The morally healthy, whole, natural man was not merely the peasant, but the Russian peasant, who alone was able to preserve the exalted moral principles of the Russian people in their pristine state. 'Peasant' became synonymous with 'Russian', and sentimentalism's scheme of oppositions took on a new, ethnic, meaning. The principal opposition became that between the Russian and the Western European, and sentimentalism became the bearer of ideas that had as much to do with national self-regard as with social ethics.

The early stage of Russian peasant genre painting is represented by unconnected but significant works, of which two cycles of paintings, by Mikhail Shibanov (died after 1789) and Ivan Yeremenev (active after 1790), are outstanding for their originality and artistic merit.

Mikhail Shibanov was a serf who belonged to Prince Grigori Potyomkin of Tauris, favourite of Catherine the Great. He painted portraits of the Empress and of her lover, the young officer Dmitriev-Mamonov, in travelling costume, and two portraits of the Spiridonov brothers, in the style of the rococo chamber portrait, all of which show the influence of the most important Russian representative of this genre, Fyodor Stepanovich Rokotov (c.1735–c.1808). It was, however, with two canvases discovered in 1917 that Shibanov entered the history of Russian art: 'A Peasant Meal', on the back of which is an inscription reading, 'This picture depicts peasants of Suzdal Province. Painted in 1774 by Mikhail

PLATE 17
Mikhail Shibanov, *Celebrating the Wedding Contract*, 1777.
PLATE 18
Mikhail Shibanov, *A Peasant Meal*, 1774. During the eighteenth century a number of foreign painters set about recording the peculiarities they observed in native manners and customs. The academic artist Shibanov was among the first to seek to convey accurately the charm of the lifestyle and customs of the peasants without sentimentalizing them.

Shibanov'; and 'The Wedding Contract', also with a lengthy inscription which reads, 'A picture depicting peasants of Suzdal Province celebrating a marriage contract, and painted in that Province in the village of Tatarov in 1777 by Mikhail Shibanov'.

The two pictures are quite exceptional for their time in terms of the accomplished nature of the painting and their unusual subject matter, and they establish Shibanov as the founder of the serious type of peasant genre painting. Subjects familiar in the Western European peasant genre from the works of Jakob Jordaens, for example – the repast, the wedding feast – are here transposed into Russian terms. The events depicted are suffused with an aura of hallowed tradition. A quality of stasis and solemn order informs the pictures and rules out any suggestion of realism. Shibanov's techniques are close to those of icon painting, of which Suzdal is a major centre. The immobile posture of the bride, whose figure is the semantic and compositional focus of the picture, the documentary accuracy and spirit of inventory in which the clothing and headdress are depicted invite comparison with *parsuna* painting – the icon-like secular portraits of the sixteenth and seventeenth centuries – while at the same time the bas-relief quality of the composition is reminiscent of academic historical canvases. Differing tendencies are thus transformed into an epic and monumental whole. The rich, earthy colouring of the pictures, too, is remarkable, especially in the meticulously drawn wedding costumes of the women.

A series of important watercolours by Ivan Yeremenev, depicting blind people and peasant beggars, rival Shibanov's paintings in terms of their unity and power of expression. Their emotional content and figural structure are, however, wholly different. The monumental treatment of the individual figures, their sharp outlines, their solitude and even isolation, suggest the *trompe-l'oeil* of the theatre. Indeed, there is documentary confirmation of just such a link. We know that Ermenev, who was employed to look after the infant Paul I, made figures for a toy theatre for him. Further confirmation comes from the fact that the watercolours were kept in the Hermitage in a folder marked 'Examples of Russian costume'. Such was Ermenev's talent that he was able to endow even such objects as these with a powerful sense of pathos. The impression is further strengthened by the expressive contrast between the light transparency of the watercolours and the heavy, gloomy nature of the figures.

The folk theme is also reflected in the landscape genre, which emerged as a separate trend in Russia in the 1770s. Besides the works of the landscape painter and Academician Ivan Tonkov, who painted broad vistas scattered with small but realistically depicted figures, a number of anonymous works have survived which also show rustic holidays, church festivals, and folk promenades in the countryside. There is more than a suggestion of romanticized utopia in this colourful world of pastoral idyll, with its rustic buildings and the sturdy individuality of the peasant characters.

Portraits In the 1780s and 1790s the folk theme is strikingly present in portrait painting. Notable among these are a portrait of a peasant woman in Russian national costume by Ivan Argunov (1771–1829), and one of a Torzhok peasant woman, 'Khristinya', by Vladimir Borovikovsky (1757–1825). They are simultaneously masterpieces of sentimentalist portraiture, and the high point of the peasant theme in late-eighteenth-century art. Both works belong to the variety of the half-length chamber portrait, which was popular among the nobility. They differ markedly, however, from the norm in their strikingly lyrical quality. In each case, the national costume is a major element in the composition, complementing and enhancing the pure, artless character of the subject herself. These women are not simply individuals but images of an ideal. Spiritual beauty shines through the physical loveliness of their features. They are clearly intended as symbols of the ethical qualities of one part of Russian society and embody the ideal of moral and physical perfection of the Russian people.

Another celebrated Russian portraitist of this period also treated the peasant theme. This was Dmitri Grigorievich Levitsky (1735–1822), who painted a portrait, for the Moscow Foundlings' Home, of a rich freedman and merchant, originally a serf of the Sheremetyevs, N. A. Sezemov, who had donated 20,000 roubles to the institution. Notwithstanding the uncompromisingly Russian dress and plebeian face of the sitter, with moustache, beard and characteristic pudding-basin haircut, Levitsky gives it the full-dress portrait treatment. The 1785 portrait of Levitsky's daughter Agasha seems, however, to succeed in bringing together the features of the paintings of both Shibanov and Argunov. She is dressed in rich national costume, and there is a poetic quality, even a suggestion of *parsuna* painting, in the treatment. The surrounding objects are prominent and depicted as if part of a

PLATE 19
Ivan Argunov, *Portrait of a Peasant Woman in Russian Costume*, 1784.
One of Argunov's finest paintings, this depicts a girl in a sumptuous feast-day costume. There is no clue to the context, but one might envisage her in a number of contemporary roles – for example, as the heroine of Maykov's pastoral drama to music, *A Rustic Holiday, or Virtue Rewarded*, or as a participant in one of the festivals common on the country estates of the nobility, where favourite diversions for the owners were displays of folk dancing and singing, or the games played by serf children.

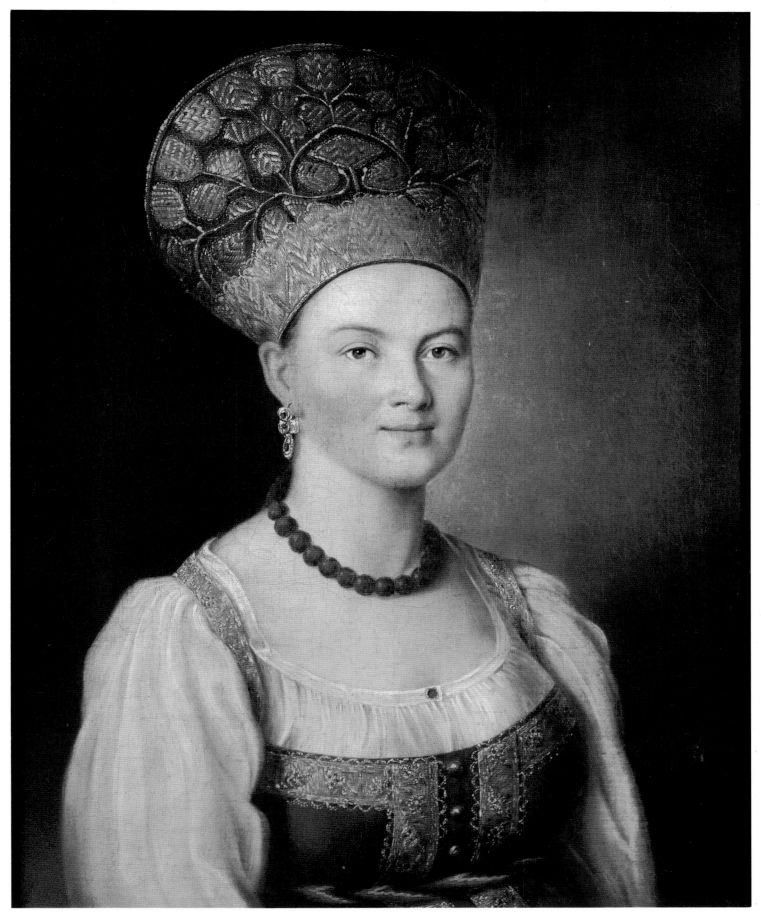

PLATE 19

PLATE 21

PLATES 20 & 21
Carlo Rossi, Designs for peasant houses in the
village of Glazovo, near the Palace of
Pavlovsk, 1815.
These designs are one of the earliest instances
of a professional architect, among the most
prominent classicists of the early nineteenth
century, designing peasant houses in a Russian
style. Yet curiously the arrangement of the
ensemble follows a distinctly classical idiom
with its centre structure (seen in the detail) and

balanced side pavilions. Such conscious design
was quite alien to the asymmetrical organization
of the layout of a typical village. The architect
has adhered to the canons of classicism, while
following the style of Russian peasant building.

still life; Agasha rests one arm on a table with a 'folk' still-life arrangement: a round loaf of bread, a salt cellar and a jug of *kvass* on a brightly coloured tablecloth. Her portrait also resembles works of the peasant genre, and differs from portraits of the nobility in the unusual boldness with which colours taken from icon painting are combined – in this case, an intensely blue *sarafan* (the traditional peasant pinafore), contrasting with a jacket of a warm pink.

To sum up: we find in the late 1700s the emergence of the peasant portrait – a genre derived from costume painting in which the actual element of portraiture is relegated to a subordinate role. Primary importance is attached to the creation of a folk type embodying the Russian ideal of beauty and national character.

Russian Art and the Historical Events of the Early Nineteenth Century

Historical periods seldom conveniently coincide with the beginnings and ends of centuries. For Western Europe the nineteenth century, considered as the age of industrial capitalism and bourgeois democratic revolutions, effectively began not in 1800 but with the French Revolution in 1789. For Russia the beginning of the new century spans a period of thirteen years, between the Patriotic War against Napoleon, in 1812 and the Decembrist uprising of 1825. These two events brought the Petrine period of Russia's history to an end. With it went a host of generally accepted values, including the idea that enlightened absolutism was the ideal form of government. Enlightened absolutism had been seen as a means of uniting individual and monarch in a mutually beneficial system of hierarchies, and the questioning of its value led to a break in the traditional alliance between the autocracy and the gentry. The pre-eminence of the state's opinion on artistic matters, and its patronage of art, ceased to be accepted unquestioningly. Among a whole complex of highly topical problems in need of solution, the most urgent was what attitude to adopt towards the Russian people, Russian life and Russian history.

From the universal to the national The concepts of the People and the Nation were crucial to the nineteenth century. Whereas in the eighteenth century the focus of attention had been the human race as a whole, now interest centred on national and ethnic identity. The historian Nikolai Karamzin (1766–1826) – of whom Alexander Pushkin wrote that 'he

discovered Russia for us as Columbus discovered America' – remarked regretfully on the hidden costs of Europeanization. 'We became citizens of the world but ceased, in some cases, to be citizens of Russia. The fault is Peter's.'[1] This articulation of what had happened did not, however, have any bearing on Karamzin's sense of priorities. For him, as a man of the Enlightenment, national culture was simply not on a par with the universal culture of mankind. 'The particular refinements which constitute the character of a people's poetry must yield to universal refinements. The former are changeful, the latter eternal. A fine thing it is to write for the citizens of Russia, but better still to write for all mankind.'[2]

The next generation of citizens of Russia, the Romantics, were inspired by precisely the opposite ideal: to create for the Russian people. A contemporary writer has remarked: 'A corollary of the demand for folk character, with which European Romanticism begins, was the need for fairly extensive research both into the historical life of each people, and also into the history of the national art and its art forms Thus historicism and folk character merge as the most important principles of art in the Romantics' consciousness. They see them as one indivisible whole, and this becomes the aim, force, and principal stimulus of their creative work.'[3]

Thus although Romanticism evolved in Russia at the same time as elsewhere in Europe, it had, from the outset, quite a different character. The threat of the Napoleonic invasion and the effort of repelling it awakened a strong sense of national cohesion. There was simply nothing in Russia to fuel what was the burning issue for European Romanticism: the tension between the individual and society. Underlying the apparently similar movement of Russian Romanticism is the quite opposite idea of an organic link between the individual, the folk and the nation.

Immediately before, and especially during, the years of the Patriotic War there was a great upsurge in Russia's sense of national identity. 'National awareness was awakened in Russia no longer ago than the great year of 1812,' wrote the literary critic Vissarion Belinsky (1811–48). Not for nothing was the war against the French named Patriotic. The ordeal enabled everyone not only to grasp intellectually the decisive role which the people of Russia had played in shaping her destiny, but to experience it in their very hearts. In the course of the great change of outlook taking place, new social and ethical values evolved which imbued the concepts of folk and

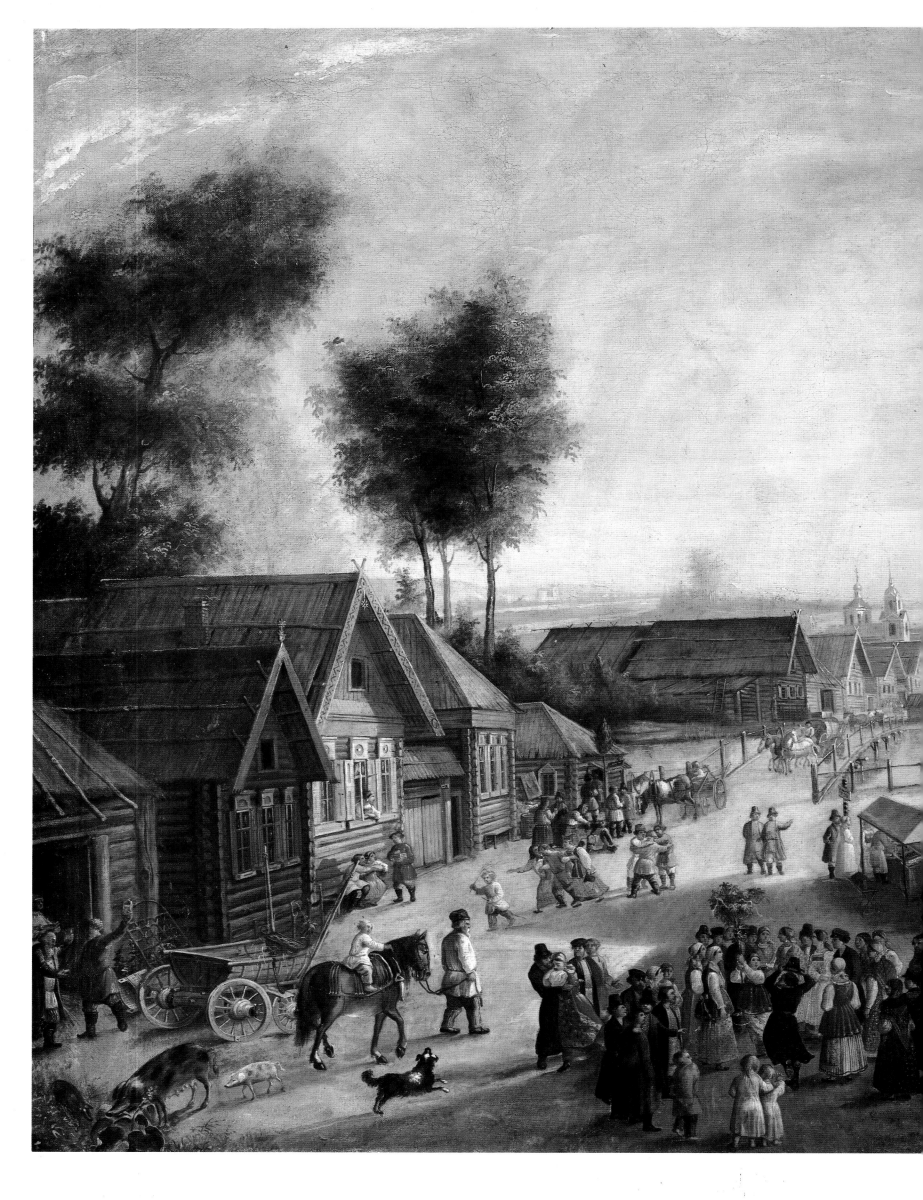

PLATE 23

PLATE 22
Anonymous, *Trinity Day at Tsarskoe Selo*,
mid-nineteenth century.
After Peter's Westernization of Russia,
society existed on two different levels of
consciousness. Despite the secularization of
the cultural elite, life in the countryside
continued as it had for centuries. For the
peasantry, existence was dominated by the
seasons and punctuated by festivals. The rich
and timeless quality of old Russian country life
is well conveyed in this painting. It was to
prove an inspirational source throughout the
second half of the nineteenth century in the
Slavophile search for a national identity.
PLATE 23
Alexei Tyranov, *Women Weaving*, first half of
nineteenth century.

national character with new meaning. The ethos of service to the state which permeated every aspect of the way educated, Europeanized Russia thought about its social role was gradually transformed into a quite different understanding of civic duty: the ethos of service to the people.

This aspect of Russian Romanticism was reinforced by certain features of Russian history. The creation of the Russian state in the late fifteenth century had been instigated by a central authority, Ivan III. The reforms of Peter the Great intensified the process of centralization, but at the same time brought about a great schism – social, spiritual and cultural – in Russian society. Imposed on the people from above – rather than being gradually embraced by them – the Westernization of Russia was one of the underlying determinants of Russian life, even when it engendered a reaction against itself. This reaction aimed to eradicate the division and restore the earlier, pre-Petrine unity of the folk culture. To this essentially cultural problem was added a political question: should serfdom be abolished? If so, how? Was it even possible to restructure Russian society along Western lines? These were all aspects of a larger question. What was Russia's future in history to be? What path of development was she to follow? In other words, the way in which the fate of the bulk of the population, the peasantry, was decided would also decide the fate of Russia, as a nation and as a culture.

The Decembrist uprising Along with the Patriotic War of 1812, the other pivotal event of Alexander I's reign was the December uprising of 1825, in which a group of disaffected army officers staged an unsuccessful coup, aimed at establishing a more liberal form of government. The Decembrists themselves were well aware of the link between the two events, acknowledging themselves as 'the children of 1812'.

In Russia, then, the nineteenth century began with two epoch-making events which changed the destiny of the country and its culture. New Russia's second century, unlike her first, was to take place under the banner of a revival of national culture. The socialist writer Alexander Herzen acknowledged this: 'Every thinking person could see the terrible consequences of the complete breach between national Russia and Europeanized Russia.'[4] The beginning of the new century saw the first signs of a bifurcation in Russian social and artistic thought which, fifteen or twenty years on, would lead to the appearance of Slavophile and westernizing circles,

magazines, and publications. From the mid-1820s onwards the movement to affirm national identity and renew the old Russian and folk traditions in art was associated primarily with the Slavophiles.

The events of 1812 and those of 1825 differed in their effect upon the fine arts and architecture. The war of 1812 gave a tremendous boost to the folk theme in the fine arts – with the increase of patriotism, people ceased to look abroad for artistic influences and concentrated on Russian sources. For architecture and the applied arts, however, it was 1825 which would have the greater repercussions. Following the crushing of the Decembrist uprising, Herzen observed: 'A long, agonizing pause . . . a delay, a holding of the breath, a moral bewilderment, began gradually to resolve itself into the thought that the way forward was to be sought in the folk itself, rather than in the introduction from outside of alien forms.'[5] We shall examine the effects of this new idea later.

Architecture Paradoxically, while this idea was germinating, Russian patriotism expressed itself artistically through a wholehearted espousal of the prevailing European neoclassicism. This trend was evident in the heroic historical canvases produced at the time, in the monumental sculpture and, above all, in architecture. Over the twenty years following the war, not only the flirtation with Gothic, but also all attempts to express the national character in architecture were put to one side. (It was not until the mid-1820s that signs of a revival of the nationalistic trend in architecture appeared, in the form of the Byzantine style.) It was tacitly acknowledged that great events of universal significance, such as the victory over Napoleon, must be commemorated in universally meaningful forms, ordered and classical. It was the spirit of classicism that predominated in the extensive rebuilding work embarked upon immediately after the departure of the French from Moscow, which had been devastated by a great fire. Restoration was completed by 1825, and included a number of classical ensembles of buildings linked by wide, tree-lined avenues. Over the same period, the centre of St Petersburg was turned into an enduring memorial to the Russian victories and the power of the Russian state in the most grandiose town planning initiative of its time. In the new buildings, however, a more severe, spare classicism prevailed. It became customary to use the Greek version of the orders, rather than the Roman, in architecture. The original Doric was especially favoured.

PLATE 24
Alexei Venetsianov, *Harvest Time, Summer*, mid-1820s.
Venetsianov was a landowner of Greek descent, who studied at the Imperial Academy and was strongly influenced by Dutch and French painting. In about 1825 he withdrew to a country estate where he devoted himself to depicting the lives of the peasantry in a fresh and simple way that defied the cold virtuosity of the official academic training. His work is notable for the success with which it conveys the quiet dignity of peasant life.

PLATE 24

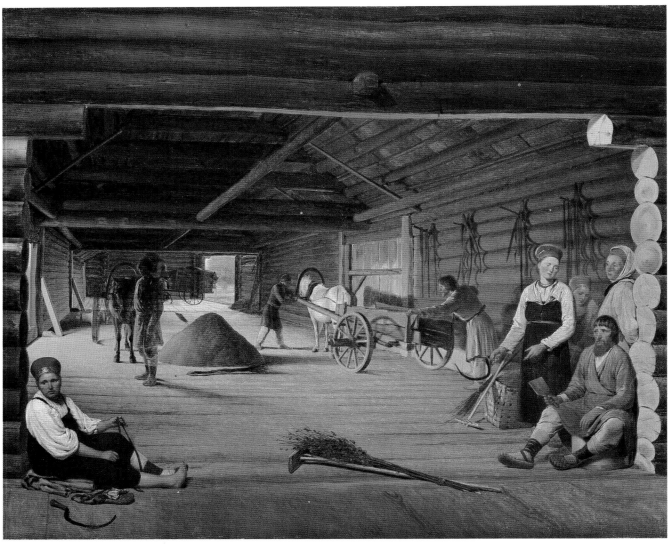

PLATE 25

Although an enthusiasm for classical Greece was common to all of Europe, and to the New World also, in Russia it acquired specifically nationalistic overtones. From the Russian point of view, the country's own national culture could be seen as deriving from Ancient Greece, perceived as the immediate predecessor of Byzantium. At all events, a close link can be discovered between the themes of nationhood, patriotism and heroism in vogue in the first quarter of the century and the first direct turning to the tradition of Ancient Greece in the history of Russian art.

The fine arts Interpretation of the Russian theme in the fine arts underwent a curious evolution. Seen through the prism of emergent Romanticism, classical prototypes were emulated in both painting and sculpture. In the climate of patriotic enthusiasm the members of the Free Society of Devotees of Letters, the Sciences and Arts, founded in St Petersburg in 1803, decided to erect a monument in Moscow to the seventeenth-century heroes Kuzma Minin and Dmitri Pozharsky. Completed in 1818, after the ancient capital had been liberated from the French, the monument came to symbolize two patriotic wars: the war against the Poles, in which Minin and Pozharsky had fought, and the war that had just ended. The monument, by Ivan Martos (1753–1835), is a curious paraphrase of classicism's historical paintings. The

PLATE 25
Alexei Venetsianov, *The Threshing Floor*, 1821.
Venetsianov's search for a mood, and the means
with which to express it, were tireless, and led
him on this occasion to take down one side of a
barn to admit more light into its dim interior.

standing figure of Minin wears a Russian smock that is indeed reminiscent of a Greek tunic, and does not clash with the overall classicist concept behind the work.

The ancient world was seen as embodying ideals of naturalness, freedom and a just civic order; and these, in combination with a heroically elevated treatment of the image of the people, ensured the ascendancy of 'classicization' in the decades immediately following the Patriotic War. In the 1810s the vogue for neoclassicism spread to graphic art and sculpture. A notable example of the latter is the celebrated series of medallions by Fyodor Tolstoy (1783–1873) entitled 'The Patriotic War' (1812). A certain amount of 'classicization' is evident also in paintings and figurines depicting peasants. To sum up, in the decorative, applied and fine arts we come time and time again upon echoes, to a greater or lesser extent, of the Greek fashion in architecture. In architecture, too, the Greek colonnades and porticoes, and use of the Greek system of orders, particularly in the memorial churches which became common in those years, were perceived as a Graeco-Russian synthesis of the universal and the national.

Venetsianov and his School

The awakening interest in Russian folk culture, which we have already noted, gained momentum in the first third of the nineteenth century with the work of the genre painter Alexei Venetsianov (1780–1847) and his followers. It needs to be emphasized that what we are talking about is not the creation of isolated masterpieces, as in the second half of the eighteenth century, when representation of folk life and folk characters acquired an independent value over and above its ethnographic interest. This was, rather, a major movement with its own stylistics, poetics and subject matter, and as such it stood in opposition to classicism. Venetsianov was a major technical innovator, but more than that, he instigated a change in the hierarchy of genres which had prevailed until his time. The struggle with the Academy of Fine Arts to have painting of folk scenes recognized as the equal of the historical genre was to prove prophetic. The further development of the fine arts in Russia would see the domestic genre (including the peasant genre) taking pride of place.

Venetsianov was prophetic, however, only so far as theme and subject matter were concerned. His works proclaimed a conception, born of the Patriotic War, of the people as the moral, spiritual and social mainspring of historical development, and thus worthy of a formal, 'elevated' artistic style. In this respect he had virtually no followers.

Venetsianov turned to the peasant genre after a prolonged and intensive search for his own path in art. In 1818 he came to a turning point, when he became one of the first full members of the St Petersburg Society for the Founding of Colleges on the Method of Mutual Instruction, one of the legal organizations of the Union of Welfare (part of the movement which was later to support the Decembrist uprising), whose aim it was to spread literacy among the 'simple people'. The enlightened members of the nobility were appalled by what a contemporary called the 'complete ignorance in which simple people in our country languish, particularly tillers of the soil'. In that same year Venetsianov left the civil service and St Petersburg to devote himself to teaching painting to young people on his estate, Safonkovo, in Tver (now Kalinin) province. He also provided medical treatment for his peasants, and set up an elementary school for their children. And he began to paint scenes of the countryside and peasant life.

Venetsianov's earlier works had reflected the moods prevalent in progressive Russian society. They were topical, and full of the spirit of criticism and satire. In Venetsianov's socially and ethically engaged work, criticism and satire preceded affirmation; depiction of the city life of the aristocracy preceded depiction of the life of the peasants; the satirizing of Gallomania preceded the poetic depictions of folk life.

In the words of the historian Mikhail Allenov, 'the major event which determined Venetsianov's very conception of genre painting was the great military struggle of 1812. This drew the attention of progressive Russians to the victorious people, who stood before them in an aura of moral greatness and perfection which deserved to be immortalized in art. They deserved immortalization not through classicist assimilation to ancient heroes, but in their own, real, direct individuality. The question which Russian society wanted art to answer was, "What are the underlying positive values on which the life of the people is based; how is it superior to the ephemeral values enslaving man in the dog-eat-dog world of power and civil service careerism?" As a result the interest in Russianness was channelled into the peasant genre. For the same reason it is not a critical genre, and did not concentrate attention on negative, oppressive aspects of folk life. Here, a critical approach would have been not only premature but would even in some sense have detracted from the moral ideal

PLATE 26

PLATE 26
Stepan Pimenov, *Girl Water-Carrier*, Imperial
Porcelain Manufactory, early nineteenth
century.
An idealized figure of a peasant girl who,
dressed in *sarafan* and *kokoshnik*, has some of
the classic simplicity of a Greek sculpture. The
work belongs to the same psychological
climate as the paintings of Venetsianov.
PLATE 27
Baron Mikhail Klodt, *Ploughing*, 1872.
Although this was executed as late as 1872, the
artist differs from his contemporaries, who
were more interested in social issues than in
creating a poetic image of peasant life. In this
respect, Klodt shows himself a lyrical painter,
the natural heir of Argunov and Venetsianov.

His painting conveys a sense of the wide
expanse, even monotony, of the gentle Russian
landscape, qualities later celebrated by Levitan
and Nesterov, and which, in the words of the
writer Count Alexei Tolstoy, impel the Russian
to 'embrace nature, brothers, foes and friends'.
The landscape is, of necessity, a formative
influence in the creative response of architects
and of artists alike.
PLATE 28
Alexei Venetsianov, *Spring Ploughing*,
mid-1820s.

PLATE 27

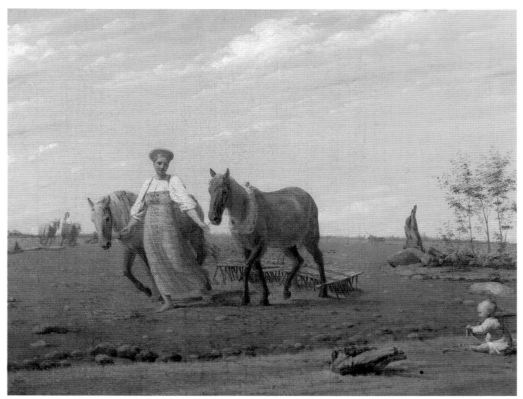

PLATE 28

which the best representatives of Russian society saw as being embodied by the people or, more precisely, by peasant Russia. If it was to be equal to its historical mission, the Russian genre had necessarily to be a poetic and poeticizing genre. That is precisely what Venetsianov's peasant genre achieved.'[1]

Closely related to the ideals and aesthetics of sentimentalism, Venetsianov's peasant paintings are far removed from a mundane genre approach. In rising above simple reality, they may be likened to sentimentalism, with its opposition to the unnaturalness of aristocratic culture to the patriarchal, peasant culture, synonymous with Russian folk culture.

Venetsianov's conception, which sees the people as the prime mover of history and as meriting representation in a historical canvas, shows him to be a typical Romantic. He depicts a world where beautiful people live in complete harmony with nature. It is a gentle, uneventful world. It is life permeated with a strong sense of lyricism. Venetsianov's peasants are unmistakably Russian peasants. Landscape and people are a single, harmonious unity. The merely individual yields to what is universal to all peasants and, by implication, to all Russians. The absence of event from the pictures and the absence of action from the characters seem to pluck them out of the current of real, fast-flowing time. As Allenov has justly said, there are none reaping at the harvest, none ploughing where the field is tilled. This device is a familiar Romantic technique for elevating a 'vulgar' motif. In Venetsianov's pictures peasants are depicted for the first time in the context of their life's work – as people who must toil for a living. The specific detail employed to characterize their life within society is something that has been learned from the more superficial peasant genre of the second half of the eighteenth century. It is supplemented by the depiction of rakes, brooms, sickles, harrows, and distaffs. The implements of peasant labour have a quality at once allegorical and down-to-earth which likens them to the attributes of allegorical and mythical compositions.[2]

The 'discovery' of the peasant as a worthy subject for depiction in high art had something in common with the Renaissance discovery of the secular world; and we find certain features of Renaissance painting – particularly the work of Piero della Francesca – being employed, though in much modified form. Figures are placed in the foreground, enlarged and universalized. If a figure is not in the fore-ground, its size is exaggerated to make it the focal point. To the same end, a large-scale foreground may be juxtaposed with a distant background, the middle distance being omitted. This device was widespread in Renaissance art and popular with the Romantics. As in Renaissance paintings, the distortion emphasizes the significance of what is depicted in the foreground.

The composition of Venetsianov's 'Wet Nurse with Child' evokes the Italian Renaissance Madonna and Child. The same association occurs in the painting 'Harvest Time. Summer', with the peasant woman sitting in the foreground with her infant. The peasant woman leading the horses in the picture 'Spring Ploughing' evokes more complex associations. Her graceful, gliding figure, feet barely touching the ground, seems almost to be hovering, like the figures in Botticelli's 'Primavera'. At the same time, however, this motif of a female figure, disproportionately large compared with the horses on each side, is a symbol of great antiquity in Russian art: the Protectress. This goddess symbolizes the fertile power of the Earth, and is found in every form of Russian folk art: embroidery, weaving, carving and painting on wood. The use of this poetic metaphor exemplifies Venetsianov's original approach, not only to the classical sources of the ancient world but also to folk art.[3]

The treatment of a humble subject in a high compositional manner placed Venetsianov in opposition to the values and teachings of the Academy of Fine Arts. If he was to go forward he had no option but to work out new rules and devise new values. None of Venetsianov's predecessors had had such ambitions or called the traditional values into question. His decision to 'abandon all the rules and modes acquired in twelve years of copying in the Hermitage' and to paint 'without adding the mode of any other artist . . . à la Rembrandt, à la Rubens and so on, but simply, as it were, à la naturelle' testified not to a negation of rules and modes as such, but merely to non-acceptance of the rules and modes of classicism.[4]

Venetsianov's critical analysis of Franz Kruger's rather mundane genre painting 'Parade in Berlin', in which, he says, 'there is nothing of the ideal, the great and inspired such as we find in Raphael's Madonnas', but where there is 'observation of nature', and where 'the personality of each figure is there to see', prompted him to express his own artistic credo. Its crux was the assertion that pictures of ordinary people in tradi-

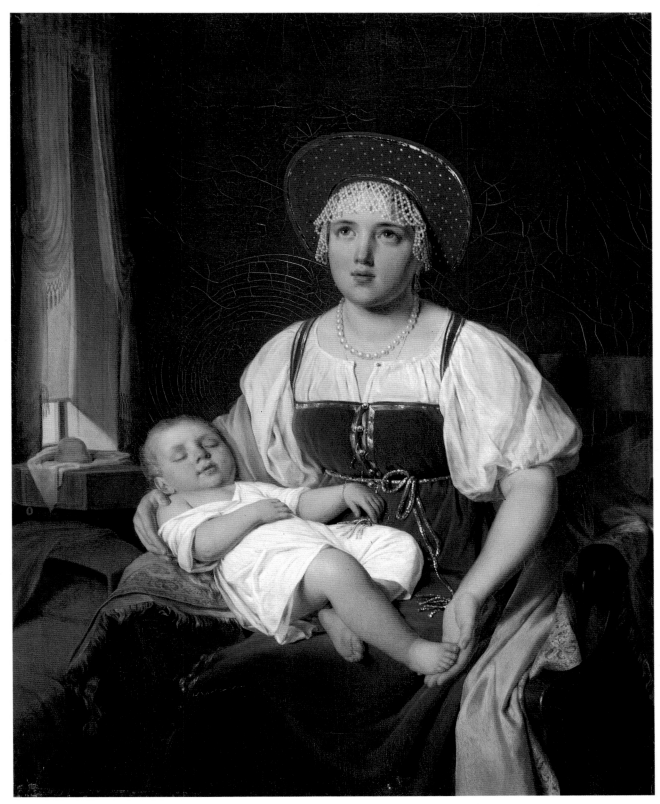

PLATE 29

PLATE 29
Anonymous, *Wet-nurse with Child*, early
nineteenth century.
It remained the custom in Russia for wet-
nurses to wear folk costume even into the
twentieth century. The peasant nurse played
an important role in the lives of Russian
children, whose earliest memories were
formed through the repertoire of old tales and
customs.

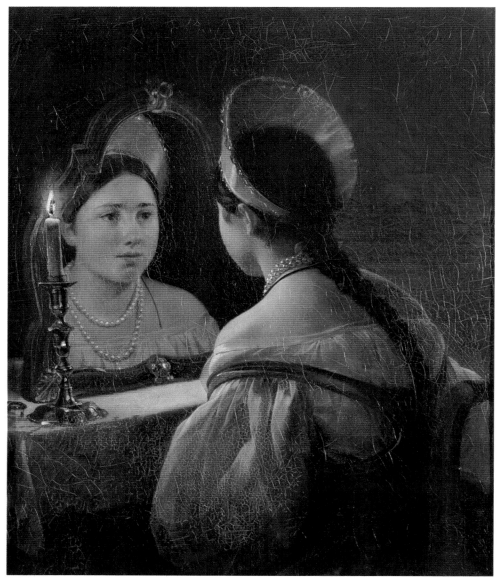

PLATE 30

tional Russian dress belong to the high historical genre. 'I should be much beholden to my fellow artists,' Venetsianov remarked sarcastically, 'if they would resolve for me the question of whether the picture in question belongs to the Historical kind. It would seem that by the laws hitherto accepted it should belong to the Flemish or Domestic kind, but in no wise to the Historical Are we then to conclude that we are not to dare to call historical monuments the statues erected to our great warriors Prince Kutuzov and Barclay de Tolly, sculpted by M. Orlovsky, in which they are dressed in uniforms and greatcoats; that they should be classed as monuments of the Domestic kind'[5]

For people of the 1820s and 1830s, the authentic rendering of costume was of crucial importance. Costume was of major significance in paintings of Russian subjects and became a stylistic token, with very specific implications for the way the image would be accented and treated. The terms of the commission for the monuments to Kutuzov and Barclay de Tolly included the requirement that they be portrayed in contemporary dress, rather than in the fashionable classical

PLATE 30
Karl Briullov, *Svetlana a Russian Girl Telling Her Fortune*, 1833.
The greatest Romantic Russian portraitist of the second quarter of the nineteenth century, Briullov here depicts his subject following a peasant superstition. She stares into the mirror by the light of a candle, hoping to see the face of her future husband.

togas. Indeed, many people agreed with Venetsianov in preferring authenticity in such cases. Alexei Olenin, President of the Academy of Fine Arts, insisted that the sculptor of the warriors for the Narva triumphal arch in St Petersburg, to celebrate the return of the Russian troops after the taking of Paris in 1814, should depict them in contemporary clothing.

The times demanded that art should express the spirit of the people, adhering closely to what a contemporary observer called 'geographical and chronological truth in physiognomy, dress and accessories'. This affected even painters whose creative interests lay elsewhere. For example, Karl Briullov (1799–1852), who had painted a celebrated historical canvas 'The Last Day of Pompeii', as well as magnificent portraits, also painted 'Svetlana: a Russian Girl Telling her Fortune before the Mirror', based on a famous ballad by Vasily Zhukovsky, in which he envisaged her in full folk costume.

Venetsianov's characteristically poetic and epic interpretation of peasant subjects was continued by his pupils, including Alexei Tyranov (1808–99), Nikolai Krymov (1802–31) and, particularly, Grigori Soroka (1823–64). With few exceptions, however (Soroka, for example, or Krymov, who died young), his pupils introduced substantive changes into genre painting – not only in subject matter but also in the manner of realization. This started off as what seemed to be only a minor shift of emphasis. What had been primarily a peasant genre changed into depiction of the humdrum life of the urban lower orders and middle strata of the population: officers, would-be intellectuals and the like. As the conceptual framework of a patriarchal world was left behind, so the view of life became more complex. The emphasis shifted from the peasant life – taken as a symbol of Russia itself – to a more detached interpretation of Russian society, with all the diversity of professions and classes which that implied. The paintings of Pavel Fedotov (1815–52) typify this trend.

Graphic art In the early nineteenth century graphic art played the pioneering role in developing the folk genre. The vehicle was mass-circulation printed illustrations which realistically portrayed everyday life. Genre graphic art was contemporaneous with the first peasant genre paintings of Venetsianov. *The Magic Lantern*, a magazine published in 1817, included etchings suitable for projection, portraying, for example, 'The Spectacle of St Petersburg Itinerant Vendors'. Each page showed one or two characters in their everyday dress, together with the goods they sold, such as a woman selling berries from a bast basket and a dairymaid bearing a jug on a yoke. This documentary approach to the depiction of chimney sweeps, pedlars and other colourful characters from the city streets found its way into formal painting and into applied art, particularly in the form of porcelain figurines. The variety of types represented in magazines and periodicals continued to increase, and the sheets became more complex in their composition. We may instance the illustrations to two collections of essays and articles: *Physiological sketches*, which the poet Nikolai Nekrasov edited in 1841, and *Our own folk, drawn from life*, St Petersburg, 1841, illustrated by Vasily Timm (1820–95). The latter's Russian art sheet, published between 1851 and 1862, became extremely popular, evolving into a curious cross between an illustrated chronicle and an encyclopedia of Russian life.

The first half of the nineteenth century saw a democratization of the Europeanized fine arts of Russia – not only of their themes but of the art forms themselves. Woodcut printing enjoyed a great revival with the adoption of a cheap way of producing printed illustrations for mass circulation, the design being applied lengthways along the grain.

With magazines and books of the 1840s aimed at a mass readership, the golden age of the illustrated publication began. The art form with which the average reader was most at ease was the *lubok*, a popular woodcut, in which text and illustrations were given equal importance. The illustrations became enormously important in mass-circulation magazines and books, which differed from those of earlier times in their larger format and in the fact that the composition of the page commonly included not only pictures but also ornamentation such as illuminated initial capitals, framing and head- and tail-pieces. Books shook off the severe influence of neoclassical architecture and acquired a newly decorative, colourful look. One result of the mass market for woodcuts and lithography, which included a vogue for views of St Petersburg, Moscow and other towns, was a revival of the style of the *lubok* woodcut in the manner and formal idiom of illustrations. It breathed new life into some of the design features of manuscript and old printed books and, to some extent, of frescoes and icons. The old hagiological icon, with its large central image and smaller side illustrations, engendered a single illustration which usually combined several scenes occurring in different times and places. Like

the icon's side illustrations, these were complete in themselves but were also an integral part of a larger design. An ornamental border of natural forms or architectural motifs framed each scene, both integrating it and forming a complex but unified illustration.

By the second quarter of the nineteenth century, of all the fine and applied arts, only mass-circulation graphic art demonstrates a typological kinship with architecture and the structural revival of the old Russian and folk art tradition which we met when considering the design of churches 'in the Greek manner'. We shall meet this kind of deeper kinship again when we examine how architecture reverted to the design traditions of old Russian building between the middle of the nineteenth century and the beginning of the twentieth.

The Russian Costume Portrait

We must now break our chronology and return to the beginning of the eighteenth century, in order to demonstrate the kinship of some aspects of art that seem at first sight to be unrelated. We shall be talking about dress and about a particular kind of portrait, the costume portrait – specifically the portrait in Russian national attire.

The very wearing of Russian dress was symbolic of adherence to particular ideals. Since earliest times, the way people dress and adorn themselves has had symbolic value. Clothing, headgear and jewellery have traditionally proclaimed the fact that a person belongs to a particular social class, and even that he or she holds certain political beliefs.

Thus it is not surprising that among Peter the Great's edicts reforming Russian society there was one stipulating Western attire. By changing his subjects' appearance, as well as their environment, he declared manifestly that Russia was embarking on a European path of development.

Issued in January 1700, the edict required 'boyars and members of the royal entourage and noble lords of the Council of Boyars and members of the Court and butlers and scriveners and Moscow nobles and government officials and townspeople and all ranks of service and clerical and trades people and servants of boyars in Moscow and in other towns, to wear Hungarian clothes' (Hungary was generally regarded as possessing an 'advanced', Western-looking culture).[1] A further edict, issued in August of that year, commanded 'all manner of persons' – other than the clergy, carters and peasants tilling the soil – to wear Hungarian or German dress;

another stipulated French dress for feast-days. Again and again Peter forbade the wearing of traditional Russian dress: 'No person whatsoever shall wear Russian dress nor Circassian kaftans, sheepskin coats, trousers, boots or shoes, nor are artisans to make them, neither are they to be sold in the markets.'[2] Strict supervision ensured that the orders were obeyed, and failure to conform was punished severely. At first adherents of the old dress were fined, but later the wearing of Russian dress or a Russian beard was punished by exile to hard labour and confiscation of property.

A quarter of a century later, towards the end of Peter's reign, European dress had become part of the way of life of Court society and the Russian nobility in general. At Court and in the civil service the style of dress continued to be strictly regulated, including the fabric, colour and ornamentation. In 1782 alone, three edicts were issued by Catherine the Great on the subject of which dress was to be worn on which days by persons of either sex upon their attendance at Court. On major holidays ladies and gentlemen were permitted to wear gold and silver Muscovite brocades, and on other holidays and other days silken materials of all kinds; gentlemen were allowed also to wear wool.[3]

Among the bulk of the population, however, even the draconian measures implemented during Peter's reign were unable to undermine loyalty to Russian dress. Merchants and townspeople generally remained loyal to the traditional culture, and so continued to wear Russian-style clothes.[4] In a famous description of St Petersburg at the end of the eighteenth century, the scholar Ivan Georgi noted: 'Among those of the merchant class the greater number retain the ancient attire to this day . . . the old dress affected by the wives of merchants and townsmen is: a long gown, the "sarafan", a warm short jacket, the "dushegrey", of brocade, silken and cotton material, faced with gold or silver . . . lace or braid, with silver or gilded buttons, closely spaced at the front from top to bottom: they wear the semicircular "kokoshnik" headdress, the married woman's headdress, with caps beneath, little fur coats, and hats and shoes.'[5]

Peasant traditions Right up to the beginning of the twentieth century, the peasantry – especially the women – clung to their traditional style of dress. Even in Peter's time the peasants were permitted to wear a beard and moustache, and the peasant women to wear a plait. The men continued to wear kaftans, smocks and the old trousers, and the peasant

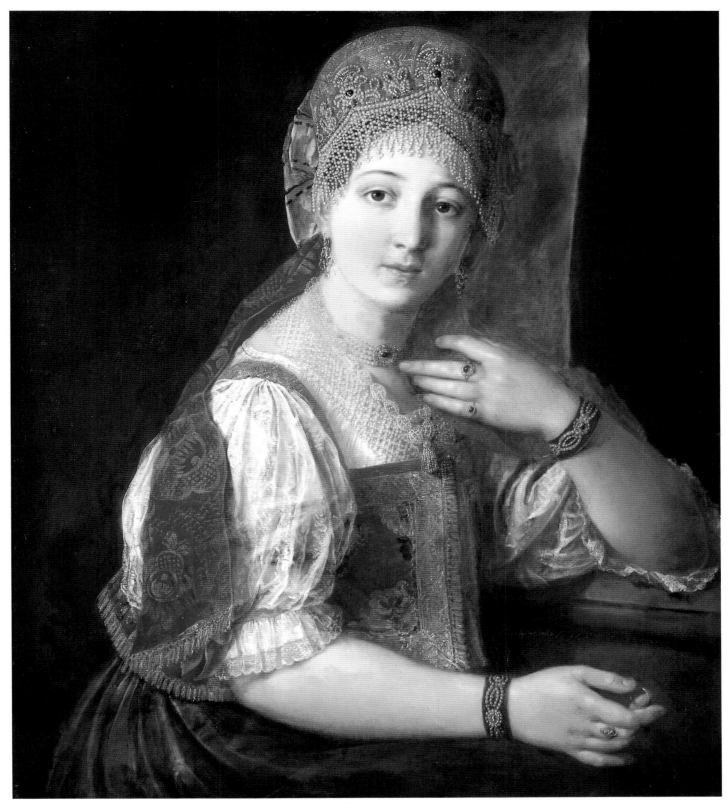

PLATE 31

PLATE 31
Nikolai Alexeev, *A Young Girl in Russian Costume*, 1837.

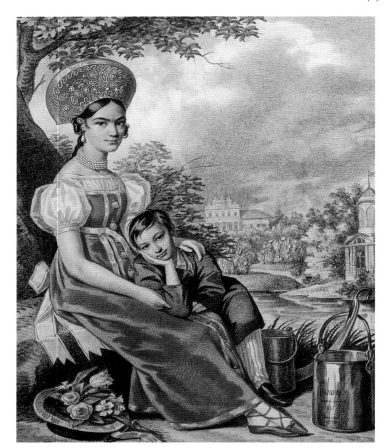

PLATE 32

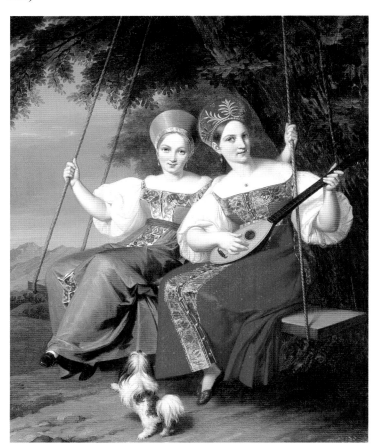

PLATE 33

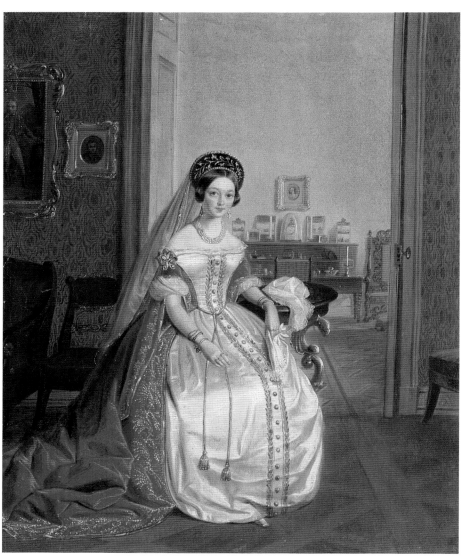

PLATE 34

women to dress in *sarafans* and smocks; and traditional headgear and adornments were retained.

The most widespread ornamentation was buttons, an essential feature of outer clothing for men and women alike. *Sarafans* and kaftans were fastened by a row of closely spaced wooden or tin buttons. The women's feast-day smock fastened at the bosom with a large silver stud button. The principal adornment for women was a necklace – usually of several strands – made of large beads of glass, wood, or sometimes pearls. The peasants' headdress for feast-days was elaborately embroidered with beads, and in the North, particularly wealthy peasants and merchants wore river pearls.

Pearls deserve a word of their own. Embroidering with pearls was very widespread in Russian applied art from the earliest times. The clothes of the great were patterned with pearls, and pearls adorned many items of secular and religious regalia. The rivers and streams of Northern Russia abounded in freshwater oysters. The small, irregular pearls they produced made a beautiful adjunct to the distinctive folk costume that women wore on feast-days.

With the new interest in the peasantry as the guardians of Russian tradition, it was natural that portraits of peasant women, in their colourful folk costume, should come to express the ideals of sentimentalism, with its affirmation of the 'natural' equality of people, whatever their social origins. Such portraits became a way of expressing Russianness in painting.

Russian dress at Court Another manifestation of interest in folk costume had already begun to appear during the reign of Catherine the Great. This was the introduction of Russian dress at Court – worn only for particularly grand occasions. It was a small, but highly symptomatic innovation. Only recently the wearing of Russian dress had incurred punishment and persecution. Now it came to stand for qualities regarded as particularly important for the ethos of the state. According to an article in the periodical *Russian Archive*, published in 1870, towards the end of her reign the Empress not only had a decided preference for Russian dress, but 'possessed no other kind of festive costume'.[6] The ceremonial Court dress combined the forms of the dominant French fashion (the dress parted in front to reveal a petticoat beneath) with elements of old Russia (a suggestion of the *sarafan* gown, the sleeves thrown back and open armholes). It was completed by ornamentation typical of folk costume and by a

headdress in the form of a low semicircular *kokoshnik*, as worn by married women, or a maiden's sickle-shaped *povyazka* headband, both embroidered with pearls.

In the early nineteenth century, with the quickening interest in Russian tradition generally, the fashion for Russian costume received a new impetus. This applied primarily to women's clothing – men's clothing, in Russia as elsewhere in Europe, becoming increasingly sober. But whereas in Catherine's time the trend for Russian-style dress was prescribed from above, something restricted to Court circles for feast-days, now it emerged as a more subtle Russianizing of Western fashion, generally adopted by the nobility. Fashionable dresses, draped and high-waisted, in thin materials, took their inspiration jointly from classical Grecian sources, and from the basics of Russian folk costume such as the *sarafan* and the smock. Jewellery also changed, and here too the influence of folk traditions was clearly in evidence. In place of elaborate parures of precious stones, fashion now decreed necklaces of several strands of pearls, pearl earrings, *kokoshnik* headdresses and *povyazka* headbands embroidered with pearls, and also pearl bracelets and diadems.

With changes in the social mood, the interest of Russian educated society in folk dress revived periodically throughout the nineteenth century. Although in the towns the process of Europeanization of dress was irreversible, traditional costume could be seen in at least two strikingly different contexts: at Court, where it continued to be worn at grand receptions, and in noble households, where it was worn by wet nurses. As late as 1866, Théophile Gautier remarked, of a visit to Russia, 'Just as you are about to complain of a lack of quaintness in the clothes people wear, a wet nurse passes by. The formal dress which the grandest ladies wear on special occasions at Court is cut to the same pattern and, sparkling with diamonds, contributes in no small measure to the sumptuousness of the occasion.' The custom for noble families to retain a wet nurse in national costume, which was as common in Spain as in Russia, struck the romantic Gautier as symbolic. 'One might fancy that civilization, whose development banishes national colour, is exercised to leave its children at least some memory of it. Here, then, they bring the children a woman in the old national costume. She is, as it were, the image of their motherland.'[7]

In 1834 Nicholas I issued a decree on the creation of formal dress in the Russian manner for ladies of the court. Here again

PLATE 32
Karl Gampeln, *Portrait of a Young Woman and Child*, 1827.
This colour lithograph is taken from a watercolour by Gampeln.
PLATE 33
E. Jakobs, *Two Girls on a Swing*, 1835.
Painted by a German artist, this is an outsider's romantically sentimentalized view of a Russian subject.

PLATE 34
Anonymous, *Portrait of Princess Obolenskaya-Neleditskaya-Meletskaya in Russian Court Dress*, mid-nineteenth century.

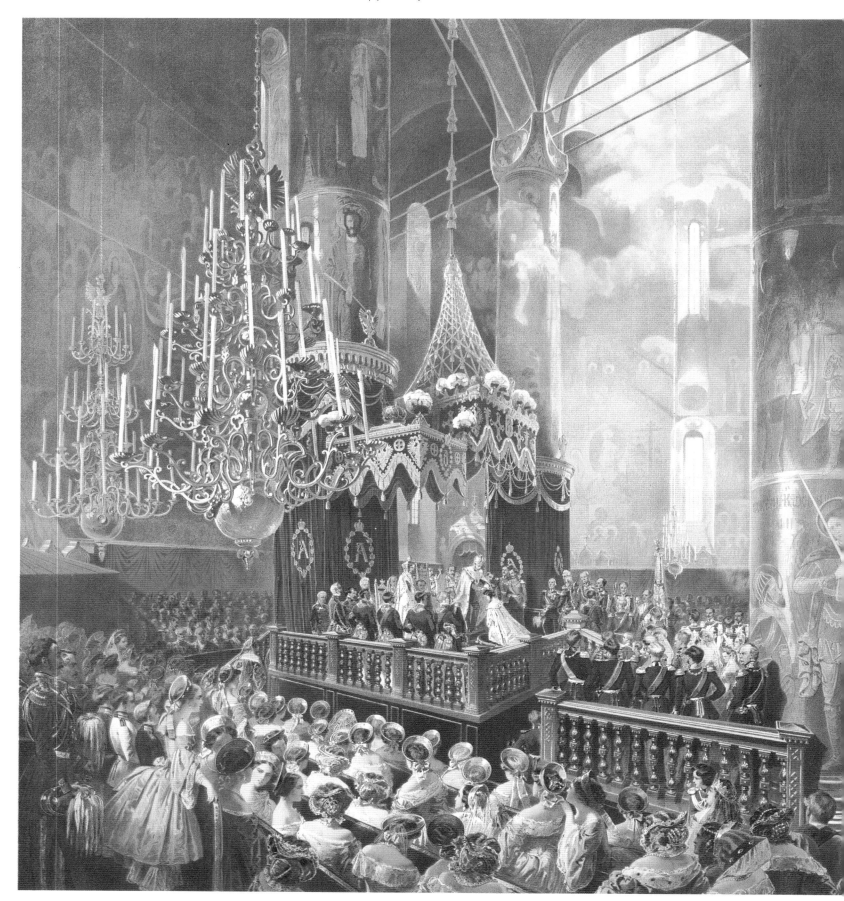

PLATE 35

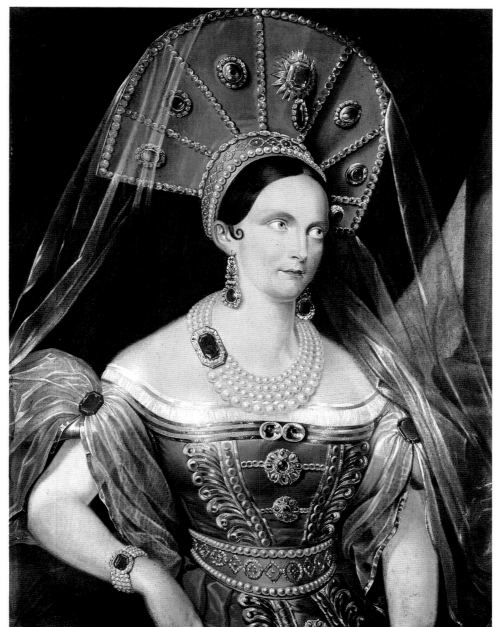

PLATE 36

PLATE 35

Illustration from the commemorative album produced for the coronation of Emperor Alexander II, 1856.

A leaf from the album which depicts the crowning of the Empress by the Emperor during the service in the Cathedral of the Dormition. The coronation, a superbly stage-managed spectacle, drew heavily on rituals which dated back to the solemn rites of the Emperors of Byzantium. In the foreground the ladies of the court are seen in Russian dress.

PLATE 36

After Franz Kruger, *Portrait of the Empress Alexandra Fyodorovna*, 1830.

Catherine the Great's introduction of the wearing of 'Russian' dress on formal court occasions showed how much had changed since Peter's compulsory Westernization had led to the Europeanization of dress under her predecessors. The practice of depicting the nobility in this costume constituted a new trend in portraiture which became commonplace during the reign of Nicholas I (1825–55). Although all but one of the nineteenth-century Empresses were German by birth, they all embraced Orthodoxy and Russian customs with fervour, the consort of Nicholas I being no exception. Much painted by contemporary artists, she was a cool, German beauty whose graceful manners were remarked by Pushkin. She is seen here wearing an exaggeratedly stylized and bejewelled *kokoshnik* headdress. The inspired elegance of Russian court dress, reflecting the native love of ornament and opulent jewellery, was based on the costume of the old Muscovite court. It was widely acknowledged to be the most beautiful of that of all the European courts.

the cut, colour, material and nature of the ornamentation were minutely prescribed. The colour of the velvet, the character of the gold and silver embroidery, even the length of the train correlated with the wearer's social status. The costume of the maids of honour and ladies-in-waiting was completed by a *kokoshnik* headdress with a white veil for married women, and a *povyazka* headband, also with a veil, for young girls. The dress code instigated by Nicholas I was retained in its essentials right up until 1917, changing only in details in accordance with the line currently fashionable.

The middle and latter half of the nineteenth century saw educated society again developing an enthusiasm for Russian folk costume, this time for men. This was related to the spread of Slavophile and, later, of populist, or *narodnik*, ideas. Members of the Russian intelligentsia began to wear boots and Russian side-fastening *kosovorotka* shirts; in the second half of the century Russian embroidered shirts were much in vogue, as can be seen from descriptions of the way the Slavophile philosopher Alexei Khomyakov dressed, or from portraits of Leo Tolstoy and Vasily Stasov, or from Peter Ilyich Tchaikovsky's shirts in the Tchaikovsky Museum in Klin, with their patterns embroidered in red thread. Intellectuals and would-be intellectuals began to sport beards and moustaches, hitherto worn only by peasants, and long hair. The 'Russian' enthusiasms of the autocrats of Russia were reflected in changes to army uniform, with baggy *sharovary* trousers tucked into boots, and the introduction of the shaggy *papakha* fur cap. Alexander III was represented thus attired in a statue that stood in front of St Petersburg's Nicholas Railway Station.

Portraits of the nobility The beginning of the nineteenth century saw the arrival, on the crest of the patriotic wave, of a variant of the society portrait: the lady in Russian costume.

There were two sources for this. One source was the late eighteenth-century portraits of peasant women by accomplished artists, such as Borovikovsky's 'Khristinya', and Argunov's peasant girl, already described. Another source was the so-called merchant portrait, sometimes also called the genre portrait. This belonged to the folk culture of the towns. The merchant portrait has features characteristic of primitivism: an archaic mode, a wooden pose, an inventory-like approach to associated objects, the according of equal weight to the person portrayed, their accessories and their ornaments – all depicted in meticulous detail – and a dogged insistence on getting the likeness right, with no idealization.

In the portraits of ladies of the nobility in Russian costume these two sources merge. In peasant and merchant portraits, as indeed also in the gentry portrait in Russian costume, a faithful representation of the sitter is certainly the primary aim, but it is not the only aim – as is evident from the loving detail with which the clothing and headdress are depicted. Costume is an important part of the portrait's meaning, analogous to the accoutrements in the folk portrait which metaphorically relate the occupation and virtues of the person portrayed. In the case of the aristocratic portrait, however, it is an expression of identification with Russian tradition.

The iconography of portraits of the gentry in Russian costume can be reduced to two principal types. The first might be called the idyllic or sentimental. The charming peasant-lady, in her Russian costume, is depicted against a romantically stylized mountainous landscape or in a country park. The second type is the patently formal, family or full-length portrait. Here the figure is represented against a background of sumptuous drapery or a formal interior.

The formal costume portraits of such ladies in waiting as Neleditskaya-Meletskaya, or that of the Empress Alexandra

PLATE 37

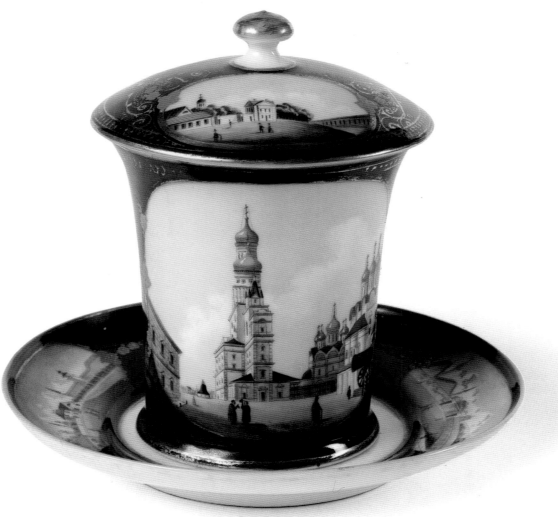

PLATE 38

Fyodorovna, wife of Nicholas I, both painted in the 1830s, typify the official policy on revival of the national heritage. The 'idyllic' portraits are assuredly related to the rococo and sentimentalist chamber portrait, especially to the kind of lyrical portraits of women which Borovikovsky painted. But whereas the earlier portraits aimed simply to depict a beautiful person living close to nature, the later ones have an overt 'message': that the sitter wishes to be associated – if only in a painting – with such a life and with the purity and simplicity it bestows.

These semantic differences are reflected in stylistic differences. In formal portraits the European element is in evidence: the colours are more restrained, and the dress considerably more Europeanized than in the intimate portrait.

Russianness is symbolized partly by the dress, but principally by the headdress and jewellery: beads, pearl bracelets, earrings, pendants, and *kokoshniks* sewn with pearls. The likeness is often no less pointed and uncompromising than in the merchant portrait. In idyllic portraits an exact likeness is subordinated to conveying a Russian ambience. This is achieved partly by the arrestingly bright local colours characteristic of folk art, particularly reds and blues. Like Venetsianov's peasant paintings, the idyllic portrait places the figure against a distant background, omitting the middle ground.

The portrait in Russian costume survived to the turn of the twentieth century. Vasily Surikov (1848–1916), a great Russian painter of historical canvases, also produced costume

PLATE 37
Cup painted with a view of Cathedral Square and the Church of St Catherine in the Kremlin (see plate 12). Popov Manufactory, mid-nineteenth century.

PLATE 38
Cup and saucer ornamented with a view of Cathedral Square in the Kremlin, Popov Manufactory, mid-nineteenth century. Representations of Moscow monuments became common in applied art and printed graphic design after the defeat of the French in the 'Great Patriotic War' in 1812.

portraits. From the mid-1800s onwards, however, this kind of portrait no longer adhered to fixed conventions; individual painters imposed their own distinctive styles upon it. It had been quite a different matter in the 1810s to 1830s, when a direct link existed between style and genre. This can be seen in the work of Karl Gampeln, who painted scenes of folk holidays as well as costume portraits of the idyllic variety. His work reflects the stylistic features accepted within a particular genre: against the folk scenes, with their distinctively rural features and even a suggestion of caricature, painted with a cursory 'journalistic' brushstroke, there stand the poetic portraits, refined to perfection, of beautiful Russian women.

The National Theme in Applied Art

In applied art the Russian theme made headway only patchily in the period we are considering. Nothing analogous to, say, the Greek-style baroque church or the Russian neo-Gothic façades could be found in the treatment of interiors or the design of minor forms, such as furniture, light fittings, wallpaper, stoves and fireplaces.

In some forms of applied art, however, there were echoes of developments in the fine arts. Items made of glass, porcelain or silver, for example, including tableware, vases, figurines, trinket-boxes and snuffboxes, and flatware, displayed this trend. The shape of some items, vases and bowls, for example, allowed them to be decorated with paintings or sculptural groupings of statuettes. Large, important pieces were treated in accordance with prevailing architectural style. This was true particularly of ornamental vases, which were often decorated with copies of paintings by famous artists, or engravings or lithographs, suitably adapted to fit the size of the item.

The gradual spread of the folk theme in decorative objects can be seen clearly in the items produced by the Imperial Porcelain Factory from the late 1700s to the mid-1800s. The beginnings of its prosperity coincide with the first moves away from Saxon prototypes and towards an interest in Russian characters and Russian life. This in turn comes back to the appointment, in 1779, of a new principal designer, Yakov Rashett, Professor of Sculpture of the Academy of Fine Arts. Rashett and his assistants reacted against an earlier series, created in the mid-eighteenth century, which featured 'Negroes' and 'Chinamen, or persons in oriental attire'. They created two new series of figurines. The first, 'The Peoples of Russia', dates from the early 1780s and is based on the engravings in the scientist and Academician Ivan Georgi's book *A Description of All the Peoples Inhabiting the State of Russia*. It was followed by another series, 'Craftsmen and Street Hawkers of St Petersburg'. Shortly thereafter, peasants began to serve as subject matter for figurines.

Predictably, this new trend was accelerated by the patriotic upsurge of 1812. The parallel genre and 'classicizing' treatments of the folk theme which had first appeared in the late eighteenth century continued in the first half of the nineteenth, but on a much larger scale. Alongside the Imperial Porcelain Factory, all the private porcelain factories of Russia began to produce figurines of either genre or an idealized, neoclassical character. The former consisted mainly of characters drawn from the common people of the towns, the latter of peasant types – reflecting the current notion of the peasantry as embodying the spirit of Russia.

Pimenov The peasant theme in Russian porcelain was most eloquently expressed in the works of Nikolai Pimenov (1784–1833), who was in charge of the modelling studio of the Imperial Porcelain Factory from 1809 to 1831. In his monumental sculpture Pimenov was a champion of classicism. He sculpted outstanding groups for the most important buildings of neoclassical St Petersburg: Hercules and Antaeus, which stood in front of the portico of the Institute of Mining; the chariot of Glory, which surmounted the arch of the Army General Headquarters on Palace Square; and the figure of Glory and the warriors on the Narva triumphal gates. His miniature works for the Imperial Porcelain Factory are a sculptural parallel to the works of Venetsianov.

It was to Pimenov's overall design and from his models that the Imperial Porcelain Factory created one of the most magnificent of all formal dinner services, the Guriev service, named after the director of the Imperial Chancellory who commissioned it. Work began in 1809 on this splendid collection, which consisted of 4,500 pieces. Sculpture, painting and the finest traditions of porcelain-making were brought together in a remarkable synthesis. One of the features of this elegant dinner service is the generous use of model sculptures. The figurines, executed with a rare perfection, are representations of Russian peasant women. Individual and grouped figures are integrated into the structure of the items – serving, for example, as the pedestals of fragile openwork vases, bowls and baskets.

PLATE 39
A pair of figures of dancing peasants, porcelain,
Popov Manufactory, mid-nineteenth century.

The sculptural groups are the compositional focus of the work and beautifully express the idea behind it: a celebration of Russia. This theme also runs through the painting on the porcelain, which is close in spirit to the work of Venetsianov, and ranges from sets of architectural and landscape views of towns and renowned country estates to scenes from folk life borrowed from the paintings of various Russian artists.

That balance between the ideal and the typical so well realized in the sculptural groupings of the Guriev dinner service are also found in other miniature sculptures of the Imperial Porcelain Factory. The best are 'Girl Water-Carrier' – shown in Plate 26 – and the matching 'Boy Water-Carrier', 'Girl with Berries' and 'Girl with a Broken Jug'. In these, the lyrical element is more pronounced than in the figures of the Guriev dinner service, and a quality of intimacy and of an idyllic life more clearly expressed. The figure of the 'Girl Water-Carrier' is particularly enchanting.

Painting on such bucolic themes as holidays, merrymaking, weddings, and girls on swings decorate not only dinner services but also large ornamental vases. The vases of the first half of the nineteenth century retain the form of their classical prototypes; but in their strict, elaborately architectonic composition – always symmetrical and with a clear sense of the direction from which they are to be viewed – the main focus of interest is their paintings. After 1812 we find the folk and peasant theme being joined by illustrations of the Kremlin cathedrals, the Bell Tower of Ivan the Great, the Sukharev Tower and St Basil's Cathedral.

Metalwork The upsurge in national feeling after 1812 also inspired gold- and silversmiths. Just as on porcelain, the monuments of Moscow were depicted in niello (known as Tula work) or stamped on snuffboxes, trinket-boxes and cigar-cases. A major centre for the production of silver ware was Vologda. Patriotic subject matter from the war and, again, views of Moscow were much in evidence on items produced by skilled engravers. The earliest such work, the lid of a snuffbox by the celebrated silversmith Ivan Zuev, dates from 1816 and depicts the great fire of Moscow. A complete travelling dinner service by Sakerdon Sinitsyn was displayed at the Vologda Provincial Exhibition of 1834 and subsequently at the 1839 Exhibition of Russian Manufactures. The lids of two silver sauce boats were decorated with niello engravings of views of Vologda's cathedral, kremlin and embankment.

Looking back over the late eighteenth and early nineteenth centuries, we can see that the Russian theme was similarly interpreted in both the fine and applied arts. Its influence was confined to choice of subject matter, depicting the common people (both peasantry and townsfolk) and, to a lesser extent, historic landscapes and hallowed ancient sites. By contrast, in architecture, the national element was associated with the heritage of medieval state and ecclesiastical architecture. From the second quarter of the nineteenth century all this began to change. The national element began to be interpreted in applied art much as in architecture, in terms of shape and structure rather than representationally. How and why this occurred is one of the topics dealt with in the next chapter.

PLATE 39

PLATE 40

THE BYZANTINE STYLE
1825–1850

The Emergence of the Byzantine Style

So far as architecture is concerned, there was a radical difference between the first quarter of the nineteenth century and the second. In the first quarter of the century classicism was victorious; in the second, the spread of nationalist ideas. Once again, as in the baroque churches 'in the Greek manner' and in neo-Gothic, architecture was employed to express the national identity. Now, however, nationalism became unambiguously the dominant trend. This was the new growth point, and all the subsequent major artistic discoveries and initiatives drew upon it.

What took place in the second quarter of the century was more than just an evolution of tendencies already in evidence at the turn of the century. Although less radical than the previous upheaval under Peter the Great, it nevertheless entailed a questioning of the conventional wisdom and a shift, in architecture, to its diametrical opposite.

Before we look at the characteristic features of the new nationalist architecture, we need to understand the attitudes that brought it into being.

As the nineteenth century progressed, the earlier belief that classicism was a universal artistic language began to be questioned. The conviction grew that there can exist no norms in art universally applicable for all men in all places and at all times. The art of the classical world was now seen as expressing not universal human values, but the spirit of a nation. Although it had been raised to a superlative degree of perfection, classicism remained simply the national style of Greece and Rome. In Western Europe – and even more so in Russia – the tradition of medieval and folk art came to be seen as more than the equal of the classical tradition. Works re-creating the spirit and techniques of medieval culture were considered to embody the nineteenth century's most cherished values.

The Byzantine–Orthodox connection In Russia the understanding of national culture entailed a search for an appropriate word to describe it. Neither the term 'Greek' nor 'Gothic' could any longer be used to designate Russianness, for both suggested the universal, or at least the universally European. The term eventually chosen was 'Byzantine', or 'Byzantine style'. As we shall see, it was only loosely related to the architecture of Byzantium. Even the word 'Byzantine' had Western associations (Byzantium being the direct heir of classical Greece); but it also pointed to the factor that crucially distinguished Russian from Western European culture: its belonging to the tradition of Byzantium and the Eastern rite of Christianity.

The reasoning behind this is complex, but can be reduced schematically to the following: the essence of each national culture is determined by the spiritual ideals of its people; the Russian people is Orthodox – indeed the channel through which Orthodoxy receives its fullest expression; Orthodoxy was transmitted to the Russians from Byzantium; consequently the origins of the Russian national and spiritual ideal go back to Byzantium. This ideal was embodied most fully and faithfully in the church-building of the Middle Ages.

The notion that the true Russian style was Byzantine – that it was reviving the fundamentals of Byzantine art – was universally accepted. The Slavophiles (who rejected the Western influence upon Russia) busied themselves with a rigorous theoretical groundwork for elaborating the concept of Russian folk character and the creation of a truly national Russian art. 'The artist does not create by his own power,' stated the Slavophile poet Alexei Khomyakov; 'it is the spiritual power of the people which creates through the artist.'[1]

PLATE 40
Fyodor Solntsev, Sweetmeat dish from a porcelain service made for the Grand Duke Constantine Nikolaevich, Imperial Porcelain Manufactory, 1848.

Political developments The nationalist trend in the arts was stimulated and strengthened by the Decembrist uprising of 1825 and by the reaction that followed it. This first collision between the intelligentsia and the autocracy showed that an irreconcilable conflict had arisen – one that would largely determine the course of Russian history for the remainder of the nineteenth century and into the twentieth. The Decembrist uprising showed too that the philosophical values that had prevailed throughout the eighteenth and early nineteenth century were played out. The alliance of enlightenment and power, and the understanding of civic duty as service to the state, were finished. In the Decembrists' ethic, the idea of service to the people took precedence.

The accession of Nicholas I (in 1825) ushered in a state policy sharply opposed to the enlightened absolutism of the recent past – one that has been called 'unenlightened absolutism'. In this context, 'unenlightened' is used metaphorically, to emphasize that henceforth the autocracy would take its bearings from and identify the future of Russia with the common people, rather than the aristocracy. This shared attitude, then – a turning towards the mass of the Russian people – proved greater than the political differences between the autocracy and the intelligentsia, and provided a solid basis for the growth of a truly national culture. The new ethos was summarized by Sergius Uvarov, Nicholas's minister of education, in the slogan 'Orthodoxy, Autocracy and Nationality'. In the cultural sphere it produced 'official populism' and, in turn, the official encouragement of the Russo-Byzantine style. If not actually inspired, the style was at least considerably accelerated by consistent support, legislative action and initiatives from above. Once again – as under every ruler since Peter the Great – an artistic trend was instigated by the monarch himself.

The new Byzantine-style churches Quite naturally, the new artistic ethos expressed itself in a spate of church-building. Not only were many new churches built, but they tended to be considerably larger and taller than those built in earlier times. There was also a noticeable shift in the source of the funds for church-building: an increasingly large proportion of the money came from the peasantry and from the growing bourgeoisie.

Although many of these churches – including the magnificent Church of the Redeemer in Moscow, which we shall examine later – have subsequently been demolished, many fine examples remain. Perhaps the most illuminating sources of information on them, however, are the two albums of designs published in 1838 and 1844 and compiled by the eminent architect Konstantin Ton (1794–1881). These included not only the designs of churches already built or commissioned but also specimen projects for churches of various kinds. Publication of the second album was followed by an imperial decree to the effect that these designs were to be followed in the building of all new churches.

Analysis of the designs in these albums and of architectural practice in the second quarter of the nineteenth century enables us to establish the characteristic features of the new Byzantine-style churches. What is immediately apparent is that the term 'Byzantine' was wildly inappropriate, for the designs incorporate only some Byzantine features. The lack of similarity between the Russian buildings ascribed to the 'Byzantine' style and actual Byzantine churches, which today seems blindingly obvious, resulted less from ignorance than from the fact that such knowledge was, for the time being, considered somewhat irrelevant. The term was being used metaphorically, to link Russia with its heritage. In fact, the architects overlooked almost none of the types of church that existed in the seventeenth century. One of these was the single-domed parish church, which consisted of three parts aligned on an east–west axis: a bell tower, a refectory or church hall, and the church itself, with a semicircular, rectangular or enclosed apse. This is known as the 'ship' form of church. The dome of such a church might serve to let in the light, or it might be purely ornamental, erected over a closed, vaulted roof.

Unlike the smaller, single-domed parish churches, the five-domed church in the form of a cross, topped with cupolas, came in a number of varieties: light might be admitted by all five domes or only one. A church might belong to the cathedral type, whose distinctive feature was its compact, cuboid frame, or replicate the type of the parish church with bell tower, refectory and church proper, already described.

A variation on the one-domed and five-domed churches was the church with a single or five-fold hipped roof, which revived the pyramidal outline of the sixteenth- and seventeenth-century churches with their multiple roofs and towers. These were, however, revived in a form modified by the large five-domed church of the medieval period, in that the domes were widely spaced – a classical, rather than an old Russian

PLATES 41–45
Fyodor Solntsev, Details of drawings made from medieval manuscripts.
The son of a serf on the estate of Count Musin Pushkin, Solntsev was born in 1801. He showed artistic promise and was sent to study at the Imperial Academy in St Petersburg. In 1830 he began to travel all over Russia, visiting the ancient cities and making numerous detailed drawings of buildings and of ornament, some of which was discovered in manuscripts and studiously copied. He also made accurate copies of silverware, including icon covers. From 1843 he enjoyed the patronage of Nicholas I, and his drawings were published in an immense work, *Antiquities of the Russian State*, which appeared in six huge volumes in 1852. For the next fifty years it served as an encyclopaedia of medieval and popular art, used by artists, silversmiths and designers.

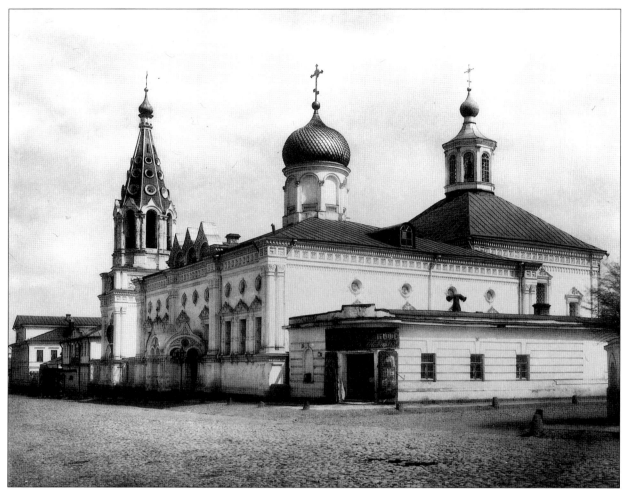

PLATE 46

touch – and belfries were also installed in the side domes.

Another type of old Russian church, the *pod kolokoly* or 'church with bells' (as opposed to those churches built with separate belfries) was also revived, but again in an atypical version. Old Russian churches with bells had a compact, tower-like frame with a single dome. In the new Byzantine-style churches, small hipped roofs to the sides were often decorative and blind, as in seventeenth-century churches with multiple hipped roofs.

Bell towers Most Byzantine-style churches had bell towers, which could be either integral or freestanding. In the nineteenth century two types of bell tower which had evolved in the seventeenth century became widespread: the hipped-roof and the domed variety. The hipped-roof bell tower was a multi-tiered composition of rectangular and octagonal seg-

ments placed one on top of the other. The upper tiers (or tier) of the bell tower, containing the open arches of the belfry and crowned with a hipped roof, were octagonal. The overall design of a hipped-roof bell tower was akin to that of the churches themselves, with a characteristic combination of segments known as 'eight on four'.

The second, domed type of bell tower, also multi-tiered, might consist of octagonal, prismatic or octagonal *and* prismatic segments. They were crowned, like the churches, by a dome on a cylindrical drum. Most bell towers of this type appeared later than the hipped-roof kind, at the end of the seventeenth century. In the nineteenth century the domed bell tower became as popular and widespread as the hipped-roof type. Moreover, given the nineteenth century's penchant for increasing the size and height of religious buildings,

PLATE 46
Church of Saints Peter and Paul, 1649, rebuilt 1859.
This Moscow church demonstrates how a number of features of religious architecture current during the second half of the nineteenth century show the familiar classical tradition consciously modified by references to a Russian past. Here, the relatively small original structure has been rebuilt out of all recognition.

PLATE 47
Church of the Annunciation on the Banks, near Pliushchikha, Moscow.
In the background is a typical seventeenth-century structure with a characteristic cluster of five diminutive domes raised on slender drums. In the foreground the nineteenth-century bell tower is in a hybrid style – the lower section a modified neo-Gothic, but with a tent roof distinguished from its seventeenth-century prototypes by its enlarged scale.

bell towers of this type, which better complemented columnar, upsweeping compositions began gradually to predominate.

Ornamentation The Byzantine style borrowed more selectively from the past in its decorative style than it did in structure. More often than not, the prototypes for the churches themselves were the delicate early Muscovite and Vladimir-Suzdal churches. Ornamentation was not extensive, being derived from buildings which themselves were relatively spartan in their decoration. The ogival outlines common in Muscovite architecture of the fifteenth to seventeenth centuries were especially popular. Façades of churches were adorned with multiple perspective portals with ogival decoration; the windows had ogival surrounds; wall segments met roofs in tapering ogees; and the bases of domes were decorated with ogival *kokoshnik* pediments.

The influence of the classical tradition was much in evidence in the way in which the old Russian prototypes were interpreted, and in the choice of ornament adopted. It can be seen in the heaviness, even stockiness of the body of the churches, whose height is often less than that of their domes.

Protagonists of the new style The pioneers of the Byzantine style were veterans of St Petersburg neoclassicism. Vasily Stasov, for example, designed a new church for Kiev, mod-

elled on the old Muscovite churches of the fifteenth and early sixteenth centuries. It was built in 1828–9 on the actual foundations of the first stone Orthodox church in Russia, the Tithe (*Desyatinnaya*) Church, which had been destroyed at the time of the thirteenth-century Mongol invasion. He also designed the Church of Alexander Nevsky, in the Russian settlement of Alexandrovka in Potsdam, near Berlin. Another exponent of the style was Abram Melnikov, architect of the Church of the Transfiguration in Nizhny Novgorod, which was built in 1828–35 on the site of an old church that had been demolished and which preserved the aspect of the original to a remarkable degree. A third champion of the style was a young graduate of the Academy of Fine Arts, Nikolai Yefimov, who submitted a first project for the restoration (as it was considered at that time) of the Tithe Church, which was rejected. However, the triumph of the Byzantine style during the reign of Nicholas I is most closely identified with Konstantin Ton, whose work we shall examine in the following section.

Fine and applied arts Before continuing our survey of the Byzantine style in architecture, we should note that something similar to it appeared in the fine and applied arts. This, too, posited a return to ancient Byzantine and old Russian sources. 'Return Raphael to legend and remove all his powers to the Byzantine source,' wrote Sergei Shevyryov, who

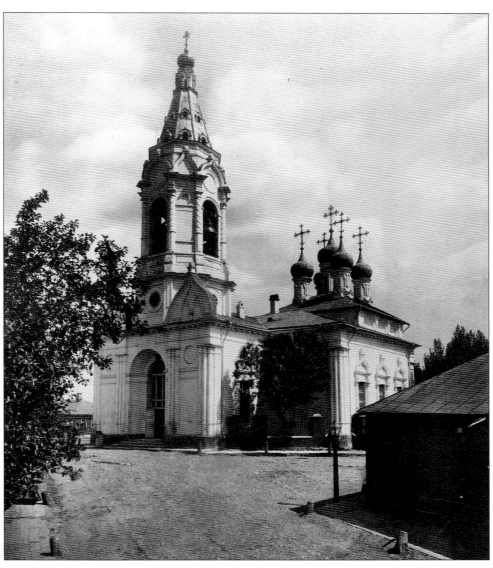

PLATE 47

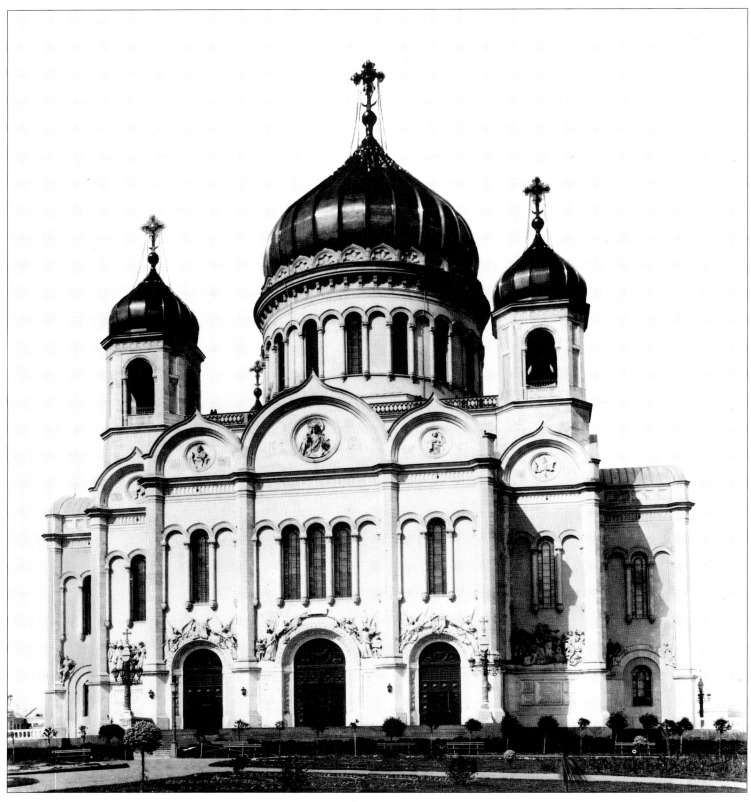

PLATE 48

PLATE 48
Konstantin Ton, Cathedral of Christ the
Redeemer, 1839–89.
Already begun under Alexander I as a
thanksgiving for the delivery of Orthodox
Russia from the French, the construction of
the Cathedral of the Reedemer under Nicholas I
became the expression of the first serious
attempt to create a major ecclesiastical building
in a national Russian style. Ton was a favourite
architect of Nicholas I and his designs for

belonged to the older generation of Slavophiles.[2] The sentiment was echoed by Apollon Grigoriev, who belonged to the younger generation. The beginnings of this movement could be traced back as far as the painting of Vladimir-Suzdal, and to icon-painting as it was practised in Palekh, Mstera and Kholuy.[3] Although it was not until the end of the nineteenth century that the movement to revive national traditions in the fine arts achieved anything like the significance it had in architecture, these were not mere words, and the very fact that they were expressed shows which way the wind was blowing.

Ton and the Cathedral of the Redeemer

The architect Konstantin Ton came to fame in 1829, when, after several heats of a competition to design the Church of St Catherine, at Kalinka Bridge in St Petersburg, had failed to produce a winner, Ton was invited to take part on the recommendation of Alexei Olenin, President of the Academy of Fine Arts. Ton heeded the Emperor's express wish to see the church designed in the mode of old Russian architecture, thus ensuring a happy outcome not only for his design, but also for his own career. By this time the Emperor had evidently finally decided that classicism no longer had a future. Two years later, in 1831, the leading classicists in architecture, sculpture and painting were pensioned off, and young architects more in sympathy with the new trend, including Konstantin and Alexander Ton, Alexander Briullov, and Vasily Glinka were offered chairs in the Academy of Fine Arts.

In his design for the church at Kalinka Bridge, Ton drew on discoveries made by Stasov. He employed the type of the fifteenth- and sixteenth-century early Muscovite cruciform-domed church, tri-apsidal, with four interior columns, roofing over the semicircular external walls, and a typical ornamental arched band decorating the façades. Ton's design is, however, more imposing and elegant than his sources. His church has five domes, and the transitions from the principal space to the domes are modulated by rows of ogival *kokoshnik* decoration.

The Cathedral of Christ the Redeemer It was with Ton's design for Moscow's Cathedral of Christ the Redeemer that the trend towards the Byzantine style became irreversible. From its inception, this project (not to be completed until 1883) was of major significance. It was built in fulfilment of a vow which the Emperor Alexander I had made in one of

Russia's darkest times, when she was under partial occupation by the French. At the end of 1812, when the last French troops had finally left Russian soil, Alexander issued a manifesto for the building of a church of thanksgiving. The competition to design it was won by Alexander Vitberg, who proposed a magnificent building in classical style, based upon St Peter's Basilica in Rome. Building began in 1825, but came to a halt shortly afterwards. Vitberg was accused of embezzlement of state funds – unjustly, as it transpired – and exiled to Vyatka. Seven years after the death of Alexander I in 1825, Nicholas I returned to the project. At his instigation, building was recommenced in a new style, in accordance with new ideas and to the design of a new architect. In 1832, as part of celebrations to mark the twentieth anniversary of the Patriotic War, the foundation stone of what was to be the largest cathedral in Russia was ceremonially laid in the historic centre of the old capital on the banks of the Moscow River, on the second highest site in Moscow, next to the Kremlin Hill. It was to be taller than the Bell Tower of Ivan the Great. Work commenced in 1839.

Everything about the Cathedral of Christ the Redeemer is symbolic: the style, the site and the size. It was erected just outside the Kremlin, forming part of the ensemble of which the Kremlin is the centre. This was to emphasize its bond with the history of old Russia, represented by the Kremlin, but also its independence from it. Located directly opposite St Basil's Cathedral, it created a symmetrical effect corresponding to a symmetry in the symbolism of the two churches, commemorating as they did two pivotal events in Russian history – in the case of St Basil's, the conquest of Kazan and Astrakhan by Ivan IV.

Sources The composition of the Cathedral of Christ the Redeemer is derived from the Cathedrals of the Dormition in Vladimir (1158–61, reconstructed in 1185–89) and in Moscow (1475–79), both five-domed cathedral churches. The unusual design and elaborately decorated interior of the church – shaped like a Greek cross, with rectangular additions at each of the four junctions of the four equal limbs; the strictly centripetal plan and the absence of that essential feature of Russian Orthodox churches, the semicircular apse, had their prototype in a different source: the celebrated tent-roofed Church of the Ascension in Kolomenskoe, built in 1532. The same source suggested the design of the gallery skirting the exterior of the cathedral. There is, however, a significant dif-

churches were realized throughout the Empire. Hailed by the Metropolitan Filaret of Moscow as 'a book in stone', the cathedral was a model for buildings 'In which we can read the greatness of the present, the venerable memory of past history and an example for generations to come.' The younger generation was not so sure. Stasov, chief spokesman for the aesthetic values of the Wanderers and their contemporaries, referred contemptuously to the largest and most

luxurious church in Moscow in the 'new national style' as 'neither new, nor national, nor even a style'. The cathedral was demolished in the 1930s.

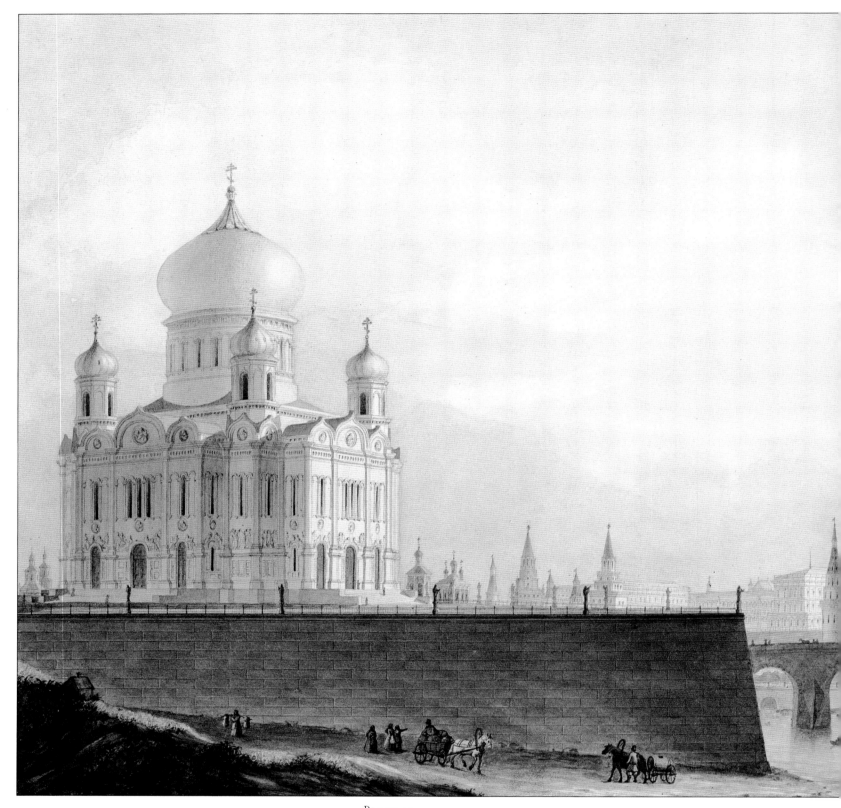

PLATE 49

PLATE 49
Alexander Ton, *The Cathedral of Christ the Redeemer with a View of the Kremlin*, 1837. This depiction of the Cathedral of Christ the Redeemer was made by the architect's brother before building was begun and shows one of a number of variants which Ton made for the project. When finally built, modifications had been made to the shape of the domes, the drum and the side belfries. In the background loom Ton's Great Kremlin Palace and the Armoury.

The picture is devised to convey how the centre of Moscow would look with cathedral and palace complete. The impact of this ambitious building programme on the architecture of the city can be clearly seen. Particularly evident is the way in which the massive scale of the new structures contrast with the more intimate dimensions of the existing churches and other buildings at the heart of the old capital.

PLATE 50

PLATE 50
Fyodor Solntsev, *Grand Prince Andrei
Ioannovich Bogolyubsky*, undated.
The portrait, drawn and painted on vellum in
the manner of a medieval manuscript, provides
us with an insight into how the art of pre-Petrine
Russia was perceived through the eyes of the
nineteenth century. The lettering is stylized,
characteristic of nineteenth-century work; the
period it most strongly evokes is the seventeenth
century. Although a deliberate attempt has been
made to draw the figure in an iconic manner it is
evident that the draughtsman has been trained in
naturalistic perspective.

ference. In earlier churches the gallery – whether open, as in the church in Kolomenskoe, or enclosed, as in St Sophia's Cathedral in Kiev (c.1018–37) and in many later churches, including the Church of the Transfiguration (dating from the sixteenth century), in Ostrov, Vyazma – was always constructed so as to be lower than the main part of the church, producing the stepped composition and pyramidal silhouette characteristic of sixteenth- and seventeenth-century Russian religious architecture. By contrast, the gallery of the Cathedral of Christ the Redeemer is two-tiered and of equal height to the cathedral proper. From outside the gallery is not seen as a separate element, and so does not detract from the building's sense of unity.

A number of other, more minor architectural touches in the new church had old Russian prototypes. These included the ogival *zakomary* (arched gables) where sections of the outer wall met the roof, a feature of the old Muscovite churches which Ton reintroduced. The arcading around the façades – part blind, part open – was derived from a similar band on the Cathedrals of the Dormition in the Kremlin and in Vladimir. The new memorial cathedral also revived a feature typical of the architecture of Vladimir-Suzdal: rich sculptural ornamentation of the façades. This was the work of Ramazanov, Alexander Loganovsky, Matvey Chizov and Pyotr Klodt. Other characteristically old Russian features were the compact and sculptural nature of the central mass of the building and the equal status of the four façades.

The church's secular importance as a memorial to the Patriotic War dictated that it should be built on a grand scale. In height it measured 103 metres (338 feet); in width, 79 metres (259 feet). For those travelling towards Moscow the cathedral could be seen from a distance of thirty kilometres (twenty miles) or more. It was visible from practically every point in the south, southwest, west, and northwest regions of Moscow.

The construction of the Cathedral's exterior was completed by 1859; work on the interior occupied the second half of the century. The magnificent interior – largely the creation of Alexander Rezanov (1817–88), who was director of works in the 1870s and 1880s – was remarkable for its spaciousness, its architectural unity and the way in which the eye was carried upwards. In this respect it shows a tendency one might almost call Romantic – a typically nineteenth-century flair for organizing internal space in original ways. Unlike most

Catholic churches, Orthodox churches show little sense of orientation along an east–west axis. Instead, major importance is attached to a vertical orientation. There is a simple reason for this: these features reflect the dogmas of Orthodox Christianity, and in particular the anthropomorphic symbolism of the basic elements of the church. In Orthodox iconography a representation of Christ Omnipotent, Christ Pantokrator, is located in the vault of the central dome; the Apostles are depicted in the piers between the windows of the drum of the dome. In the pendentives over the columns supporting the central dome are the Evangelists. The parts of the church become the symbol and embodiment of the figures depicted in them. In its totality the church is a symbol of Christ and Christianity itself, overarching and sanctifying the space it contains. This interpretation of the function and symbolism of a church goes a long way to explain the features specific to the church architecture of old Russia; the major attention paid to the expressiveness of the external frame of the building, the relatively modest dimensions of the interior spaces, the sculptural quality, compactness and splendidly open sight lines of the whole complex, the equal status of the façades and the vertical sweep of both façades and interiors.

The Cathedral of the Redeemer was erected partly in accordance with this tradition, although the need to accommodate 10,000 worshippers dictated a considerably larger interior. The influence of the ground plan and spatial resolution of the Church of the Ascension in Kolomenskoe, with the lines of its interior directed dynamically upwards, and its emphatic predominance of vertical dimensions over horizontal, is clearly to be felt in Ton's plans. He also draws on other, equally celebrated sources: the rich and complex interplay of domes and vaults in Hagia Sophia, Constantinople, and the perfectly cylindrical shape of the interior of the Pantheon in Rome. In fact, in many of Ton's designs, including that of the Cathedral of the Redeemer, the vertical upthrust is more forcefully expressed in the interiors than in the façades. The unusual device was employed, for example, in St Catherine's Church at Kalinka Bridge, of using a conical drum to increase the perspective and so reinforce the impression of height. This technique was adapted from the Church of the Redeemer in the Wood (in the Kremlin) and the Church of John the Baptist in Diakovo.[1] What matters here, however, is not the revival of particular, sometimes very rare, devices but the general orientation on the height of the interior. This is a

PLATE 51
Fyodor Klages, Interior view of the Cathedral of Christ the Redeemer, 1883.
This painting was executed in the coronation year, at the time of the inauguration of the Cathedral. Many artists and sculptors contributed to its embellishment. The walls were faced in marble, porphyry and Kievan labradorite, and the iconostasis – the sanctuary screen – was given the form of a white marble chapel. Although the cathedral was intended to evoke Byzantine Russian tradition, the images are rendered in a characteristically Italianate style. The principles of Byzantine sacred art were not yet rediscovered and so the painting of the Italian Renaissance continued to provide the model of perfect beauty in art.

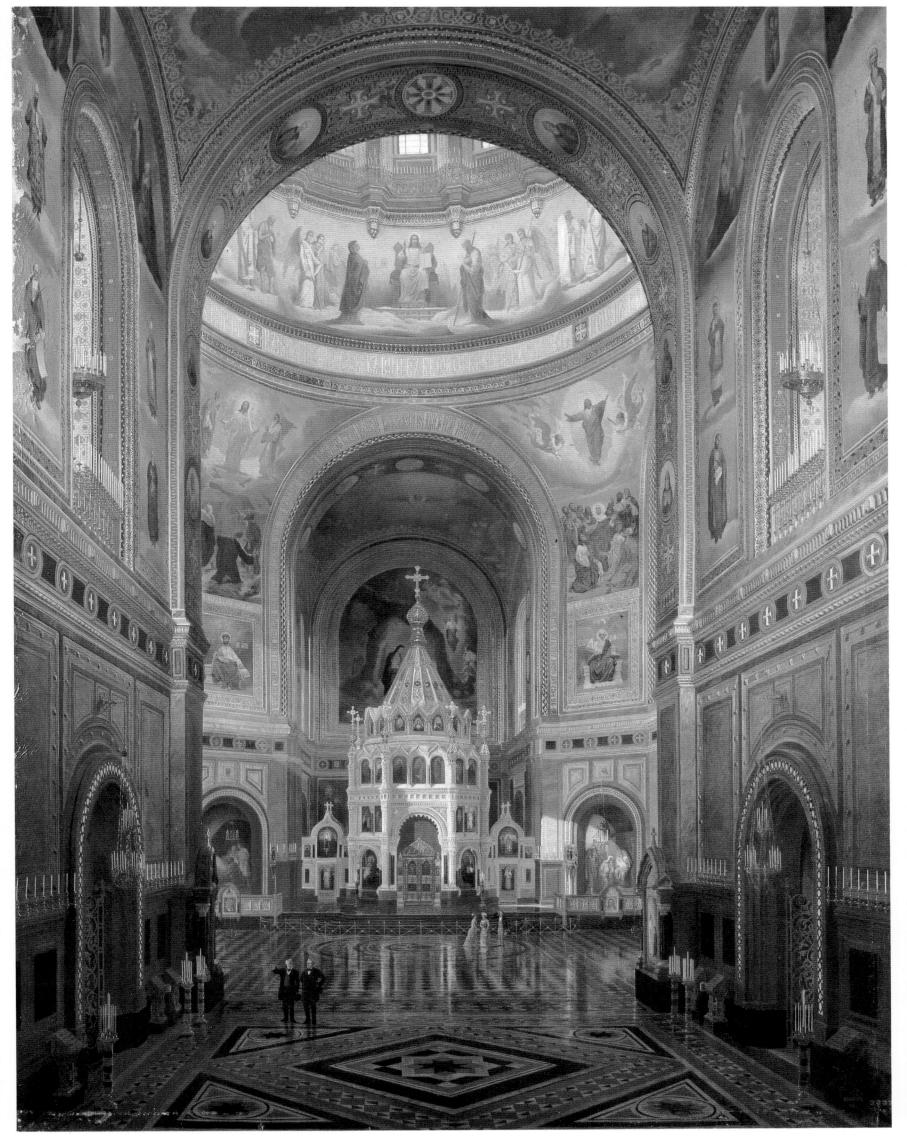

PLATE 51

Plate 52

Plate 53

Plate 54

characteristic of a great many Russian churches, and in particular of the Naryshkin tent-roofed churches with no interior pillars.

In the Cathedral of the Redeemer everything was subordinated to bringing out the compositional and symbolic significance of the central space beneath the dome. It was one-and-a-half times higher than the length of each of the arms making up its cross form. Flooded with light pouring in from the great windows of the drum and reflecting from the gold background of the murals, the central space seemed full of radiance, the effect intensified by the contrast with the muted semi-darkness of the arms of the cross, into which light filtered only through the windows of the two-tiered gallery.

The obligatory iconostasis did not detract from the centripetal composition of the interior. Following a trend, first discernible in the classical period, of dispensing with the traditional high, multi-tiered iconostasis, which would have cut off a significant part of the central space from the area provided for worshippers, and reviving the modest altar partitions of the early Christian churches, Ton found an original solution in pre-Muscovite tradition. The iconostasis was kept relatively low compared with the chancel and was shaped like the profile of a small tent-roof church. This truly Russian solution was unprecedented in the history of nineteenth-century church architecture, and was never repeated.

Murals The builders of the cathedral reverted to the ancient practice of completely covering the walls with painting, and revived the gold backgrounds customary in the early years of Christianity and in the art of Kievan Rus. This was not, however, a straightforward imitation but a genuine creative synthesis of the old tradition and modern artistic principles. A prominent feature of the mural painting of Russian churches in the eighteenth century and first quarter of the nineteenth was the inclusion of very individual painted-in frames, which served – like the frames of easel paintings – to set off the subject matter. In the mid eighteenth century these had been complex and baroque, and in the classical period architectural and ordered. In the Cathedral of the Redeemer they were ornamented with old Russian motifs. At the same time ornament had a prominent part to play in the architectural, representational and decorative patterning of the space within the church, creating a unified, even rigorous, framework which encompassed the whole of the interior and harmonized with the system of the sacred paintings. The

alternation and rhythm of the basic elements of this framework; the way in which it interacted with the structural architecture, the rhythms, disposition, form and dimensions of window openings and archways; and the ways in which walls and vaults were integrated, made it an important unifying element of the whole composition. It helped to make the mural paintings, in which the size of the figures and the extensiveness of the compositions were greatly enlarged as the modern idiom dictated, into an integral part of the interior. Among the artists who contributed to the work were Fyodor Bruni, Vasily Surikov and Viktor Vasnetsov.

In the Cathedral of the Redeemer the significance which figural wall-painting had had in old Russian art was both revived and increased. An architectural awareness, inherited from classicism, also came into play. The ornamentation, executed to old patterns, now framed elements basic to the building's construction and composition, emphasizing the logic of the divisions and spatial organization of the interior. Classicism's principle of employing decorative painting in churches to illusory tectonic effect was reinterpreted to serve a neo-medieval structure.

The Byzantine Style and Town Planning

With the building of the Cathedral of the Redeemer, the lead in architecture passed from St Petersburg to Moscow. This is not to say that architecture in St Petersburg was at a standstill; almost simultaneously with the commencement of work on the Cathedral of the Redeemer, another major church-building project – St Isaac's Cathedral – was under way there. In style, however, St Isaac's, an imposingly neoclassical building by the French architect Auguste Ricard de Montferrand, belongs to the first quarter of the nineteenth century (though it was actually completed in 1858), whereas Ton's church expresses the new state policy favouring the Byzantine style. In its size, composition and location, it implicitly declared Moscow's ascendancy over Peter the Great's capital. Moscow was central to the history and culture of Russia, and came to stand for them, and generally to be seen as having the major role to play in restoring the fractured continuity of the country's past. Important building initiatives in the ancient capital during the 1830s and 1840s had an impact on the entire nation.

The Cathedral of the Redeemer not only substantially changed the appearance of the centre of Moscow; it also initi-

PLATE 52
Joseph Kaminsky, Church of St Gregory the Theologian, 1880 (now demolished).
Here, an interpretation of a Byzantine dome combines with more typical Russian features such as the tent-roofed tower. The debt to Ton is apparent.
PLATE 53
Church of the Dormition, Moscow, 1857.

PLATE 54
Nikolai Nikitin, Church of the Mother of God of Kazan, 1881.
Situated on Moscow's Kaluga Square, this church's appearance is almost entirely neo-Byzantine. During the second half of the nineteenth century the first attempts at such a style could be undistinguished – in this case, note the unsuccessful marriage of the onion dome with the Byzantine drum.

ated a new stage in the planning of Russian towns. A conscious attempt to revive the old Russian architectural tradition was evident not only in the erection of new Byzantine buildings, but also in the policy towards, preservation of earlier buildings. For the experts whose job it was to decide the fate of old buildings, the main consideration was the date. Only pre-Petrine buildings were categorized as being of great historic or artistic merit. The destruction or reconstruction of later buildings was permitted without a qualm.

The vertical element The building of the Cathedral of the Redeemer, with its great height, stimulated a revival of the old system of verticals of churches and bell towers, which were such a distinctive feature of the Moscow skyline. These towers were built by the banks of the Moscow River and the Yauza, in the centre and in outlying regions – virtually everywhere in the ancient capital.

Riverside sites were the first to be chosen for the construction or reconstruction of buildings in the Russian-Byzantine style. Within sight of the new church, on both banks of the river, bell towers were added to the Churches of St Sophia and St Nicholas on the Moscow River, and to the Ivanov Monastery, among others. Lofty, multi-tiered bell towers were built on the principal roads leading to the Kremlin: on Bolshaya Nikitskaya (now Herzen Street), the bell tower of the Monastery of St Nikita; on Tverskoy, the bell tower of the Monastery of the Passion. A bell tower was erected to Konstantin Ton's design at St Simeon's Monastery in the eastern suburbs of Moscow, on the high bank of a bend in the Moscow River. All were built between 1830 and 1860.

The location of the St Simeon's bell tower shows a concern for symmetry akin to that of the placing of the Cathedral of the Redeemer opposite St Basil's. Here the St Simeon's bell tower counterbalanced the bell tower of the Novodevichy Convent, located as it was on the Moscow River at the southwest edge of the city. Its multi-tiered, columnar composition was suggested by the bell tower of Ivan the Great (in the Kremlin), and of the monasteries of Joseph of Volokolamsk and the Novodevichy Convent.

In pre-Petrine Russia it had been customary to locate the principal vertical – usually the bell tower – in the centre of an ensemble, thus emphasizing its enclosed, introspective nature and the centripetal quality of the treatment of space. In the baroque period, a bell tower was normally placed on the periphery of the monastery ensemble, usually over the gate-

house. This destroyed the equilibrium of the ensemble and quite changed the emphasis. As the most dynamic element of the composition, the bell tower now transformed the monastery wall from something guarding an inner space into something that impinged upon the space outside the monastery, similar to the principal façade of a building facing the street. From centripetal, the ensemble became centrifugal. Here we find the Russian principle of organizing the space of ensembles using the verticals of prominent buildings being merged with a Western European principle, which one might call the principle of the street, or of the façade. This organizes architectural space by means of the façades of buildings along a street or square.

St Petersburg Although Moscow had become the focus of architectural innovation, St Petersburg, too, acquired a number of churches in the approved Byzantine style. On the outskirts of the city regimental churches were built to Ton's design in commemoration of the Patriotic War of 1812 and dedicated to various regiments: the Semyonov, Chasseurs, Cavalry and Grenadiers. The first of these bore a marked resemblance to the Cathedral of the Redeemer in Moscow. Other churches of this kind included the previously mentioned Church of St Catherine at Kalinka Bridge, on the Fontanka Canal, designed by Ton in 1829; the Novodevichy Monastery of the Resurrection at the Moscow Gate; the Church of the Resurrection in Malaya Kolomna; and the Old Believer 'Yedinoverie' Church of St Nicholas – all designed by Nikolai Yefimov; and others by such contemporary architects as Roman Kuzmin and Ivan Grebenka. These and other churches were the beginning of a systematic policy, implemented from the nineteenth until the early twentieth century, of giving St Petersburg a national Russian aspect. Byzantine-style building in St Petersburg had, then, a special significance over and above what it had in other parts of Russia: it was a counter-attack on the Western values which had created the city and flourished most fully there.

As in Moscow, the new churches were typically sited on the banks of rivers and Canals, where they became a prominent feature of the skyline. Ton's regimental church of the Chasseurs was erected at the confluence of the Obvodny and Vvedensky Canals, that of the Semyonov Regiment by the Obvodny Canal and that of the Grenadiers near the embankment of the Bolshaya Nevka. Special mention should be made of the Cavalry Regiment's Church of the Annunciation,

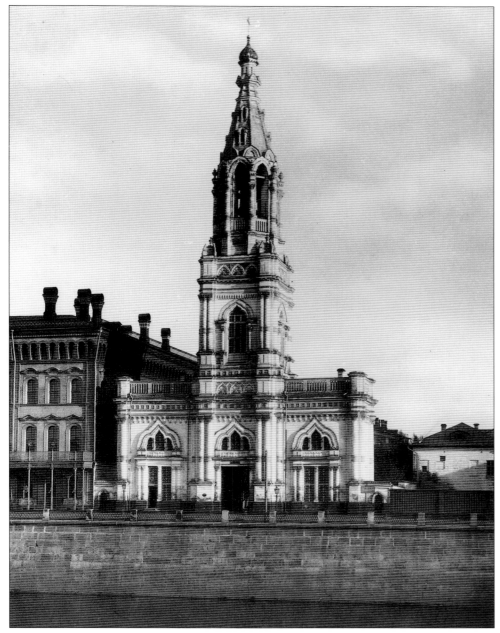

PLATE 55

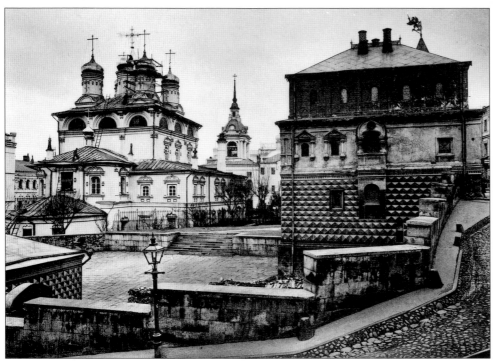

PLATE 56

PLATE 55
Nikolai Kozlovsky, Bell tower of the Church
of Sophia the Divine Wisdom, 1868.
The bell tower, situated at some distance from
the Cathedral of Christ the Redeemer, was one
of a number of buildings erected as part of a
general plan to integrate the great mass of the
cathedral by introducing a number of loftier
buildings to punctuate the existing low skyline.
This tower was conceived as having an
appropriate place in the view from the bridge
over the Moscow River, with the cathedral in the
distance. The church which it serves contains a
fine cycle of frescoes in the revived Russian style
and executed as late as 1927.

PLATE 56
Fyodor Rikhter, House of the Romanov Boyars
in the Monastery of the Sign, 1859.
The House of the Romanov Boyars, on the
right of the photograph, was 'rediscovered' in
1856, as a result of the intensified interest in
history. Originally the house of Nikita
Romanovich – grandfather of the first Romanov
Tsar – it was purchased in 1856 by his
descendant, Alexander II, who caused it to be
restored. The work was entrusted to Rikhter, a
prominent Moscow architect, who, between
1857 and 1859, surveyed and researched its
original form. In the course of restoration the
building was largely redesigned – in particular
the wooden upper floor, the original of which
had been completely destroyed, was
improvised. In adapting the building for use as a
museum, Rikhter reorganized the modest
interiors as the chambers of a seventeenth-
century town house. New nurseries, servants'
quarters and reception rooms to designs by
Fyodor Solntsev were added.
The building on the left is the Cathedral of the
Sign, dating from the 1680s.

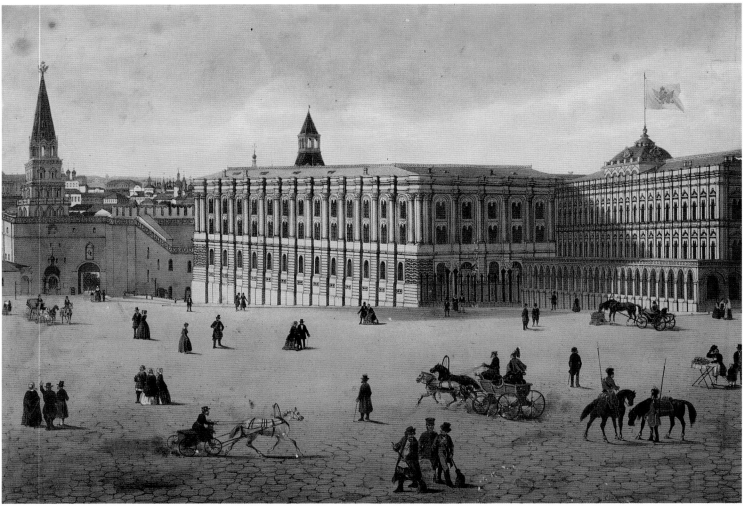

PLATE 57

which stood near the Moika Canal in the centre of the recently created Square of the Annunciation (now Labour Square), near the Bridge of the Annunciation (now Lieutenant Schmidt Bridge). It was visible from the River Neva and intended, together with the chapel built actually on the bridge, to lend nationalist colour to paintings of the banks of the Neva.

Revival of the system of verticals, initiated by Ton's churches and bell towers in Moscow and St Petersburg, had an extensive impact in the provinces. From this period until the end of the century, towns and villages all over Russia acquired the local variant of the Cathedral of the Redeemer (albeit somewhat scaled-down). More often than not, these new Byzantine-style churches were sited in the centre of a spacious square, visually punctuating the town's architecture at a crucial point.

In the provinces, in country areas and the smaller market towns, church architecture had been developing within the unbroken vernacular architectural tradition. This was still the situation in the 1830s to 1850s, when the new wave of Russian-Byzantine church-building reached them. With the exception of a few provinces which were outside the mainstream of development, the surviving authentic old Russian tradition was paradoxically and finally squeezed out by the traditionalist architecture of the modern period.

A church erected in the middle of a vast square totally dominated the one- and two-storey Russian settlements. The increase in the number of churches built and the simultaneous

PLATE 57
Indeytsev, *The Great Kremlin Palace and Armoury*, engraving from the 'Panorama of Moscow', 1880s.
The main elements in the ambitious project for the reconstruction and rebuilding of the Kremlin, instigated by Nicholas I, were the Great Kremlin Palace and the Armoury, both designed by Konstantin Ton. These are immediately adjacent to Cathedral Square and directly associated with the old palaces of the

increase in their size did not have any parallel in domestic architecture. Even in the major provincial cities the number of floors of a standard dwelling did not alter, with few exceptions, in the course of the eighteenth and nineteenth centuries. Even in city centres, where the building material was stone, two storeys was the norm, with even three-storey buildings few and far between. In Moscow itself four- and five-storey buildings remained a rarity throughout the second half of the nineteenth century. The extent of that impact was without parallel in the rest of Europe, and without precedent in Russia.

Town planning between 1830 and 1917 is characterized by a systematic drive to implement the town plans which had been drawn up at the turn of the eighteenth and nineteenth centuries. Its ethos was to continue and develop what already existed, so that it was in opposition to the town-planning ideas of classicism, with their emphasis on a fundamental reworking of old Russian town design into new, all-embracing schemes. The town planners of the nineteenth century tended to use or incorporate features of early plans, whereas strict adherents of classicism had tended to implement and impose completely new systems, ignoring old buildings which were still standing.

Another feature of town planning in the period we are examining is its departure from the emphasis placed by the preceding period on street layout. In the eighteenth and early nineteenth centuries planners were concerned mainly to make the ground plan of streets and squares artistically expressive. In the later period the accent switched to the plan and elevation of the buildings themselves, which, as it were, arrange the space above ground level, independent of the line of the street defined by frontal façades. The interaction of these two ways of organizing space produced a fascinating combination of post-Petrine regularity with the old Russian picturesqueness – a wonderful abundance of verticals and a sense of freedom and abandon in building design.

Polychromy The Byzantine style reintroduced into towns a characteristic feature of Russian architecture which had been out of fashion during the neoclassical period. This was polychromy, the combining of bright, vibrant colours. It could be seen in the multicoloured domes of the churches, crowned with gold crosses, and the saturated colouring of the walls, achieved by means of paint, stucco or brickwork. The variety of the colour was one of the most obvious features of Russian architecture that gave a uniquely original aspect to Russian towns and villages; that and a multitude of domes, a love of an abundance of verticals and compositions made up from a great number of component parts, which were such an important aspect of the Russian sense of form.

This sensory richness especially delighted Théophile Gautier on his visits to Russia in the 1850s and '60s. 'One can imagine nothing more beautiful, rich, sumptuous, fabulous than these domes with their gleaming gold crosses, these little belfries with their bulbous crowns, these six- and eight-faceted spires with their ribbed, pierced, rounded facets, expanding beneath the motionless commotion of snow-covered roofs. . . . Also the azure headpieces spangled with golden stars, the domes of smooth copper sheets fitted one to the other or laid like tiles to resemble the scales of a dragon, or again onion domes, coloured green. . . . The question of polychromy in architecture which is still so furiously debated in our country,' he added, 'has long been decided in Russia. Here the architects gild and silver and paint the buildings in every colour. . . .'[1]

Rebuilding the Moscow Kremlin While the enormous Cathedral of the Redeemer was slowly taking shape, the appearance of Moscow was also being altered by another colossal project: the new Great Kremlin Palace.

In terms of its magnitude and importance, and in the desire to make a statement about Russia's identity, the Great Kremlin Palace (1838–49) may be compared to an earlier, unrealized project for a Kremlin palace by Vasily Bazhenov (1738–99). The thinking behind the two projects was, however, strikingly different. Bazhenov had planned an apotheosis of the Europeanization of Russia and, implicitly, an endorsement of the break with old, pre-Petrine Rus. These values were openly proclaimed in the composition of his huge complex. Bazhenov created a grandiose classicist ensemble which wholly disregarded the inimitable charm of the ancient Kremlin architecture. Realization of his design would have destroyed the Kremlin as a living part of the historic city. An edict of Catherine the Great dated 15 March 1771 ordered that the section of the Kremlin wall facing the Moscow River be dug up to make way for the new building. Four years later, as a result of incipient subsidence of the foundations of the ancient cathedrals and the danger that these, the most revered shrines in Russia, would be destroyed, work was stopped and the wall restored.

Tsars on the brow of the Kremlin Hill, their principal façades facing the Moscow River. Their design is an early attempt to formulate a new architectural style, evocative of Byzantium and old Rus, during the second quarter of the nineteenth century. The prototype for the palace's window surrounds and its overall composition was the Terem Palace, built in the reign of Tsar Alexis Mikhailovich and concealed behind the new buildings. On the ground floor of the new palace were the Imperial private apartments and state rooms finished in marble and malachite. On the first floor, which had a double tier of windows, were the reception halls of the orders of Saints George, Vladimir and Catherine.

The circumstances surrounding the creation of a new imperial palace in the Kremlin give us a valuable insight into the way people thought at the time. The idea germinated in the course of the restoration of the old Belvedere, or Terem, Palace, begun in 1835 under the direction of the artist Fyodor Solntsev. The aim was to restore to the ancient palace of the tsars, in the words of Solntsev himself, 'its primal Byzantine aspect'.[2]

The new plans for the Great Kremlin Palace were the work of Konstantin Ton, working now in partnership with four other architects: Fyodor Rikhter, Ivan Kaminsky, Nikolai Chichagov and Pyotr Gerasimov. This time respect for the historic appearance, structure and design of the Kremlin was the primary consideration; indeed the significance of the new buildings can be fully appreciated only in the context of their ancient neighbours. The watchword was continuity of the national tradition, the achieving of a harmonious unity of old buildings and their modern reincarnations.

The new palace was sited where it had been traditional since the fourteenth century to locate the palace of the grand dukes, tsars and emperors of Russia – high on the south part of the Kremlin Hill, near the Cathedral of the Annunciation. In the days of Rus the main buildings of this ensemble had faced inward, towards Cathedral Square. The decision that the principal façade of the palace should face the Moscow River dated from 1743, when an L-shaped palace – the Kremlin Winter Palace – designed by Rastrelli was erected on the site of an earlier building. This was modified and reworked a number of times in the course of the second half of the eighteenth and early nineteenth centuries, until in 1838–49 the present building was constructed.

Like his classicist predecessors, Ton brought elements of regularity to the view of the Kremlin from the Moscow River. The strongly horizontal lines of the colossal palace, which has 700 rooms and whose principal building, facing the river, is 125 metres (410 feet) long, reinforce the horizontal of the wall at the foot of the Kremlin Hill.[3] The rhythmic interaction of these two surfaces emphasizes and augments the expansiveness of the river valley, which resembles an imposing highway.

Analogous changes, based on two opposing principles, also occurred in the nature of the Kremlin ensemble itself. The grouping of the various churches and the Ivan Tower on Cathedral Square remained typically pre-Petrine: an interplay of a variety of different, inward-looking forms. By contrast, the unitary mass of the new palace is geometrically exact. It was very much as a result of Europeanization that Russian palaces eventually all came to be designed in the form of a single unit. One of the strands which fed into the design of the palace complex was undoubtedly classicism: this was, after all, the tradition in which Ton had been brought up; it was, however, combined with a clear intention of renewing the old traditions.

A synthesis of these two principles had also been instrumental in the shaping of the architect's overall design. The ground plan of the palace is a rectangle, with an inner courtyard. The state rooms were located in the south wing, which faces the river, and in the east wing. The empress's reception rooms were placed in the west wing, while the fourth, northern side of the complex was filled by the ancient Terem Palace, designed in 1635–36 by Bazhen Ogurtsov, Trefil Sharutin, Antipa Konstantinov and Larion Ushakov. This became an integral part of the new palace, and also served as the prototype for the composition of the façades of the two new wings containing the state rooms.

Ton made no attempt to recreate the picturesque composition of the Terem Palace, which was out of sympathy with a building in the Byzantine style. The new palace did, however, imitate the way the Terem Palace was subdivided, as well as its ornamentation. Windows with ornate surrounds were arranged regularly on the façade, and the line of the Terem's storeys was retained. The Great Kremlin Palace has a projecting lower storey which provides an open, peripheral gallery suggestive of the galleries of the Terem Palace. Although the new palace was a two-storey building, it was given the appearance of having three storeys in order to be in sympathy with its neighbour; the state rooms of the south and east buildings have two tiers of windows.

This brief description of the Great Kremlin Palace illustrates the problems inherent in reviving an earlier style. The success of the revival depends to a great extent on the degree of similarity (in both ground plan and elevation) between the new buildings and their prototypes. In the case of a church, the continuity of function and liturgy makes possible – even inevitable – a faithful copy of the prototype. However, secular buildings, including palaces, are more susceptible to change and hence less amenable to a stylistic revival.

The Armoury Integral to the Great Kremlin Palace is the Armoury, a museum of relics and treasures of the past. It was

PLATE 58
Window in the Terem Palace of the Kremlin, seventeenth century.
The original seventeenth-century white stone window surround, embellished with meticulously carved birds within foliage, formed a model for Ton's ornamentation of the windows in the neighbouring Grand Kremlin Palace. Examples of this stonework were precisely copied by Solntsev for his book *Antiquities of the Russian State*.

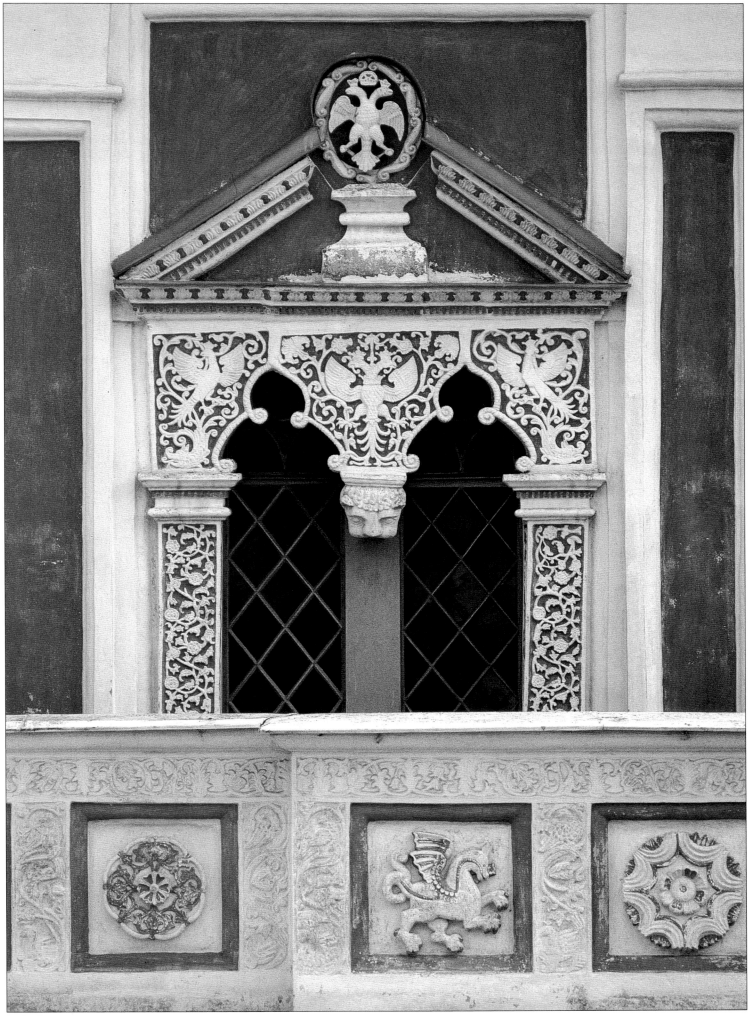

PLATE 58

designed by Ton, and built in 1844–50; others involved in the project included Nikolai Chichagov, Vladimir Bakarev and Pyotr Gerasimov. Like the palace proper, the Armoury was designed to fit sympathetically into its context of ancient palaces and churches. Despite the symmetry of the main façade of the palace, the complex as a whole remains true to the old Russian tradition of the picturesque ensemble. The unity of the major buildings here is not the symmetrical disposition of identical parts, but the interaction of buildings picturesquely arranged relative to one another. Similarities in the composition of the façades of the two edifices underline their unity: the projecting basement, the regularity of rhythm, the similar windows. Their differences – such as the most dynamic element of the Armoury's façades, the spiralling, carved pillars created in imitation of the Naryshkin churches – emphasize their autonomous status within the greater unity.

The decision to turn part of the palace into a museum was typical of the day, especially in Russia – reflecting not only the enthusiasm for museums *per se* which had arisen in the eighteenth century but also the new attitude that a royal palace belonged, in a sense, to the people, as well as to the monarchy. The monarch was seen as the 'keeper of the Holy Grail': the nation's cultural heritage. Nicholas himself confirmed this: 'Our Kremlin Palace . . . shall be a new and worthy ornament of Our well-beloved ancient capital, all the more so since it accords fully with the edifices surrounding it, which We hold sacred also for the memories of centuries past and of the great events of the history of Russia which are associated with them.' Metropolitan Filaret said, 'Wishing to live a life not apart and private but fully shared with his people and realm, the Tsar has decreed that his house should both belong to the Tsar and be of the realm, that it should speak of the Tsar and his realm, that it should be a scroll and a tablet of stone in which are to be read the greatness of the present, and the hallowed memory of the past, and edification for the future.'[4] The new reverence for Russia's architectural and artistic legacy was apparent not only in the development of the Byzantine style, but also in the attitude towards existing old Russian buildings. Indeed, the first intensive restoration work to be undertaken in the history of Russia dates from this period. The historic buildings played no less a role in the regenerated Kremlin than did the new; in fact, the new buildings showed the old in a fresh light, as belonging to the nation as a whole. This was seen as their most important function.

The preservation and restoration of the ancient buildings and their integration into the new complex, the tactful treatment and happy coexistence of Ton's new buildings, therefore had a strong political function. The buildings thus restored were seen as historic national shrines.

The Byzantine Style in the Fine and Applied Arts

The Byzantine style received its fullest expression, as we have noted, in architecture. Significant developments in the applied arts and painting occurred mainly in the restoration of ancient buildings and the provision of icons for the many new churches.

One of the foremost figures in restoration work was Fyodor Solntsev (1801–92), who was responsible for the restoration of the Terem Palace. Solntsev's career as an artist and archaeologist began in the mid-1830s, when the President of the Academy of Fine Arts proposed to the new graduate that he should 'engage himself in the area of archaeology and ethnography to the benefit of gentlemen studying art at the Academy'.[1] Solntsev became one of the most outstanding exponents of 'art archaeology', a characteristic discipline of nineteenth- and early twentieth-century scholarship. In fulfilment of his task he travelled extensively around Russia 'for the purpose,' he wrote, 'of sketching our traditional customs, vestments, weapons, ecclesiastical and royal plate, goods and chattels, harnesses, and other objects pertaining to historical, archaeological, and ethnographical knowledge'[2] – led, in the artist's own words, by the desire 'to compile a complete painter's course, in archaeology and ethnography for artists'.[3] His work consisted of discovering, researching and cataloguing the relics of national culture for subsequent incorporation in Russian historical paintings, or for use in the design of buildings, furniture, or plate.

Art archaeology was exceptionally important in the development of nationalist art, particularly in the first half of the nineteenth century, before the advent of photography. Solntsev's drawings furnished a lavish six-volume edition of *The Antiquities of the State of Russia* (1849–56). Along with Nikolai Yefimov, he was one of the first to survey and sketch the ancient churches in the towns of Russia. Solntsev's drawings were the basis for renovation, as one of his contemporaries wrote, 'in the Moscow Kremlin of the Tsar's Terem Palace and the palace churches; and the chamber of the

PLATE 59
Fyodor Solntsev, Title page from *Antiquities of the State of Russia*, 1856.
Printed by Imperial command, this sumptuous, six-volume work had an enormous influence on design. The title page is designed as a wooden pavilion ornamented with fretwork. Paired recesses on either side encase suits of armour. It is interesting that, despite the conscious stylization of the design, the state eagle is in the current nineteenth-century form.

PLATE 59

PLATE 60

Kremlin Palace was adorned with suitable furniture, carpets, plate, and the like'; he 'discovered and restored the ancient mural painting in the cathedral of the monastery in Kiev, he discovered the frescoes of St Sophia's Cathedral in Kiev. . . in various towns of Russia he discovered, renovated, and restored to their original state many relics of Russian art',[4] and proved in the process 'that the distinctive Russian style can often hold its own against styles adopted from foreigners' (something not regarded as at all self-evident in Russia in the second quarter of the nineteenth century).[5]

That an artist-restorer and archaeologist should have become one of the pioneers of the national movement in art was possible because of the contemporary approach to restoration. What was most valued in a restoration project (as

in a new building) was not scholarly accuracy in relation to the original but an inspired, creative reinterpretation of it. This is evident from the way in which critics rated most highly work which, from a modern viewpoint, least merit being described as restoration: work in which the artist 'by the power of the poetic attuning of his soul and of his hypotheses strives to convey the character of the original, not only with archaeological accuracy but also with that sublime feeling which moves the architect himself in moments of creation and lays upon his works the seal of true beauty and creativity'.[6]

In restoring the Terem Palace Solntsev faced considerable problems. Only insignificant fragments of the original interior decoration had survived. Restoration proceeded 'in accord with the overall character of surviving decoration',

PLATES 60–62
Fyodor Solntsev, Plates from *Antiquities of the State of Russia*, 1856.
Three illustrations from *Antiquities of the State of Russia*. The plates shown – antique saddlery, a sleigh and the boyhood throne of Peter the Great and his half-brother, Ivan – illustrate Solntsev's close observation and rendering of detail.

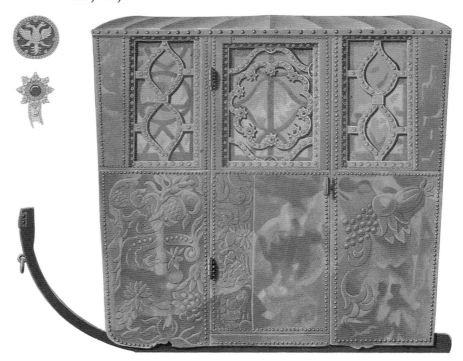

Plate 61

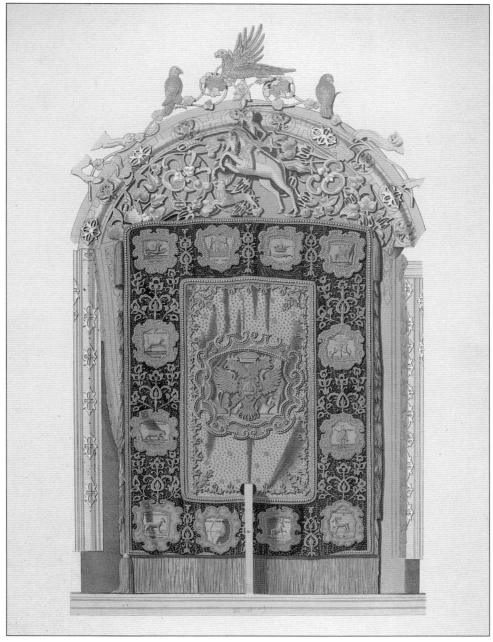

Plate 62

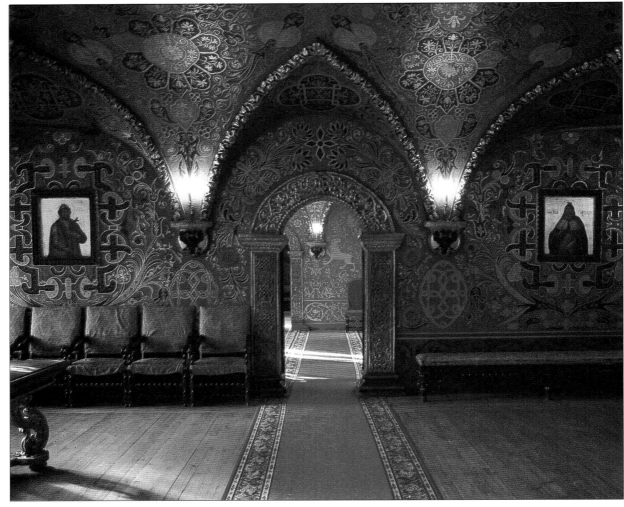

PLATE 63

based on contemporary notions of traditional Russian style. Solntsev later recalled that Nicholas I rejected fourteen restoration projects before approving the fifteenth.[7] There was an immense amount of work to be done, and it was exceptionally diverse. Solntsev devoted special attention to the fourth tier of the Terem Palace, which in the seventeenth century had been the chambers of the tsar. He transformed them into the first reconstructed early Russian interior. Painting of the walls and vaulted ceilings was undertaken by Solntsev himself; oak window frames and stained glass were installed, and reproduction seventeenth-century furniture and tiled stoves introduced.

The chambers were of modest height and size, the ceilings in the form of low vaults, with the vaulting compartments over the windows, and entirely covered with wall painting. This mural painting dominates the interiors. In every room large, ornate patterns, imitating carved motifs taken from the surviving wooden windowsills and stone portals, carpeted the walls and, in part, the vaulted ceilings. Representations of the saints and of one or two episodes from the history of the Church were incorporated into the mural painting on the vaulting and, in some of the chambers, also on the walls. These were painted in the style of frescoes and icons of the mid- to late seventeenth century. They recreate not the complex, multi-figural type of fresco but the isolated figures most often painted on church pillars. The design and disposition of the ornamental patterns of foliage of the murals follow the architecture, highlighting and emphasizing its divisions and

PLATES 63 & 64
Terem Palace, Moscow Kremlin, 1635, as
renovated by Fyodor Solntsev.
The seventeenth-century private apartments of
the Tsar were the first reconstructed interiors in
the old Russian style. Solntsev reintroduced
tiled stoves, frescoes, oak surrounds and stained
glass.

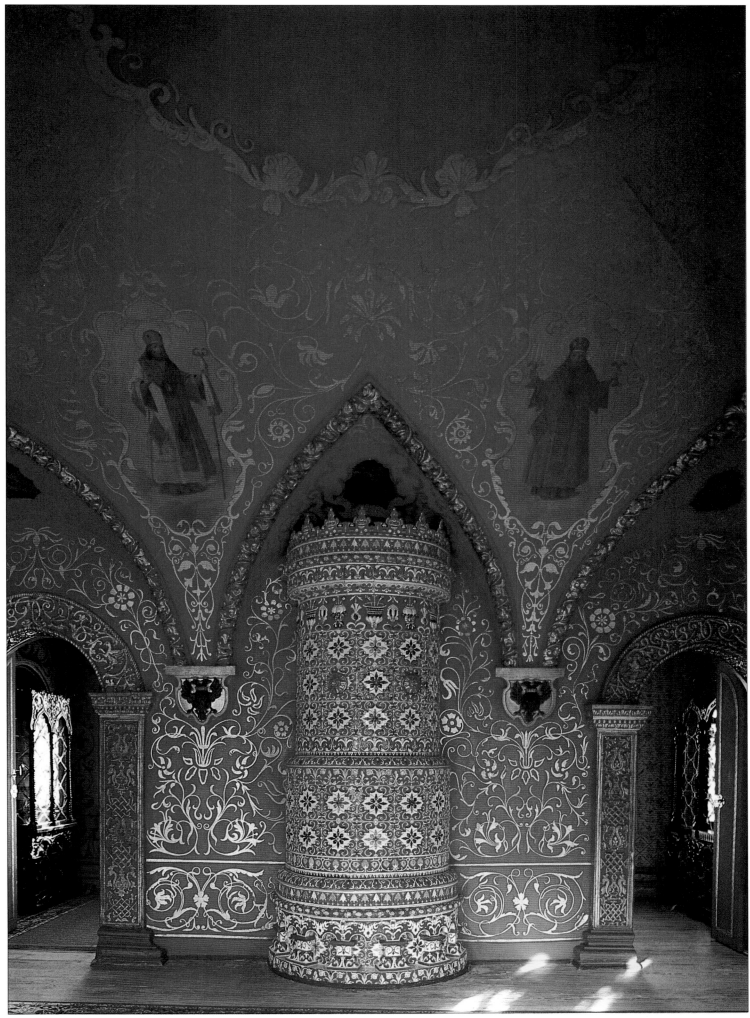

PLATE 64

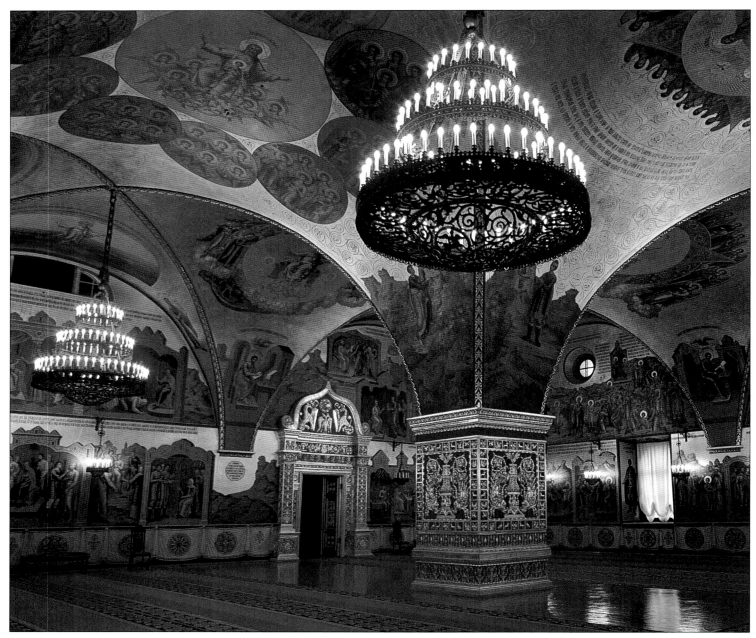

PLATE 65

PLATE 65
Marco Rufo and Pietro Solario, Interior of the
Faceted Chamber, Moscow Kremlin, 1491.
First used as a throne room and for the reception
of ambassadors, the Faceted Chamber also
served as a setting for great banquets. The walls
are covered with nineteenth-century murals.
PLATE 66 & 67
V. and I. Byeloussov, *St Vladimir, Grand
Duke of Kiev, and his Sons* and *Grand Princes
Rurik, Igor and Sviatoslav*, murals in the
Faceted Chamber, 1882.
Preceding the coronation of Alexander III in
1883, and the celebrations attending it, a
decision was taken to redecorate the Faceted
Chamber in the Kremlin which, since its
construction in the fifteenth century, had been
used as an audience chamber and for state
banquets. When the rich red velvet which had
covered the walls since the coronation of the
Emperor Paul, almost a hundred years earlier,
was removed, traces of frescoes depicting

Biblical themes and stories from Russian
history were discovered. This decorative
scheme had first been executed for the son of
Ivan the Terrible and renewed in the
seventeenth century by the court painter,
Simon Ushakov. New frescoes repeating this
scheme were commissioned from the
Byeloussov brothers, who came from the
village of Palekh, in the district of Vladimir,
celebrated for the skill of its icon painters.
The painting reflects the renewed emphasis on
history and shows the contemporary state of
icon painting before the process of cleaning the
ancient icons had begun. An architectural
backdrop organizes the scenes in plate 66, the
figures being enclosed within arches, a device
that first appeared in icon painting in the late
seventeenth century. Despite stylization, the
figures are quite naturalistic and a degree of
perspective has also been introduced.

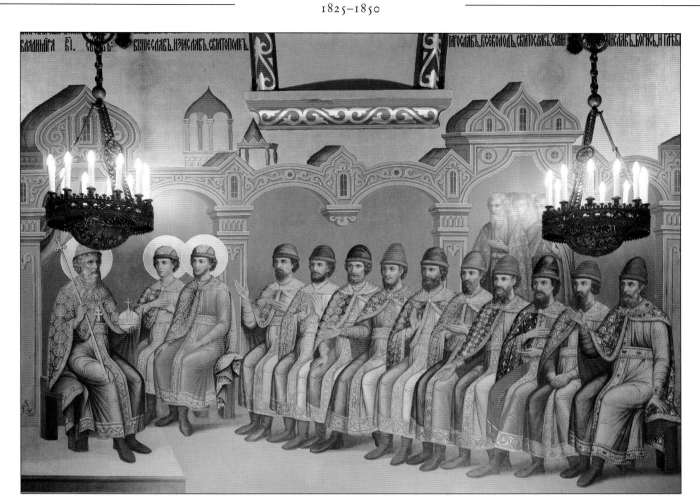

PLATE 66

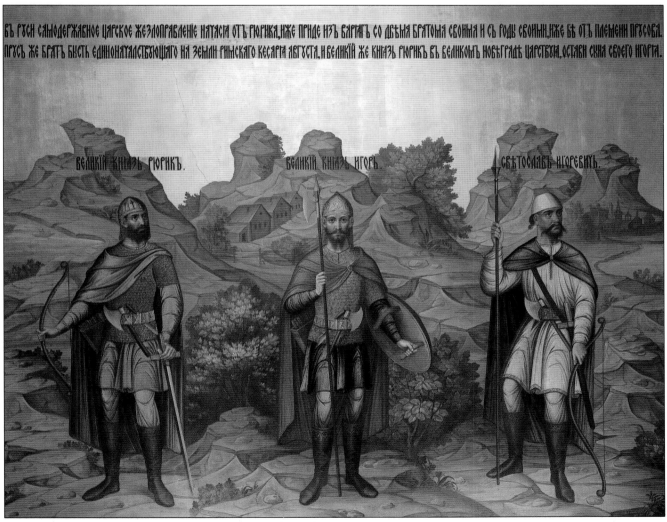

PLATE 67

constructional features: the ribs of the window vaults, the surfaces of walls, the shape of the vaulting.

The décor of the Terem Palace, as restored to Solntsev's designs, was to be definitive for the later *style russe* domestic interiors and also for many church interiors where subsequent fashion was for extensive surfaces solidly decorated with scattered motifs. Solntsev was virtually the first artist educated in the Academy and elected to membership of it who appreciated the idiom of ancient frescoes and icon painting. He saw old Russian art as an ornamental, festive art of vivid colours and gleaming gilt, in which spirituality combined naturally with decorativeness.

Similar tendencies can be found in Solntsev's easel paintings. In his depictions of the saints he repeats the iconography and idiom of old Russian art, emphasizing the decorative and the ornamental. The vestments of the saints, adorned with scattered patterns of plant designs based on motifs from illuminated books and stone and wood carvings, assume an individual vibrancy and complexity of patterning and colour which is characteristic of the period we are examining.

Solntsev was also a pioneer in applied art. He created a dinner service in harmony with the Byzantine style of the new Great Kremlin Palace, for which it was intended. It was one of the first works of applied art in this style and in both its motifs, among them the double-headed Imperial eagle, and its symbolism it is very close to the décor of the Terem Palace, where the dominant idea is the bond between tsar and people. A second service was made to his sketches for Nicholas I's son, the Grand Duke Constantine Nikolaevich, in which the Grand Duke's monogram, GDCN, was incorporated in the decorative design of every piece.

In describing the Great Kremlin Palace we noted the evenness in the placing of emphases, the equal status accorded to the different storeys and the lack of prominence of the principal axis. In the murals of the Terem Palace we have noted the way they emphasized the wall surface. We find the same feature in the composition of both the Kremlin and the Grand Duke's dinner services. Whereas in neoclassical porcelain we find vases and cups possessing the same sense of having a frontal façade as in architecture of the period, in the case of these two dinner services the vases, cups and soup tureens are evenly decorated, the ornamentation rhythmically disposed. And yet the effect is not monotonous. By combining motifs of varied character Solntsev achieved an exceptionally rich unity of decoration.

Another design feature of this porcelain is its extensive borrowing from diverse sources, which, although often mutually incompatible, reveal their underlying unity when viewed within a broader context. In applied art of this period, a wide variety of sources were drawn on: items from different periods, made of different materials, with different technologies and in different traditions. In designing porcelain pieces, in particular, Solntsev imitated the effect of the precious stones employed in embroidery, in metal plate and in the binding of the Gospels. Here we find designs recreating the interwoven patterned ornamentation of ancient manuscripts, patterns from peasant embroidery and a variety of motifs culled from ancient wood and stone carvings. In decoration and

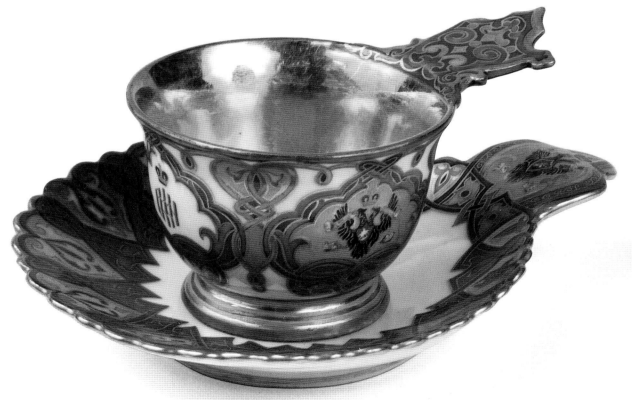

PLATE 68

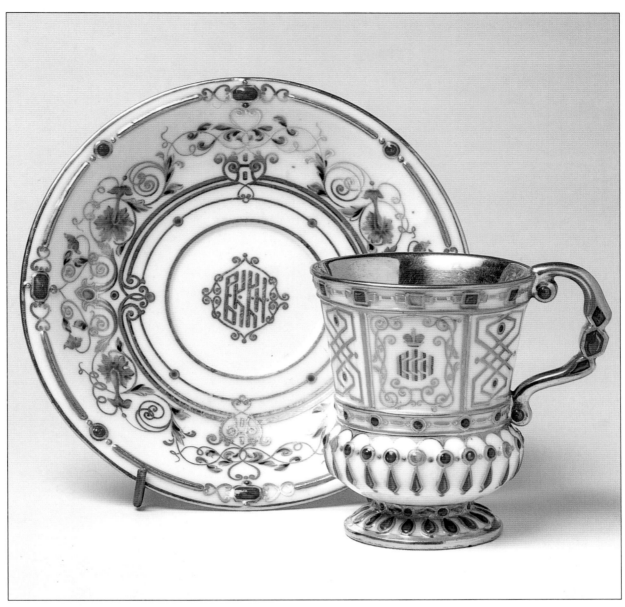

PLATE 69

surface texture, the porcelain mimics such varied materials as metal, wood, enamel and embroidery.

Attempts to revive the original Byzantine style in the applied and fine arts were paralleled by an awakening interest in old Russian art as a historic heritage, rather than purely as an adjunct to worship. Ivan Snegiryov's works on the significance of Russian icon-painting were published in 1848 and 1849. A number of anniversaries that fell in the mid-1800s – including the 700th anniversary of the founding of Moscow

(1847) and the 50th anniversary of the Patriotic War (1862) – led to a flood of practical and educational initiatives in art and architecture. Memorial churches were built, interiors renewed, new iconostases erected. Of particular significance was the restoration to their original appearance of the great architectural masterpieces of Vladimir-Suzdal, of St Ipatius's Monastery in Kostroma and the Pitsunda Church in Abkhazia in the Caucasus. The House of the Romanov Boyars, like the Terem Palace in the Kremlin, was reconstructed,

PLATES 68 & 69
Fyodor Solntsev, Cups and saucers from a porcelain service made for the Grand Duke Constantine Nikolaevich, Imperial Porcelain Manufactory, 1848.
The service for the Grand Duke Constantine, second son of Nicholas I, was designed by Solntsev with interlacing ornament derived from medieval manuscripts and incorporating the Grand Duke's crowned cypher. Apart from this service, Solntsev designed another specifically

for use in the Kremlin Palace and therefore intended to evoke pre-Petrine Russia and Byzantium. Richly coloured in vivid green, black and burnished gold, some of the designs for the Kremlin service were based on seventeenth-century metalwork. Adapted for porcelain, the results were not altogether successful.

in this case, a reconstruction of the way of life of the boyars. Here too the interior design and décor had virtually to be reinvented.

Restoration of the interiors of historic Russian buildings served, with its use of folk and national motifs, as a preliminary to the spread of Russian-style décor into the domestic interior (a development we shall explore in the next chapter). The popularity of the 'Russian' interior was also evident in stage sets for plays on Russian themes. We have already noted the relationship between new directions in theatrical décor and costume and Russian-inspired works in architecture, applied art and painting in the eighteenth and early nineteenth centuries. That relationship continued into the second quarter of the century. Some theatre designers renowned for their settings for plays with Russian subjects were also creators of architectural designs in the Russian spirit. Among these, Andrei Roller, stage designer of the imperial theatres, deserves to be mentioned. He designed the stage settings for Mikhail Glinka's operas *Ruslan and Ludmila* (1842) and *A Life for the Tsar* (1836), which raised Russian musical theatre to unprecedented heights. He also designed a Russian-style dining room in 1841 in the palace of Tsar Nicholas I's brother, Grand Duke Mikhail, at the same time working on the settings for Alexei Verstovsky's opera *The Grave of Askold*.[8]

The work of Grigori Gagarin In 1856 the Academy of Fine Arts started a class in Orthodox icon painting to assist with the decoration of the interior of the Cathedral of the Redeemer. Nominally under the direction of Professor Timofei Neff, it was actually inspired and instigated by Grigori Gagarin (1810–93). Gagarin was well known for his portraits, drawings, and watercolours of Caucasian landscapes and scenes, and he published albums entitled 'The Picturesque Caucasus' and 'Costumes of the Caucasus'. He was a typical Romantic in his style and choice of subject matter, and one of the most committed advocates of reviving the national character of Russian art, in connection with which he undertook a trip to its Byzantine source, Constantinople, in 1834. His enthusiasm for Russian antiquity expressed itself, he said, in a constant urge 'to study it with a pencil in my hand'.

The writer Vladimir Sollogub states in his memoirs that his novella *Tarantass* was conceived as a text to accompany Gagarin's drawings.[9] Published in 1847, the book was one of the most striking attempts to represent the Slavophile utopia

in a work of art. The text and illustrations contrasted images of Russia as she was and as she would be, portraying the prosperity and the flourishing of her culture and art, which would follow the return of Russian culture, after more than a century of schism, to the life-giving springs of folk and national character. The idyllic nature of the hoped-for future is balanced by romantic irony in the way the present day is depicted, and by a tragi-comic ending, but these do not detract from the overall seriousness of the author's intention and beliefs. The illustrations include both the down-to-earth and the idealistic – the latter represented mainly by decorative architectural illustrations. The frontispiece depicts a fantastical, fairy-tale future Russia and is formed of stunningly composed motifs and variations from ancient buildings, in which the features of St Basil's Cathedral, the Saviour's (Spasskaya) Tower and the Kremlin churches may be made out.

The Academy's icon-painting class showed how widely held was the belief that one should follow traditional sources when creating religious paintings or designing churches. The same attitude lay behind Gagarin's album 'Illustrations from the Holy Gospels, in free imitation of the most ancient sources'. The author explained in a brief note: 'I have tried to rejuvenate the ancient Byzantine sources which express Christian feelings with primal simplicity' in the hope that the work 'will serve to encourage those who wish to travel the path of perfecting Christian art in Russia'.[10] Gagarin's qualification about 'free imitation of the most ancient sources' – free rather than pedantically literal – was a matter of principle for Romantics like himself. As we have seen, free imitation was rated above faithful reproduction, even in restoration work.

The sources given for the illustrations in Gagarin's album are predominantly Byzantine and Early Christian. Comparison of his 'free imitation' with the prototypes reveals a precise re-creation of the traditional iconographical schemes of Byzantine and old Russian art, but also a historical accuracy and realism in the treatment of surroundings and landscape which are uncharacteristic of the originals. Similarly, the purpose of the Academy's class in icon painting was to promote 'historical accuracy' and 'appropriate elegance' in works of religious fine art.[11]

In the religious works of some of Gagarin's colleagues, such as Fyodor Bruni and Timofei Neff, we find an idiosyncratic fusion of the principles of the Academy and of old Russian art. The familiar features of post-Renaissance painting,

the solid three-dimensional quality of figures, begin to dissolve. Proportions become elongated, eyes enlarged and figures outlined. Often the figures are not so much standing as hovering in the air. The colour values also begin to change. The colours are local, they become more saturated, the blocks of colour are sharply divided from each other.

These artists painted in two quite different styles. In religious painting they were guided by the iconographical conventions and, to a much lesser extent, the artistic idiom of earlier times; when painting subjects from Russian history, on the other hand, they used the techniques and idiom of the modern period, striving for historical authenticity in the setting, characterization and costumes.

The class in icon painting stimulated the development of research into ancient art. Examples of original Byzantine painting and ancient Greek sculpture as well as medieval Russian art were acquired with government funds and deposited in a new Museum of Ancient Christian Art, the name of which was soon changed to the Museum of Ancient Russian Art.

Works by practitioners of the Byzantine style seemed to their contemporaries truly a rebirth of Russian antiquity. Ivan Kramskoy (1837–87), spiritual leader of the *Peredvizhnik*

painters or 'Wanderers', who supported travelling art exhibitions, declared, 'I went to see the art exhibition in the Kremlin cathedrals. It is wonderful, of a piece with Suzdal, and ornamented with gold. It is Byzantium itself. Truly, Beideman and Bruni have come within an inch of this style.'[12]

At the end of the 1850s the Byzantine trend in Russian art was beginning to split into two separate strands. Now a more authentically Byzantine style, drawing on original Byzantine sources, began to emerge from the Russo-Byzantine style. Buildings in this new style were designed by Dmitri Grimm. A reviewer assessed the significance of the design of a church by Grimm, commemorating the christening of St Vladimir: [the architect] 'shows a new way forward . . . and a profound knowledge of the purely Byzantine style of the first centuries of the spread of Christianity'. Grimm, celebrated for his surveys of the monuments of Byzantine architecture, had succeeded in creating 'a design for a church in a purely Byzantine style'.[13] The transformation of the Museum of Ancient Christian Art into the Museum of Ancient Russian Art points in the same direction. The striving after scholarly accuracy in the regenerated national style demanded an analogous precision in the name applied to it.

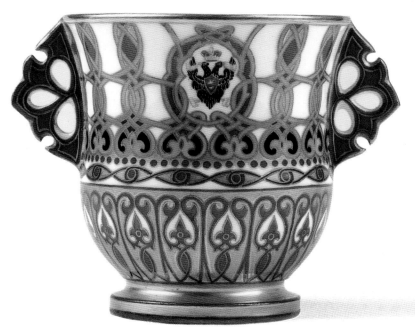

PLATE 70

PLATE 70
Fyodor Solntsev, Cup from a porcelain service
for the Kremlin Palace, Imperial Porcelain
Manufactory, 1840s.

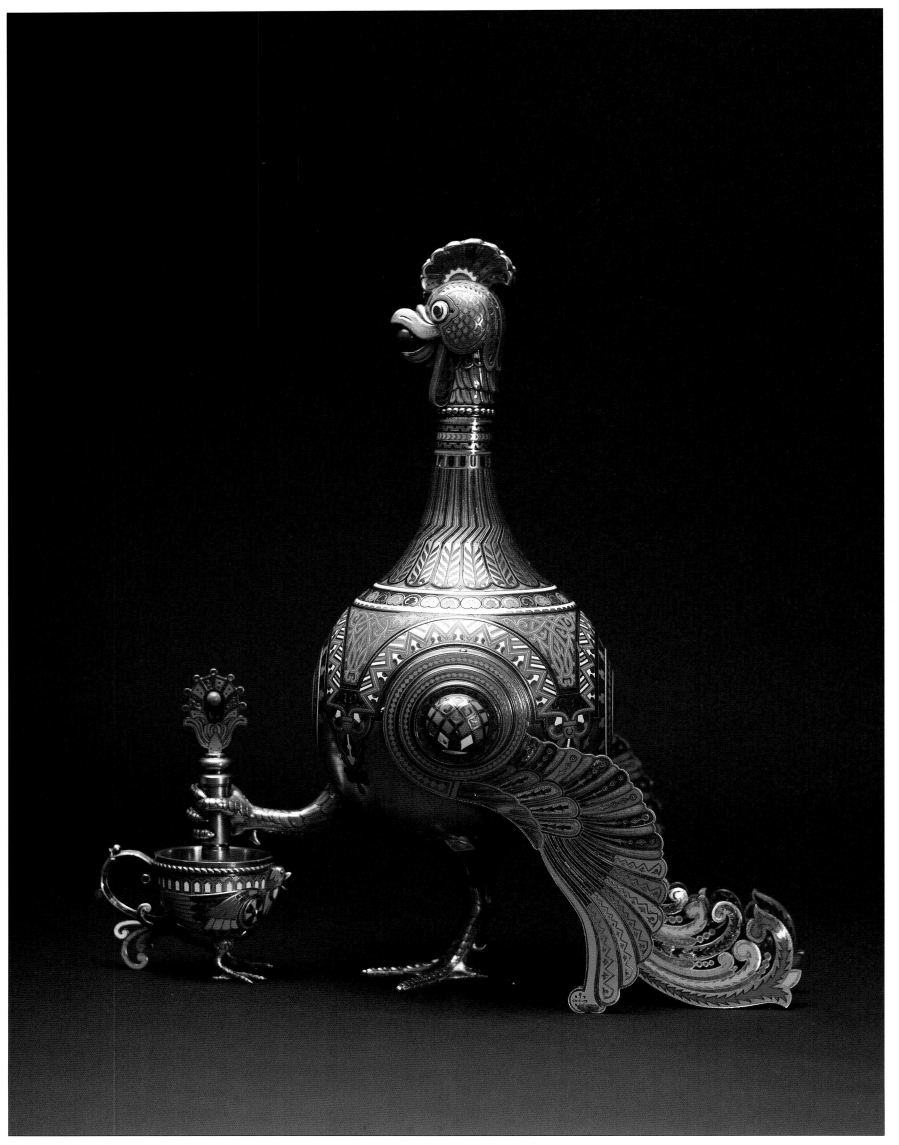

PLATE 71

THE RUSSIAN STYLE 1850–1900

The Russian Style Comes of Age

In the second half of the nineteenth century the sense of uniqueness of Russia's culture turned from its earlier focus on the Byzantine towards the nation's ethnic originality – specifically its folk art. The change in emphasis was reflected in another change in terminology. Now we find the term 'Russian style' – or, in other countries, *style russe* – becoming established. This grew out of the conviction that the national style required a more rigorous basis. During the Romantic period the artist had been free to re-create the features of his original source in accordance with his own vision, and this permitted a metaphorical title, such as 'Byzantine', for the national style, whereas the more scientific attitude of the later 1800s found metaphor unacceptable. The new title proclaimed unequivocally that what was being revived was indigenous Russian culture.

As in the early 1800s, the nationalist movement was most fully expressed in architecture and applied art. We have been reminded of the distinctive way Russian architecture jumped from the medieval to the modern period: the abrupt break with national tradition initiated by the reforms of Peter the Great. We have also seen that the urge to heal that fracture was one of the determining factors of Russian culture. In the second half of the nineteenth century efforts were made to restore cultural integrity by reviving national and folk tradition and assimilating it in 'high' culture, and to impart enlightenment to the mass of the people on a scale and with a political purposefulness previously unknown.

This Russian movement had parallels elsewhere in Europe, especially in the Balkans and Central and Northern Europe, where the problem of nationality in architecture had an urgency not found in Western Europe. In each case the explanation is to be found in the sheer scale of the historical task facing each of these nations. For the peoples of the Balkans and those of Central and Northern Europe, the main problem was national self-determination, the gaining of independence, creating an independent state, throwing off foreign domination, and developing a national culture. The task facing Russia was no less significant, but quite different.

Politically, the 1860s and 1870s were a period of reform in Russia. Serfdom was finally abolished in 1861, and reform of local government and of the legal system became a reality. The major issues continued to be social, and related to the question of folk character.

Architecture and applied arts Different art forms reflected these concerns in different ways. The main method of giving buildings a Russian appearance was the use of decorative detail borrowed from old Russian architecture or folk art. Especially popular were motifs suggestive of the patterns of peasant embroideries or the elaborate architectural decoration of seventeenth-century churches in such cities as Moscow, Kostroma and Yaroslavl. Other motifs included woven designs and ornamentation reminiscent of the illumination of old manuscripts, the carved decoration of the churches of Vladimir-Suzdal and traditional woodcarving.

Whereas the earlier Byzantine style had been primarily employed for churches, the Russian style appeared in secular architecture also. Indeed, it was ubiquitous. Buildings in the new style sprouted up everywhere: in towns, suburbs and villages. It was the style for peasants' cottages, for the housing of factory and railway workers, and for the mansions and dachas of the rich. Public buildings in Russian style were the pride of city centres. And, of course, the style prevailed in the new churches which were going up in ever-increasing numbers all over the Empire.

PLATE 71
Viktor Gartman, Spirit flagon and *charka* (small vessel used for spirit), Khlebnikov Manufactory, 1875.
The silver flagon is richly and skilfully ornamented with *champlevé* enamel. The cock's head forms the stopper, one raised leg serves as a spout, while the other leg and the tail provide balance. The flagon epitomizes 'merchant taste' of the time. It is an imaginative rendering in what was perceived to be an old Russian style. The result, however, is ponderous. Whereas a traditional Russian perception of the bird would have been symbolic and abstract, this rendering is static, drawing on the imagery and the patterning rather than the spirit of old Russia.

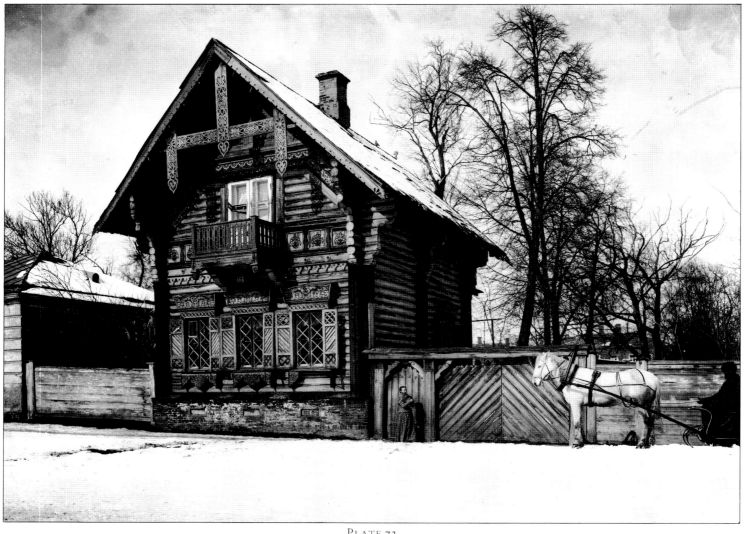

PLATE 72

The Russian style also dominated applied art, both ecclesiastical and secular. This included metalwork (railings for fences and gates, embankments and bridges; canopies and porches, balustrades and parapets) and various other forms of applied art, such as furniture, light fittings, tableware, wallpaper, stoves and fabrics – in fact everything connected with domestic and public interior decoration. Russian-style ornamentation adorned the covers of books. It was propagated through cheap mass-produced packaging as well as expensive *objets d'art*, illuminated addresses, albums and souvenirs. It would be impossible to list fully the variety of products to which *style russe* was applied. Originally an elite taste, confined to the aristocracy, the Russian style in applied art, as in architecture, became a classless phenomenon belonging to the entire Russian people.

The fine arts The situation in secular painting and sculpture could not have been more different. There, complete indifference to Russian and folk art traditions reigned. For all their diversity, the trends in fine art had one feature in common: re-working the artistic language of the modern period in their own way, none of the artists ventured beyond its familiar artistic norms. Paradoxical as it may at first seem, the main obstacle to coming to terms with the experience of national art was the shared range of concerns of architecture and fine art, and their having already absorbed notions of folk character. The factors that in architecture and decorative and

PLATE 72
Nikolai Nikitin, Pavilion built for the
historian Mikhail Pogodin, 1850s.
Built in the 1850s in imitation of a peasant *izba*
in the courtyard of Pogodin's Moscow house.
Mikhail Pogodin, the son of a serf
administrator in the service of Count
Stroganov, studied under the historian
Karamzin and was appointed to the chair of
Russian History at Moscow University in
1835. His research and publications played a

applied art stimulated a revival of folk and national tradition, in fine art served as obstacles to coming to terms with it.

As far as easel painting was concerned, Russian realist painters succeeded in creating an expressive, many-faceted original image of Russia. The paintings of such major artists as Pavel Fedotov, Vasily Perov, Ilya Repin, Vasily Surikov and Isaac Levitan, among others, present their individual interpretations of the theme of the folk and nation. Each created his own vision of Russia. Each demonstrated his own understanding of the people, the spirit of Russia and Russian history, whether in a historical painting, a landscape, or a genre study from life in town, country or country estate. Alongside these first-rank painters we may honour the work of talented painters of the second rank who have left us expressive representations of Russian folk life: artists such as Andrei Popov, with 'Folk Scene at a Fair' and 'Booths in Holy Week in Tula'; Alexei Chernyshov with 'The Organ Grinder' or 'Departure'; and Alexander Morozov, 'The Congregation Leaving a Church in Pskov'.

What Venetsianov had so passionately championed now became a reality: authenticity in the depiction of dress, character, nature and architecture, including monuments of old Russian architecture. Following his example, the bas-relief quality of classical perspective and basic three-colour palette were superseded. The new approach required the most accurate, detailed re-creation of real life. However, scholarly accuracy in the reproducing of historical or folk attire, folk types, the historical landscape, everyday implements and objects of the peasant household or of old Russian buildings did not, as we have already said, necessarily entail any shifting of the formal idiom of the fine arts in the direction of old Russian or folk art. Subject matter, not style, served as the outlet for the national spirit in nineteenth-century Russian easel painting.

The explanation of this can be found in the audience for whom this art was intended, and in the ideology behind it. The paintings speak to us of the life of the people and the country, but they were not created for the common people, and they existed outside the sphere of popular culture. This art speaks the language of the society that created it, the cultural language of the educated classes. By contrast, any tendency that appeared in the graphic arts to advance beyond Russia's relatively narrow confines (as did the mass-circulation magazine, for example, or illustrations of views or popular subjects) immediately fell under the influence of traditional techniques and forms – techniques, however, that were close to such folk art forms as the *lubok* woodcut or the icon, which themselves were lineal descendants of the art of the Middle Ages and which preserved its traditions.

Unlike the situation in the fine arts, in these other art forms the expression of folk character and nationality naturally entailed a renewal of the appropriate artistic idiom, and the use of devices and forms which transmuted into a universal and readily comprehensible symbol of the ideas represented.

The Folk Variety of the Russian Style

The years 1850–60 saw the birth, elaboration and gradual dissemination in urban architecture of an important form of the Russian style – the peasant or folk variety. It grew from a synthesis of two architectural trends which until then had been developing independently. One of these stemmed from the experience of professional architects who had worked on such rural projects as specimen plans for peasant huts and inns. A notable example was Karl Rossi's plan for the village of Glazovo; others of the 1830s and 1840s included those of Konstantin Ton. The other trend was the appearance in cities of such country-style buildings as the 'Russian Hut' café and restaurant in St Petersburg's Yekaterinhof public park (designed in the 1820s by Auguste Ricard de Montferrand) and the Nicholas Cottage in Peterhof (1834, Andrei Shtakenshneider). Architects of the second half of the nineteenth century drew on this experience, and developed and applied it to building in wood in towns and cities and other types of settlement (factory villages, and railway, factory and other estates); it was used for every conceivable type of building, but principally, of course, for dwellings in town and country. The earliest known example is the Pogodin *izba* at Devichy Fields in Moscow, which was built as an annexe to the home of the historian Mikhail Pogodin and was designed in the 1850s by Nikolai Nikitin.

It seems likely – although it has never been proved – that the peasant variety of the Russian style sprang up in Moscow and St Petersburg simultaneously. Its appearance is traditionally linked with the St Petersburg school of architecture. Vasily Stasov considered Gornostaev to have initiated the trend: 'Gornostaev was the first architect to draw our attention to the original patterns of Russian towels and the carved

crucial part in the reawakening of interest in the country's past. He was an avid collector, amassing manuscripts, icons, coins, medals, embroidery and rare editions; in 1851 his collections were acquired for the state by Nicholas I for the price of 150,000 roubles, and divided between the Imperial Public Library, the Patriarchal Collection in the Kremlin and the Hermitage. The pavilion is an early exercise in the Russian style, following

closely the forms of an *izba*. There was already a precedent: in 1834 the Emperor built a wooden 'cottage' in the grounds at Peterhof as a surprise for the Empress Alexandra Fyodorovna. It was distinctly and specifically in the Russian style, although visitors from abroad tended to confuse the look with that of a Swiss chalet.

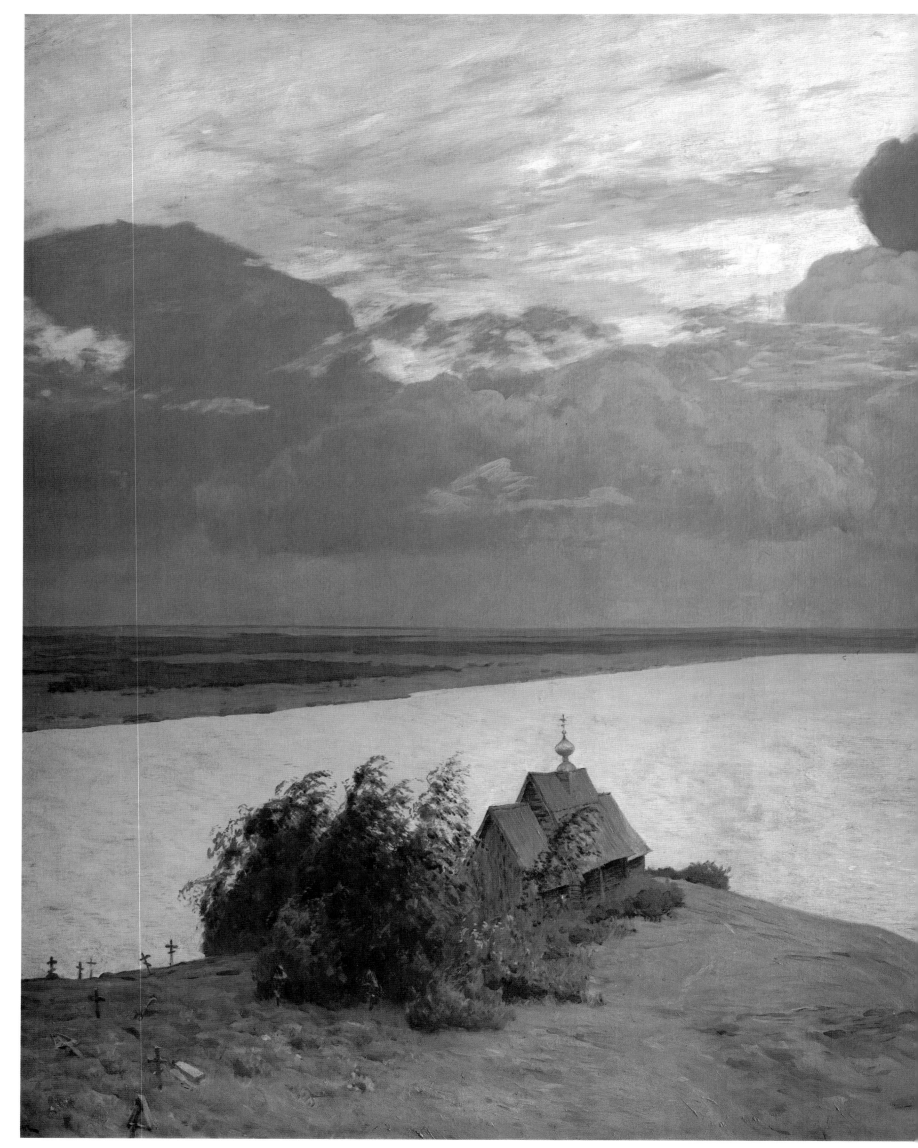

PLATE 73

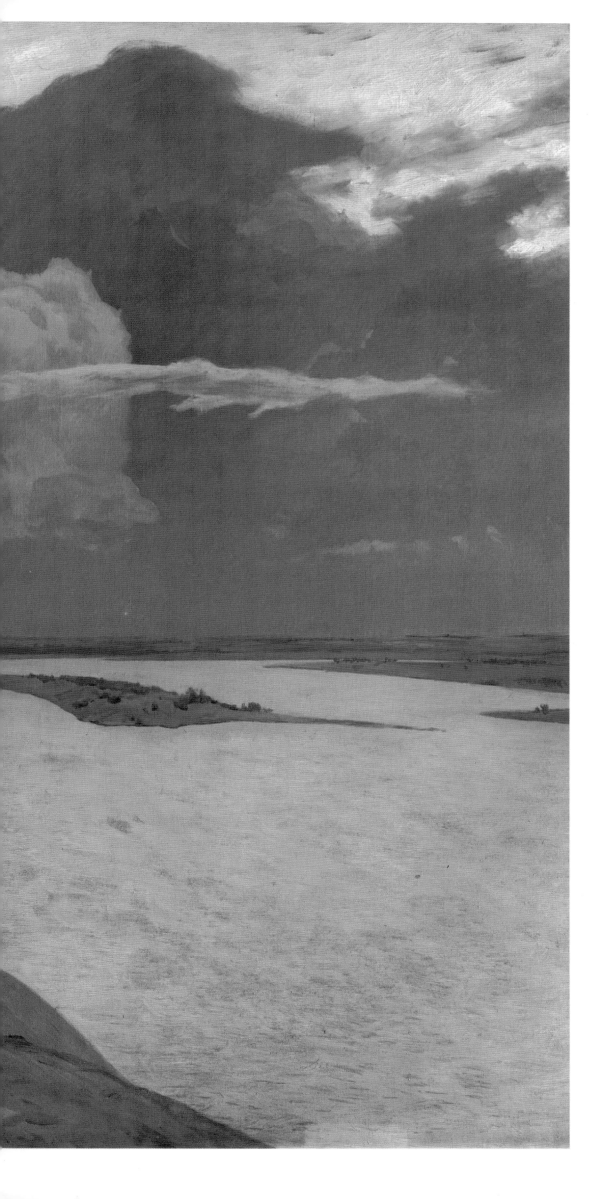

PLATE 73
Isaac Levitan, *Above Eternal Peace*, 1894.
The technique of Levitan's masterpiece owes
no direct debt to the Russian heritage, nor was
it the artist's aim to revive indigenous culture.
The painting nevertheless provides an allusive
perception of Russia – a silent, timeless
landscape, undisturbed by human presence.
The artist has rendered a concept of space that
reflects the spirit of Russia. His selection of
motifs to characterize her – a northern wooden
church, and an abundance of water and sky –
combine with a symbolically elevated
viewpoint to give a picture simultaneously
lyrical and melancholy.

PLATE 74

PLATE 74
Ivan Petrov-Ropet, Design for pavilion for a
French trade exhibition, 1879.
This pavilion was intended to promote Russian
tobacco.

and painted ornamentation of Russian huts and all manner of domestic objects of the Russian peasant. He pioneered the introduction of these elements into the new Russian architecture.'[1] However, the most prominent representatives of the trend were Viktor Gartman and Ivan Ropet, whose real name was Ivan Nikolaevich Petrov. Gartman is best known outside Russia as the artist whose paintings inspired Mussorgsky's *Pictures from an Exhibition*.

The Russian style of Ropet and Gartman gave the peasant a prominence in architecture analogous to the place he

Every old Russian town has a charm of its own, and a special character derived from its wooden buildings. The buildings dating from this period, however, have features that are quite different from or even in flat contradiction to the building in wood of the second half of the eighteenth century, which ideally aspired to be indistinguishable from architecture in stone; it systematically emulated the forms of stone public buildings, palaces and mansions. Official policy towards architecture in the latter half of the eighteenth century and the first three decades of the nineteenth aimed to

PLATE 75

occupied in literature, following publication of Dmitri Grigorovich's story 'Anton the Luckless' in 1847. 'The writer said the word which was on the tip of everybody's tongue,' observed the contemporary critic and historian Yevgeny Soloviev, 'and that word was "muzhik": the common or garden peasant muzhik in his coarse, heavy smock, at his dreary toil, in his humdrum life, enduring his humdrum, but sorely trying, lot. Grigorovich had found the word, and the muzhik took pride of place in literature.'[2] And so it was too in architecture. Everywhere – but most significantly in the cities – something took place in the late 1850s and 1860s that was analogous to the muzhik's arrival in literature.

banish from frontal façades and from those parts of buildings that were visible from the street anything reminiscent of traditional old Russian methods of building in wood.

However, the abandonment of one principle is invariably followed by its replacement with an opposing principle. The year 1858 saw the repeal of the requirement that residential property not designed by an architect should incorporate model façades. (Since the time of Peter the Great a variety of standard façades had been approved by the government, and all builders and architects had to observe the rules of design thus set.) This created favourable conditions for architecture, which until then had developed along formal lines, to accom-

PLATE 75
Viktor Gartman , Design for a gateway to a
trade exhibition.

PLATE 76

modate itself to the tastes of the majority: merchants, artisans and townsfolk. What now occurred was the introduction into urban architecture of the traditions of folk wooden architecture.

The movement begun by Gornostaev, taken up by Gartman and continued by his younger contemporaries, including Ropet and Hippolyte Monighetti, had radical overtones. These architects were among the creators of the variety of the *style russe* which most adequately gave expression to the spiritual climate of their time.

The eminent art critic Vasily Stasov noted that the ideals for which architecture in the second half of the nineteenth cen-

tury was seeking shared their origin with the ideals of realism and folk character in all the arts. Stasov provided a link with the social mood of the 1860s and 1870s. He wrote: 'Since Emperor Alexander II's accession to the throne, and since the Crimean campaign which so invigorated and renewed our spirit, there has been powerful and fruitful movement in every department of Russian art. Like an eagle literature has flown on ahead of all her other sisters, awakening intellects and talents everywhere. Painting has been the most responsive to this mighty call and has revealed for all to see the powers of the Russian soul which had for so long been slumbering as if never more to wake. Nor has architecture lagged behind the

PLATE 76
Silver model of an *izba*, Fabergé Workshops, 1894.
The model serves as a smoker's compendium. The roof lifts to reveal a mechanism to dispense cigarettes, the pump is a water-sprinkler to moisten the cigarette tip, and the woodstack conceals a match-holder. This large-scale, naturalistically realized model was made in 1894 and is therefore a comparatively late rendering of a subject represented countless times from the

early eighteenth century. The peasant lifestyle, founded on a closeness to nature and the living tradition of Orthodoxy, was basically unaffected by the Westernization of the upper classes. The qualities celebrated in Russian literature and the artefacts of the peasantry inevitably also attracted the interest of architects, artists and craftsmen.

general great movement. She too has been ashamed of her long sleep and of her shaming role as a slave who did not dare to utter a single word of her own, only copying from her betters in Europe. Now she too has put her hand to independent and truly national activity.'

What was new in this art was not its advocacy of the importance of socially relevant ideas, or its championing of 'the Russian character'. Art had been developing under that ideal since the time of Romanticism. What was new was the much greater and more focused awareness of the issue of folk character. There was a consensus that the country's future was inextricably linked to the future of the peasantry and of other working people. This interest found its way into every type of art, encouraging the appearance in painting and literature of numerous works on topics from Russian history and peasant themes; in music, of Russian motifs and topics. It also facilitated the growth of Russian historiography and archaeology. Inevitably, the 'discovery' and the resulting popularity of peasant art also had a great impact on the development of formal architecture.

There are two aspects of this discovery which deserve our attention. First, it was made by the younger generation, people just beginning their studies at the Academy. Second, it began with manufacturing design: design of domestic items, furniture and utensils. It spread to the building of dachas (mainly wooden), then to the villages and suburbs, and finally, in modified form, into urban architecture in stone.

Work by the devotees of the new peasant variety of the Russian style was illustrated in the annual publication *Motifs of Russian Architecture*. Every year from 1874 until 1880, it published their designs for furniture, utensils and buildings, ranging from churches to dachas. It was published by the architect Reynbot, and around it gathered the most radically minded supporters of the *style russe*. Among its regular contributors were Gartman and Ropet. All of the designs utilized folk motifs. For example, the common prototype for both dachas and schools was the peasant hut. Here, of course, it was greatly enlarged and embellished, using elements derived from old Russian mansions, Elizabethan country houses and Russian dachas and larger country houses of the 1830s and 1840s. In church architecture there was a revival of the compositional schemes of the wooden churches of rural Russia. The source of the designs' abundant ornamentation was the decoration of wooden huts (fretwork motifs were published in the adjacent pages of the journal), peasant embroidery, fabric designs, the ornamental carving of peasant implements such as distaffs, and, finally, illumination from pre-Petrine manuscripts.

It was generally acknowledged that wood was the material *par excellence* of folk and national art. The Russians were considered to be a nation of carpenters, and it was believed that the originality of the Russian aesthetic ideal was primarily manifest in works made of wood. This is the background to Stasov's assertion that wooden buildings in the *style russe* were 'the most important, the most talented, diverse, arresting, and elegant of all our architectural styles. Real Russian architectural motifs are being used, already existing folk motifs created by the Russian people itself in its cottages, its tableware and utensils, and in the hundred and one objects it uses every day . . . The architect is creating on the basis of purely national material with his own creative imagination leading him in new directions. The great historical merit of the new Russian architecture is that it is creating in that fundamental folk material, wood.'[3]

There is undoubtedly an element of exaggeration in Stasov's assessment of the importance of nineteenth-century wooden architecture. Nevertheless, there was considerable significance in this use of wood as a material with its own artistic merits demanding appropriate forms.

It was in wood that all rural public buildings (such as schools, hospitals and village halls), churches, houses, dachas and landowners' country houses were designed.

In urban architecture, the Russian style began to be seen in houses and also in exhibition buildings, which were typically made of wood and glass. Wooden buildings in the new style preceded those in masonry; Russian-style houses preceded Russian-style public buildings.

Exhibition halls The influence of temporary wooden exhibition halls on the character of Russian urban architecture was immense. The wooden pavilions of the 1870 Manufacturing Exhibition in St Petersburg and the 1872 Polytechnical Exhibition in Moscow gave a new impulse to the development of construction in wood in the Russian style, after its first beginnings a decade earlier. These were also the stimulus for the appearance of Russian style in urban building in stone. We shall return to this in more detail below, merely mentioning here some of the most original designs created by champions of the folk variety of the *style russe*.

PLATE 77

PLATE 78

PLATE 77
Grigoriev, Pavilion of the Charitable
Institutions, All-Russian Exhibition, Nizhny
Novgorod, 1896.
PLATE 78
Grigoriev and Lebedev, Pavilion at the
Nizhny Novgorod Exhibition, 1896.
The All-Russian Exhibition of Industry and
Art was held in 1896 in Nizhny Novgorod, a
flourishing trading centre on the Volga. The
pavilions were mostly designed in wood, as

was usual, and demonstrate the continued
adherence of architects to the folk variety of
the Russian style.

PLATE 79

Gartman's work is characterized by a combination of constructional inventiveness and the use of inexpensive materials, of politically radical thinking, and of artistic originality and open-mindedness. His was the idea of creating a travelling folk theatre, and he it was who designed the first Russian movable folk theatre (for the 1872 Moscow Exhibition). Lavishly decorated with wood carving, it was described by Stasov as 'a true popular theatre both in its overall design . . . and in the originality of the carved wooden ornamentation everywhere in evidence'.[4]

Gartman developed the idea of a theatre that could be dismantled, and even planned the detailed composition of façades with open external galleries, taken from urban folk architecture – specifically, temporary structures erected for the 'people's holidays' regularly organized in the major cities. An essential component of these structures, which could be erected in an instant and dismantled with lightning speed, were the booths, or *balagany*. In these theatres all sorts of performances were presented. To the constructional ideas and structural peculiarities of *balagan* theatres, Gartman added on his own initiative the rich wood carving typical of Russian folk art.

Gartman also drew upon folk art when finishing the interior of his theatre. The auditorium was decorated with light woodcarvings of folk art motifs and with hangings which repeated the intricacies of Vologda lace and folk embroidery,

PLATE 79
Mikhail Preobrazhensky, Parish church and school designed for the All-Russian Exhibition at Nizhny Novgorod, 1896.
The architect who designed this prototypical church, which also served as a school, was the author of an album of model designs for parish schools, published by the Holy Synod, the governing body of the Church first instituted by Peter the Great. This model building uses traditional Russian forms and techniques. The structure was designed to be dismantled and re-erected, and when the exhibition ended it was transported to a nearby village and put to practical use.

retaining their characteristic colour scheme of a red pattern on a white background, shot through with occasional striking touches of dark blue. The unbleached linen hangings of the royal box contrasted vividly with the red-patterned walls. Against the large architectural forms the openwork tracery of the embroidery seemed particularly delicate.

One of the first generation of Muscovite enlightened merchants, Porokhovshchikov, was an active propagandist of the folk variety of the Russian style. For adherents of the young movement, the 1872 Exhibition became something of a manifesto and a demonstration of their artistic credo. At the time of the Exhibition, Porokhovshchikov had a mansion built in the same spirit as its pavilions. Designed by Andrei Gun, it was built in Moscow in Starokonyushenny Street, one of the side streets off the Arbat. It was of wood, with hewn log walls, and lavishly decorated with carving.

Theatre and music There had been a temporary folk theatre on Varvarinsky (today Nogin) Square, the outside of which had been adorned not only with carving but with a sign portentously proclaiming 'Art for the People'. Porokhovshchikov built a permanent reminder of it in the shape of the concert hall of the Slavyansky Bazaar Restaurant, rich with carvings and hangings decorated with Slavic motifs.

Russian Romantics, including the devotees of the peasant style, retained their loyalty to a hierarchy, originating with Romanticism, according to which architecture and music were the most important art forms. Within architecture, an important role was ascribed to theatres and opera houses.

The designs of Gartman's Folk Theatre for the 1872 Exhibition, of the Slavyansky Bazaar Concert Hall, and of Ropet's theatre in Krasnoye Selo, near St Petersburg, established a tradition, later widespread, of designing theatres in *style russe*. We may cite the municipal theatres of Samara (now Kuybyshev) and Voronezh, among others. Wooden folk theatres and summer theatres were, on the other hand, designed in accordance with the peasant variety of the Russian style. In this context Porokhovshchikov's initiative had a significance far beyond the mere creation of a new concert hall. With an interior executed in the Russian folk style, adorned with a group portrait of Slavonic composers, it carried a complex historical, cultural and political subtext. The portraits of the Slavonic composers embodied the culture and spirit of their peoples. The symbolism of locating the group portrait in a milieu strikingly endowed with the emblems of

Russianness turned this hall into a symbol of the unification of the Slavonic peoples under the leadership of Russia.

Peasant Architecture in Russian Towns

As we have seen, one of the major aspects of the Russian style was the discovery by professional architects of peasant architecture, and the subsequent use of peasant or folk motifs in their work. At the same time, vernacular architecture itself was enjoying a new lease of life. Not only was it beginning to appear in towns – thanks to legislation passed in 1856 and 1858, which permitted this for the first time – but it was itself becoming urbanized in the process. At last it was possible – in some areas for the first time ever – to put up buildings in the towns which had the look of folk architecture, or which had drawn on that tradition. Here was acknowledgement that two cultural traditions, the professional and the vernacular, were of equal historical significance.

Folk architecture in town and country now came together again. As the peasant influence came back in the towns, so, in turn, peasant architecture absorbed features of urban architecture, and the appearance of suburbs and villages became increasingly alike. In the second half of the nineteenth century rural wooden architecture and urban architecture developed along the same lines.

Less obviously, but no less importantly, the weakening of state control and the abolition of planning restrictions opened up the way to the introduction of popular tastes, including those of the urban masses.

Urban and rural building were developing along the same lines, but they were far from being the same thing. In the late 1700s and early 1800s many Russian towns had been re-planned and reconstructed. In the villages the same process had been under way, but slowly and gradually. In the 1830s and 1840s when transformation of the villages was at its most intensive, the planners' recommendations – for example, for the width of streets, the size of each house lot – still had purely advisory status, and lacked the statutory force to reconstruct the towns.

The Europeanizing of peasants' houses The re-planning of the village streets and squares was one aspect of the transformation. The other was the transforming of peasants' huts, which, more than any other type of building, defined the appearance of a village. This began with a gradual copying of

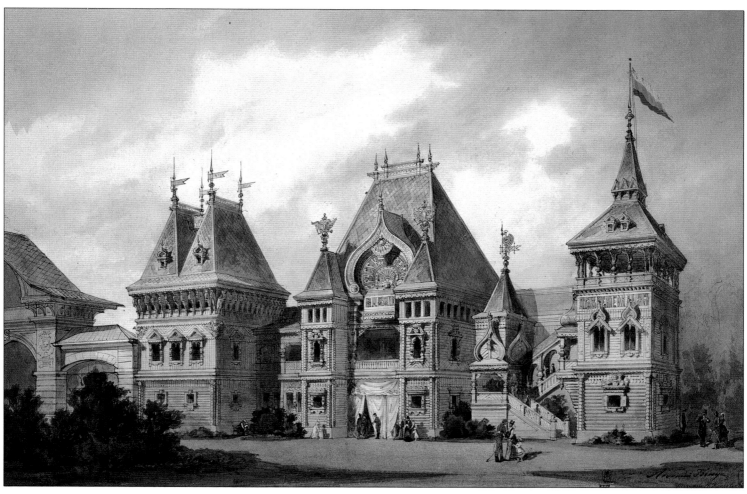

PLATE 80

stylistic and constructional techniques and forms from professional architecture and reflected a growing desire by the peasantry – evident since the later 1700s – to adopt various features of the elite culture as status symbols. At this period, settlements had begun to be laid out regularly, along the lines of the general re-planning in the towns. The peasant's house took on a number of urban features. Whereas previously it had been a basic log hut, completely symmetrical, with the development of streets within the villages the front façade became gradually more elaborate. Fretwork decorated the windows. Roofs became less heavy, constructed of planks rather than logs, and ornamented gables and balconies began to appear. Windows were enlarged as glass became cheaper. These innovations affected only dwellings; outbuildings were unchanged. Nor did they have more than a minimal effect on

traditional rural church architecture which – embodying the spiritual values of the peasant's world – was its most conservative element.

This 'Europeanized' peasant dwelling was so natural and harmonious that Karl Rossi saw it as the embodiment of folk character in architecture. He was also reacting against the typical dwelling of the end of the eighteenth century when, in 1815, he designed the village of Glazovo, near Pavlovsk, in the peasant idiom – virtually the first of its kind in Russian professional architecture. The plan was commissioned by the Dowager Empress Maria Fyodorovna, widow of the Emperor Paul (1796–1801).

Similar to Rossi's peasant cottages were designs of the Department of the Tsarskoe Selo Board of the Village of Upper Kuzmina, which Nicholas I judged a model for the

PLATE 80
Leonty Benois, Russian Pavilion, 1888.
Leonty was the son of Nikolai Benois, who had built the stables at the palace of Peterhof in 'Tudor' style, and the brother of Alexander, a prominent artist and critic of the aesthetic movement *Mir Iskusstva* ('World of Art'), which helped to bring about a fundamental change in the artistic climate of the 1890s. His design reflects the vision of a younger generation than that of Pomerantsev and

Parland. Here, he abandons strict symmetry overloaded with ornament in favour of a simplified design, easier to achieve because he is working in wood.

PLATE 81

countryside, 'built in the pure Russian taste'. On that basis they were included in an 1831 album of 'Plans for the Good Ordering of Settlements'.[1] These set the tone for the authors of later albums of model projects for the design of villages and rural buildings which were published in 1841, 1851 and 1853.[2] Intensive redesigning and reconstruction of villages took place between the 1830s and the 1850s on this authority. The results were as radical as the wholesale re-planning and reconstruction of the towns on regulation lines which was carried out at the end of the eighteenth and beginning of the nineteenth centuries. There was, however, one significant difference in that this time the reconstruction or building from scratch was based on the traditions of peasant architecture.

In 1856 an edict was published rescinding the statutory nature of the model plans for rural buildings located adjacent to highways or visible from them. Within two years a further edict permitted the construction in towns of private buildings 'whose façades deviate from the model designs'.[3] No sooner did this directive appear than the urban masses expressed their artistic, social and ethical values very clearly. Those sections of the urban population not belonging to the educated middle classes – skilled workers, craftsmen, merchants, traders and peasants who were settling in the towns – showed their artistic, social and aesthetic tastes decisively in the buildings they created: Russian houses in what was seen as the 'peasant taste'.

For a relatively short period, from the 1860s to the 1890s, the paths of professional architecture and folk wooden architecture converged. By the beginning of the twentieth century, wooden and stone architecture (vernacular and professional

PLATE 81
Pyotr Shestov, Design for Polivanov's country dacha in Shmetsk, 1876.
The outskirts of major Russian towns were built up with wooden dachas of this kind, either with log walls exposed or, as here, covered with cladding and decorated with fretwork. Similar designs were used for the houses of technical specialists in industrial and railway settlements. Many of the houses in Russian provincial towns were wooden even at this date, the window frames and porches often lavishly carved.

respectively) were again going their own ways. Vernacular architecture (whose traditions are alive to this day in private home building in villages and small towns) has remained faithful into our own time to the techniques that evolved in the mid-1800s, while professional architecture passed through a succession of styles – most recently post-modernism.

The Russian wooden house　Modest one- or two-storey wooden houses elaborately decorated with carving were until recently – and where they survive, still are – the standard type of building in old Russian towns, particularly the smaller ones. In the latter half of the nineteenth century and the early years of the twentieth, the inimitable character of Russian towns derived from the contrast between the high-density building in stone of the central streets and a sea of richly carved wooden houses in the outlying areas.

These areas of wooden buildings are not chance agglomerations of particular buildings, but have the sense of integrated architectural ensembles, with the artistic unity and expressiveness of space organized architecturally on the basis of definite principles. Fundamental to these were various legal restrictions mainly concerned with fire prevention. Wooden buildings were not allowed to exceed two storeys in height, and their total length and the size of the firebreak between them were also regulated. In the towns of European Russia the building of wooden houses of more than one storey was prohibited. A wooden second floor was permissible where the ground floor was of stone (an especially popular design), or a house wholly of wood could have a wooden mezzanine. A special edict permitted two-storey wooden houses in the towns of Siberia and the far east of Russia, where they are a striking feature.

The appearance of a house is affected by whether it has a stone foundation storey, and whether this is blind or a half-storey with low-ceilinged premises for workshops, storage or cellars. Another important aspect of a building's individuality is the finish of the outer walls. The logs might be exposed, or covered with weatherboarding. If exposed, the logs might be hewn in a number of ways. There were different ways of jointing them. Cladding admits of much diversity and makes for façades of distinctive appearance. The smartest and most expressive attribute of a wooden house is, however, its carving.

Carving is used to accentuate the outlines and rhythm of the basic elements and divisions of a house: the upper sections of walls, the frames and lintels of windows and doors, the decorative parapet above gates and corner sections of houses, attics, loggias and the balustrades of balconies.

The overall composition of these buildings shows a masterly combination of structural and ornamental features, of the functional and the exuberantly decorative. For sheer diversity and inventiveness, however, the greatest ornament is the stunningly elaborate window casing. Equally diverse are techniques of carving. Carving can be 'blind', deeply incised, or convex, or fretted, with parts sawn out. Incised carving is usually geometrical, whereas the fretted variety tends to be pictorial, the most popular motifs being pots with flowers or plants, coiling stems, drapery with tassels, plant motifs or scroll patterns suggesting foliage. Fretwork can be high relief, sometimes layered, or openwork. Like precious lace it adorns the tympanum of a pediment, cornice and frieze of a house. Often it features on casings – on its own or in combination with unpierced relief carving.

In many old Russian towns, primarily in the large towns of Siberia, it is the wood rather than the stone buildings that seem the most significant and imposing. The word that comes to mind to describe these vast, looming buildings, with their wealth of ornamentation, is 'palatial'. The author of a book about the early twentieth-century wooden architecture of Tyumen coined the term 'Siberian palazzo' to describe them.[4] Photographs cannot adequately convey the impact these houses have on the onlooker, but even from photographs one is amazed that buildings so thoroughly in the vernacular tradition can be so sumptuous. One cannot help comparing them with the palaces of the St Petersburg baroque. In both cases we find a monumental, regal quality, an exultant festivity, and a more-than-generous lavishing of ornamentation.

The Russian Style in Stone Architecture

Up until the second half of the nineteenth century, building in stone and brick had followed the traditions of classical architecture. Now it began to imitate wooden architecture and to follow the Russian style. This trend included both religious and secular architecture, from houses to public buildings. Although it flourished in St Petersburg and other cities, it was most prevalent in Moscow.

By this time Moscow had become the centre of Russian culture, and this leadership favoured the dissemination far

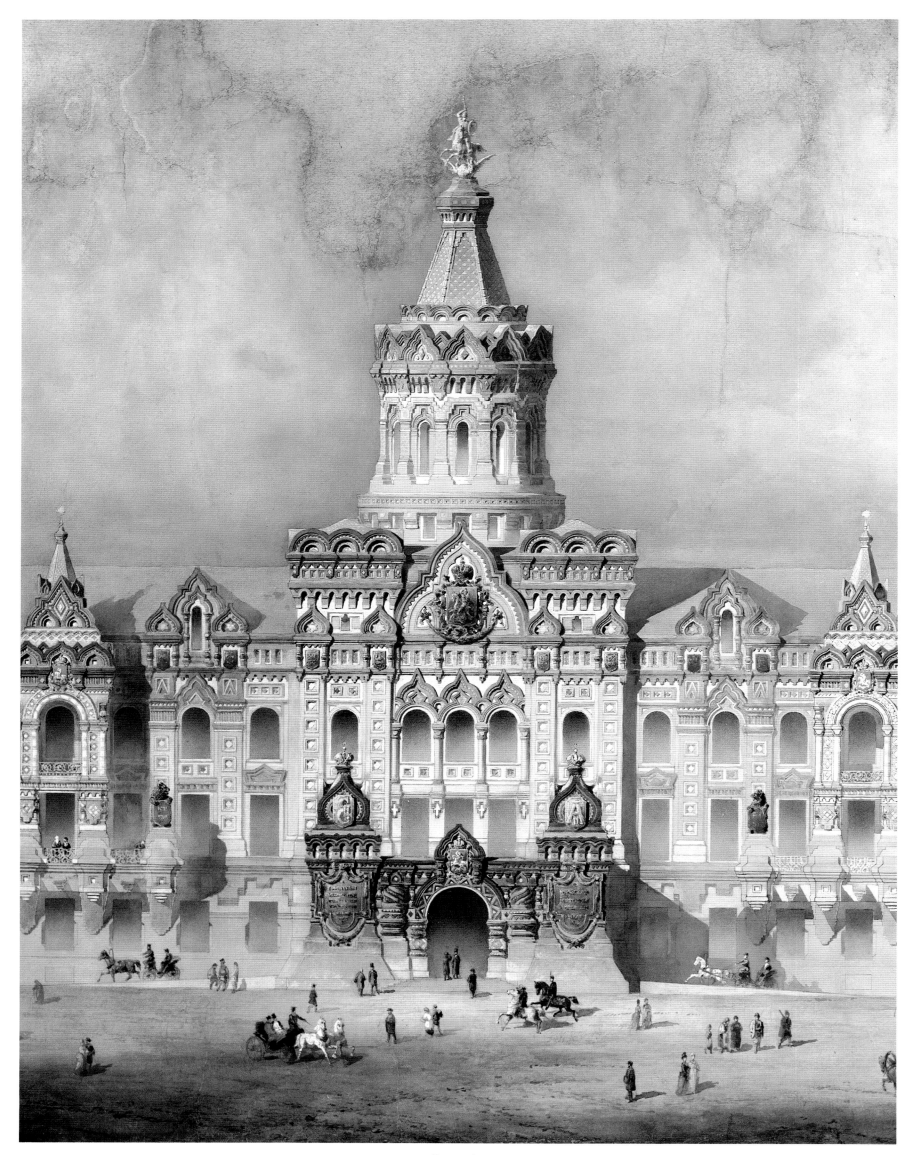

PLATE 82

and wide of the Russian style in secular building. Much of the centre of the old capital was reconstructed in the Russian style, although with a view to making the new building a continuation and development of what already existed. This principle, which was followed very strictly in areas with historic buildings, applied particularly to such hallowed focuses of Russia's tradition as the Kremlin, Red Square, and the inner-city merchants' quarter of Kitai Gorod.

In Moscow the link is particularly clear between building in the Russian style in wood and the subsequent major public

development after the abolition of serfdom.

The Exhibition's Russian-style pavilions of wood and glass – or, in the case of the Marine Pavilion, of metal and glass – occupied sites in the Kremlin and the Alexandrine Park and on the Kremlin embankment. The Exhibition also saw the opening of a folk theatre on Varvarinsky (now Nogin) Square. Although only temporary, the Exhibition was the first large-scale attempt in the history of post-Petrine Russia to restore a Russian appearance to secular buildings outside the Kremlin.

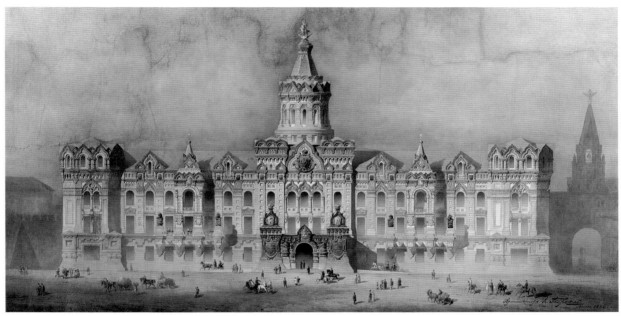

PLATE 83

buildings in the same style. The Moscow merchants began to build numerous detached masonry townhouses in the Russian style. In both Moscow and St Petersburg the second half of the century saw the construction of multistorey public buildings and blocks of flats in the Russian style.

One particular event gave a tremendous boost to the use of the Russian style for stone buildings. This was the Polytechnical Exhibition organized in 1872 by Moscow University's Society of Devotees of Natural Science, Anthropology and Ethnography. Timed to coincide with the bicentenary of the birth of Peter the Great, it cast a retrospective glance over two centuries of the development of Russia along European lines. At the same time it reviewed the first decade of the nation's

In their entirety the exhibits collected for the Polytechnical Exhibition gave a comprehensive picture of Russia past and present. It was decided to create three museums to house them: the History Museum, designed by Vladimir Shervud and A. A. Semyonov; the Museum of Russian History (Polytechnical), designed by Nikolai Shokhin and Hippolyte Monighetti, which was to reflect Russian science and technology in history and the present day; and the Museum of Agriculture, designed by Nikolai Nikitin. The museums were allocated prime sites in the historic centre of the city. The History Museum was built opposite St Basil's on Red Square (whose Russian name, Krasnaya ploshchad, originally meant 'beautiful square'), and the Polytechnical Museum on Old

PLATES 82 & 83
Konstantin Tersky, Design for the Moscow
City Duma, 1886.
Rezanov's 1876 design for the Duma was not
used, and a new competition was held a decade
later. This entry combines elements from
seventeenth-century Russian architecture
with the symmetrical composition of
classicism, and introduces a tower in the centre
of the façade in the manner of a Western
European town hall.

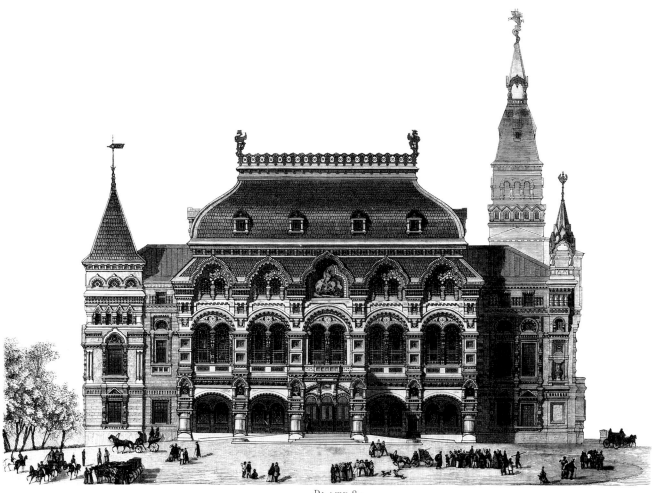

PLATE 84

Square near the Kitai Gorod wall. The Museum of Agriculture was allocated land in the Alexandrine Park, but was never built because of lack of funds. The location and purpose of the buildings made it a foregone conclusion that they would be built in the *style russe*. The construction in the 1890s of the Upper and Middle Market Arcades, designed by Alexander Pomerantsev and Roman Kleyn respectively, finally restored to Red Square a Russian look in harmony with its ancient buildings.

The abundance of Russian-style buildings and, most importantly, their prominence in the city's architecture testify unambiguously to the existence of a consensus among those commissioning the buildings and the architects. All the major construction initiatives from the 1870s into the 1890s give clear evidence of a consistent effort to 'Russify' the heart of Moscow.

Vetoshny Drive (now Sapunov Drive) then ran parallel to Red Square, linking Elijah Street (now Kuybyshev Street) and St Nicholas Street (now 25 October Street), two of the three main streets of Kitai Gorod. The Russian-style façades of the main and second buildings of the Upper Market Arcades rose on both sides of it. Not far from Red Square, in St Nicholas Street, the Zaikonospassky Arcade was built in the 1890s with a spruce Russian-style façade designed by Mikhail

PLATE 84
Alexander Rezanov, Design for the Moscow City Duma, 1876.
An earlier, unrealized, design for the Duma building was devised shortly after the passing of the decrees on urban reform in 1870. As with the adjacent Historical Museum, the building's style was governed by its location, and it was devised to harmonize satisfactorily with the neighbouring Kremlin and the Kitai Gorod district. A symmetrical composition was enforced by the necessity of building the Duma on the foundations of an earlier building. The architect has tried to offset this by the introduction of small side towers, asymmetrical with the high tower on the façade opposite the Iverian Gateway.

PLATE 85

Vladimir Shervud, Historical Museum, Moscow, 1883.

The construction of a museum of history in Moscow was an event of major significance, both because of the site – in close proximity to St Basil's, the Kremlin walls and towers and the Iverian Gate, all medieval structures of red brick – and because of the understanding it was intended to provide of the historical process and of Russia's evolution. The committee presiding over its construction included Count Uvarov, Minister of Education; the noted historian Zabelin; and the architect, of English origin, Vladimir Shervud. Shervud conceived the building as an expression of the centralized, patriarchal nature of Russian history, which he also saw expressed in St Basil's. He attempted to provide the structure with an ecclesiastical character to express 'the fact that the church is not just a holy idea in our popular history but the primary cultural element of our nationhood'. The building is composed of several parts, differentiated in height but supported and unified by a square base. The sequence of interior halls was designed to represent different historic epochs – the Dark Ages, dimly lit; the period of Kievan Christian culture, flooded with light – and each section was given appropriate roofing. The tall exterior towers, which were designed to reflect those of the Kremlin and to evoke the idea of a sacred city, did not meet with Zabelin's approval – he felt their upward thrust to be 'too Catholic' and not appropriate to the Russianness of the original concept.

PLATE 86

Dmitri Chichagov, Moscow City Duma, 1892. The Moscow Duma building was erected only after two preliminary competitions. The winning entry shows the endurance of classical, ordered balance and repose, here with superimposed 'Russian' ornament. The Duma was situated flanking the Iverian Gateway. It was covered with profuse ornamentation adopted from seventeenth-century architectural motifs. Despite these trimmings, the building remains characteristic of the nineteenth century.

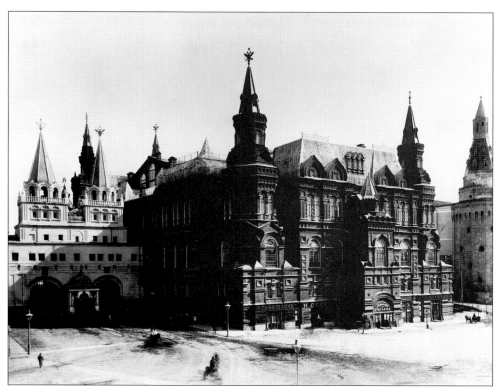

PLATE 85

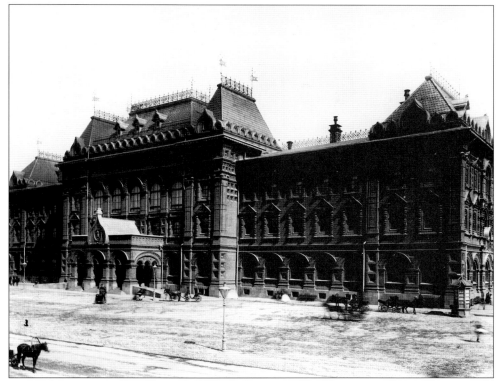

PLATE 86

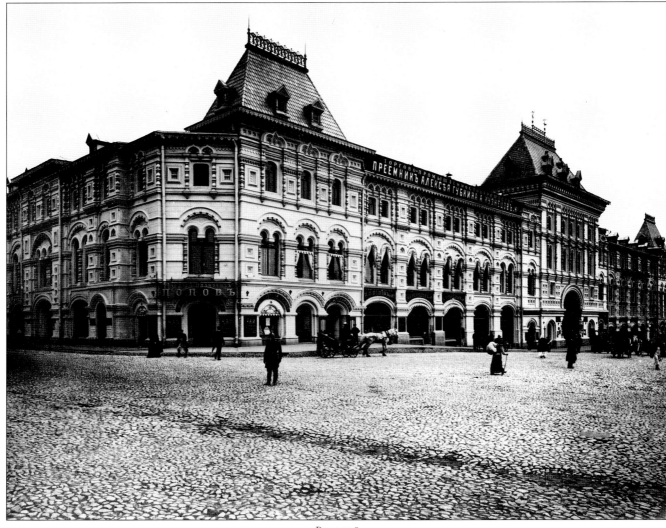

PLATE 87

Preobrazhensky. One section of the Arcade, crowned with a high tented roof, stood at the end of the vista along Vetoshny Drive.

Just in front of Red Square, on a stretch of Tver Street now demolished, stood the Loskutnaya ('Patchwork') Hotel, built in the Russian style by Alexander Kaminsky, with a picturesque façade decorated with coloured tiles. It stood opposite the Iverian Gates of Kitai Gorod, with their two tent-roof towers (also no longer extant), which led on to Red Square. On the old Resurrection (now Revolution) Square, Dmitri Chichagov's (1836–94) building for the Moscow City Duma was erected between 1887 and 1893. Two central streets, Theatre Drive (now Prospekt Marksa) and St

Nicholas Street, were joined by the buildings of Tretyakov Drive (1873), which opened on to both with wide arches. These buildings exemplified the choice of a style in keeping with the way an area had evolved. The façades of the buildings to the sides of Tretyakov Drive and the façade facing Theatre Drive, along which the Kitai Gorod wall extended at that time, have Russian-style towers. The gateway arch was crowned with a tower which echoed the ancient towers of Kitai Gorod. The façade fronting St Nicholas Street, on the other hand, was designed in neoclassical style, in order to harmonize with other buildings in that street.

At the end of St Nicholas Street, not far from the ancient towers of the Kitai Gorod wall and the Church of the Mother

PLATE 87
Roman Kleyn, Merchant Trading Rows,
Moscow, 1891.
The Merchant Trading Rows were built to
replace an earlier covered market in the
neoclassic style designed by Beauvais in 1815.
As redesigned, they were intended to
harmonize with the red brick medieval
structures nearby. For use by traders in heavy
goods, access was allowed to an enormous
interior courtyard.

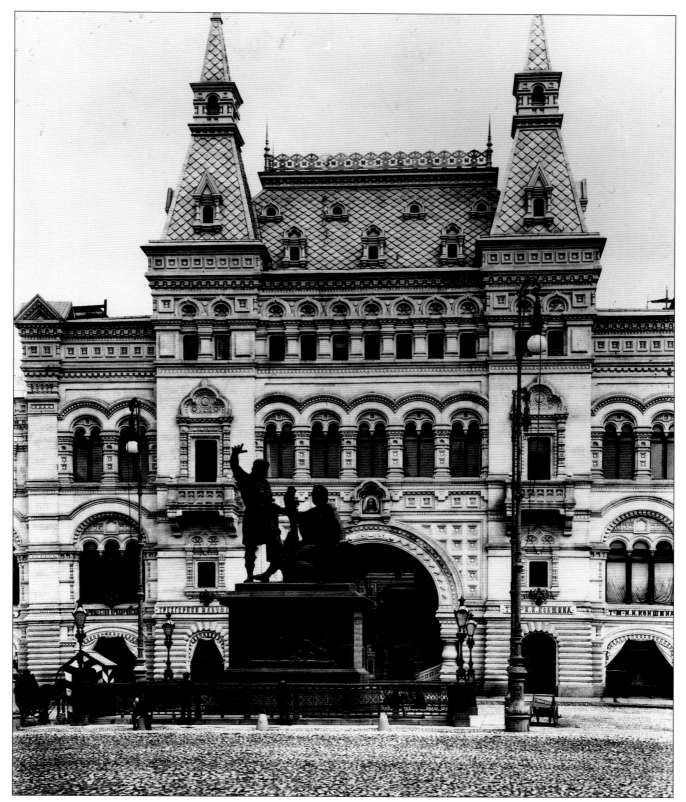

PLATE 88

PLATE 88
Alexander Pomerantsev, Upper Market
Rows, Moscow, 1893.
The Upper Market Rows occupied part of the
site previously occupied by Beauvais'
discreetly elegant classical building. As
reconstructed, they are an assertive statement of
Slavophilism. Martos' early nineteenth-
century classical monument to Minin and
Pozharsky is seen in the foreground.

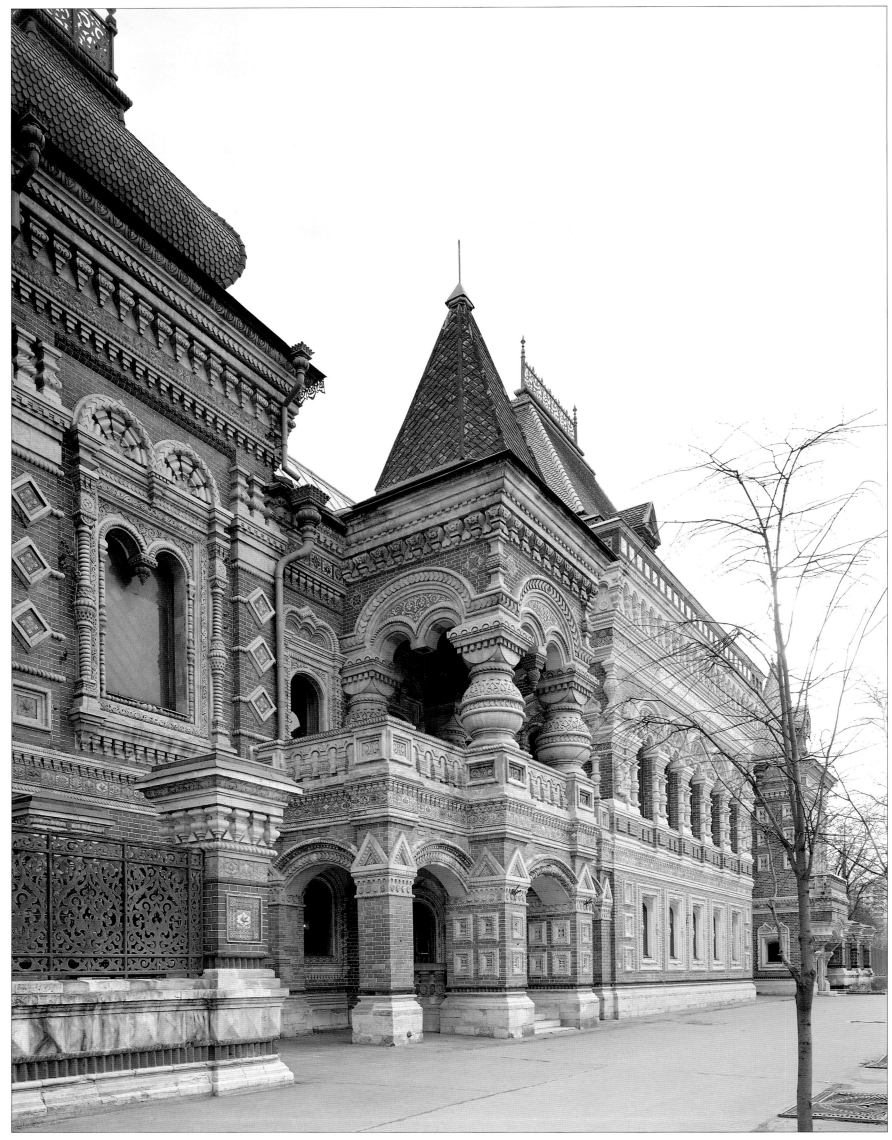

PLATE 89

of God of Vladimir, Kaminsky's Chapel of St Panteleymon was built. In conjunction with the dome of I. I. Kondratenko's Lubyanka Passage, all these buildings together created an expressive system of verticals fringing Lubyanka (now Dzerzhinsky) Square. The overall view and the skyline were a happy combination of the verticals of buildings of different periods, echoing, complementing and repeating each other. Into this medley of revived old Russian forms, from the eastern side of the Kitai Gorod wall came the Moscow Merchants' Society Building (designed by Boris Freydenberg), the Polytechnic Museum and the memorial chapel to the Grenadiers who fell at the taking of Plevna in 1877, during the Russo-Turkish war in Bulgaria, erected in 1887 at Elijah Gate Square to the design of Shervud. The little tower on the southern façade of the Polytechnical Museum, the towers of the Elijah Gate and the domes of that architectural gem, the late seventeenth-century church of St Nicholas of the Great Cross, all came together in a bristling of verticals on the eastern side of the Kitai Gorod wall, which provided a second focal point – after the Elijah Gate itself – for this impressive square. The prominence of this eastern quarter of central Moscow was greatly increased in mid-century after Kalanchevskaya (now Komsomolskaya) Square was formed on the eastern outskirts with three railway stations on it, and the Nizhny Novgorod and Kursk stations were built in southeastern Moscow.

After the abolition of the imperial theatres' monopoly in 1883, both capitals experienced a boom in theatre-building. A number of Moscow theatres – for example, Korsh's Theatre in Bogoslovsky Lane (now Moskvin Street) and the Paradise Theatre in Great Nikita (now Herzen) Street – were built in the Russian style.

There is a significant correlation between the past history of a given town, the nature of its economic and cultural development and the extent to which the Russian style is found in its civil architecture in stone. The insistence in this period on building in harmony with the prevailing style of existing architecture was also of importance. For example, apart from a few churches, there were almost no public buildings in the *style russe* in St Petersburg. The style is sparsely represented in the stone architecture of Tver, the first large town after St Petersburg to be systematically built up in the spirit of classicism to model designs based on the norms of regulation town planning. The same holds true of other cities similar to Tver, which prospered in the eighteenth and early nineteenth centuries.

Things were very different in pre-Petrine Russian towns and in centres of trade and industry with high growth rates and with rich and energetic merchants. Here the Russian style was widely used for commercial buildings and banks, local government buildings (municipal dumas and *zemstvo* boards), schools and hospitals, museums, hotels, theatres, mansions and developments of flats. In towns of this kind – those on the Volga, for example – whole areas were developed in the Russian style. We may instance the ambitious development for the annual St Makarius market in Nizhny Novgorod. The same was true of towns that grew out of trading settlements adjacent to monasteries, such as that of the Trinity and St Sergius (now Zagorsk), or trading and craft villages such as Kimry, which plainly take their cue from Moscow in the design of their central public and commercial buildings in the Russian style.

Echoes of the seventeenth century As we noted earlier, the Russian style in architecture often drew upon the decoration of seventeenth-century churches. This reflected a similarity in aesthetic spirit between the seventeenth and the later nineteenth century; both ages – in Russia and elsewhere in Europe – were marked by a love of rich ornament. In the Russian style this tendency was indulged with wild abandon. Buildings erupted in a multiplicity of forms, in dazzling combinations of colours; intricate, convoluted patterns covered their walls. The dissimilarity in form and function between the seventeenth-century prototypes and the buildings designed in imitation of them (between a church and a bank, for example) naturally obliged architects working in the *style russe* to rely primarily on ornament in reviving the earlier tradition. This was not, however, the whole story; extensive and varied use was in fact made of other aspects of the architectural heritage.

Materials began to be employed which were regarded as typically Russian; these included red facing brick (walls of red brick with white stone detail were a favourite colour combination of the Naryshkin baroque) and tiles of varied colours (typically combined with red brick walls in the seventeenth-century Moscow and Yaroslavl schools of architecture). Turrets and hipped roofs were often covered with moulded tiles or galvanized iron.

Such materials were chosen partly for aesthetic reasons and

PLATE 89
Nikolai Pozdeev, Town house of the merchant Igumenov, 1892.
The Igumenov house, with its brick patterning, inspired by seventeenth-century architecture, is a striking example of the reinterpretation of older forms. Early Russian buildings were usually of wood or a wooden upper storey constructed over a brick base. The pre-Petrine houses consisted of several separate structures, or *kleti*, linked together by covered passages and exterior staircases, and each unit with a separate and distinct roof. Grouped together, these roofs lend a picturesque quality to the overall silhouette. In the Igumenov house, the lightness and delicacy of seventeenth-century architecture is replaced by a ponderous weightiness. The building, heavy with ornament, seems rooted to the ground.

PLATE 90

PLATE 91

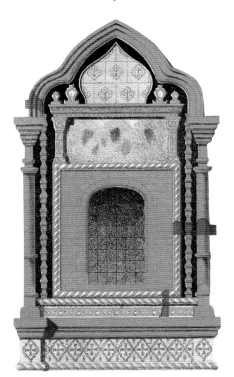

PLATE 92

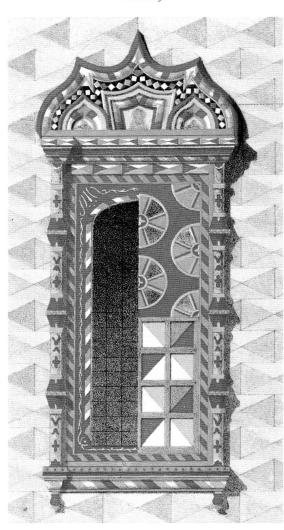

PLATE 93

PLATES 90–93
Architect's drawings of window surrounds in
Yaroslavl, nineteenth century.
In the seventeenth century Yaroslavl was an
important trading centre where rich
merchants competed with one another to build
and endow the most resplendent brick
churches, ornamented with ceramic tiles and
with profusely decorated interiors. When new
architectural solutions were in the process of
developing in the course of the nineteenth

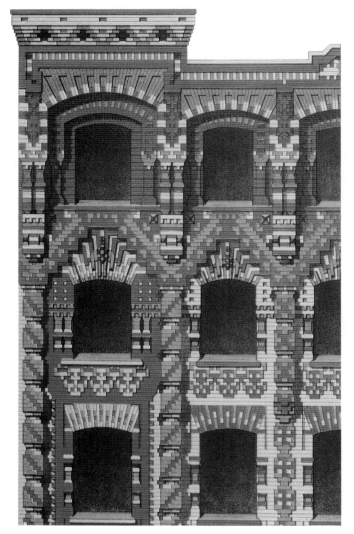

PLATE 94

partly for their practicality. Facing brick came back into use in the 1860s and the 1870s after a century and a half of disuse, along with decorative tiling. Not only did these make possible intense and highly attractive colour combinations on façades (and, in those days, at relatively low cost); they also obviated the need for frequent maintenance and repainting – a notable drawback of buildings faced with plaster. The return to 'Russian' materials and the rebirth of the national sense of colour had thus both a constructional and a decorative aspect. Often craftsmen would enhance the effect of blanket ornamental patterning in multicoloured brickwork – which might imitate the cross-stitch patterns of peasant embroidery, or the fancy brickwork of old Russian buildings – by adding decorative

details such as elaborate window surrounds or multicoloured tile inserts. The latter technique was a distinctive feature of seventeenth-century religious architecture.

Another feature of sixteenth- and seventeenth-century architecture, both religious and secular, that was revived in the Russian style was the combination of more than one building within a larger complex. The appeal of proliferating forms also appeared in buildings with multiple turrets.

The façades of public and residential buildings now acquired a curious multi-plane quality. They were composed as if intended to be viewed in more than one way: from afar, to be seen in the context of a street or square; and from a short distance, with appreciation of the intricate ornamentation of

century, the first interest for those researching old Russian art tended to be in the works of the seventeenth century – the art that was created on the eve of Peter's Westernization. The richly ornamented and patterned window surrounds reproduced here are characteristic of this interest.

PLATE 94
Nikolai Fedyushkin, Sivkov House, St Petersburg, 1876.
The renewed interest in elements from indigenous Russian traditions took various forms, including the use of brick – a durable and decorative facing material, with the potential for providing strong colour contrasts. This façade has a handsome, evenly decorated, ornamental surface, producing a dense, carpet-like effect.

PLATE 95

PLATE 96

PLATE 95
Alexei Gun, design for a linen cupboard,
early 1870s.
This extraordinary cupboard, made for a
member of the Imperial family and extremely
characteristic of its era, is not so much Russian
as typical of an international movement. It
displays strong allusions to the Italian
Renaissance as well as some superimposed
'Russian' ornament – 'embroidered'
ornamental *trompe l'oeil* towels suspended to
the left and right, and interlacing ornament
within the recessed panels. It was against this
type of extreme and irrelevant ornamentation
that the designers of the next generation were to
react.
PLATE 96
Alexander Rezanov and Alexei Gun, Dining-
room in the palace of the Grand Duke
Vladimir on Palace Embankment, St
Petersburg, 1872.

The Grand Duke, president of the Academy of
Art, was keenly interested in contemporary
design. He was a famous shot and the
ponderous style of his 'Russian' dining room,
shown here reproduced in the magazine *The
Architect* in 1875, is not far removed from that
of a German hunting lodge. The accompanying
description reads: 'The banqueting hall is
finished entirely in the Russian style: the walls,
as also the ceiling, the panelling etc., are
moulded, and subtly coloured in imitation of
oak... The large-scale paintings with themes
from Russian folklore painted on coarse canvas
by Mr. Verishchagin which are suggestive of
tapestries. On the wall space between the
paintings, Russian ornament is offset by a
turquoise background... The chandeliers and
wall brackets are of polished red copper, the
furniture of oak with leather upholstery; the
curtains of natural linen with Russian patterns
lavishly embroidered in silk.'

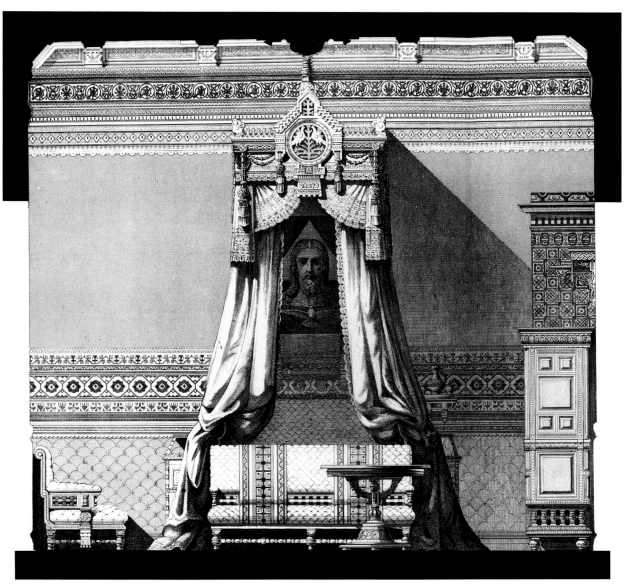

PLATE 97

PLATE 97
Alexei Gun and Pavel Kudryavtsev, Bedroom
in the Bashmakov apartment, St Petersburg,
early 1870s.
The designs of Russian-style interiors were
frequently described in great detail in the
press. The bedroom in Bashmakov's much-
admired apartment is described in *The
Architect* in 1873: 'The room is decorated in a
warm greyish-yellow, the framed ceiling is
painted the colour of beech, of which wood
the furniture is made. Beneath a fretwork
cornice runs a frieze of ceramic tiles in blue and
green. The walls are framed with the same
beech and lined with fabric... The cord
around the frames, on the walls, and on the
furniture... is elegantly framed by a blue and
red border of elaborate continuous patterning,
taken and adapted from our peasant towels....
All of this lends individuality and harmony
and all the elements are worked out with

minute attention to detail.' The complex
recessed and carved ceiling is shown in the
detail illustration on the right.

PLATE 98 PLATE 99

the façades. These aspects do not conflict because the façades were consistently and evenly covered with ornamentation. The small was an integral part of the great. Moreover, the greater aspect included not only the surface of the façade but also large decorative elements, especially such three-dimensional features as oriels and turrets. This can only enhance the rhythms of the composition, the larger elements helping to integrate the building into a street or square, or even into some larger unity extending beyond the limits of the network of streets. A building might be included in the historic system of verticals, aesthetically organizing urban space not only at the level of the individual building familiar from regulation town planning, but also in ways related at a deeper level to the old Russian town planning, by linking up a series of circle or ring roads by means of wide boulevards radiating from the centre point.

Religious architecture As in the Byzantine style of the preceding period, the building of churches offered much greater scope for fidelity to the old Russian prototypes than did the design of new secular buildings based on churches; and here again we find nineteenth-century architects engaged in a wholesale structural revival of the heritage. Revival of

individual elements followed naturally. As in secular building, the main source for imitation was seventeenth-century architecture, including St Basil's Cathedral which, although erected in the sixteenth century, had been radically reconstructed in the seventeenth. The new churches incorporated all the typical Russian-style features: picturesque composition involving multiple building units, elaborate outline and colour combinations, diversity of materials and, finally, purely national old Russian forms such as the faceted *shatyor* tower and the *kokoshniki*, or stepped gables, of the seventeenth century. The resurrecting of the national heritage in church building was thus able to escape the planning norms that invariably apply when the use of a secular building – a railway station, theatre, or hotel, for instance – dictates its form, and any deviation from the purely functional can appear only in applied decoration. Only churches had the freedom to copy or to follow the old forms.

Interiors and Applied Art

It is a general rule in art that new movements first appear in less important genres. This is logical enough, insofar as the new, although it emerges from what has gone before, also

PLATE 98
Hippolyte Monighetti, Design for a
candelabrum, 1873.
PLATE 99
Hippolyte Monighetti, Design for a reliquary,
undated.

PLATE 100
Hippolyte Monighetti, Design for a cover for
an album, 1867.
PLATE 101
Hippolyte Monighetti, Design for an album
stand, 1867.

PLATE 100

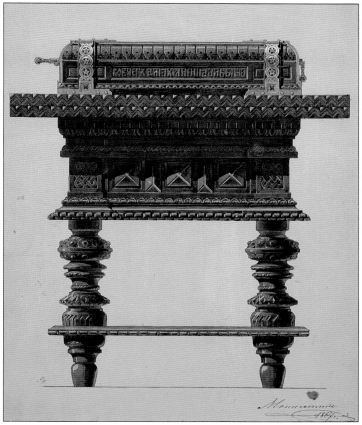

PLATE 101

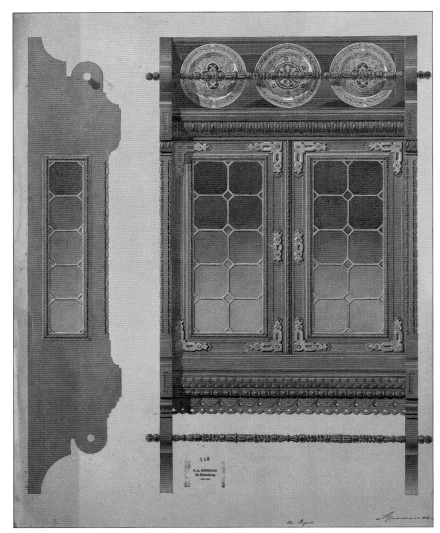

PLATE 102

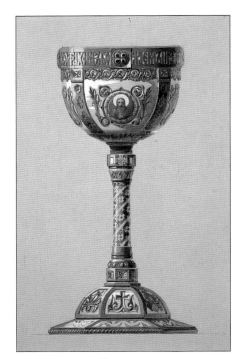

PLATE 104

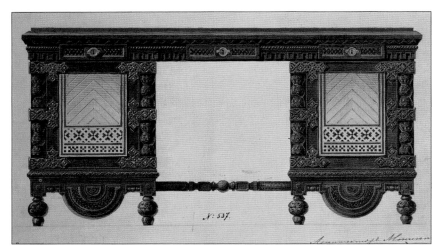

PLATE 103

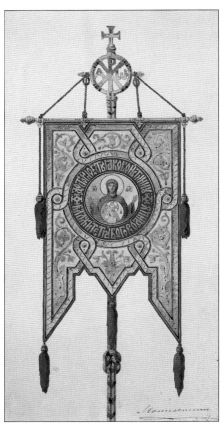

PLATE 105

PLATE 102
Hippolyte Monighetti, Design for a dresser,
undated.
PLATE 103
Hippolyte Monighetti, Design for a desk,
undated.
A desk incorporating features perceived as
typically Russian. Hanging towels are
reproduced in *trompe l'oeil*, using a lighter
wood with carved and coloured decoration,
while the ironwork may have been inspired by

the hinges on a seventeenth-century triptych.
PLATE 104
Hippolyte Monighetti, Design for a chalice,
1871.
PLATE 105
Hippolyte Monighetti, Design for a church
banner, 1864.
PLATE 106
Hippolyte Monighetti, Design for a cupboard,
undated.

negates it. At any given moment it is usually the less dominant style to which the future belongs. This was true in the later 1800s of applied art, which is one of the areas in which the Russian style flourished. When wooden urban architecture in the Russian style was beginning to appear in the 1860s, Russian-style interiors – like Russian-style stone buildings – were still a thing of the future. At this moment the young Viktor Gartman and his contemporaries at the Academy of Fine Arts were beginning to design Russian-style furniture for St Petersburg factories, and Hippolyte Monighetti produced his first works for the Court. It was not until the 1870s that the Russian style became fashionable in stone architecture and the decoration of interiors.

For the first time since the age of Peter the Great, art now developed without official interference. The spread of the Russian style to applied art, architecture and interior design took place without the instructions and initiatives from above which had characterized its progress during the reign of Nicholas I. To be sure, the new style received some royal encouragement. The interiors of royal palaces began to be decorated in it – one example being the dining room in the prodigious palace of Grand Duke Vladimir Alexandrovich, designed by Alexander Rezanov and Andrei Gun. Monighetti created Russian-style interiors, furniture and plate for the imperial yacht *Derzhava*. But royal patronage

was by no means the only kind. At the same time, Gartman was designing the interiors for the Folk Theatre at the Polytechnical Exhibition of 1872. Gun and Pavel Kudryavtsev were designing the 'Slavonic Bazaar' restaurant, Porokhovshchikov's house in Moscow and Bashmakov's apartments in Mizhuev House in St Petersburg.

Whatever the status of a residence – whether apartment, mansion or palace – the custom was to decorate one or a few rooms in the *style russe*. Rarely was decoration in the *style russe* throughout, except in second houses in the country.

At this period there was a persistent link between the function of a room and the style in which it was decorated. Reception rooms were customarily in Renaissance-revival style, boudoirs in rococo, men's studies and bathrooms in Moorish style, and libraries in neo-Gothic. The Russian style was reserved for dining rooms and, less frequently, bedrooms. The convention applied to the dwellings of nearly every social group, from Grand Duke Vladimir's palace to the humble flat of a clerical worker. The only difference was in the size of rooms and the lavishness of the treatment.

In finishing an interior, just as when designing the façade of a building, architects followed the conventions of their time, taking account of the building's function, in the way they allocated room space and arranged furniture. The return to national tradition did, however, differentiate Russian-style

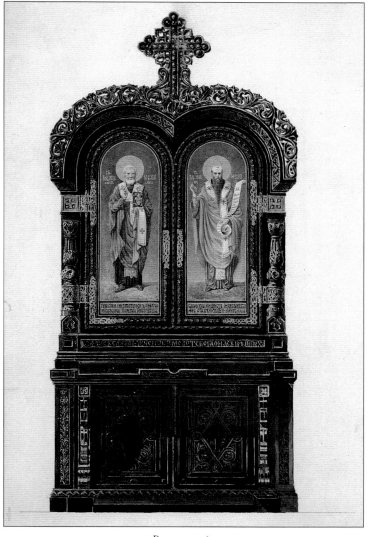

PLATE 106

PLATES 107–111
Hippolyte Monighetti, Designs for various
items for use on the Imperial yacht *Derzhava*,
1872.

Monighetti designed most of the furnishings
for the *Derzhava*, Alexander II's Imperial
yacht, 'a miracle of comfort and luxury'. Most of
his designs incorporate motifs and devices that
evoke the sea, but that also belong within the
general vocabulary of late nineteenth-century
design. In the objects shown here, a bold
combination of colours has been used – black,
green, gold and blue – together with geometric
and interlacing ornament. The cupboard is an
accomplished hybrid, incorporating elements of
Russian style loosely integrated with fashionable
Renaissance ornament.

PLATE 112
Hippolyte Monighetti, Bedroom in the palace
of the Grand Duke Vladimir Alexandrovich,
1872.

The palace, built in St Petersburg for the
Grand Duke, brother of Alexander II, a few
blocks from the Winter Palace on the
Embankment, expresses the shift in taste
which took place after the death of Nicholas I
in 1855. Neoclassicism was finally abandoned
as an official style. The palace was built in the
style of the early Florentine Renaissance, yet it
contained a number of interiors in the current
interpretation of Russian style. The bedroom
is dominated by the ceramic stove and the
profusion of fretwork. Monighetti was known
for his striking use of strongly contrasting
colours and here, together with visual
references taken from a peasant *izba*, among
them the hanging decorative towels, are
reminiscences from the Moorish style
fashionable earlier in the century. The
Vladimir Palace was an influential focus for
artists as well as statesmen and foreign visitors;
the Grand Duke and his energetic consort
dominated the social and artistic life of the
capital.

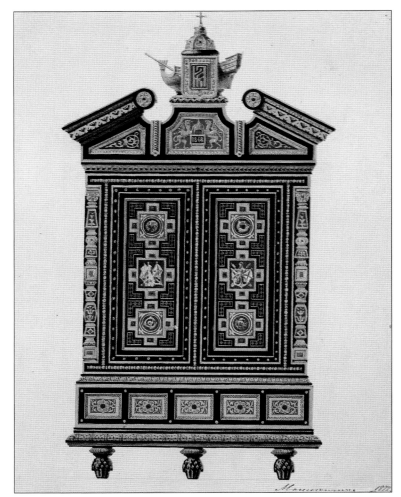

PLATE 107

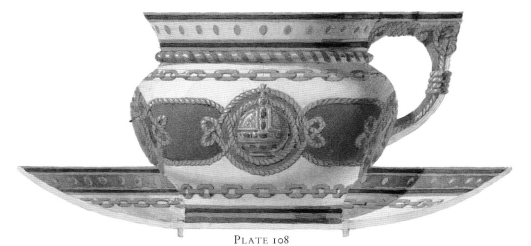

PLATE 108

PLATE 109

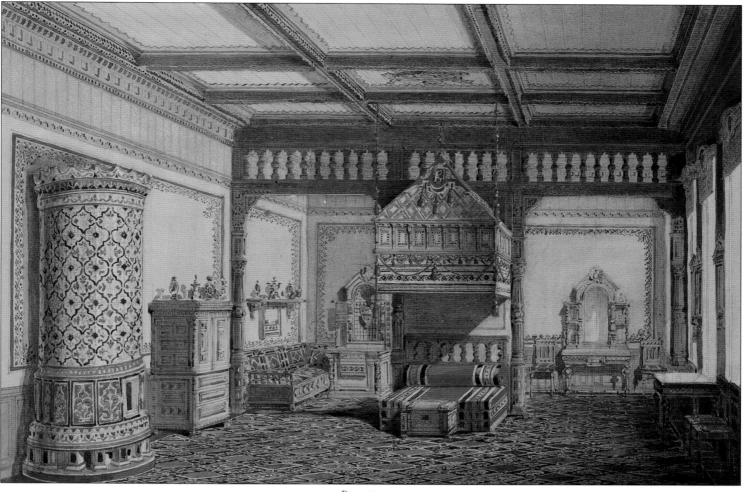

PLATE 112

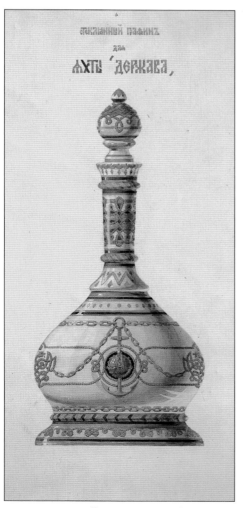

PLATE 110

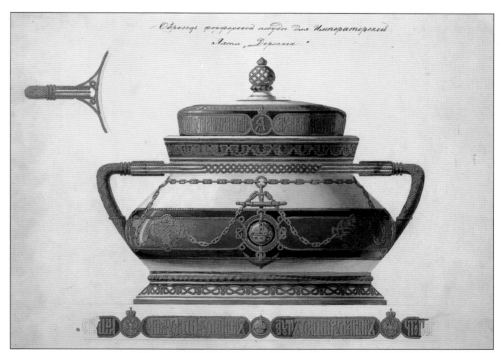

PLATE 111

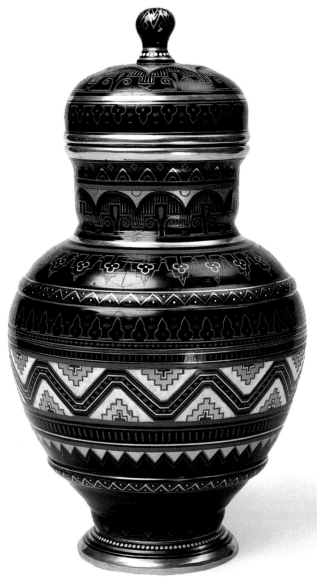

PLATE 113

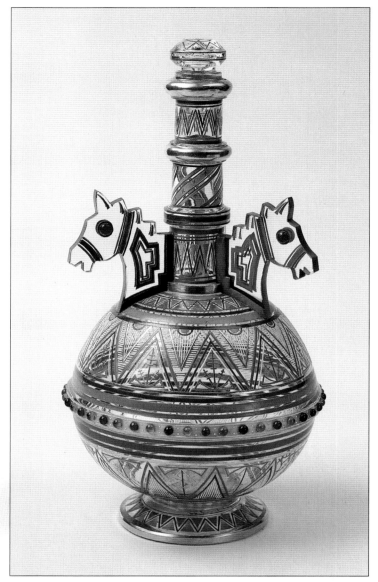

PLATE 114

interiors from those in other styles of historicist architecture in certain significant ways. Most obvious were the extensive and varied use of wood (or imitations of wood) for panelling on walls and ceilings, or for such decorative features as cornices, door and window surrounds, and the embellishing of ceilings and walls; the use of ceramic tiles in the facing of stoves, in decorative friezes and as a foil for woodcarving; the use of soft furnishings and upholstery embroidered with motifs derived from peasant cross-stitch embroidery. Motifs from peasant embroidery and from woodcarving were utilized in decora-

tive painting. The turning to Russian techniques and materials (linen for curtains, embroideries, ceramic tiles and woodcarving) went hand in hand with the use of imitations. Mouldings dyed in an oak colour imitated 'wooden' beams for ceilings, and so on. The illumination of manuscripts, fancy brickwork, brick and white stone casings were imitated in carved wooden ornamentation.

In the Russian style, then, two tendencies were combined. The tradition of Europeanized Russian architecture contributed the imitation of certain materials by means of sub-

PLATE 113
Viktor Gartman, Lidded container, Imperial Glass Manufactory, 1870s.
This work demonstrates the ubiquity of the cross-stitch patterns of popular embroidery.
PLATE 114
Viktor Gartman, Decanter, Imperial Glass Manufactory, 1870s.
Clear glass, enamelled and gilded.

PLATE 115
Silver bowl, spoon and base, with *champlevé* enamel decoration, Ovchinnikov Workshops, 1878.
The bowl and stand are ornamented with stylized cockerels combined with patterns derived from popular cross-stitch embroidery.

stitutes (stone had been widely imitated by wood or by brick and plaster). The tradition of medieval Russian architecture contributed 'Russian' materials and their general utilization, affording extensive possibilities of finish. Both of these tendencies were focused on reviving traditional motifs, rather than on any modification of the forms and structures of objects. In this respect the use of Russian style in applied art paralleled its use in civil architecture.

Sources The special characteristics of Russian-style applied arts can be seen in their preferred sources: folk art, ornamental fretwork and the illumination of ancient manuscripts. In part this derives from what was seen as the authentic Russianness of these sources and in part from the belief, widespread in the 1850s, in the affinity between particular styles and materials.

The way in which the Russian style spread was also affected by what might at first seem fortuitous circumstances, specifically the publication of several different studies of traditional ornament in rapid succession. In 1870 Butovsky, director of the Moscow Stroganov Art College of Technical Drawing, published an album entitled 'A History of Russian Ornament from the Tenth to the Sixteenth centuries, from Ancient Manuscripts'. A year later, Vladimir Stasov published a similar album, 'Russian Folk Ornamentation', which also contained examples of embroidery. In 1872 Stasov additionally published 'Samples of Russian Ornamentation'. Here, alongside the patterns of Russian towels from Gartman's collection, designs that the architect had developed from those patterns were presented. These were for wooden buildings, including ornamental carving for their decoration. The publishers hoped to show 'how the patterns of beautiful Russian towels can be brought together into one elegant larger

unity, and how, together with motifs derived from the illuminated capital letters of our ancient manuscripts, these may serve contemporary Russian architecture and decorative art'.[1]

Motifs of Russian Architecture, a design magazine already mentioned, began publication in 1876. It contained designs primarily for Russian-style wooden dwellings, interiors and furniture. Its examples for the decoration of buildings and items of furniture and utensils were drawn from the albums of Butovsky and Stasov. Manuals on interior finishing and furniture albums recommended that there should be 'a large open buffet or cabinet for the dining room in the Russian folk style A high-backed chair for the dining room, upholstered in tooled leather or mock velvet, with a fringe and steel nails. A second chair, with a high, fretted back, the seat upholstered with leather or velvet . . . in the Russian folk style'.[2]

Actual objects of folk art might be utilized to achieve the effect. The heroine of Chekhov's story 'The Grasshopper', Olga Ivanovna, is the wife of a young doctor and an artist herself. She 'plastered the walls with *lubok* woodcuts, hung up bast shoes and sickles, placed a sickle and a rake in the corner, and *voilà*! she had a dining room in the Russian style'.[3]

Objects shaped like peasant huts, implements and utensils also filled the flats of Russia's radical intelligentsia. The artist Vladimir Konashevich recalled, 'My ABC book had been put together for the children by my mother's elder brother If not actually a member of the Populist Party, he was a populist by conviction. The book was crammed with cart axles, scythes, harrows, hayricks, drying barns, and threshing floors In my father's study in front of the writing table stood an armchair whose back was the shaft bow of a harness, and whose arms were two axes . . . on the seat a knout whip

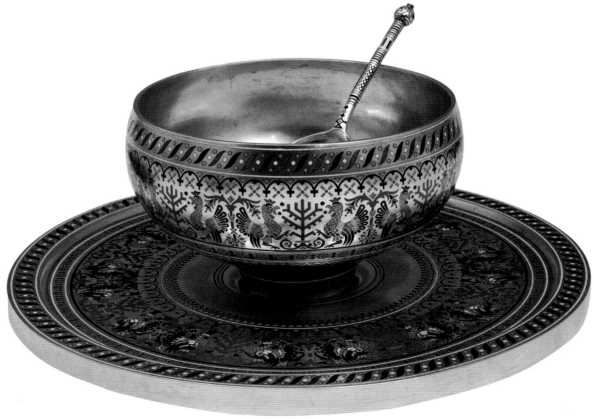

PLATE 115

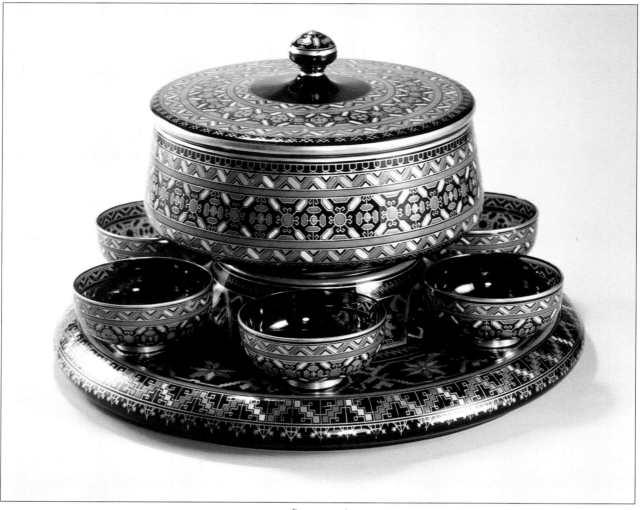

PLATE 116

and a pair of bast shoes perched, all carved in oak. The finishing touch was a real little peasant hut which stood on the table. It was made of walnut, and full of cigarettes.'[4]

That armchair, designed by Shutov, was to be found not only in the study of Konashevich's father, but in those of many another member of the intelligentsia. There is one in Chekhov's house in Yalta, now a museum, and several in the collection of the State History Museum in Moscow. Even Alexander III had one. Many armchairs had proverbs carved on the bow of the back in the old Slavonic script: 'Still waters run deep,' 'More haste, less speed.' Tables, shelves and whatnots overflowed with inkpots in the form of wells with well sweeps, domestic objects in the form of casks, old-fashioned coffers, peasant huts, horseshoes and low, wide peasant sledges. Wooden plaques for hanging on the wall came into fashion. Entwined with their ornamentation was the archaic script of suitably Slavonic inscriptions along the lines of 'Seek not the beautiful, but the good,' or 'A hut is gladdened by what enriches it.'[5]

It would be a mistake to regard the cluttered interiors of this period as a mere fashion; these objects had a symbolic value that satisfied a deeper need. In old Russian art, as the academician Fyodor Buslaev emphasized, the same shape 'might sometimes be given to the church as a whole, to a sarcophagus, to the church plate, for example the ciborium and the censer. That is, small items of church plate were given the Romanesque, Byzantine or Gothic shape of the church as a whole What was imposing in its grandeur in a colossal

PLATE 116
Punchbowl and glasses, coloured glass,
enamelled, St Petersburg, 1873.
PLATE 117
Cup and saucer, Kornilov Brothers, late
nineteenth century.

church seemed familiar and neat in a small object.'[6] The shared shape of items of different character and scale in the Russian style testifies, as it did in the medieval art of Rus and Western Europe and in the art of other periods, to something else: the rootedness of certain notions, the symbolism of shapes and the universal recognition of the meaning they express.

Increasingly, in this period, we find the domestic interior becoming more than ever a kind of self-portrait. Individual preferences, social position, one's line of business, one's personal values were deliberately emphasized by the decoration and furnishing of the home, although naturally this individualization was subject to the conventions of the period.

Within the Russian theme in interiors two sub-categories or tendencies coexisted: the peasant look, already described, and the boyar – the choice of effect depending on the social status of the owner of the home concerned. The boyar tendency naturally predominated in circles close to the Emperor, among the civil service aristocracy and among the merchant class.

A vivid impression of the boyar tendency can be gained from a note in a contemporary magazine about an inspection 'by civil engineers and architects of the boyar dining hall in the house of His Majesty's Master of the Hunt, Dmitri Sipyagin, decorated in a strict seventeenth-century style. . . . The doors, upholstered in dark violet velvet, with silver handles and ornamentation, lead to a low, vaulted room, divided into two parts by an arch with a silk portière. The walls and ceiling of the room are painted with scrolls of gold on a maroon background; in different sections of the ceiling parts of the owner's family coat of arms are depicted. Along the top of the panelling there extends the following inscription in Slavonic lettering: "The Boyar Dmitri Sergeevich Sipyagin and his lady the Boyarinya Alexandra Pavlovna Vyazemskaya built this dining hall." Everything about it, from the old icon with its cloth embroidered with silks and gold, to the oak furniture upholstered in gold brocade, is redolent of deepest antiquity, with nothing offending against the harmony of the style.'[7]

This 'harmony of the style' was comprehensive. It extended equally over a whole range of objects created by various hands, in various materials, in various enterprises, in various parts of Russia and for various social strata. There was a complete system of 'transferable' Russian-style themes, motifs and shapes. These included the motifs from peasant embroideries referred to earlier, ornamentation of various styles taken over from manuscripts (among which wild beasts were particularly popular), lions with luxuriant tails, and the twining stems ending in trefoils, which can be traced back to reliefs in the churches of Vladimir and Suzdal.

Mimicry of materials The tendency to use one material to mimic another – already noted in Russian style architecture and interiors – was also widespread in decorative objects. There were no limits to this. Any material and any item might mimic materials and techniques in ways which, at first glance, are wholly unexpected. Porcelain and crystal were used to imitate enamel; decorative painting imitated encrustation

PLATE 117

PLATE 118
Fyodor Rückert, Icon depicting the
Presentation of the Virgin in the Temple,
encased in a silver and cloisonné enamel
setting, 1899 – 1908.
Rückert worked first in the Moscow workshop
of Fabergé, and later as an independent master,
selling his products through his former
employer. The cloisonné enamel in a selection
of pastel hues in this piece eclipses the painting
and overpowers the theme. Yet alongside such
works a renewed interest – encouraged by the
Imperial commission of 1902 – led to a revival
of icon painting. The general standard of icon
painting at this period was of a higher quality
than anything produced in the previous two
centuries. This object represents a virtuoso work
of the jeweller rather than an icon in the true
sense of the word.

PLATE 119
Bratina, gilt and cloisonné enamel, Fabergé
Workshops, 1902.

PLATE 120
Silver-gilt tankard, decorated with filigree and
cloisonné enamel, Ovchinnikov Workshops,
late nineteenth century.
The form of this tankard echoes that of a
shatyor, but is also characteristic of the
fashionable Renaissance revival. Its ornament,
however, has an oriental opulence which in
Western Europe would have been considered
'barbaric'.

PLATE 118

PLATE 119

PLATE 120

PLATE 121

with precious stones, woodcarving or cross-stitch embroidery; printed souvenir headscarves imitated *lubok* woodcuts; cardboard book covers mimicked the ornate metallic binding of old religious books; sweet papers and chocolate wrappers imitated mosaic. There was no end to the inventiveness.

At the same time natural materials and the objects made from them in pre-Petrine times also made a comeback. Fashion favoured wooden chairs and armchairs upholstered in leather with forged copper nails; hard wooden chairs, benches, and armchairs without upholstery, manufactured to old Russian designs; embroidered linen draperies, curtains and towels. The perennially popular tiled stoves began to be built in the forms and with the tiled decoration of the pre-Petrine period. The characteristic colour range of green, yellow, white and blue used for these stoves was revived.

It would be impossible to mention all the ways in which applied art drew on the Russian tradition and the Russian theme. The manner and extent to which tradition was revived depended, as in architecture, on the type and function of the object. In purely ornamental objects, such as small porcelain, earthenware or silver items, historical and peasant subjects became popular, and were treated in much the same way as they were in easel painting and monumental sculpture. At the same time there was a type of literal revival which resembled that in religious architecture. Saltcellars modelled on the salt boxes of old Rus were manufactured and came into use. Varieties of old-fashioned tableware were revived – now, admittedly, as choice gift and commemorative items: wine bowls, ladles and goblets. In traditional objects and, of necessity, in new objects with no counterpart in old Russian and folk art, another common revival was the use of ornamental shapes in new and decorative applications. Each of these modes of expressing the national idea may be found in its pure form or in combination with another.

Metalwork and jewellery The products of such goldsmiths' and silversmiths' workshops as those of Sazikov, Ovchinnikov, Grachov, Semyonov, Mishukov, Khlebnikov and Fabergé copied and adapted the shapes of objects and the old patterns in use in the Kremlin workshops in the sixteenth and seventeenth centuries. Silver items decorated with enamelling enjoyed great popularity. Enamelling on ornamental filigree, which had been much appreciated in Rus, reappeared on products ranging from tableware to women's jewellery. In the 1860s earrings, brooches, clasps and buttons were made of stone or enamel on filigree.

Although the products of these various firms had much in common, each had its own unmistakable identity. Sazikov's was one of the first, in the mid-1800s, to start production of fine miniature silver sculptures. Its craftsmen regularly incorporated miniature sculptures into such items as silver tea-sets. The firm's silversmiths went on to create items decorated with busts and sculpted groups. Sazikov's also pioneered ornamental silver sculpture on historical themes. For the Great Exhibition of 1851, in London, the firm produced a masterpiece – a two-metre (six-and-a-half-foot)-tall chandelier with a sculptural group centred around Prince Dmitri of the Don, the hero of the Battle of Kulikovo. The sculptor was Baron Pyotr Klodt and the artist Fyodor Solntsev.

The Moscow firm of Ovchinnikov led the field in the production of silver items decorated with multicoloured enamelling and filigree ornamentation. Ovchinnikov enamels were notable for their extraordinary range of colours and meticulous workmanship. The workshop produced an extremely varied selection of gift items: saltcellars in the form of wooden salt boxes, wine bowls, ladles, goblets, tea caddies, trinket boxes, cups, spoons, tea glass-holders and vases.

Resembling Ovchinnikov in their product range and loyalty to the Russian style was the firm of Khlebnikov. In addition to enamelling they specialized in another once-widespread technique, niello work – the inlaying of engraved silver with a metallic black composition. Khlebnikov products were often adorned with sculptures. The firm also made small ornamental silver sculptures but, unlike Sazikov's, predominantly on peasant themes. Sculptures for the decoration of writing or dining tables were usually mounted on stone stands.

Unlike the large firms of Ovchinnikov and Khlebnikov, Semyonov's small factory had a fairly narrow specialization. It produced fine-quality, domestic rather than decorative, niello-work items: tea and dinner cutlery, coffee and tea services, snuff-boxes, cigar cases, tea glass-holders, tumblers and saltcellars. In Semyonov's products the ornamentation, executed in niello or gilding with niello, old Russian and predominantly based on plant forms, often accompanied views of the historic buildings of Moscow. In a dinner service featuring views of Moscow, different items were decorated

PLATE 121
Ivan Petrov-Ropet, fabric casing for *The Zvenigorod Collection of Byzantine Enamels*, 1892.
The second half of the nineteenth century saw a revival of good book design, which owed much to the rediscovery of the medieval sources of books on Orthodoxy. The revival left its mark in particular on lavish productions in a Russian style, such as this.

with medallions depicting the Kremlin, the Great Kremlin Palace, the Ivan the Great Tower, the Cathedral of the Redeemer and St Basil's. A large jam dish with twelve matching spoons bore old Russian ornamentation, and on the reverse of the spoons were illustrations of historic buildings.

Glass and ceramics　The Russian style was very much to the fore in the ceramic and glassware output of all the factories, from the largest, like those of Mikhail Kuznetsov and of the Maltsevs, to the most modest. Russian-style products were especially popular between the 1870s and the 1890s. The traditional shapes of carved wooden and die-cast metal utensils were reproduced in glass. Particularly common was enamelled decoration on crystal items, such as goblets, decanters and vases. Equally popular in ceramic wares, including vases, cups, and ornamental and everyday plates, was decorative painting in imitation of embroidery. In crystal items we also encounter the imitation of carved wood.

Printing and book design　A domain of boundless variety for the Russian style was book design, – including everything from unique, highly artistic (and very expensive) folios, such as the volume *The Zvenigorod Collection of Byzantine Enamels* (1892), based on Ropet's sketches, to mass-produced works of literature, albums, covers for sheet music and similar items, created by unknown or new designers like Fyodor Shekhtel, later the doyen of Russian *moderne*, or art nouveau. Many different sources were mastered and drawn upon by the designers of books and book covers. The cover might take as its inspiration, transformed beyond all recognition, an icon – possibly one set in a precious casing, as in the case of *Byzantine Enamels*. Another source – one having a narrative, intricate quality, intended to be studied closely and at length, was the miniatures of Russian manuscript books, with their lavish framing of the page, their large and splendid capital letters, their headpieces and colophons, and their handsome script. Elements and motifs from a variety of

sources were combined to create a new, more complex work. Four or five varieties of the old Russian cursive script might be used on the cover of a single book.

In the course of the second half of the nineteenth century mass-produced graphic design – including such things as announcements of royal occasions, wall calendars, menus for ceremonial banquets, sweet papers, soap wrappers, boxes of matches, advertising posters, theatre bills and programmes – was transformed from a merely utilitarian or informational medium into one with a consciously artistic dimension. The metamorphosis bears witness to the developing of a new relationship between commercial and 'high' art. No sooner had mass applied art appeared than it began immediately to develop in accordance with the rules of high-style architecture and applied art.

Mass-produced graphic design had all the stylistic features of unique works of applied art created by serious artists: the same motifs and the same techniques of mimicry. For example, headscarves were printed with a variety of subjects drawn from other media. Some of them copied ABC books, others a variety of lubok pictures on historical or morally improving themes; still others were printed with motifs commemorating state occasions and were intended as souvenirs.

Concluding our history of the Russian style of the second half of the nineteenth century, we should emphasize once more that it was the only stylistic movement in this period which could lay claim to being truly universal and comprehensive. In the extent of its dissemination and popularity, in both architecture and applied art, it had no rivals. Its influence was absent only in those forms of fine art which were more or less exclusively associated with the culture of the educated classes, notably easel painting and monumental sculpture. Even here we can discern the beginning of trends that would, in the last two decades of the century, result in a reconciliation of the arts within a universal national style.

PLATE 122
Ivan Petrov-Ropert, Binding of *The Zvenigorod Collection of Byzantine Enamels*, 1892.
PLATE 123
Fabric bookmark for *The Zvenigorod Collection of Byzantine Enamels*, woven in gold and silver thread with a line from Euripides, 'Turn these eloquent pages which exalt the wise', Sapozhnikov Workshops.

PLATE 124
Title page for *The Zvenigorod Collection of Byzantine Enamels*.
PLATE 125
Page bearing the dedication to Alexander III, *The Zvenigorod Collection of Byzantine Enamels*.

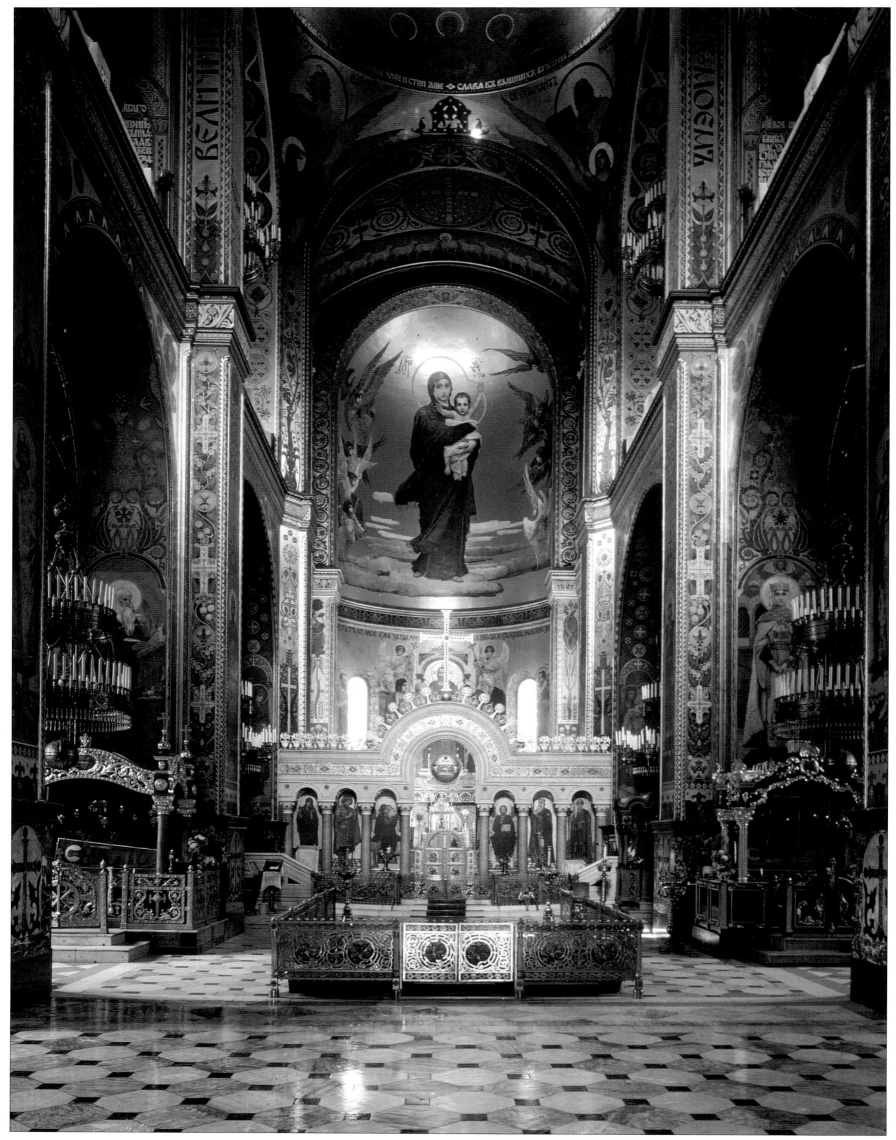

PLATE 126

THE NEO-RUSSIAN STYLE

The Birth of the Neo-Russian Style

For the purposes of Russian art history, the *fin de siècle* begins in the early 1880s. At this time there appeared a new approach to architecture, easel and mural painting, and applied art – a new understanding of what art was about and the first indications of a new artistic idiom.

Needless to say, no major change of direction occurs overnight; neither does it affect all areas of art simultaneously. The change took place slowly, a step at a time, particularly in the 1880s. Gradually it spread to new areas and gained momentum.

In defining the 1880s as the beginning of a new period, and 1880–81 as the moment the great change began, we need to sound a note of caution about the conventions of periodization and their limitations. The early 1880s are very much a case in point. This was a time associated with no fewer than three major building projects, each belonging to a different period of the revival of the national tradition in architecture. In 1883 the solemn dedication took place in Moscow of the Byzantine Catheral of the Redeemer, the foundations of which had been laid more than forty years earlier, in 1839. Another important project was the commemorative church to be built over the spot where Tsar Alexander II was assassinated. Designed by Alfred Parland, it was in the Russian style (as were the other designs submitted for it); the foundation stone was laid on 6 October 1883, and the building itself dedicated in 1907.

The third significant event in the architecture of the early 1880s was the design and construction in 1881–82 of a quite different church: the one built at the artists' colony at Abramtsevo, near Moscow. This project, and others initiated there, marked a qualitatively new approach to the national tradition, which is known as the neo-Russian style.

The colony at Abramtsevo, which we shall be examining in detail later in this chapter, was both a product of and a stimulus to a whole new spirit in Russian art and thought generally. The neo-Romantic movement in Russia, which would ultimately give birth to Russian art nouveau (or *style moderne*, as it was called there) and to symbolism in literature, was linked with a new manifestation of the ongoing Russian urge to rediscover the national culture.

Signs of the new thinking could be found in philosophy, aesthetics, music, literature and historical scholarship. In 1880 the magazine *Russkii vestnik* ('The Russian Herald') published Dostoyevsky's novel *The Brothers Karamazov*. In one of the chapters, 'A Russian Monk', Dostoyevsky presents his own utopian view of Russian life transfigured by religion and morality and based on love and charity. Leo Tolstoy's outlook and personality also changed radically in the 1880s. His subsequent religious and philosophical works all contain a passionate call for moral purity.

On a simpler level, there was an upsurge of interest in, and energetic publication of, Russian folk tales, and an enthusiasm for old Russian poetry and legends. Illustrated editions of Russian tales for children were extensively published for the first time.

The continuing interest in folk architecture now turned its attention to the vernacular architecture, primarily religious, of the Russian North. This region had been left aside in the nineteenth century by more rapidly developing parts of the country. As a result, it retained, unalloyed, the artistic traditions of pre-Petrine Russia. This architecture was 'discovered' in 1883–89 in the course of a survey by V. V. Suslov.

In tracing the development of a national style, we have seen how new trends manifested themselves first in architecture,

PLATE 126
Viktor Vasnetsov, *The Mother of God with the Infant Christ*, view of painting in the apse of the Cathedral of St Vladimir, Kiev, completed 1895.

being taken up gradually, in varying degrees, by other visual arts. At the start of the new era it was the turn of fine art: religious art (icon and church mural painting), easel, monumental decorative painting, graphic art and, in part, sculpture. For the first time since the age of Peter the Great, when the modern period began for Russia, all forms of visual art were looking to a non-classical tradition. Practitioners of the fine arts now took to mining national tradition in a way that had long been customary in architecture and, more recently, in applied art.

For this to happen a number of closely interrelated factors had to come together. New views were needed on the proper contribution that art should make to society; the relative status of the different art forms had to be revised; and a change had to come about in creative method and artistic idiom.

The artistic hierarchy In the middle and second half of the nineteenth century architecture and applied art were accounted low art forms. Literature was the most highly valued of the arts. Some of the revolutionary democrats, such as Dmitri Pisarev and Nikolai Chernyshevsky, even denied architecture and the applied arts the right to be called art. In Pisarev's view the arts were of use to the extent that they facilitated enlightenment and helped humanity deliver itself from prejudices blocking the path to the building of a rational society. Because architecture and applied arts were seen as lacking any didactic potential they were relegated to the status of crafts.

Artists themselves did not go along with such extreme views, although the *peredvizhniki*, with their enthusiasm for

taking art to the masses, shared the radicals' conviction of the leading role of literature and the fruitfulness of its influence on the fine arts and architecture. This was true even of Stasov, their leader, who shared the respect of the Slavophiles for architecture and the applied arts as something that belonged to the people as a whole. This 'literaturocentrism' was common throughout the nineteenth century, and gave philosophers no end of trouble as they tried to determine where exactly architecture fitted into the system of the arts. It is one of the paradoxes of Russia's cultural history that at the very time when architecture and the applied arts were becoming most responsive to the tastes of its people (as opposed to the tastes of the elite, as in the eighteenth century), their ideological role was being vigorously negated. Odd as it may seem, those most active in denying these arts any social relevance were those who advocated radicalism, 'relevance' and tendentiousness in art. Making a fetish of relevance and radicalism in literature – even though it was the leading art form in nineteenth-century Russia – made them astonishingly insensitive to ways in which social relevance and folk character could be expressed in forms other than literature and realist painting.

One of the supporters of a revival of the applied arts wrote despairingly: 'Russian artists spurn the idea of working for commercial art. They are the bearers of the sacred flame and cannot lower themselves to the designing of fabrics or wallpaper. The sculptors are not to be outdone by their colleagues who paint What self-respecting sculptor would ever agree to create a template for an inkwell, dinner service, silverware or a candelabrum?'[1] Konstantin Makovsky

PLATE 127

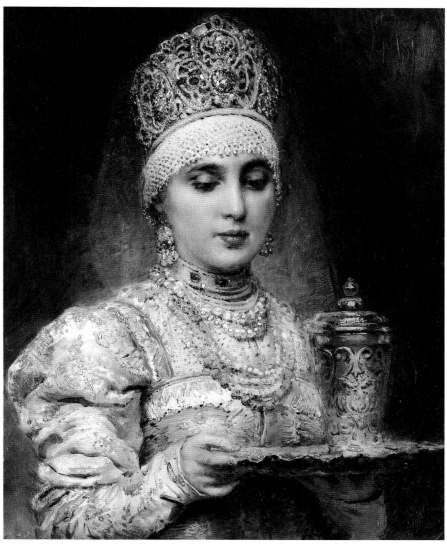

PLATE 128

(1839–1915) wrote a heavily sarcastic review of the 'Contemporary Art' exhibition of domestic interior decoration organized by the cosmopolitan *Mir Iskusstva* ('World of Art') group. Makovsky was one of the outstanding painters in the second half of the nineteenth century, a participant in the 'revolt of the fourteen' (an incident in 1863 in which fourteen Academy students in their final year resigned rather than paint the compulsory set mythological subjects), and a founder member of the *Peredvizhnik* (The Cooperative of Travelling Art Exhibitions). He created large-scale genre and historic paintings. 'I hear,' he remarked acidly, 'that it has occurred to a number of the artists who toy with decadence to open a furniture shop in St Petersburg, or something of the sort I have to say this does not surprise me in the least. The only thing painters who cannot paint pictures can do is busy themselves with furniture . . . "But cannot furniture, in your opinion, [asks his hypothetical opponent] be considered a branch of art?"

'"Of course it can, but in that case, boots also can be considered a branch of art . . . No, if you are an artist, your first duty is to paint pictures, and if you don't want to paint pictures, you are not an artist." '[2]

Such was typically the view on art and the right occupation of the artist held by those who had graduated from the St

PLATE 127
Konstantin Makovsky, *Boyarina*, undated.
PLATE 128
Konstantin Makovsky, *Boyarina bearing a Tray*, undated.
During the third quarter of the nineteenth century, the predominant movement in Russian art was concerned with depicting grim social and moral issues in a 'realistic' manner. Makovsky reacted against this trend and became a successful society painter. During the 1870s and '80s he worked on historical genre paintings, showing life in the Terem in minute detail. His works were highly popular and much copied, in particular cold-painted in enamel on objects of *vertu* by silversmiths.

Petersburg Academy of Arts or the Moscow College of Art, Sculpture and Architecture. Right up to the end of the nineteenth century, the design of furniture, objects of applied art, domestic interiors and their decoration was solely the job of architects and interior decorators.

Towards artistic unity　By the end of the nineteenth century such denigration of the practical arts was being challenged, and a search for a universal style for all the arts was under way. For the first time since the Renaissance, craftwork was proclaimed the equal of so-called 'pure' art. The most active supporters of this position included some distinguished converts from the fine arts. The painter Alexander Benois (1870–1961) said, 'In all essentials so-called "commercial art" and so-called "pure art" are sisters, twins whose mother is beauty, and who resemble each other so closely that it is sometimes difficult to tell them apart.'[3] Léon Bakst (1868–1924) analysed the position: 'The forms which today's art is assuming show that it cannot do without directives from a great kindred art to legitimate what it produces, which at present is wholly without meaning. Even the popularity of the majority of the canvases of contemporary painters is not enough. Architecture is the mother of the arts and the greatest achievement in terms of spatial form . . . it will give painting great surfaces of serious, severe stone which the painting of the future will unite with its majestic, simple images communicated by a synthesis of means. The stone of walls and sculptures . . . will set the new painting face to face with the grand, the monumental, with man as the flower of nature, not with man crushing nature. . . .'[4]

Artists who had received a 'proper' artistic education, rather than merely an education in technical or commercial art, now began to work professionally in commercial and advertising illustration, book design, and furniture and architectural design. At the turn of the century we find typically, alongside the traditionally versatile architect working in every form of the plastic and architectural arts, the newly versatile painter or sculptor engaged in applied and monumental art, architecture and stage design. This trend to universalism extended to practitioners of the applied arts, especially those who worked for the Church. The applied artist moved out by a natural progression into the art of large forms: architecture and mural painting. Finally, one last very important and characteristic feature of the move towards a universal style is the fact that, for the first time in Russian art's modern history,

every variety of religious art was included in the mainstream development of high art. This was particularly true of religious fine art.

The move towards unity entailed an expansion and a heightening of the idealistic conception of art already referred to. The purpose of all art, many people believed, was to uplift the spirit – even the morals – of the individual and of society as a whole. These goals were, however, to be achieved in more subtle, less openly didactic ways than had been advocated by the *peredvizhniki*. Even the acknowledged leaders of realism embraced the new ideology. Between 1893 and 1897 the painter Ilya Repin (1844–1930) published a series of articles whose burden was to acknowledge the need for an art in which 'journalistic values yield to morality, and utilitarianism to eternity'.[5] Other axioms are well known and often quoted, such as Valentin Serov's remarks about the need for 'joyful' painting; or Leo Tolstoy's call to create a moral art which would 'infect' people, causing them to become better and happier. Close to Tolstoy's ideas is Nikolai Roerich's dream of 'good' art capable of changing society, 'where there exists that great dismal quality of our time, vulgarity omnipotens, where people see and feel through vulgarity'.[6] Good art, he believed, with its capacity to bring joy and beauty to people and awaken noble impulses in them, is omnipotent and all-powerful. From such an art it will be possible to 'learn to be joyful, to learn to see only the good and the beautiful! . . . And we shall have no time for gazing upon what is hateful. The jubilation of malice will go from us. . . .'[7]

P. P. Muratov, a well-known art critic, wrote, 'The painter should soar above the material of his creation, re-establishing, as it were, his lost primacy over the world. . . . From the elements of the existent world the artist should create a world of his own.'[8] The word was out. The painter had been likened to the architect, creating, like him, his own world. Here is the fundamental basis of the change of direction and of the urge of artists to engage with applied art and architecture.

Acknowledging the main purpose of the arts as being the affirmation of eternal truths, and reconsidering the attitude which held easel painting to be the chief of the fine arts, propelled painters in the direction of architecture and applied art. It restored to architecture its status as the mother of the arts. The search for a universal style revealed more than a shared artistic quest. More important still was the fact that the search followed guidelines laid down by architecture. Architecture

PLATE 129
Vladimir Pokrovsky, Chapel of the Prokhorov family, Novodevichy Monastery, Moscow, early twentieth century. This small building demonstrates the virtuosity with which the architects of the early twentieth century were able to reinterpret features of pre-Petrine architecture in a totally new way. Here, exaggerated proportions are combined with extended, fluid curves of outline. The swollen dome and the spreading, flattened low-relief sculpture over the doorway are also new developments.

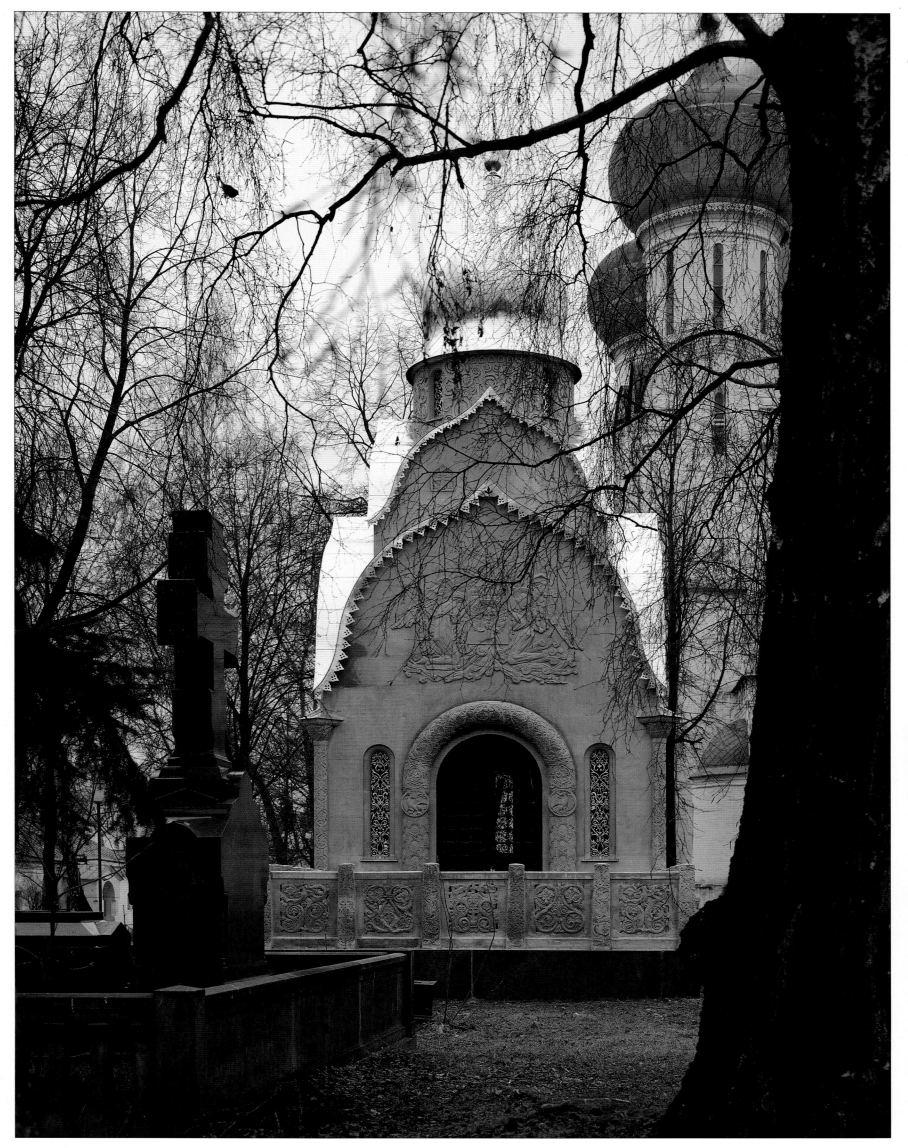

PLATE 129

was understood as the creation of a new world different in appearance from the natural world. With the passage of time the coming together of fine art and architecture on this basis became increasingly obvious.

Development of the neo-Russian style The return to a shared foundation of the fine and practical arts took place within the framework of the neo-Russian style, whose further development became a manifestation of the rebirth of that unity. We may distinguish three stages in the development of the neo-Russian style.

The first of these took place in the 1880s and early 1890s, and was associated primarily with the work of the artists of the Abramtsevo circle, which we shall examine shortly.

The second stage extended from the end of the 1890s to about 1910 and saw a widening of the sources to which artists turned for inspiration. Alongside peasant art, which had featured so prominently in the earlier Russian style, it turned, for the first time, to urban folk art, in the form of the *lubok* woodcut and the signboard; archaization appeared, and an interest in the proto-Slavonic roots of Russian culture. In architecture the neo-Russian style partly overlapped with other forms of modernism, such as functionalism and art nouveau , or *moderne*.

This continued into the third stage, beginning about 1910, which saw the appearance of avant-garde trends, such as Cubism and Suprematism, in fine art and of a strictly rational modernism in architecture and applied art. Simultaneously, the search in art for a new canon became marked. In this, extreme innovators in painting and architecture joined forces with their former antagonists, the allies becoming known as neoclassicists. The neo-Russian style in art and architecture generally was influenced by neoclassicism. In architecture the visible rationalism of compositions was reinforced, and the sharpness of articulations, the simplicity and geometrical nature of forms became more pronounced. Another feature was that at this period borrowing from the folk or national tradition was not by any means always associated with recognizably national forms.

We end our investigation in 1917. International art history is rather definite in considering the period we are examining to extend over the first third of the century, and grounds could be found in our particular case which would argue in favour of this. It would accommodate the avant-garde and neoclassical movements, and be partly appropriate also for secular architecture and art. The latter do indeed come to the end of an era in the 1930s, with a dividing point at the end of the first decade of the century, but this holds true only for these movements and for those particular art forms.

Although modernism in general continued to develop well into the twentieth century, and certain avant-garde tendencies within the neo-Russian style flourished into the 1930s, most manifestations of the style did not survive the Revolution. For the neo-Russian style in architecture and applied art, for icon painting, the miniature, and fresco painting, which drew on the old Russian heritage, for the whole vast sphere of religious art over which the neo-Russian style also extended, 1917 is indisputably the watershed.

For all the multiplicity of movements, for all the individuality and dynamism with which the artistic process developed at this time, the uses to which the Russian medieval and folk art traditions were put at the turn of the century had something in common which, although difficult to formulate, is nevertheless plain to see. It was absolutely fundamental, and much deeper and more important than the differences. At its most general we may describe it in architecture and its related applied arts as an abandoning of faithful reproduction of a prototype; in painting and sculpture it was an abandoning of faithful, accurate re-creation of reality. Replicating the model in architecture, depicting reality on its own terms in art, ceased to be obligatory and ceased to be considered the measure of the beautiful. We may characterize the approaches to tradition of the nineteenth century and the turn of the century as, respectively, scientific accuracy and lyrical subjectivism; as different methods which sought, on the one hand, precise re-creation of the source and, on the other, its lyrical transformation. In the first case the tendency was towards analysis, verisimilitude and detail; in the second, towards synthesis, stylization and creative interpretation. The fundamental approach underlying the new artistic system was stylization.

Like any other national style, the neo-Russian style was credible only given a recognizable visual correlation with the national heritage. With the appearance of abstract fine art and of architecture and applied art which displayed no visible features of the traditional styles of the past, the neo-Russian style had outlived its usefulness. A great paradox occurred: even as works were created on principles analogous to those of old Russian and folk art, even as structures came increas-

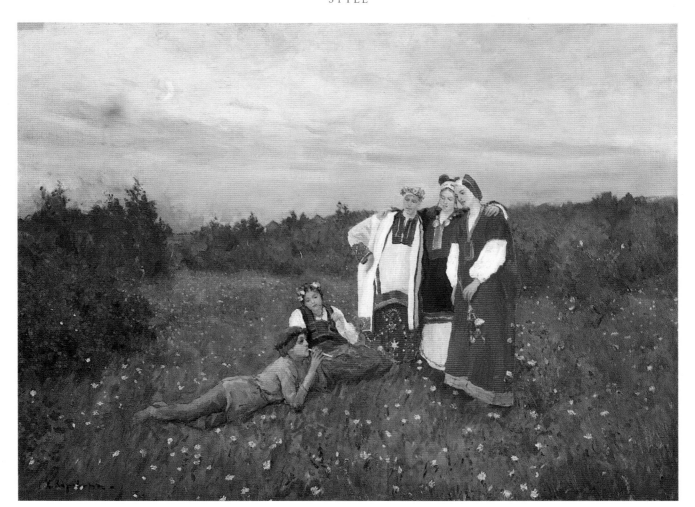

PLATE 130

ingly to reflect the basic traditional constructional conventions, there was, at the same time a loss of visual similarity – even of the most remote, metaphorical kind. The neo-Russian style as a phenomenon of the avant-garde had come, by 1920, to the end of the road.

Abramtsevo

We can state precisely the date and place of birth of the new movement in Russian art. The place was Abramtsevo, a country estate near Moscow where, in 1875, the great, branching tree of *fin-de-siècle* Russian art, and, to a large extent, twentieth-century Russian art in general, began to grow.

The owner of Abramtsevo, Savva Mamontov (1841–1918), was a wealthy Russian industrialist and patron of the arts who succeeded in bringing together on his estate the sup-

porters of all that was new and progressive. What is more, he succeeded in creating the right conditions to enable the movement to find expression in every kind of artistic activity: painting, architecture, applied arts and stage design.

Located near a village of the same name, the estate of Abramtsevo dates from the mid 1800s, when the Slavophile writer Sergei Aksakov lived there. Aksakov was the author of *A Family Chronicle* and *The Childhood Years of Bagrov, Grandson*. Like Mamontov, who acquired Abramtsevo in 1870, Aksakov believed in the independent value of art as an important social force and in the need to revive the Russian cultural tradition as a means of overcoming the centuries-old rift between the people and the intelligentsia.

Savva Mamontov and his wife Yelizaveta, *née* Sapozhnikova, came from the new class of enlightened merchants.

PLATE 130
Konstantin Korovin, *Northern Idyll*, 1886.

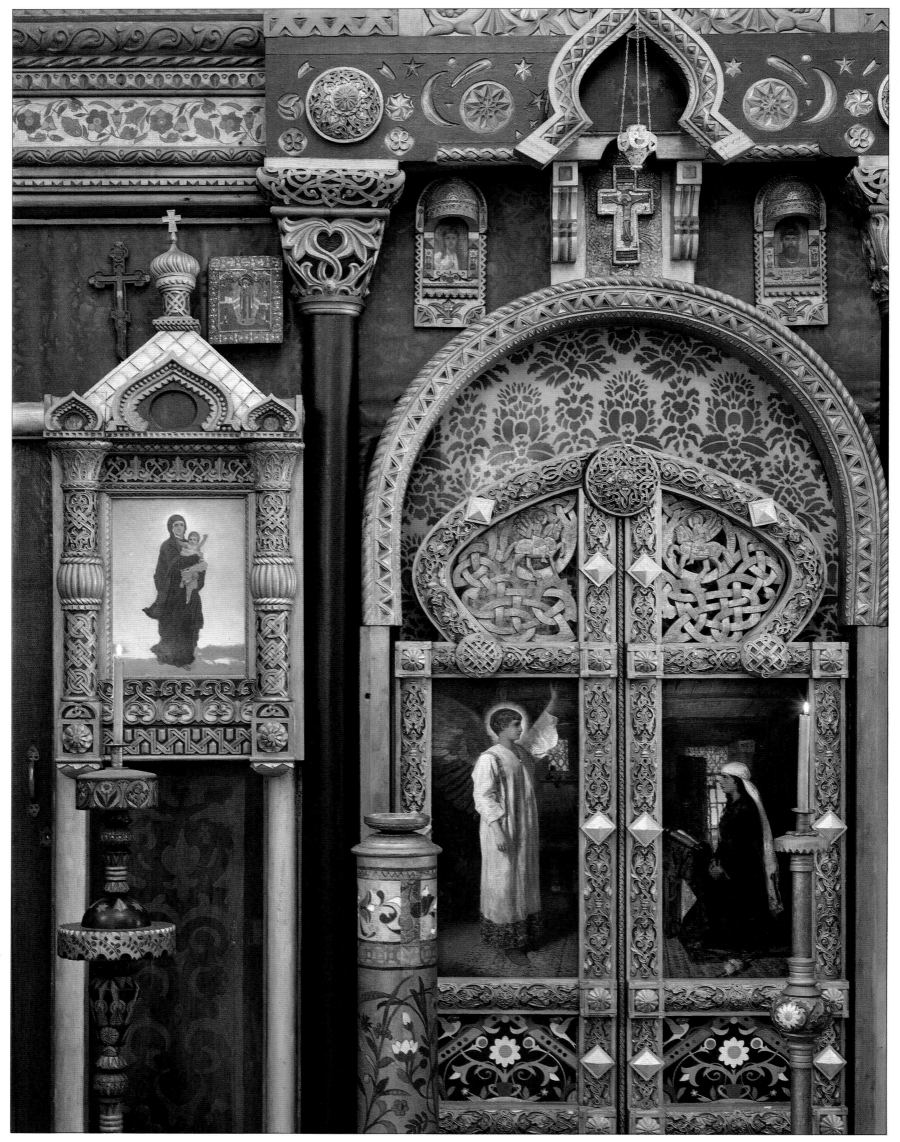

Plate 131

Mamontov's 'great Teacher' was Fyodor Chizov, a brilliant man of many talents who was the partner of his father, Ivan Mamontov, in his railway construction business. Chizov had a unique combination of business acumen and a keen interest in both science and art. A mathematician by education, and from 1857 an honorary fellow of the Academy of the Arts, Chizov had been a professor at St Petersburg University in the 1830s, paid homage to Slavophile ideas in the 1840s and was an active entrepreneur during the period of reforms in the 1860s. He was both a close friend of the Aksakov family and, at the same time, Ivan Mamontov's executor and his sons' trustee. Among the Mamontovs' other friends were the historian Pogodin and the rich merchant Kokorev. The latter founded Moscow's first art gallery, and also commissioned Nikitin to design the 'Russian *izba*' as a present for Pogodin.

Support for the Slavophiles' ideas came principally from the merchants during the reform period of the mid-1800s. The Slavophile doctrine provided the Russian merchants with an ideological platform. Its demands for the development of originality and individual initiative, for cutting through the snares of state regulation and for abolishing the anachronism of serfdom were consonant with every aspect of social life: commerce and industry, the sense of national identity and cultural self-expression. This is the background against which we have to see the decision of the young Mamontovs to set themselves up with this country house, which was to become an expression of their wish to see the cultural tradition of the Russian people continue. Savva Mamontov's belief that the Russian tradition was a vivifying source for contemporary art was something he had been imbibing since childhood, as was also his belief that the beautiful was useful, and the useful beautiful.[1] People who knew him well confirmed this. At his memorial service, the eulogy, given by the painter Viktor Vasnetsov, expressed deep gratitude for Mamontov's contribution to Russian art: 'There is a need not only for people who create art itself, but also for those who create the atmosphere in which art can live, flourish, develop, and perfect itself. Such were the Medici in Florence, Pope Julius II in Rome and all those others who created an artistic milieu in their people.

'Such a one was our departed friend, Savva Ivanovich Mamontov.'

'It is not enough to say of Mamontov', Vasnetsov continued, 'that he loved art. He lived and breathed art just like we artists. Without art and its life-forming beauty he would not have survived a single day. It was his, and our, element.'[2] The great Russian actor Konstantin Stanislavsky, founder of the Moscow Art Theatre, spoke even more strongly: 'Art guided Savva Mamontov in everything he did . . . art shone through even in his philosophy and his religion.'[3]

Mamontov's energy and outgoing nature were well complemented by the firm, rather matriarchal views of his wife, Yelizaveta, with her practical love of the people, profound piety and active involvement in social justice. 'The Mamontovs established themselves on the ruins of the way of life of the old landowners,' wrote Yelena Polenova. 'With great respect for the Aksakovs' traditions, they adopted their love of the village and the Russian countryside; its spirituality and lyricism, and a certain patriarchalism; their reverent cult of that 1840s circle of dreamers which once had gathered at Abramtsevo. The 1860s inspired them to work actively for the benefit of the people. To all this they brought beauty and a life-giving artistic inspiration which informed every aspect of their life, and which gave Abramtsevo a place of honour in the history of Russian art.'[4]

The ideas cherished at Abramtsevo were related to those of the Russian symbolist movement. Inspired partly by French symbolism, the Russian movement had a strongly mystical aspect and a faith in the transfiguring role of art and beauty. In the words of one of its ideologists, Andrei Bely: 'The ultimate aim of culture is to re-create humanity. In this ultimate aim it engages with the ultimate aims of art and morality . . . the new life and the redemption of mankind will be born of art.'[5] In their understanding of what kind of art this should be, however, most of the Mamontov circle parted company with the symbolists. Their ideal, and that of Mamontov himself, was a national, Russian art, rather than art in general. 'I deeply believe,' Mamontov wrote, 'that art will play an enormous role in re-educating the Russian people; and that Russian society, and morally regenerated art, are perhaps destined some day to serve as a light and a source of spiritual renewal for Western Europe also.'[6]

Another key principle in the Abramtsevo artistic credo was that of synaesthesia: the interpenetration of the arts, a unitary style embracing them all. The evolution of a new hierarchy of the arts which esteemed applied art over easel art (seen as not directly useful), new tendencies in easel painting itself and in religious art – all were born in Abramtsevo.

PLATE 131
Iconostasis of the church at Abramtsevo, 1882.

Art in Abramtsevo was completely free of the supervision of the Academy of Fine Arts. It was entirely the result of a private initiative and the voluntary activity of like-minded enthusiasts. Similar developments were to be found elsewhere in Europe, particularly in England, where the Arts and Crafts movement had begun with the building of the Red House (1859) for its instigator, William Morris. In Russia the beginnings took different forms, including the building of a church, the painting of pictures on themes from folk tales and legends and with stage settings for private theatre performances.

Artists gravitated to Abramtsevo for many other reasons besides the inspiration of the Mamontovs. They were attracted by the opportunities it provided for constant interchange with colleagues, as well as for first-hand experience of the life of the people and countryside.[7] Abramtsevo's proximity to Moscow allowed them to take part in the city's cultural life.

The World of Art In 1898 the magazine *Mir Iskusstva* ('The World of Art') began publication. The aesthetic credo of its circle of young St Petersburg artists was based in part on the principles and practice of the Abramtsevo circle. They shared a belief in the value of art for its own sake, and in the permeation of life by beauty. Notwithstanding the fact that

Mir Iskusstva had a predominantly Westernizing, European orientation which conflicted with the Slavic orientation of the Abramtsevo circle, the similarity of their basic ideals is beyond dispute. Evidence of this is Mamontov's participation in the financing of the magazine in the first years of its existence and the amount of space the magazine devoted to the work of Vasnetsov and Polenova.

Even as we remember Abramtsevo's pre-eminent position as a nursery for art nouveau, as well as for neo-Russian style, we should also note that it was part of a pattern. Between the mid-nineteenth century and the beginning of the twentieth a number of merchant families emerged as patrons of Russian cultural growth.

In the vicinity of Abramtsevo several centres of patronage appeared. It is enough to list the estates of close relatives and friends of the Mamontovs. Kireevo, near Khimki, was the estate of Savva Mamontov's elder brother Fyodor, who was a friend of Viktor Gartman, and who died young. The most productive years of Fyodor's short creative life were passed on the estate, and it was here that Gartman lived his last years. Mamontov's daughter Maria Yakunchikova, later a famous designer, took her first steps as an artist under Gartman's tutelage. Yelizaveta Mamontova's brother, V. G. Sapozh-

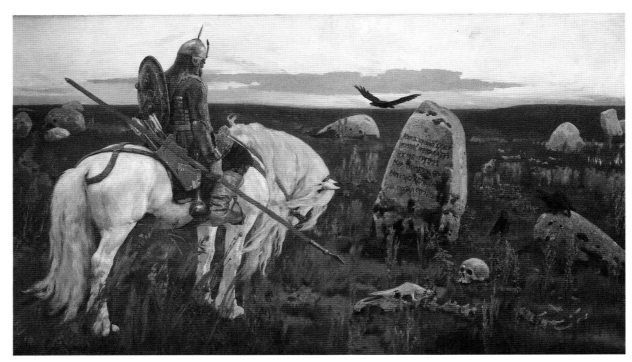

PLATE 132

PLATE 132
Viktor Vasnetsov, *The Warrior at the Crossroads*, 1882.
Much admired by his contemporaries, Vasnetsov was a leading figure who helped to promote a change in direction in the Russian arts during the reign of Alexander III. The son of a priest, he rejected the entrenched current trend of the Wanderers, protesting against the narrow realism that was an essential attribute of their literature and painting. Although in

many ways a weak painter, he was an important influence on a younger generation who were to benefit from his trailblazing role. It is his work, together with Vrubel's, that bridges the gap between the Wanderers and the World of Art. Having absorbed the rich cycle of church traditions from childhood, his patriotism was different from that of the Wanderers. His painterly methods, however, were similar to theirs. He presented fairy tales

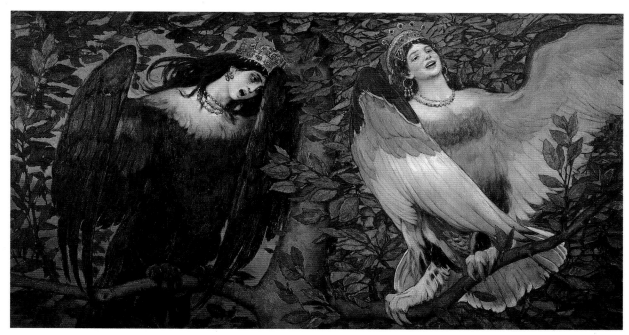

PLATE 133

nikov, who also studied drawing under Gartman, was for many years a trustee of Stroganov College. Dramatic performances and musical evenings were organized in Kireevo.

Next to Lyubimovka, in the village of Kurakino, was the dacha of Pavel Tretyakov, one of the founders of the Tretyakov Art Gallery in Moscow. In the former village of Listvyana, not far from Abramtsevo, was the dacha belonging to old Ivan Mamontov's brother, Nikolai Fyodorovich. This branch of the Mamontov family was noted for its musical talent and patronage of musicians.[8]

Vasnetsov and Russian Art

If the Mamontovs had a talent for gathering artists together and supporting the growth of newly emergent trends in art, then the man who provided the creative impulse behind the new searchings was undoubtedly Viktor Vasnetsov (1849–1926). He was called 'the trail-blazer' by Ilya Ostroukhov, a great artist and collector who succeeded Tretyakov as director of the Moscow Art Gallery. Vasnetsov's name is linked with a change of direction in Russian art which had its counterparts throughout the world. He was not only one of the first artists to address himself to Russian folklore; he was the first painter who managed to find an apposite manner of interpreting the subject matter of tales and legends.

The importance of Vasnetsov's innovations extends beyond easel painting; he also produced murals and theatre design. This turning to new themes and forms, also adopted by other painters, was part of a movement later known as the artistic transformation of the environment. It reflected a faith in the benign effect of art and beauty.

The Soviet art historian Eleanora Paston has studied Vasnetsov's career in the context of his times: 'For Vasnetsov's development and searchings as an artist, this move towards non-easel forms of art, which seemed to take place quite by chance in the artistic atmosphere of Abramtsevo, was in actuality a real revolution. This goes not only for Vasnetsov's own creativity as an artist, but also for the discovering of a new path for all of Russian art.'[1] The unity of art and life which had at first been a game for the members of the circle, gradually grew into a mission and a duty. Vasnetsov himself regarded transformation of the environment as making possible his ideal of restoring the community of interests of artist and peasants of the Middle Ages, when they had lived for shared interests, rejoicing in shared joys and grieving over shared sorrows. This was the ideal to which Vasnetsov's creative endeavours were directed. For him the task was not only artistic but also moral, social, philosophical and religious. Vasnetsov loved Yelizaveta Mamontova deeply and felt very

in a way which was believable by using a technique that was open and concrete. This skill was central to his charm and his influence with his audience.

PLATE 133
Viktor Vasnetsov, *A Song of Joy and Sorrow*, 1896.
Representations of Sirin and Alkonost, the birds of good and ill omen, were widely familiar through folk woodcuts (*lubki*). Here depicted by Vasnetsov, they assume a palpable presence.

close to her spiritually. He wrote to her: 'How the artists of old amaze us by the depth and immediacy and sincerity of their depiction. How fully and fearlessly they accomplish their tasks. Where do they get it all from, this warmth, this sincerity and courage? Not all of them are geniuses, by any means! . . . There is a simple answer to the question. We have to picture to ourselves how, in earlier ages and in his own age, all the people surrounding the artist, great and small, educated and ignorant, profound and simple, believed in the same things as he did. All of them lived and drew sustenance from the same aspirations. That is how artists great and small could find work to satisfy them heart and soul; how every heartfelt word they uttered was received with joy and gratitude. What passionate love they put into the churches they built, and the picturesque poems they wrote, and the entire worlds they hewed out of stone. And the whole crowd was agog, and waited eagerly, and rejoiced in the creations of its artists.'2

In Abramtsevo Vasnetsov glimpsed a semblance of this desired community of interests of artist and people, and saw some possibility of accomplishing the task, if only in part.

A graduate of St Petersburg Academy of Fine Arts, Vasnetsov first became well known as a genre painter, creating pictures of everyday subjects. The last of his works of this type was 'Playing Patience', which he painted in 1879.

It was at this point that Vasnetsov turned to the subject matter of folk tales and legends. He effectively founded a new genre by 'discovering' an area for painting which heretofore had been beyond the pale of serious art. Vasnetsov decided to dedicate his talent wholly to genre folk-tale painting. It was a turning point in his life. His departure from the Academy of Fine Arts, his permanent removal from St Petersburg to Moscow, and the exhibiting, at a travelling exhibition in 1880, of his painting 'After Prince Igor's Battle With the Polovtsy', are only the outward manifestations of an inner crisis. 'I can't explain exactly how it came about that I changed from a genre painter into a slightly fantastical historical painter,' Vasnetsov wrote to Stasov 'I only know that even when I was most completely absorbed with genre painting, during my time at the Academy in St Petersburg, I never ceased to be aware of vague historical and fabulous visions, so that there was no contradiction in my heart between genre and historical painting It was, of course, in gold-domed Moscow that the final, conscious transition from genre paint-

ing occurred. When I arrived in Moscow I felt I had come home and that now there was nowhere else I wanted to travel to. The Kremlin, St Basil's Cathedral . . . almost reduced me to tears, so much did I feel in my heart that this was part of me, and never to be forgotten.'3

The epic style In the 1870s Vasnetsov's illustrations of tales and legends and his sketches were quietly preparing his transition from the everyday genre to the area of folk tales and legends. Already not only the subject matter, but even the later compositional techniques can be detected, as well as the innovations in embryo which in the 1880s and 1890s would bring him to the forefront of Russian painting. In 'After Prince Igor's Battle with the Polovtsy', Vasnetsov depicts a real-life event in defiance of the canons of accurate realism which were accepted at that time in historical painting. He draws on the description of the battle – which ended tragically for the Russian prince – given in the twelfth-century epic *The Lay of the Host of Igor*. Vasnetsov's originality lay in depicting the event with means close to the verbal and pictorial traditions of folk art. As a painter he found a way of conveying visually the attitude to time and space, to heroes and events, which are found in tales and legends. The writer Dmitri Likhachev comments, 'In folklore there is no temporal perspective established by the personality of an author, just as in medieval art there is no spatial perspective established by the position of the immobile eye of an artist observing nature.'4 In an epic, exact proportions relating the man to the environment are also lacking. The landscape is not precisely characterized. It is depicted in a stylized and conventional way, the geographical background to most legendary feats being 'the open field' or 'a city built of stone'. The sky is described even less than the ground, with the result that the main event or the hero looms large, the hero being the indisputable centre of the narrative. In *The Lay of the Host of Igor*, however, the location of the action is described in more detail than in the legends. Everything is colourfully depicted – not in any figurative sense but quite literally: it is characterized by colour. The colours in folklore are brightly decorative, with no suggestion of *plein air* or tonality. They are life-affirming and vivid, like the decorative painting of folk art. The description of characters' appearance is always concrete. Their features are hyperbolized, but are also constant, with certain word-combinations being constantly repeated: 'swan-woman', 'peacock-maid', 'stout-hearted lad'. This

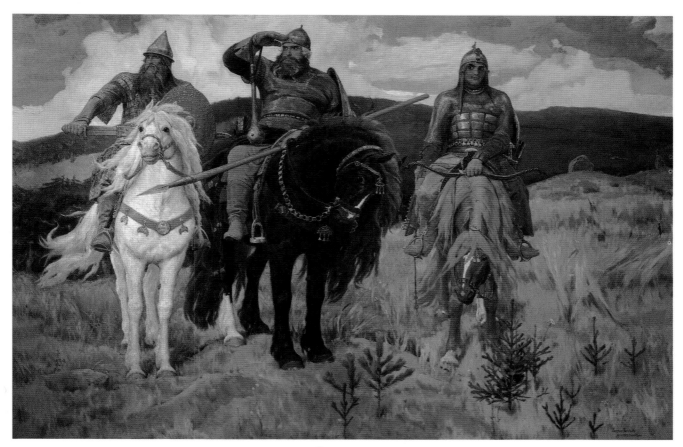

PLATE 134

metaphorical and repetitive characterization is reinforced by the rhythmical structure of the narrative. Tales and legends depict action vividly, but give epic rather than individual characterization of heroes. The heroes are a generalized, idealized image of the people itself.[5]

This is broadly the pattern in Vasnetsov's pictures. In 'After Prince Igor's Battle', for example, we are struck by the unfolding of a great expanse of rolling space – a visual counterpart to the epic's infinite space. Silhouette and outline are much enhanced. Great care is taken over the decorative treatment of patches of colour. Fragmentation and decorativeness, the emphasis of outline and linearity characterize the epic idiom employed to convey the heroic spirit of the legendary events depicted, and to impart a monumental quality.

The epic tradition invariably requires a consistent image of the hero, his every deed and move emphasized by repetition and thereby made larger and more monumental. This naturally entailed a marked increase in the size of canvases. In this respect Vasnetsov's only rival among his contemporaries was Vasily Surikov; however, the epic quality of Surikov is more traditional. It derives from the populousness of his compositions, the sheer numbers of his dramatis personae – a quantitive epic quality, as it were. By contrast, the monumentalism and large format of Vasnetsov's pictures are features of the treatment of the subject itself. Even 'After Prince Igor's Battle' has few figures, considering its subject. As in legend and folk tale, the deeds of a small number of heroes are seen in close-up. Grief for the fallen and a sense that a multitude of Russian and Polovtsian warriors have perished are expressed symbolically by depicting two principal victims of the battle, a great stalwart hero and a fair, gentle young lord, and by the enormous dark blotches of the birds of death swooping low over the earth.

This fragmentation was not the only innovation in the picture's spatial construction. Vasnetsov also rejects direct

PLATE 134
Viktor Vasnetsov, *The Bogatyrs*, 1898.
The best-known work of Vasnetsov's legend cycle depicts three heroes of epic legend, guarding the Russian frontier: Ilya of Murom in the centre, Dobrinya Nikitich on the white horse, and Alyosha Popovich. The heroes' exploits are recounted in a cycle of legends inherited from pre-Mongol Kievan Rus. Vasnetsov worked on this immense canvas for more than a decade. Enchanting more than one generation, it provided a model widely used in every possible decorative application, from silverwork to chocolate boxes.

perspective. Emphasizing outline and patches of colour causes a flattening of the space. By foregoing the aspect of any particular landscape, it becomes the 'open field' of legend. There is a change also in the very technique of the construction of space. Like an old Russian icon painter Vasnetsov combines two points of view: the spectator, as if looking down on the picture from above, takes in the whole field at once and, at the same time, sees it from below, with the result that the epic field, with its low horizon and its brightly shining moon, becomes the most striking element in the picture.

This unconventional, lyrical and epic treatment of the sub-

abandoning conventional themes conventionally treated.

At almost the same time, Vasnetsov was commissioned by Mamontov to produce a cycle of three paintings for the terminus of the Donetsk Railway, of which Mamontov was chairman. The paintings were turned down by the railway board because of their unconventionality. 'The Battle of the Russians and Scythians', 'The Flying Carpet' and 'Three Princesses of the Underground Kingdom' together made up an allegorical representation of the renewal of the region. The first painting depicted the period when Donetsk was first populated by the Slavs; the second likened the rapid progress

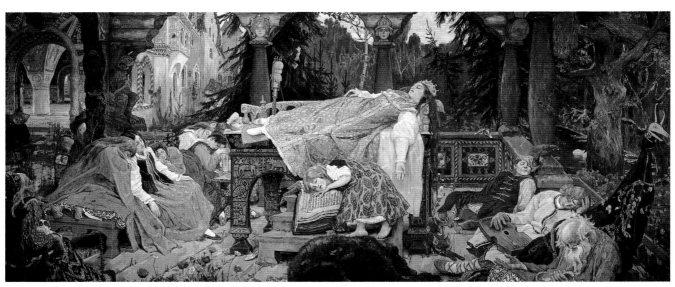

PLATE 135

ject, so far removed from accurate pictorial depiction of the aftermath of a real battle, not only bewildered many viewers but scandalized some of the mobile exhibition's organizers. One of the cooperative's leaders, Myasoyedov, protested emphatically against the picture's being exhibited. The painting's hostile reception resulted from its lack of the realistic depiction of events, which was the hallmark of the *peredvizhniki*. This blew up into a conflict which almost led to Vasnetsov's leaving the cooperative, and which was defused with some difficulty. Ironically, Myasoyedov's view was shared by Mikhail Nesterov, later one of Vasnetsov's admirers and followers, who wrote at this time of the incomprehensibility of what Vasnetsov was doing, saying that those who remembered the artist's first genre pictures regretted his

of the region, resulting from the building of the railway, to a magical flying carpet; and the third represented the incalculable wealth in the bowels of the earth beneath it. The last picture was based on a tale that told how Ivan, the son of a peasant, descended into the earth and found there three kingdoms, of gold, of precious stones and of iron, and brought the princesses of these kingdoms up to the earth's surface.[6]

The most famous painting of what is known as Vasnetsov's 'legend' cycle is 'The Russian Heroes' (*Bogatyri*, 1899). This cycle relates to the 1880s and 1890s, and displays features already familiar to us: panoramic space, a small number of large figures boldly placed in the foreground, a monumental and decorative idiom corresponding to the large dimensions of the painting, a high horizon and a combination of view-

PLATE 135
Viktor Vasnetsov, *The Sleeping Beauty*, early twentieth century.
The only work by Vasnetsov on a subject not drawn from Russian folklore. It portrays a theme from one of Perrault's French fairy tales. Nevertheless, Vasnetsov locates his characters in a fantastic setting which evokes seventeenth-century Russia.

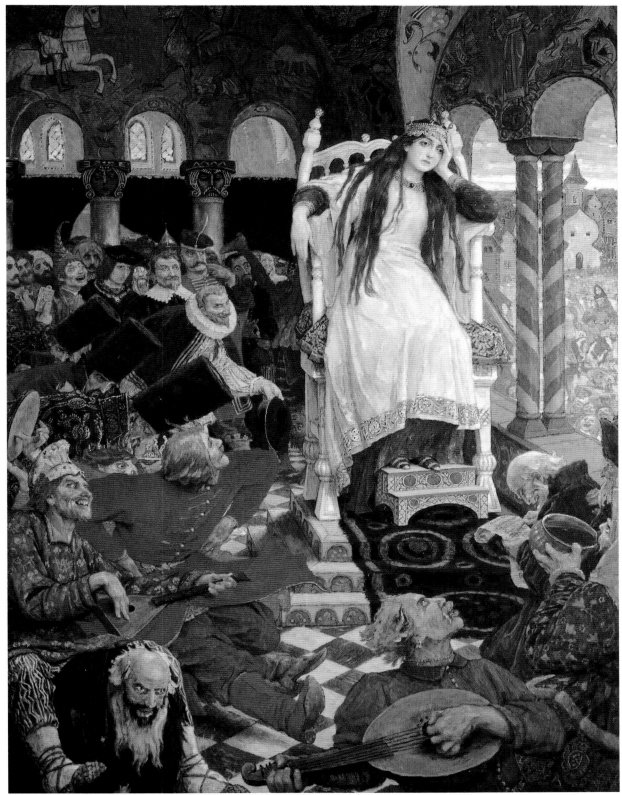

PLATE 136

PLATE 136
Viktor Vasnetsov, *The Princess Who Never Smiled*, 1914–16.
A painting for the cycle which Vasnetsov called 'The Epic Poem of Seven Tales' and on which he worked towards the end of his life. He employs his usual idiom of folklore to illustrate the larger themes of good, evil and the power of love. The cycle divides into three groups: *Baba Yaga* (1901–17) and *Kashchey the Immortal* (1917–26) personify the ugliness but also the underlying weakness of evil. *The Sleeping Beauty* and *The Princess Who Never Smiled* form the second group in the cycle. The murals depicted in the princess's palace are on themes important to Vasnetsov's spiritual view, among them *Life debating with Death* and the lives of the early church fathers. The third group of the cycle, *The Flying Carpet* and *The Frog Princess*, express Vasnetsov's optimistic belief in the triumph of good.

points from above and below which enable us to feel a unity of space outside time, such as occurs in legends and folk tales. In a number of works depicting birds of omen, for example ('Gamayun'), or birds of Paradise ('Sirin' and 'Alkonost'), Vasnetsov daringly borrowed directly, for the first time in the history of high-style Russian painting, from the iconography of the *lubok* woodcut and from folk painting. His picture 'Ivan the Terrible' has echoes of the old Russian *parsuna* painting, revived here for the first time as a deliberate artifice.

For almost half a century Vasnetsov remained true to the subjects and, to a lesser extent, the stylistic attributes he had

canvas. Direct borrowing of particular folk art forms or motifs is secondary to the overall decoration of surface. In a number of pictures, particularly those in which the epic heroes of Russia do battle with monstrous incarnations of evil, we can discern the response of an accomplished artist to current events, reinterpreting them in symbolic and metaphorical form. In the same works we see Vasnetsov adapting innovations of European and Russian painting of the 1890s and 1900s, including a linear quality and modernist stylization.

Illustrations Vasnetsov's illustrations have a strongly graphic quality, in which an ornamental linear style is

PLATE 137

developed in the 1870s and 1880s. Such evolution as did occur was mainly in the range of his colours and, to a lesser extent, in his treatment of form. In the paintings of the 1880s and 1890s, for all their vivid richness and large patches of colour, the coloration remains academic, with settings in which ochres and greens predominate. In the works from 1900 to the 1920s there is a triumph of overtly decorative colour. The colour is mostly localized, as in folk and medieval art – vivid, vibrant azure, vermilion, pink and gold, often applied in bold and even jarring juxtaposition. Vasnetsov's paintings ('The Princess who never Smiled', 'Sleeping Beauty', 'Prince Ivan's Battle with the Three-Headed Serpent', 'Dobryn Nikitich's Battle with the Serpent Zmey-Gorynych') were enormous decorative panels, losing all sense of conventional painting on

evident. He produced illustrations for many of the tales of Pushkin, including some for a commemorative three-volume edition, published in 1899 to mark the centenary of the poet's birth. In the same year he illustrated *The Song of Oleg the Seer*, which was published as a separate small volume, reissued in 1912. Vasnetsov's designs, which include illumination and headpieces, integrate with the text to form an attractive and decorative whole. The characterization, costume and accoutrements were taken from icons and frescoes, but historical accuracy was subordinate to stylization.

Vasnetsov was not alone in his search for satisfactory ways of interpreting the figures of folk tales and legend, but most of his colleagues in this respect were graphic illustrators, rather than painters. Russian books in the 1870s were awash with

images from folklore, drawing being well ahead of painting in the attempt to create a flat, decorative manner derived from verbal folk art and employing the techniques of peasant decorative art and the *lubok* woodcut. Vasnetsov's drawings for Russian tales and legends have their parallels in works by Pyotr Klodt, Sollogub and Mikeshin, and the later work of Yelena Polenova, Ivan Bilibin and Sergei Malyutin. He succeeded in integrating all the various experiments into a unified system, and, not least important, he gave the new movement the cachet associated with the highly respected genre of large-scale easel painting.

In 1899 Vasnetsov designed an exceptionally pleasing illuminated menu for a banquet at the Moscow City Council to celebrate the Pushkin centenary – the date and the Moscow coat of arms depicting St George and the dragon are shown at the head of the card. Medieval illuminated manuscripts had commonly been decorated down the left-hand margin and along the top of the page, with a capital letter integral to the design in the left-hand corner, an ornamental headpiece above the text and sometimes an illustration above that. This style of decoration had been adopted for everyday use in Russian printed graphics, in posters, menu cards and book covers. The samples we have of this kind of work by Vasnetsov show how widespread and comprehensive was the use of the language of old Russian art, and how naturally it had been incorporated into the contemporary idiom. These works also demonstrate that by the end of the century not only architects but also highly respected painters might undertake the design of a relatively commonplace object such as a menu card. The application of a motif from a religious manuscript in a mundane context indicates the end of the old hierarchy of values, and also the ways in which the goal of uniting life with art was approached. Vasnetsov's menu achieves the status of high art, and certainly its artistic merit is equal to that of his masterpieces of painting.

Neo-Russian Stage Design for the Mamontov Circle and the Russian Private Opera

From the outset the theatre was central to the Mamontov circle. It was amateur dramatics that first brought all its members together in an artistic endeavour dedicated to seeking new directions and reviving Russian national art. The staging of Alexander Ostrovsky's play *The Snow Maiden (Snegurochka)* in 1881 was, like many another of the circle's ini-

tiatives, to become a pivotal event in the history of Russian art, and primarily in the evolution of the neo-Russian style.

Ostrovsky was an outstanding playwright whose works chronicled the everyday Russian way of life. His fairy-tale play *The Snow Maiden* came as a surprise to everybody. It is a touching tale in which the Snow Maiden, the daughter of Frost and Winter, obtains the highest gift of heaven, the ability to love, and then goes voluntarily to her death for the joy of experiencing it. The play's moral and philosophical dimension is represented by the wise and legendary Tsar Berendey, whose main concern is that beauty should be present in everyday life and that all should be well in the affairs of the heart of his subjects. Quite unlike Ostrovsky's other plays, *The Snow Maiden* reflected his belief in the inseparability of the good and the beautiful and a faith in morality as an active force in society. It was the ideas underlying the fairy tale that first attracted Mamontov's circle. The play was a metaphorical representation of a wonderful future in which spiritual transformation would come about from a return to the traditions of Russian art and spirituality.

The costumes and stage sets were by Vasnetsov – his first venture outside the world of easel painting. He turned to sources in folk art that artists had hitherto ignored, such as the bulky, bulbous forms of rustic furniture and columned wooden interiors; more important even than this was his decorative, bold way of interpreting the new images. The costumes, vivid and colourful, are a case in point, directly utilizing folk fabrics, prints with the vibrancy of vivid patches of colour typically found in folk art. Most innovative of all were the 'architectural' settings. For the Prologue Vasnetsov created a sketch of the merchants' quarter of the legendary land of Berendeevka. Set in a rolling Russian landscape, the fairy-tale turrets soar skywards from the town's fantastical buildings. In Berendeevka Vasnetsov gave a pioneering interpretation of Russian wooden architecture seen in the light of epic and legend. It was strikingly unlike the fussy, archaeologically precise stage designs of Mikhail Bocharov and Matvey Shishkov – until then the most celebrated stage designers of the late 1800s. Just as in his paintings, Vasnetsov forgot about the detail of everyday life and embraced the poetic ambiance of the folk tale. This entailed stylization and a certain amount of exaggeration in order to bring out the unusual in the familiar aspect of the peasant hut, the powerful, massive bulk of the logs in the walls and the trim picturesqueness of the

PLATE 140

porch. Vasnetsov was perhaps the first to convey the charm and beauty of the peasant hut seen as a work of folk art.

Vasnetsov's supreme achievement in this production was, however, his design for the palace of Tsar Berendey. We know that when Vasnetsov was creating the set of Berendey's palace he was inspired, not directly but figuratively, by the wooden palace of Tsar Alexei Mikhailovich (1645–76) in the village of Kolomenskoe, near Moscow. Completed in 1681, the palace itself had been dismantled in the reign of Catherine the Great, and plans and models are all that survive. In creating the interior of Berendey's palace Vasnetsov had to rely wholly on his own imagination and his understanding of folk

architecture. The quaint arches of the palace are supported by pillars and columns, all lavishly carved and painted. The motifs are derived from the patterns and carving of the wooden items of the peasant household: distaffs, gingerbread moulds, battledores, tableware and furniture, as well as woodcuts and archaic pre-Petrine printed books. The fantastical columns of Berendey's palace are reminiscent both of the convoluted columns of the refectories of wooden churches in the Russian North and, in their decoration, of Easter eggs painted by folk artists.

The charm of this stage set derives from the glimpse it affords into the decorative and lyrical traditions of Russian

PLATE 140
Viktor Vasnetsov, *Tsar Berendey's Palace*, stage design for Rimsky-Korsakov's opera, *Snegurochka*, undated.
Snegurochka (*The Snow Maiden*) first opened at Mamontov's Private Opera in Moscow in 1883. The production had its roots in the private theatricals staged at Abramtsevo, and the use of a professional artist to paint the sets was revolutionary. Vasnetsov's fertile imagination conjures up a highly fantastic

vision of old Rus. His designs are one of the first indicators that it was to be the art of the theatre that would bring a younger generation of artists their international success. It was in stage design that Russia, which for so long had followed in the West's footsteps, established a model with which to enthrall the West.

folk art. It provided a key to the meaning behind the production. It embodied this meaning; moreover, it symbolized the faith of Mamontov's circle, and of Vasnetsov himself, in the life-giving role of 'good' traditional art and in the immense importance of architecture. For Vasnetsov, an outstanding representative of neo-Romanticism, architecture was indisputably 'the foremost and most successful art in educating the artistic feelings and instincts'.[1]

Mamontov's Opera The stage settings Vasnetsov created for the amateur production of *The Snow Maiden* in the Abramtsevo theatre were adapted for Rimsky-Korsakov's opera of the same name. This, however, was produced on a professional stage – another of Mamontov's enterprises. In fact, Mamontov's major achievement is considered to be his success in spreading the fame of the school of Russian composers, and in instigating a new movement in stage design. His Russian Private Opera – the name of both the theatre and the company – first opened in Moscow on 9 January 1885 (the imperial theatres' monopoly in the capitals having been abolished in 1883). The Opera was in business from 1885 to 1891 and again from 1896 to 1900. It did not by any means restrict itself to the works of Russian composers; works by Western European composers, such as Verdi's *Aida*, Bizet's *Carmen*, Leoncavallo's *I Pagliacci* and Gounod's *Faust* were also performed there, by the best European opera singers. No less thoroughly did Mamontov's Opera strive to acquaint the Russian opera-going public with Russian nationalist opera and to give them a proper appreciation of it. The fact that his theatre opened with a production of Alexander Dargomyzhsky's *Rusalka*, based on a Slavonic legend, was surely significant; its settings, too, were designed by Vasnetsov, along with Levitan and Yanov. The same year saw the staging of *The Snow Maiden*, whose set now became known and loved by a wider public.

The members of Mamontov's circle, and subsequently also the management of the Opera, did their utmost to ensure that every detail contributed to the stylistic unity of the performance. For this reason, stage design was given the dominant role in the interpretation of the production. In fact, even the direction of the opera was often entrusted to the designer. This elevation of stage design to the position of principal element in the interpretation of an opera reflects a unique, highly theatrical refraction of a new correlation between the arts, with painting moving in the direction of architecture, and with architecture becoming even more the driving force in matters of style. Stage sets, the artificial milieu in which the characters of a performance exist, were seen as reflections of real architecture, the artificial milieu in which human beings live.

The Russian Private Opera had the benefit of experience gained by the amateur theatre in Abramtsevo. Most of the designs for its productions were, however, the work of the next generation of artists: Korovin, Apollinary Vasnetsov (the brother of Viktor), Malyutin, and Vrubel, who began working there in 1896. In his designs for such Russian operas as *Prince Igor* by Borodin, and *The Maid of Pskov* (1896) and *Sadko* (1897), both by Rimsky-Korsakov, Korovin developed what he had learned from Vasnetsov's re-working of folk art into his own creative approach. A decorative, stylized idiom combined with vibrant, festive colours was Korovin's trademark. Stage design became the centre of his life as an artist, as it did later for another member of the circle, Alexander Golovin. In the twentieth century both artists continued their work on the imperial stage: Korovin at the Bolshoy Theatre in Moscow, Golovin at the Mariinsky Theatre in St Petersburg.

Apollinary Vasnetsov began his artistic career in Mamontov's Opera with settings for *The Snow Maiden* (1896) and

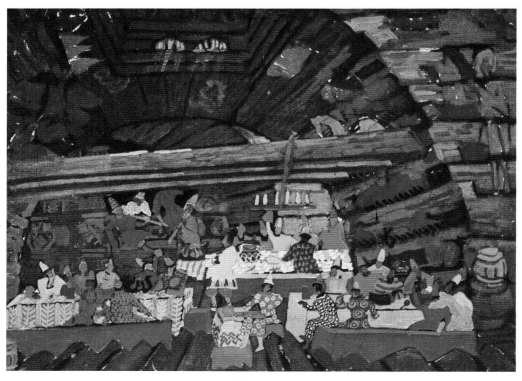

PLATE 141

PLATE 142

PLATE 141
Fyodor Fyodorovsky, Stage design for the
first act of Rimsky-Korsakov's opera, *Sadko*,
early twentieth century.
At the turn of the century stage design became
a direct vehicle for investigating and
expressing the Russian idea, projected
through atmosphere, symbolism and the
imaginative use of colour.

PLATE 142
Interior of the Moscow house of Viktor
Vasnetsov, 1894.
The house, which Vasnetsov designed himself,
was an important meeting-place for those
architects and artists who were intent on
reinterpreting the relevance of the past for the
present. The wooden interior and some of the
original furniture give an idea of the warmth the
room must have had before it was cleared of its
contemporary clutter.

for Mussorgsky's *Khovanshchina* (1897) and *Boris Godunov* (1898). His designs create a rather different image of Rus from that of Korovin and Golovin – more ancient, with more extensive use of wood, and re-created after much research into Russian history, culture and art. Apollinary Vasnetsov succeeded in conveying a believable account of the old Russian taste in architectural design. To this day it is he who largely determines the way we imagine the appearance of our ancient, long-vanished towns and villages.

Even Vrubel, the most brilliant and independent-minded of the new generation, takes Viktor Vasnetsov's innovations as his starting point. Vrubel's settings embody a different feeling for colour; a more creative approach to architectural setting, the similarity with actual, surviving medieval Russian architecture being more associative than authentic. We see this in his designs for Rimsky-Korsakov's operas *Sadko* and *The Tale of Tsar Saltan* (1900).

In the 1890s and the early 1900s, stage design for operas on Russian subjects by such artists as Golovin, Korovin, Apollinary Vasnetsov, Vrubel, Malyutin, Fedorovsky, and Yuon continue, by and large, the tradition of Vasnetsov. For all that, they also mark a new stage in its development, and in the development of the neo-Russian style. This was associated with art nouveau or *moderne*, which was now in its heyday.

The Abramtsevo Church and the Carpentry Workshop

In Vasnetsov's work we can easily trace the link between the move towards to new subjects and prototypes on the one hand, and the new experimentation in art on the other. The role of new prototypes is especially prominent in the evolution of neo-Russian architecture and applied art. In this area too, Vasnetsov and his colleagues of the Mamontov circle, the brother-and-sister team of Yelena and Vasily Polenov, were pioneers.

Yelena Polenova was the first to recognize the crucial significance of Vasnetsov's work. She was herself a major and versatile artist: a painter, graphic artist, a master craftsman and director of the Abramtsevo carpentry workshop. It was thanks to her organizational and artistic abilities that Vasnetsov's main ambitions and many of his ideas came to fruition. Polenova wrote, 'I didn't exactly study under Vasnetsov; that is, he didn't give me lessons, but somehow I became imbued with the spirit of the Russian people just by being near him.

He was one of the members of the circle in whom, more than in others, a unique, original personality and a very special and individual artistic outlook found expression. The wealth of this man's inner resources was astonishing . . . '[1] Another person who acknowledged Vasnetsov as his teacher without ever having directly studied under him, was Fyodor Shekhtel (1859–1926), the foremost architect in Moscow at the turn of the century, and Russia's leading exponent of *style moderne*.[2]

The Abramtsevo circle (Vasnetsov in particular) was no less influential in architectural and applied art than it was in painting and stage design. Among its outstanding achievements in these areas were the Abramtsevo church, the pavilion in the park there (known as the 'hut on hen's feet', after the witch Baba Yaga's hut in a Russian fairy tale), and, finally, the Abramtsevo carpentry workshop. Even though architectural design was never closest to Vasnetsov's heart (neither, indeed, was stage design), his work exercised a profound influence on the development of Russian architecture and applied art, from the 1890s to the second decade of the new century.

Characteristic of his work in these fields are stylization and decorativeness and the search for stylistic unity. The influence of an unconventional source on the composition and decoration of these art forms played the same role as unconventional subject matter had in his paintings. It facilitated, and even stimulated, the search for new ways to express the ideas dearest to him.

The Abramtsevo church Designed in 1881 and erected in 1882, the Abramtsevo church could have come about only in the unique conditions of Abramtsevo. It is a memorial church – but one built to commemorate the colony itself and their efforts to raise a temple to the religion of beauty. In raising a memorial to a life devoted to art, the members of the Abramtsevo circle were reviving in a small way something that once had existed on a large scale. As Vasnetsov recalled, 'All of us artists, Polenov, Repin, myself, Savva Mamontov himself and his family, set to work. . . . It was as if the spring had begun to flow again of the creative enthusiasm of the artists of the Middle Ages and Renaissance. But in those days the impulse had emanated from cities, whole regions, countries, peoples, while we were only the small friendly family of artists and the circle of Abramtsevo.'[3]

The church is remarkable for its simplicity: it is crowned with a single dome. Cuboid and triapsidal in form, the open

PLATE 143
Viktor Vasnetsov, Church at Abramstsevo, 1882.
The country estate of Abramtsevo, near Moscow, has a special place in the story of the evolution of nineteenth-century Russian culture. In the 1840s it belonged to the Aksakovs, a family of Slavophile writers and thinkers, and it was here that Gogol wrote *Dead Souls*. Later, it passed into the possession of the railway tycoon Savva

Mamontov, and his wife, Elisaveta, and was to serve as a similar focus for artists. In 1871 the Mamontovs built a hospital there in the wake of a cholera epidemic. Later a school was housed in a traditional wooden *izba*, and nearby a sculpture studio was constructed in the Russian style by the architect Petrov-Ropet. The plan to build a church materialized after the flooding of a river in 1880 prevented local people from reaching church at Easter.

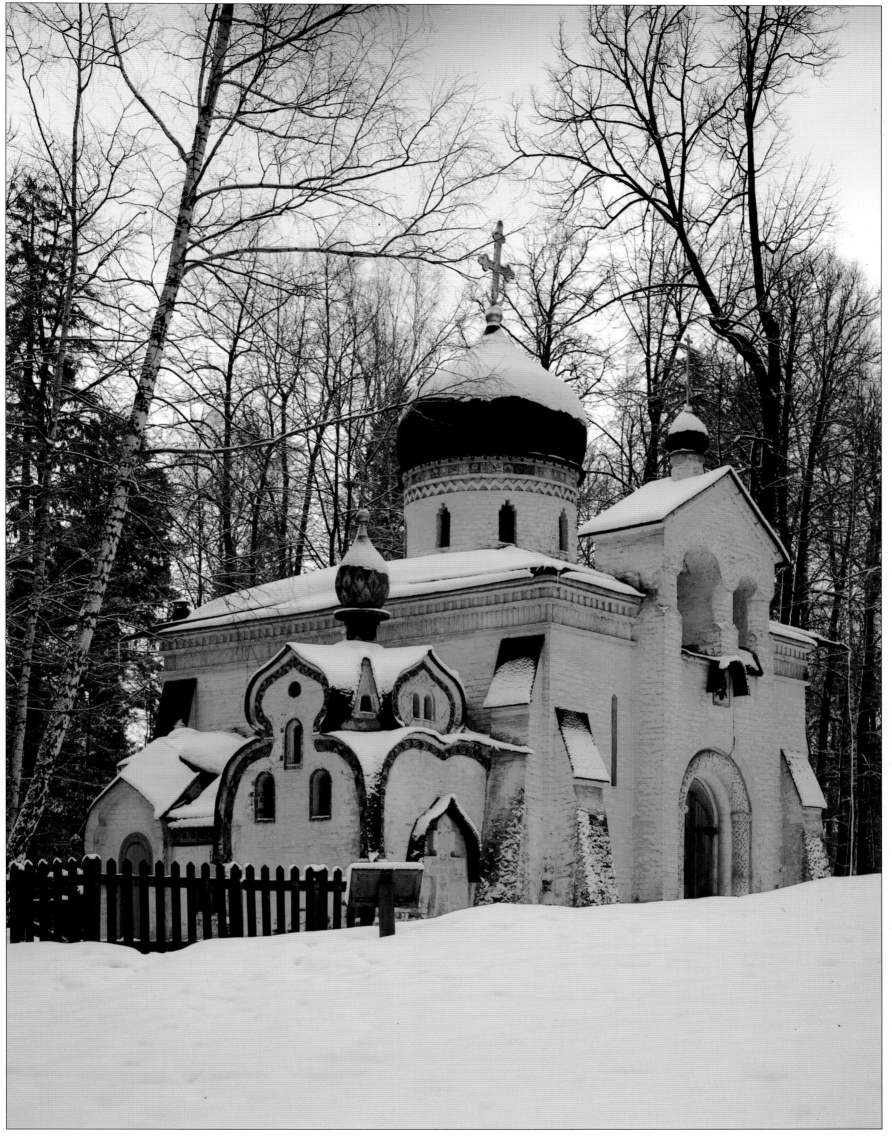

PLATE 143

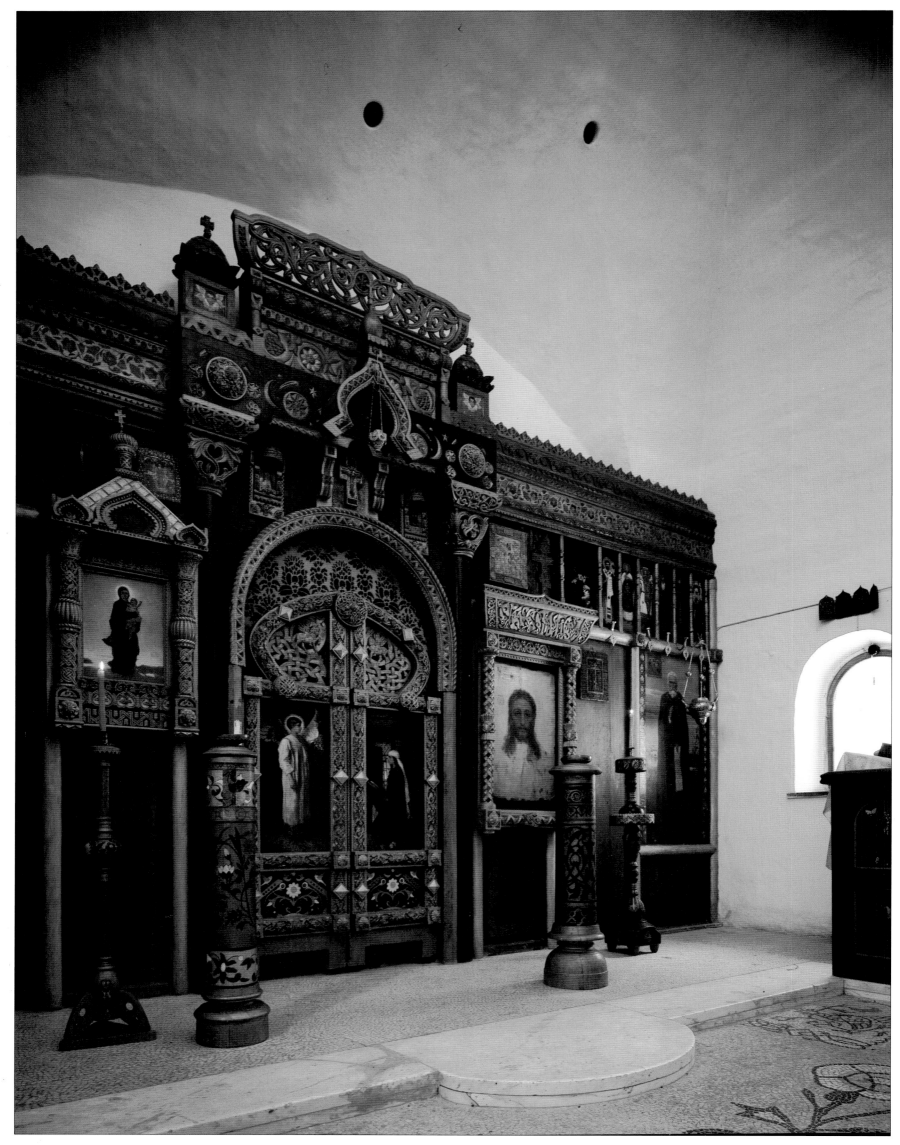

PLATE 144

sightlines of its central space and the expressiveness of its constituent parts were in stark contrast to contemporary church architecture. Its lyrical transformation of ancient traditions stands out against the more usual pedantic accumulation of antiquarian features; one of the first expressions of stylization against the stylistic looting of the preceding age.

The design of the church was chosen through a competition. The participants were Adrian Prakhov, a historian of old Russian and Byzantine art, an artist and restorer; the architect Samarin; and the painters Vasnetsov and Polenov. It was Polenov who suggested, to general approval, that they should base the design on the churches of Novgorod and Pskov and, in particular, on the twelfth-century Church of the Saviour on the Nereditsa, near Novgorod.[4] Polenov recognized in these churches a fusion of individual character with a natural, organic quality. Their sculptural forms and rhythmic richness embodied the artistic ideal which was beginning to emerge . In his winning design, Vasnetsov re-combined and re-interpreted Polenov's prototypes, although he considered the result to be more in the spirit of Moscow, compared with Polenov's. It would be more accurate to say that Vasnetsov employed various features of the architecture of Moscow, Vladimir and Suzdal, and Yaroslavl – the single dome, belfry, cuboid form and tiled, patterned exterior were drawn from a number of old Russian prototypes.

The construction of the church continued throughout the summer of 1881, with the finishing of the interior beginning in September. The walls were left unpainted, as was common in ancient churches, and invariably the case in wooden ones. The interior was dominated by the iconostasis. Again, it was Polenov who proposed the chosen model: the iconostasis of the Church of St John the Theologian on the Ishna, near Rostov the Great. This was the ancient type of *tyablyi* iconostasis, widespread at the turn of the century, in which the wood is deeply carved but not pierced.

Polenov himself made the iconostasis, whose notable features were to be further developed in the future. These included the wealth of carving techniques, the complex rhythms and the diversity of contrasts in the texture of the workmanship. The icons were the work of Ilya Repin ('The Begotten Saviour'), Polenov ('The Annunciation' on the Royal Gates of the iconostasis, and 'The Last Supper') and Vasnetsov ('St Sergius of Radonezh' and 'The Virgin and Child'). The principle of stylization was clearly applied in

Vasnetsov's designs for the painting of the choir, for the sloping surfaces of the church windows, and for the mosaic floor. In the painting, as in the architecture, a tension can be felt between the approaches of the two principal designers of the church, Polenov and Vasnetsov. Polenov treats the scenes from the Bible with historical accuracy, whereas Vasnetsov's icons, like his paintings of legendary subjects, show a willingness to depart from a literal, realistic treatment and he employs a decorative flat quality. His image of the Virgin in the Abramtsevo church was to be repeated by the artist in his grand mural painting in the apse of St Vladimir's Cathedral in Kiev.

Vasnetsov's other projects Another building by Vasnetsov at Abramtsevo represented a development of the peasant variety of the Russian style. This was a small pavilion, the wooden 'hut on hen's feet' which was a variation on the architectural motifs in Vasnetsov's canvases on folk-tale subjects. Although tiny, it was built of enormous logs. The most expressive aspect of this simple building is its actual form and the artistic and imaginative exploitation of the traditional method of construction. Laid over short, wooden 'hen's legs', the heavy logs, with their massive protruding ends increasing in length nearer the roof, gave this structure a suggestion of the fairy tale and the epic. On the sloping roof are the stylized representations of an owl and a bat – motifs that were to become popular in Russian art nouveau architecture.

Work on painting St Vladimir's Cathedral (1885–95) took Vasnetsov away from direct involvement in architecture for several years, but at the same time brought him to a better understanding of the role of the artist in architecture. Having exploited the expressive quality of colour only in interiors, he now began to see its potential in façades. In the 1890s, on his return to Moscow, he began to introduce colour extensively into façades, both on buildings that were actually realized and on some that never progressed beyond the design stage.

As we have seen, a lavish use of colour was one of the hallmarks of the Russian style; but Vasnetsov brought a new dimension to it, through the use of large surfaces of contrasting colour. In striving for an unapologetically decorative effect, he turned surface finish into one of the basic means of architectural expressiveness. Another innovation was the special attention he paid to the graceful lines of enlarged forms and the expressiveness of the outline of buildings.

The period from the 1890s to 1910 saw Vasnetsov at his

PLATE 144
Vasily Polenov and Viktor Vasnetsov,
Iconostasis of the church at Abramtsevo, 1882.
The plan for the Abramtsevo church was devised
by the Vasnetsov brothers; Repin, Polenov,
Apollinary Vasnetsov and Nesterov worked on
the iconostasis and the frescoes; Elisaveta
Mamontova and Elena Polenova made
vestments to designs by Polenov, and Viktor
Vasnetsov designed and helped to lay a mosaic
floor in the form of a spreading flower. This

communal effort marked a new stage in the
development of research into the roots of
Russian artistic tradition and led to a more
accurate representation of the past than anything
previously built.

busiest in both architecture and applied art. The period from 1892 to 1901 was especially productive, with, among other projects, construction of the chapel over the grave of Andrey Mamontov (1918), the building of Vasnetsov's own house and of the Tsvetkov house, and the design of the façade of the Tretyakov Gallery. He designed dachas and apartment houses, churches and several variants of the crafts pavilion for the 1889 World Exhibition in Paris; he formulated a project for painting the buildings in the Kremlin, and designed a new passage between the Great Kremlin Palace and the Armoury (1901). Finally, he returned to working for the carpentry workshop in Abramtsevo. At the same time Vasnetsov was

covering a carved wooden board, ornamented with a design both simple and sophisticated, on the façade of a peasant hut during a walk to the neighbouring village of Repikhovo, and bringing back some carved battledores from Saratov province. But mere collection was too passive an occupation for the active spirits of Abramtsevo, who wanted to create in the folk spirit themselves. Accordingly, a carpentry workshop was set up under the direction of the mistress of the estate, Yelizaveta Mamontova.[5] With the arrival in Abramtsevo of Yelena Polenova, who in 1884 became Yelizaveta's principal assistant, visits around the villages to collect and sketch objects of peasant art became a regular custom.

PLATE 145

approached to provide furniture designs for the Craft Museum of the Moscow Zemstvo and the workshops attached to the Monastery of St Sergius. In these years his works, including his earlier projects as well as new ones, became well known and controversial, serving as models for some, but evoking hostility and protest from others.

Although the neo-Russian style is rooted in Vasnetsov's work, his role in the history of Russian architecture extends beyond his founding of this. Like the ripples from a stone thrown into water, the influence of his experimentation spread far beyond his immediate circle – although, naturally, the farther afield we look, the less obvious is this influence. If the lineal descent from his impulse is nonetheless real for that, the links are still less easily seen.

The carpentry workshop Vasnetsov's interest in applied art stemmed from the enthusiasm of the Abramtsevo colony for collecting peasant artefacts. Polenov started it by dis-

The new workshop started from very modest beginnings indeed. Polenova bought a low cupboard at the market and painted stylized flowers and Sirin birds on it, and Vasnetsov added a stylized magpie and crow on the cupboard door. This was generally admired, and it was decided to make similar pieces in the workshop. The actual carpentry was the work of boy apprentices. Yevgenia Mamontova and Yelena Polenova painted tables, adapting motifs from the choir stalls painted by Vasnetsov and his mosaic design for the floor of the Abramtsevo church.[6] In the autumn of 1885, Polenova created a much-admired columned cupboard, modelled on peasant furniture and the motifs of folk carving and decorative painting. The majority of the workshop's pieces were designed by Polenova. Over a ten-year period, from 1885 to 1894, she created more than a hundred designs.[7] After her death, in 1898, direction of the workshop passed to Natalya Davydova and Maria Yakunchikova.

PLATE 145
Yelena Polenova, Design for a mural, 1896.
A new generation of exponents of neo-Russian style were influenced, not only by the arts-and-crafts movement, but also by the flowing forms and aqueous colours of art nouveau.
PLATE 146
Interior of the *Teremok* at Abramtsevo. This shows items collected by the artists' colony and furniture from the estate's carpentry workshop.

PLATE 146

PLATE 147

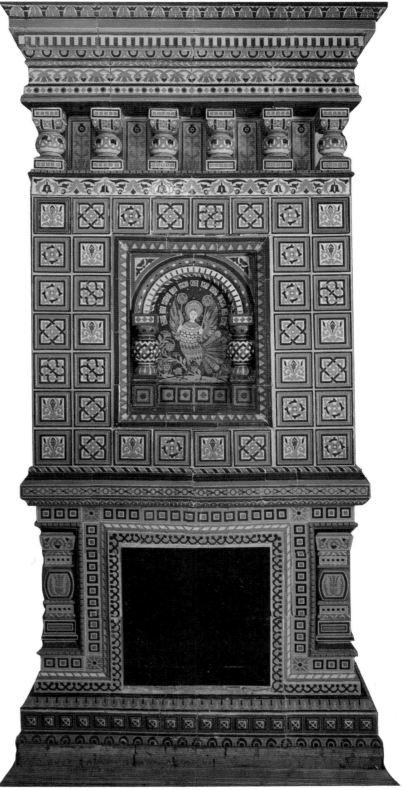

Plate 148

PLATE 147
Interior view of the wooden *Teremok* at Abramtsevo.
In the 1880s and 1890s, the period at which Savva Mamontov's artists' colony at his country estate of Abramtsevo was at its most active, the carpentry workshop was a focus of activity. To serve as models, the members of the colony had collected items of peasant craftsmanship from villages around the estate. This interior shows a display of these artefacts arranged around a number of items made in the workshop to the designs of Yelena Polenova.

PLATE 148
Ivan Petrov-Ropet, Tiled ceramic stove for the *Teremok*, Abramtsevo, 1892.
The central panel shows Sirin – the traditional bird of good omen.

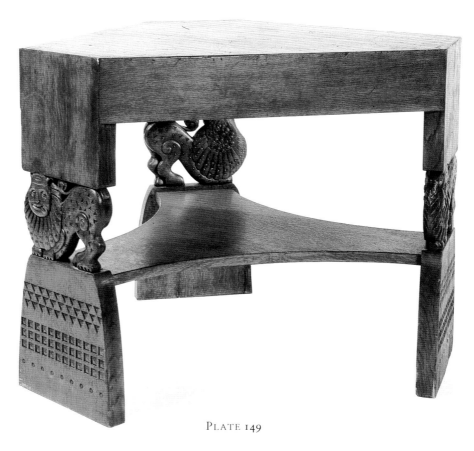

PLATE 149

Polenova's career Yelena Polenova's career as an artist partly paralleled that of Vasnetsov. In 1882 she moved from St Petersburg to Moscow, where she developed an interest in Russian antiquity, folk tales and folk crafts. Inspired by the Mamontov circle's ideals, she introduced innovations, similar to those that guided Vasnetsov in his painting and architectural projects, into such areas as embroidery, furniture design and the illustration of children's tales.

Polenova produced two cycles of these tales: the so-called Abramtsevo cycle in 1885–90 and the Kostroma cycle, published after her death in 1898. She actively promoted the idea that printing technique and quality should be essential components of book design, trying to ensure that the requirements of printing technique would be transmuted into artistically expressive devices. In her experiments she drew on folk art, and also on the work of English illustrators of children's books – particularly Walter Crane – borrowing their techniques of stylization, outlining and decorative use of colour.

She tried to create books that cohered artistically, the illustrations, design and text each contributing to the total effect.

In 1896 Polenova was responsible for the layout of the crafts section at the All-Russian Commercial Arts Exhibition in Nizhny Novgorod. The winter of 1897–8 found her in Paris, preparing the layout of the Russian crafts pavilion for the world exhibition, and working on designs for panels for the dining room in the Yakunchikovs' estate of Nara, near Moscow. Having started by painting objects made by peasants, Polenova moved on to design the objects herself; from employing existing folk art motifs, she went on to create new ones in the spirit of this tradition.

While acknowledging the importance of Polenova's contribution to the workshop, we must at the same time recognize that it was Vasnetsov who determined the way in which it developed artistically, and through it the furniture and interiors of the neo-Russian style. He was directly involved in the creation of its first works and strongly influenced its sub-

PLATE 149
Sergei Vashkov, Table, early twentieth century.
A craftsman working in a number of
disciplines, Vashkov here relies on incised
carving in geometrical patterns and shapes
flattened into a two-dimensional plane, both
found on wooden utensils from the north. The
use of the lion as a part of the structure is
unusual.

PLATE 150
Apollinary Vasnetsov, Sideboard produced in
the workshop of the Moscow Zemstvo Craft
Museum, early twentieth century.
Vasnetsov and Malyutin both worked within
the craft ideal of the time, yet the furniture
designs they produced are very different. This
sideboard is in an arts-and-crafts vernacular
which harks back to the heavier furniture of an
earlier time.

sequent output – not only through his architecture and applied art but also through his stage designs. These designs were an inexhaustible source of motifs, techniques and forms of the neo-Russian style.

The experimentation by Vasnetsov and Polenova in decorative and applied art, as in architecture, is linked with their search for new prototypes unfamiliar to their contemporaries.

The workshop produced tables with high, carved pedestals, divans with folding backs in the form of benches, massive chairs and armchairs, dressers and chests, little columned cupboards, mirror frames and corner cupboards. They are modelled on the simple, strictly geometrical shapes of old Russian furniture, icon imagery and – to the extent that it followed these traditions – peasant furniture. Two basic decorative techniques were adopted. The first was the angular, incised carving of geometrical motifs which typically decorated peasant implements such as distaffs, battledores of various types, saltcellars, horse harnesses and the backboards of carts. The second technique was the high-relief representational carving of such folk architectural features as window casings, cornices and frieze panelling. In every case the carving was subordinate to the shape of the object. Every effort was made to emphasize the object's symbolic, primeval quality. The very working of the wood, retaining its grain and structure, the subtle matt polish and use of natural stains emphasized the items' archaic appearance and the traditional manner of their creation.

The workshop's place in the craft movement The Abramtsevo workshop formed part of a general movement in Russia to revive traditions of craftsmanship. As early as the 1860s, following the abolition of serfdom, attempts had been made on landowners' estates, and later in the zemstvos, to encourage rural crafts. Supporters of this movement, who included not only landowners but also industrialists, artists and the intelligentsia, believed that it would strengthen the peasant's links with the soil and raise his standard of living.[8] Great hopes were also pinned on the supposedly regenerative qualities of handicrafts. A. V. Lvova, establishing an embroidery workshop in the Klin region of Moscow province in 1881, hoped to entice peasants away from working on railway construction which 'had a deleterious effect on their morals'.[9] Yelizaveta Mamontova, the mistress of Abramtsevo, was guided by similar considerations.[10]

After its founding, in 1885, the Abramtsevo workshop forged direct links with many of the schools and organizations involved in the craft movement – for example, with the Museum of Handicrafts and with the Stroganov College, both in Moscow (Mikhail Vrubel was invited to teach courses in the principles of stylization at the latter). In the course of the stylistic upheaval of the turn of the century, the formerly unique style of Abramtsevo came to dominate the hand-made

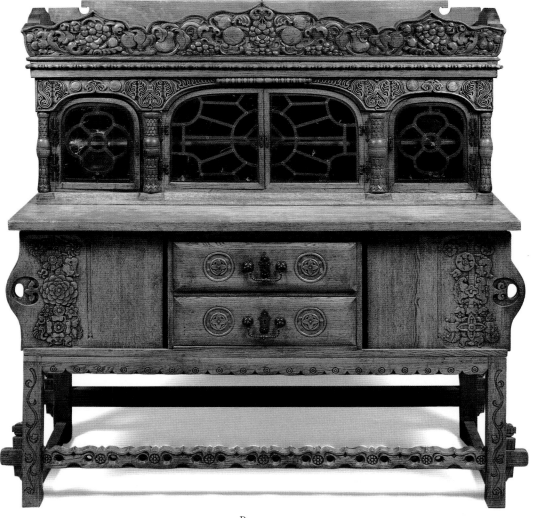

PLATE 150

furniture trade. The exhibits at the Second All-Russian Exhibition of Craft Products in St Petersburg in 1913 revealed how fruitful the impulse Vasnetsov and Polenova had given to the development of Russian applied art had been.[11] Abramtsevo had direct links with many of the newly created schools of commercial art and workshops in Moscow province, at the St Sergius Monastery estate, Khotkovo, Kudrino, and Ligachovo. Others also benefited from its experience.

The arts and crafts of Great Russia were grouped around Moscow, more precisely around the Museum of Handicrafts, where the influence of Abramtsevo remained dominant throughout the period from 1890 to the second decade of the new century. The renowned Talashkino estate looked to Abramtsevo, as did the less well-known workshops of Grodna, Perm and Nizhny Novgorod provinces.

Realizing the dream of the universal spread through the craft industry of techniques and ideas provided by the creative artist was, in the end, to prove disappointing for its creators. Essentially its success was a commercial one, and was accompanied by many of the necessary evils found in any cottage industry attempting bulk production. The heart-search-ing occasioned by this mutation, which particularly was to upset Yelizaveta Mamontova, calls to mind the similar history of the Arts and Crafts movement in England under the leadership of William Morris.

Vrubel and the Abramtsevo Ceramics Studio

The Abramtsevo ceramics workshop had its beginnings in 1888, when Yelena Polenova started to organize 'ceramics Thursdays' as a way of enabling the painters to relax. At first, painting was the dominant element; plates and dishes manufactured in Moscow were decorated with overglaze. Within two years, however, the enthusiasm for folk art in general, and especially for the use of majolica (tin-glazed earthenware), led to the founding of a ceramics studio. Opening in 1890, it marked the beginning of a new stage in the development of Russian ceramic art – specifically, the spread of the neo-Russian style into ceramics.

The studio was under the technical direction of Pyotr Vaulin, a chemistry specialist, and the artistic direction of one of the greatest artists of *moderne*, Mikhail Vrubel

PLATE 151

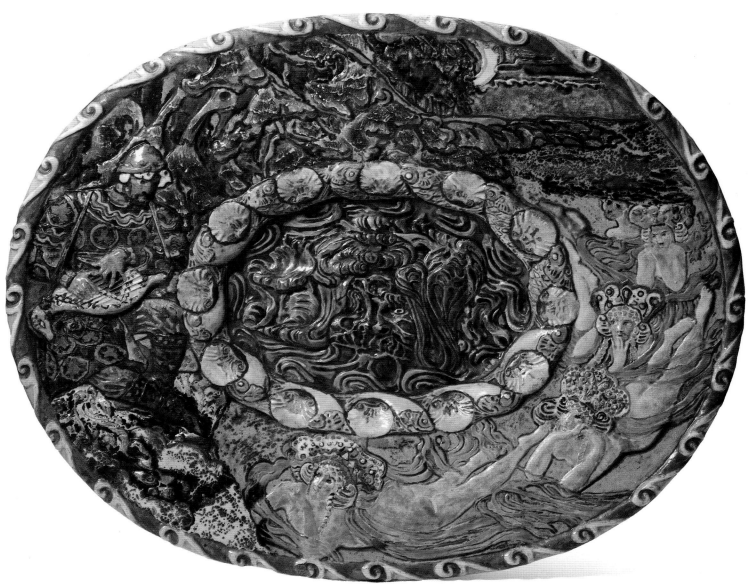

PLATE 152

PLATE 151
Mikhail Vrubel, *Tsar Berendey*, 1899.
Ceramic statuette produced in the studio at
Abramtsevo. Tsar Berendey is a legendary
character represented in various media at this
time; he also appears in Rimsky-Korsakov's
opera, *Snegurochka*, which was staged for the
first time at Mamontov's Private Opera in
Moscow in 1883, with designs by Viktor
Vasnetsov.
PLATE 152
Mikhail Vrubel, *Sadko the Fisherman*, majolica
dish, 1900.
The artist Vrubel experimented with a wide
variety of materials – wood, clay, glass and
ceramics – all of which he handled with great
imagination and sensitivity. On one occasion it
is recorded that he turned from his easel to carve
out a difficult idea in wood before attempting it
once more in paint. His original approach owed
something to his study of Byzantine painting

and mosaics during a period when he worked in
St Kyril's Monastery in Kiev. He was interested
in the way in which the icon painter worked with
superimposed planes of colours, and also in
prismatic light effects. Discussing Vrubel in
1904, the artist and critic Alexander Benois
wrote 'His art can be likened to an enchanted
garden where all the flowers, alive and fragrant,
have been invented, created and grown by the
gardener-magician.' He made original use of
tin-glazed earthenware, or majolica, to produce
a particularly rich and lustrous effect in firing.

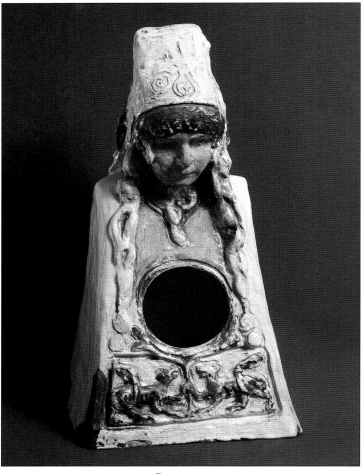

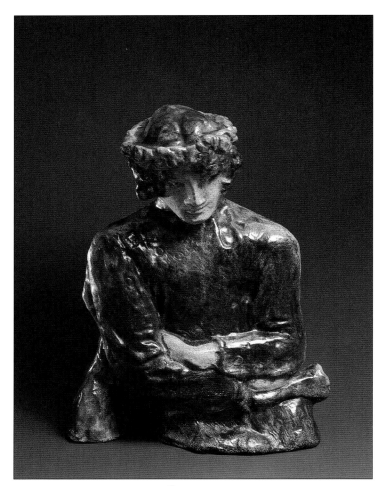

<div align="center">PLATE 153</div>

<div align="center">PLATE 154</div>

(1856–1910). Many other artists were to develop an enthusiasm for ceramics – among them Serov, Polenov, Korovin, Vasnetsov and Golovin, and members of the Mamontov family, including Savva himself and his son Andrei. For Vrubel, however, ceramics were to be a particularly important medium. They also figured prominently in the later years of Mamontov. A legal case in which he was accused of malpractice in his railway construction companies ended in 1899 with his complete acquittal, but also his financial ruin. From 1900 until his death in 1918, work in the ceramics studio was Mamontov's chief activity. He was, in addition, a competent sculptor.[1]

The ceramics studio produced items for a wide variety of purposes, reflecting the Abramtsevo circle's passion for aesthetic synthesis: vases and figurines in majolica, stove tiles, stoves and stove-benches, park and garden ornaments, fire-

places, ceramic panels and architectural ceramics for the ornamentation of façades. Major innovations came from the studio in both design and technique. During Vrubel's time as the director of the studio, a whole range of innovative syntheses, drawing on national tradition, was devised.

Vrubel had an instinctive feel for the expressive potential of a material, and he displayed this to dazzling effect in the case of majolica. Together with Vaulin he devised a new technique, reducing time and heat of firing. The lustrous rainbow coloration produced on the surface of an item resulted from the reduction of the metal oxides in the composition of the glaze. The effect had long been known, but was generally regarded as a fault. Vrubel turned it into a deliberate, widely utilized decorative method.[2]

Vrubel's creative work brilliantly confirms what Dmitri Sarabianov has said of the exceptional profundity and con-

PLATE 153
Mikhail Vrubel, Girl in kokoshnik headdress, ceramic, early 1890s.
Produced in the ceramics studio at Abramtsevo, this work is intended as the casing for a clock.
PLATE 154
Mikhail Vrubel, *Magus*, ceramic, 1899–1900.
Produced at Abramtsevo.

PLATE 155
Alexander Golovin, Jug in the form of a cockerel, Abramtsevo Ceramics Studio, early twentieth century.
The vessel derives its shape from wooden utensils, but the noted stage designer Golovin looks at the folk tradition with a fresh eye, and invests it with a lighthearted spirit.

centration of the art of the end of the nineteenth and the beginning of the twentieth centuries – Russia's 'silver age'. In this period artists belonging to quite different stages and movements do not follow one another in sequence, but every phenomenon takes its place, like the ribs of a fan, alongside every other. Here, too, there are teachers and pupils, pioneers and followers, but the pupils and followers are so original that their contribution is no less than that of the pioneers.[3] We have only to look at the Abramtsevo circle to see the truth of this assertion – especially true of Vrubel, a man of innovative genius. He reworked the initial impulses of the old Russian and Byzantine heritage and folk art so radically that it is virtually impossible to detect the outlines of the original prototype. By the sheer power of creative transformation Vrubel opened that seam in the reinterpretation of the national heritage which emerged as the Russian avant-garde in the second decade of the twentieth century. His religious painting has echoes and parallels with the creative work not only of Nikolai Roerich, with his expressionism and archaization, but also of Natalia Goncharova, the pointillistes, and the Cubist and Cubo-Futurist disintegration of form. Even when designing stoves and fireplaces, benches and tiles, where Vrubel was restricted by functional considerations, the traditions of old Russian architecture – a rhythmic arrangement of volumes and surfaces, great patches of saturated colour, and a lyrical outline – can be found, in transfigured form.

The ornament and decoration of fireplaces, stoves and stove benches gain a narrative quality through the use of patterned tiles – a device that goes back to ancient Rus. Vrubel's tiles are composed in such a way that a particular tile is perceived only as an integral link in a larger pattern.

Like Vasnetsov, Vrubel often drew on themes from the Russian epics. An outstanding example is his panel 'Mikula Selyaninovich', which was displayed in a pavilion specially commissioned for it by Savva Mamontov at the Exhibition of Art and Industry in Nizhny Novgorod in 1896, the eponymous hero being depicted in majolica. Another is the panel 'The Hero' (*Bogatyr*), representing the same kind of Russian giant, strong and good, mounted on a mighty steed which seems rooted to the soil that gave birth to it. Everywhere tradition is profoundly transformed, becoming implicit rather than explicit. In most cases Vrubel was inspired not by Russian folk or national art directly, but by its transformation in the hands of the greatest Russian artists of the modern period. Among his predecessors, Vrubel had a particular love of the poet Pushkin; among his contemporaries, of Rimsky-Korsakov. The latter's opera *Tsar Saltan* (1900), based on a poem by Pushkin, was the inspiration for a firescreen entitled 'Prince Guidon and the Swan Princess'. He also produced a series of majolica sculptures on themes from Rimsky-Korsakov's operas *Sadko* and *The Snow Maiden* and a majolica sculpture on motifs from Lermontov's poems 'The Monarch of the Deep' and 'The Princess of the Deep'.

Vrubel's sources of inspiration also included nature and Russian themes; his works included tiles with stylized flower and plant-like ornamentation, or fish, or the firebird, and the pedestal for a clock in the shape of a girl wearing a *kokoshnik* headdress.

It was at Abramtsevo – and especially in its ceramics studio – that Vrubel was most keenly aware of the influence of Russian tradition on his art. 'I am back in Abramtsevo,' he wrote

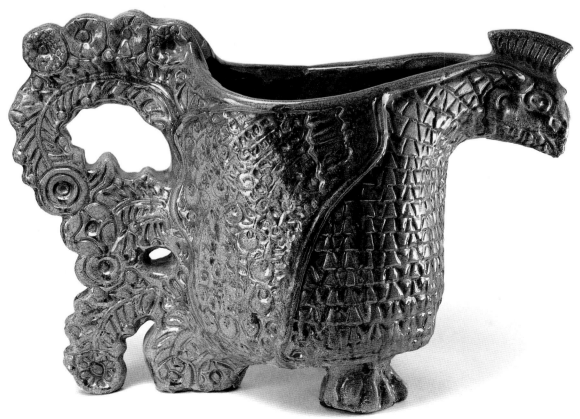

PLATE 155

to his sister, 'and again I am enveloped . . . I can hear that intimate national tone which I so long to capture on canvas and in my decoration. It is the music of the whole man, not divided up by the distractions of the ordered, differentiated, insipid West.'[4]

Influence of the Studio The Abramtsevo ceramics studio was destined to play a role similar to that played by the carpentry workshop. It became an important factor in turn-of-the-century Russian art, facilitating the spread of the neo-Russian style and *style moderne*. The financial ruin of Mamontov did not put an end to it, any more than it put an end to Abramtsevo itself.

In 1900 the ceramics studio moved with Savva Mamontov from Abramtsevo to a house in Moscow in Second Street (now Pravda Street), in Waggoners' Meadow. By 1905 the Abramtsevo Ceramics Studio was manufacturing both limited editions of art products (sculpture for interiors, ornamental vases, plates and domestic items) and mass-produced items (facing tiles, decorative tiles and marble-glazed bricks), although still on a relatively small scale.

Despite its comparatively small output, the Abramtsevo Ceramics Studio (later Factory) was of particular interest (until the Revolution) to those architects – among them Fyodor Shekhtel (1859–1926) and Yuri Bondarenko, who were working in the neo-Russian style. The best-known public buildings of Moscow were decorated with majolica panels and ornamental ceramics from the Studio – among them Yaroslavl Station and the Tretyakov Gallery. The Abramtsevo Ceramics Studio also produced majolica icons to designs by Pashkov, and tiles in the old Russian style to designs by Pokrovsky. A series of neo-Russian style majolica panels was produced to designs by Sergei Chekhonin (in particular, a panel depicting St George and the dragon on the Moscow coat of arms, for the Civic College on Great Tsaritsyn Street.

Like the carpentry workshop, the Abramtsevo Ceramics Studio was closely associated with a number of spin-off enterprises. Vaulin left in 1903 to found his own Kikerino Ceramic Art firm, near St Petersburg. Freely acknowledging the fact that his aesthetic ideas stemmed from what he had learned in Mamontov's studio, Vaulin made a point of inviting artists who had passed their apprenticeship there – men like Fyodor Matveev, Pavel Kuznetsov and Chekhonin – to work in his firm. Just as at Abramtsevo, much effort was put into resurrecting ornamental majolica, a technique that figured prominently in old Russian architecture and in work in the neo-Russian style. Among the most important commissions that came to the Kikerino firm were majolica iconostases and architectural ornamentation for the Russian cathedrals in Sofia and Bucharest. A number of commissions – for the Marine Cathedral in Kronstadt, near St Petersburg, for example – were executed jointly by the artists of Abramtsevo and Kikerino.

Under the influence of the Abramtsevo Studio the Murava Cooperative of Pottery Designers was set up in Moscow in 1904. It took its lead from Vrubel's work in ceramics, and was headed by Alexei Filippov, the first professional scholar to research old Russian ceramics. Savva Mamontov advised Dunaev's factory in Khotkovo, near Abramtsevo, on the production of terracotta, majolica and porcelain products.

Talashkino

Like Abramtsevo, the estate of Talashkino holds a special place in Russia's art. Here, as in Abramtsevo, the revival of Russian crafts – which was common enough by the 1890s – went hand in hand with a much less common effort on the part of its owners, to bring together the brightest and best of Russia's artists. The owner of Talashkino, Princess Maria Tenisheva (1867–1928), was the successor of Savva Mamontov in fostering the neo-Russian style. What had, in the case of the Mamontovs, come into being more or less spontaneously was, in the case of Princess Tenisheva, carefully thought out. 'I had long wished,' she wrote, 'to realize a certain idea in Talashkino. The Russian style, as it had been known up until then, had lost ground completely. Everybody regarded it as passé, dead, beyond all hope of resuscitation . . . I wanted . . . to see what I could do with the assistance of an artist of great imagination working on this legendary past of Russia.'[1]

Like Mamontov, Princess Tenisheva was not only rich but also artistically gifted in her own right, with an interest in art and the organizational ability to gather like-minded people around herself. A talented singer she had taken lessons in Paris from a well-known teacher, Marquesi. In Paris she also studied fine art under Gabriel Gilbert, continuing in St Petersburg and again in Paris at the respected Académie Julien. In 1892 she married Prince Tenishev, a rich industrialist. Her marriage enabled her to extend patronage and engage

PLATE 156
Mikhail Vrubel, Design for an ornamental comb for Princess Maria Tenisheva, early twentieth century.
Strongly interested in the arts, Maria Piatkovsky attended the Stieglitz School in St Petersburg and acted with Stanislavsky. After her marriage to the wealthy industrialist Prince Tenishev in 1892 she became an enthusiastic patron of artists, drawing, among others, Repin, Serov, Roerich and Bilibin into

PLATE 156

her circle. The estate of Talashkino was acquired in 1896 and turned into an artists' colony on the model of Abramtsevo. This drawing was executed while Vrubel was at Talashkino, after the Princess asked him to design the comb using some of her jewels. It is characteristic of Vrubel's work in both subject matter and style – the figure represents the Sirin and the stones are well integrated with their setting. It was at Vrubel's suggestion that Malyutin was invited to Talashkino to manage the production of the carpentry workshops.

PLATE 157
Sergei Malyutin, Design for a carpet, early twentieth century.
Design for a carpet reproduced in the yearbook of the Moscow Architectural Society for the year 1912–13.

PLATE 158

PLATE 158
Sergei Malyutin, Wooden cup carved with the figure of the Tsaritsa of the Sea, Talashkino Workshops, early twentieth century.
This cup is a characteristic example of the utensils produced in the Talashkino carpentry workshops as part of the campaign to reinvigorate local crafts and to stave off the threat posed by industrialization. Malyutin's work is characterized by a contrived coarseness and an innate sense of strong colour.

PLATE 157

PLATE 159

PLATE 159
Mikhail Vrubel, Design for a church at
Talashkino, 1899.
This unrealized design shows a sophisticated
understanding and interpretation of the way in
which old Russian architecture grouped
individual units to form an organic synthesis.

PLATE 160
Yuravleva, Ceramic tile, Talashkino
Workshops, early twentieth century.
This tile shows the influence of the neo-
primitivist movement at that time being
propagated by artists such as Larionov.

in charitable work. On acquiring the Talashkino estate, near Smolensk, in 1898, she established a school for peasant children, an artists' colony, and carpentry, ceramics and embroidery studios. Her other acts of patronage included providing the funds for two free studios of drawing in St Petersburg and Smolensk. She donated her large watercolour collection to the Russian Museum in the year it opened, 1898. For its first year the magazine *Mir Iskusstva* (*The World of Art*) was financed not only by Mamontov, but also by Tenisheva. She put a great deal of effort into reviving the technique of incised enamelling, and became a major connoisseur and historian of this art, and no mean practitioner herself.[2]

The brief collaboration of Tenisheva and Mamontov in financing *Mir Iskusstva* marked a turning point in the neo-Russian style. Mamontov went bankrupt in 1899, the last great undertaking of his circle being the 'Rural Rus' craftwork pavilion at the 1900 Exposition Universelle in Paris. This period saw the beginning of a new stage of development for the neo-Russian style, with more openly expressed stylization and the coming of age of *moderne*. The Talashkino studios were just being set up and beginning to produce their first items. They drew on the work of late Abramtsevo and developed it further, the artists of the generation that followed Vasnetsov, notably Vrubel and Roerich, taking the lead. In 1899 Tenisheva invited a renowned expert on folk embroidery, Pogosskaya, to Talashkino, as well as the artist Malyutin, and the photographer, artist and antiquarian Ivan Barshchevsky (1851–1948). Between them they organized the carpentry, ceramics and embroidery studios in 1900. Although they and the other artists worked in all techniques, each had his primary speciality. Malyutin directed the carpentry workshop, Pogosskaya the embroidery studio and

Barshchevsky the ceramics studio. In 1901 Tenisheva opened a shop called 'The Spring' in Moscow to sell the studios' products. There was hardly an initiative in Abramtsevo not subsequently developed at Talashkino, and, as a rule, on a significantly larger scale.

Like Abramtsevo, Talashkino had its private theatre and a museum of old Russian and peasant folk art, which its members saw as the source of a new enhancement of life through beauty. Like Abramtsevo, Talashkino had its own church built. As at Abramtsevo, the Talashkino artists' contribution to the development of the neo-Russian style was made through the non-easel art forms most accessible to professional painters, the creation of applied art items, and the design of interiors. And like their Abramtsevo predecessors, the artists of Talashkino contributed to church building, religious art and wooden architecture elsewhere in Russia.

As at Abramtsevo, the Talashkino art studios began with the establishment of a school for peasant children. Works of art and materials from archaeological excavations were collected in the Talashkino museum, those discovered by V. Sizov, a famed archaeologist and historian, during excavations in early 1900 in the Smolensk region forming the basis of the collection. It was on Sizov's advice that Barshchevsky was invited to Talashkino in 1897, initially to collect materials for the museum. He travelled on Princess Tenisheva's behalf around many of the provinces of Russia, especially those in the North, collecting works of folk art.

Malyutin The originality of the Talashkino products was closely bound up with the work of Sergei Malyutin (1859–1937) and of his pupils. Malyutin worked in two different genres, with two quite separate styles. As a portraitist – the most talented of the pupils of Repin – he excelled at individual characterization. He had mastered the manner of

PLATE 160

contemporary impressionism with its broad strokes and open colour. As the architect of numerous Terem tower houses, dachas, and also churches, and in his designs for *objets d'art* and furniture, he worked in the neo-Russian style. In this Malyutin, like many who thought as he did, was basically reacting against 'Berendey's palace' and Vasnetsov's stage designs for *The Snow Maiden*. The new sources of folk art that Vasnetsov had discovered were taken up and widely used by his followers and pupils, but only in respect of their ornamental and decorative motifs. In the treatment of artistic form Malyutin also drew on the work of the Abramtsevo carpentry workshop. The Talashkino folk art collection was an inexhaustible source of inspiration for him. It included myriad examples of woodcarving which had decorated peasant huts, textile-printing blocks and gingerbread moulds, as well as carved and painted implements and furnishings: distaffs, battledores, sledges, cradles, cupboards, trunks and coffers.

Malyutin directed the Talashkino carpentry workshop for three very fruitful years, from 1900 to 1903. He designed the workshop building, the Terem tower house, the church, theatre, his own house and a multiplicity of chairs, armchairs, cupboards, buffets, shelves, large and small, and decorative panels. In Talashkino a 'Malyutin' variety of the neo-Russian style evolved, which was deliberately archaic and stylized. Malyutin's architectural projects are remarkable for the lavish and varied use of colour in the carved decoration of wooden buildings, something wholly atypical of Russian folk architecture. Malyutin used plant motifs in his furniture considerably more vigorously than had his predecessors in Abramtsevo, exaggerating them and treating items of furniture virtually as sculptures. When he left Talashkino for Moscow in 1903 to take up a professorship at the university, Malyutin continued to take an interest in architecture and applied art, but they were never again to be so central to his work.

After Malyutin's departure for Moscow, direction of the carpentry workshop passed to Alexei Zinoviev (1880–1942) and Vladimir Beketov (1878–1910), both graduates of the

PLATE 161

PLATE 161
Nikolai Roerich, drawing, early twentieth century.

PLATE 162

Stroganov College of Art and Industry in Moscow. The college was renowned both for its advanced teaching methods and its support for the revival of Russian art. Zinoviev took over direction of the carpentry workshop and Beketov directed the ceramics studio and designed stage productions and furniture. Both continued the neo-Russian trend begun by Malyutin, but they each made their own contribution, distinct from that of their predecessor.

Roerich Another artist who strongly influenced the art of Talashkino was Nikolai Roerich (1874–1947). Roerich shared the utopian faith of his contemporaries in the ennobling effects of country life and the rebirth of traditional art. For him Talashkino was a special place on this earth where 'by the sacred hearth, far from the contagion of the towns, the folk create newly re-thought objects [recalling] the precepts of

their forefathers, and beauty, and the solidity of old workmanship'.[3] In the Talashkino studios Roerich's designs were used to produce a suite of furniture comprising a bookcase in three sections, an armchair, a table, an embroidered tablecloth, and friezes of majolica.[4]

The Smolensk countryside attracted Roerich by its archaeological and architectural treasures, notably the tumuli in Gnezdovo, where he conducted excavations, and the ancient Smolensk Kremlin. In the graphic art, painting and applied art that he produced in Talashkino we see the mature Roerich, a master of the expressive manner. The conventions of old Russian and folk art are to be seen in them, transfigured, simple and archaic, their decorative, expressive, rhythmical element accentuated. Between 1908 and 1914 Roerich worked at Talashkino every summer, painting the

PLATE 162
Nikolai Roerich, *Putivl*, stage design for Alexander Borodin's opera, *Prince Igor*, 1908. Whereas artists and architects of an earlier generation had primarily been interested in the works of the seventeenth century, finding inspiration in their ornamental sense and picturesque effects, the younger generation, of which Roerich was one of the leaders, was excited by the purity of line and the simplicity of form of the architecture of a much earlier

period. Roerich was particularly skilled in expressing the epic simplicity of Russia's cultural beginnings. In this design he recreates buildings of the Novgorod period.

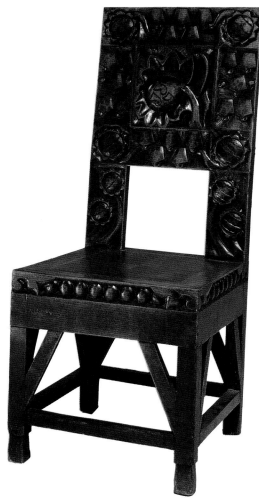

PLATE 163

PLATE 164

mausoleum church over the grave of the Princess's late husband and designing mosaics to go over its main entrance and inside the dome. In 1911 Igor Stravinsky came to Talashkino to work jointly with Roerich on the ballet *The Rite of Spring*. The ballet was first produced by Diaghilev's Ballets Russes in Paris in 1913. (After a disastrous premiere, it eventually became one of the classics of the dance repertoire.)

Roerich's applied art consists of relatively few items, which are close in spirit to those of Malyutin's. He stylized forms freely, working in an archaic manner, accentuating and even exaggerating the primitive idiom of his prototypes.

From Mamontov's bankruptcy until the Revolution Talashkino was the main centre of the neo-Russian style. Mikhail Nesterov and Adrian Prakhov worked there, the latter one of the founders of the Mamontov circle and a man who

had contributed much to the development of the neo-Russian style. Alexander Golovin was also associated with many Talashkino undertakings. Around the turn of the century he became fascinated by applied art, and assisted in creating exhibits and preparing the layout of the crafts pavilion at the 1900 Paris exhibition. He designed neo-Russian-style interiors and furniture. His was the design of the 'turret chamber' at the St Petersburg Exhibition of Contemporary Art in 1903, which was organized by members of *Mir Iskusstva*. The artist and sculptor Dmitri Stelletsky worked at Talashkino for a whole year, and was one of the first to make extensive use of the idiom of old icon painting and miniatures of the *Album of Illuminations* in easel painting, theatre design, and sculpture. Ivan Bilibin came to Talashkino several times to meet Malyutin, to discuss illustrations for

PLATE 163
Sergei Malyutin, Chair, Talashkino
Workshops, early twentieth century.
PLATE 164
Princess Trubetskaya, Armchair, early twentieth century.
This chair differs from the productions of Abramtsevo and Talashkino while benefiting from their trailblazing role. If its form were cleaned of the bronze decoration, it appears not to be based on a historic prototype. The

simplicity and clarity of the construction, the method of unifying the wooden volume, underlining its geometry, both stress the function of the object. In this respect it appears as a forerunner to later experiments.
PLATE 165
A Rich Guest, wooden carving based on a sketch by Malyutin, Talashkino Workshops, 1903.

Russian folk tales. He was working primarily as a graphic artist, illustrator and book designer, engaging also – evidently with the influence of Malyutin and the Talashkino studios – in the design of neo-Russian-style furniture. The architect Suslov was invited to Talashkino to design its church. He was one of the instigators of the study of wooden architecture of the Russian North, a restorer, and the author of curious architectural fantasies in the neo-Russian style. These are akin to the paintings and drawings of Vasnetsov's younger brother, Apollinary, who was the creator of another original genre, the historical architectural reconstruction. Supporting his work by the study of miniatures, icon painting, historical and archaeological sources, and surviving buildings, he recreated in his paintings scenes of life in the ancient towns of Russia, primarily Moscow.

The character of neo-Russian-style furniture and interiors was largely determined by the artists of Abramtsevo and Talashkino. The furniture produced in the Abramtsevo workshop, even at the beginning of the twentieth century, and the sample items made for the Moscow Museum of Handicrafts to designs by Apollinary Vasnetsov continued to develop the traditions of Yelena Polenova. Geometrical or curved ornamental carving predominated, although representational carving was also used. In the design of tables and armchairs, frame forms were common. Much use was made of the contrast between the smooth, matt surfaces beloved of *moderne* and carved decoration. The backs of chairs and armchairs were frequently of pierced ornamental construction, leaving the frame of the back plainly visible.

The furniture of such Talashkino designers as Malyutin, Golovin, Bilibin and Roerich draws on Polenova's works of

the 1890s, which were notable for their massive, heavy, sculptural forms. Even when designing chair backs and armrests, preference was given to solid, rather than framed construction, as at Abramtsevo. In blind carving, which was wonderfully in harmony with the ponderousness of the great forms, ornamentation was mainly representational, depicting flowers and plants. Particularly in items such as shelves, carved panels, door casings, surrounds, and frames for mirrors and photographs, the motifs commonly encountered stemmed from folk art: the sun, mermaids, firebirds, Sirin birds, and lions with luxuriantly spreading tails. This last motif passed from the white stone carving of the Vladimir-Suzdal churches into folk carving and then back to high art.

Of course, there are similarities as well as differences between the products of the Abramtsevo and Talashkino circles. On the whole, however, we find a tendency to construction and the use of framework in the furniture and utensils of Abramtsevo, as against sculptural wholeness in the case of Talashkino.

Interior design The neo-Russian style was found in residential interiors in two forms. For wealthy clients interiors were designed specially. At the same time, a great diversity of objects and complete suites of furniture in the neo-Russian style were to be found in the shops, manufactured both by furniture factories and by individual craftsmen. By dint of careful selection, rooms could be furnished in the neo-Russian style comparatively cheaply. In addition, individual objects, utensils and ornaments in the neo-Russian style were ubiquitous.

Neo-Russian-style interiors followed the general trends found elsewhere in Europe at that time. They took on an

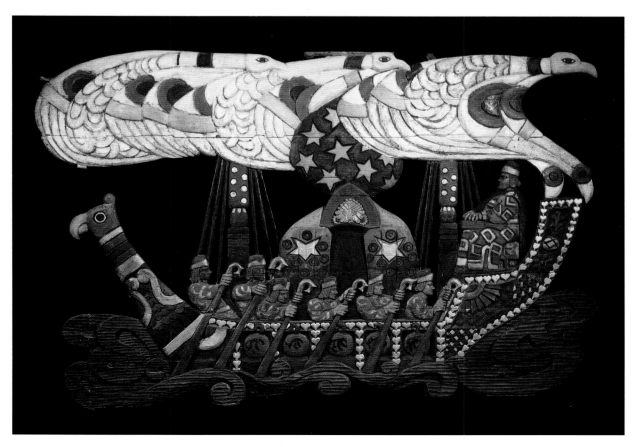

PLATE 165

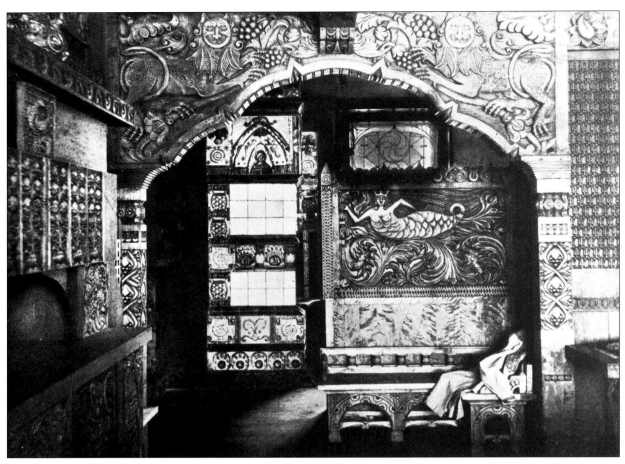

PLATE 166

architectural quality, with furniture being placed at the edges of the rooms, or even built in; complex units consisting of buffets, divans, armchairs and small reading tables were designed in this way. The form of furniture became simpler. Thickly upholstered furniture, so popular in the mid-nineteenth century, disappeared. The amount of fabric used fell sharply.

Derived from old Russian prototypes and peasant furniture, with their simple, even severe geometrical shapes and lack of upholstery, neo-Russian-style furniture was an eloquent rejection of the fussy interiors of the Russian style. Yet the style, especially in its more expensive interpretations, had a richness of its own. For example, the lavish neo-Russian-style interiors in the Moscow apartment of Pertsov, who owned a block of flats designed by Malyutin (No. 1, Soimonovsky Drive), are enriched by an abundance of woodcarving. The neo-Russian style in apartments of those

of moderate means, particularly members of the creative intelligentsia, also entailed an abundance of wood, including walls of trimmed logs and carved wooden door surrounds. Walls of trimmed logs were usual in country houses, irrespective of whether they were used only in the summer as dachas or year-round. In many cases traditional Russian motifs, such as two-headed eagles, lions or Sirin birds were used ornamentally or structurally – the overall shape of objects, the expressive contrast between smooth surfaces and spare incised geometrical shapes indicating the much-adapted Russian inspiration behind the furniture.

The Neo-Russian Style in Architecture and Applied Art

The neo-Russian style is a variety of the *moderne* movement, which was essentially a neo-Romantic movement in its focus on the emotional and spiritual world of the individual. In

PLATE 167

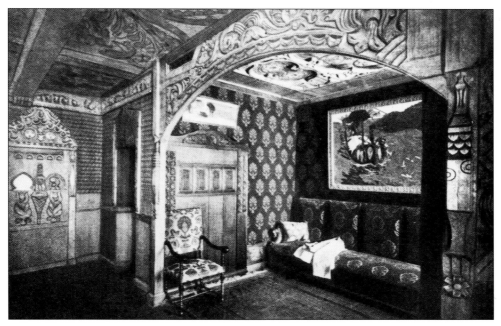

PLATE 168

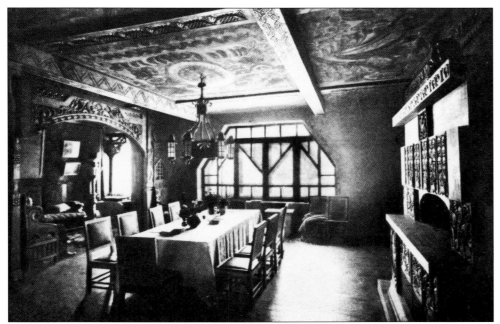

PLATE 169

PLATES 166 & 167
Sergei Malyutin, Two views of the sitting room
of the Pertsov house, Moscow, 1905–1907.
The motifs of the carving in this room are
derived from a variety of specifically
vernacular sources. The lions with their
luxuriant tails and the mermaids, *rusalki*, are
popular subjects for the carving on wooden
huts along the River Volga. The forms of the
arches and columns have their origins in those
found in wooden churches. Irrespective of
source, all the motifs have been endowed with
a vital and expressive originality which accords
with the strong emerging aesthetic of the
mature Russian style.

PLATES 168 & 169
Sergei Malyutin, Two views of a dining room in
the Pertsov house, Moscow, 1905–1907.
These pictures show the simplification of taste
and refinement of detail that had taken place in
interior decoration since the days of Grand
Duke Vladimir's 'Russian' dining room. All the
elements in the room are intended to harmonize
organically. Roerich's *Visitors from over the
Sea* hangs over the sofa in the alcove.

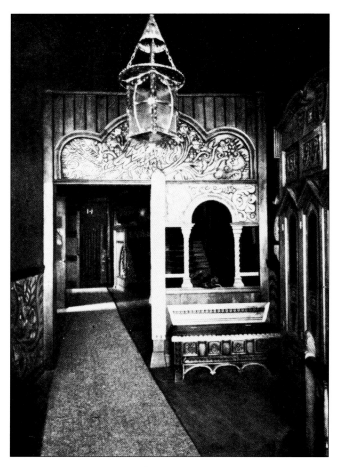

architecture this emphasis merged naturally with the struggle for national self-expression. It appeared in many types of building, notably residences: detached town houses, suburban houses, dachas, and domestic interiors of all kinds. In this light we can understand why neo-Russian-style artists were so intent on creating the objects that are part of a person's everyday environment. Another area in which the neo-Russian style took root was in churches. A third was in national pavilions at international exhibitions, which served as ideal vehicles for expressing a nation's architectural character.

At the turn of the century the initial stage of the development of the neo-Russian style was coming to an end. From the end of the 1890s, and concurrently with art nouveau in general, it became widely established in architectural practice. It was most popular in suburban, dacha and estate building, which, in Russia, continued to be in wood. Many

buildings in a distinctive synthesis of art nouveau and the neo-Russian style were erected in Russian towns, though it was less common for the style to be used in the design of apartment blocks in large cities. This resulted partly from difficulties in adapting the old Russian tradition (especially its visual, as opposed to structural features) to such large-scale residential buildings. However, the neo-Russian style was widely used in the design of many public buildings: railway stations, museums, theatres, community centres, hospitals, almshouses, schools and universities, town halls, office buildings and market arcades.

The artistic idiom of the neo-Russian style was formed mainly by painters; architects took it over, and adapted it to their own needs. The convergence of these two different art forms was facilitated by stylization and by the new emphasis on beauty for its own sake. Every element of the artistic idiom – colour, line, form, the disposition of forms and their rhyth-

PLATES 170 & 171
Sergei Malyutin, Staircase and entrance hall, Pertsov house, Moscow, 1905–1907.
The façades of the Pertsov house and the interior decoration of Pertsov's own apartments on the top floor were designed by Malyutin after his return to Moscow from Princess Tenisheva's country estate, Talashkino, in 1903. These designs represent his major work in a style evolved while working there. The material is wood, boldly carved in

simplified geometrical shapes. The furniture, ceilings, partitions and bannisters are Malyutin's reinterpretation of furniture and backdrops depicted in old icons.

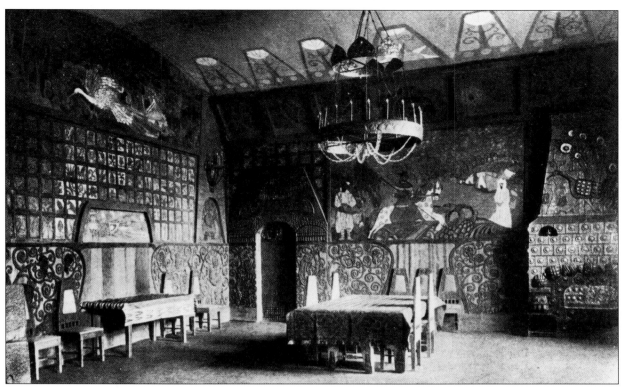

PLATE 172

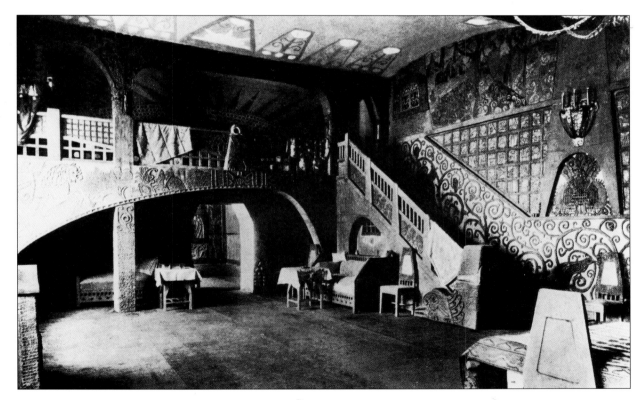

PLATE 173

PLATES 172 & 173
A. Yakimchenko, Two views of the dining room
of the Firsanova house, Moscow, early 1900s.
Luxuriantly decorated with carving, the
interior gains much of its character from a
number of murals by Polenova on themes
from Russian folk tales. Among them may be
seen her panel *The Firebird*, the design for
which is shown in plate 145.

PLATE 174

mic interconnection – was employed to serve this end. In painting this had the effect of enhancing the importance of line and surface, with a consequent rejection of deep perspective. The surface of a picture began to be seen as a decorative whole, the separate identity of image and background became blurred or disappeared entirely. Something of the sort occurred also in the decorative aspects of architecture – particularly if we regard the façade of a building as analogous to an easel painting. The wall was no longer simply a wall. Architects paid particular attention to the artistic combination of different surfaces, to nuances or contrasts, linking or distinguishing them by means of colour. The juxtaposition of different-coloured materials was one of many ways in which the 'practical' elements of a building began to be used as expressive means in their own right. Other elements might be the type of window glass, the shape of the window openings, or the patterning of sash or casement frames.

Every part of a building became 'aestheticized': its shape, its surface finish, colour, outline and body. This was true also of traditional shapes. The same thing occurred with the use of 'Russian' materials: wood, brick and decorative tiles, which were then subjected to stylization. 'Russian' structures in wood, for example, had log walls jointed in a specific way, and 'Russian' combinations of different methods and techniques of construction were used, such as combining log walls with walls faced with boarding, or solid with pierced woodcarving.

The Russian tradition of giving equivalent status to all façades and of composing important buildings (especially palaces) from several individual parts or structures was also reinterpreted. The return to this multiformal method of design came about gradually, becoming common at the end of the nineteenth century in large detached town houses in the *moderne* and neo-Russian styles. It also became the rule for the design of public buildings in the neo-Russian style. From 1910 onwards it was not uncommon even for town houses and public buildings to have an uncharacteristic neo-Russian multiple composition of this kind superimposed on basically neoclassical forms.

The distinctive qualities of neo-Russian-style architecture were exemplified in the Russian pavilions for the international exhibitions in Paris in 1900 and in Glasgow in 1901, designed by Korovin and Bondarenko and by Shekhtel respectively. In both cases the designers did not confine themselves solely to demonstrating particular Russian formal and compositional features. They were primarily interested in creating an impression of Russian architecture's sense of ensemble, especially as achieved in the complex, picturesque churches of the sixteenth and seventeenth centuries, in which the individual units have the plasticity of sculpture.

In the Paris pavilion Bondarenko and Korovin concentrated on the forms of the Russian peasant hut and ancient fortifications in wood and stone. In Glasgow Shekhtel successfully demonstrated the application of elements from wooden religious architecture in solving contemporary architectural problems.

The Glasgow exhibition The Russian village at the Glasgow exhibition of 1901 consisted of four pavilions which combined innovation with the traditional construction and layout of wood and glass exhibition pavilions already established in the second half of the nineteenth century. The exterior of the main pavilion fused the compositional features of the unique twenty-two-domed wooden church in Kizhi and the seventeen-domed church in Vytegra (the first time they had been used as prototypes) with the columnar hipped-roof churches so popular in the Russian North. Russian architecture's verticalism in the construction of the frame of buildings was expressed in the pavilion devoted to mining, which was modelled on the forms of the *shatyor*, or tent-roofed tower and barrel-like roof coverings common in wooden architecture. The extravagant silhouette and the use of different types of wood on different parts of the building were the principal design features. As in old Russian architecture, the compositional unity of each individual structure and of the exhibition complex as a whole was based on the interaction of large-scale, vertically directed volumes and the sculptural shapes of structures intended to be viewed from different angles.

A number of Shekhtel's own later designs derive from the Glasgow pavilions. These include the Yaroslavl Station (1902–4), Levinson's dacha outside Moscow, and Sharonov House in Taganrog.

Neo-Russian style in urban and village architecure
Shekhtel's was one variety of the neo-Russian style based on the forms of wooden religious architecture. A different variety was represented by the works of Malyutin, Korovin, Golovin and Bondarenko, in which a mythologized conception of the Russian turret chambers of fairy tales merged with the traits of a re-worked and elaborated Russian peasant hut. This became influential in wooden building.

PLATE 174
Sergei Rodinov, Apartment house on
Pankratiev Lane, Moscow, 1908.

Vladimir Pokrovsky, Design for a Museum of
Military History, aerial view and four façades,
1908.
In this competition design for a museum in St
Petersburg, Pokrovsky gives an assured
rendering of the mature Russian style. The
various component parts revive the old
Russian *khoromy* composition. The separate
units are assembled and linked together in an
organic grouping. The design comes as the
successful culmination of the search for
indigenous forms which had preoccupied
three consecutive generations. Pokrovsky has
populated his building with figures in historical
dress.

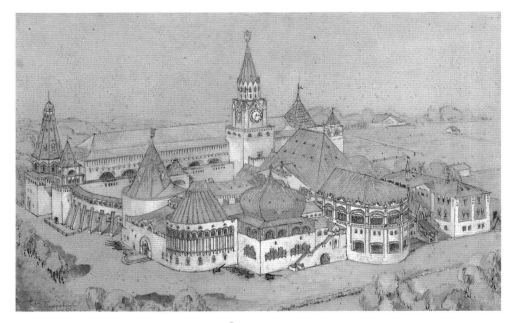

PLATE 175

PLATE 176

PLATE 177

PLATE 178

PLATE 179

Apartment blocks in Moscow incorporated the neo-Russian style either as majolica or sculptural decoration, or in a small number of symbolic forms such as portals or tower-like finishes to roofs. In some cases both techniques were used. The most vivid examples of the first type were buildings designed by Malyutin and Vashkov. Malyutin was the architect of the renowned Pertsov House, which gains much of its character from the splendid outline of the gabled roofing of its corner section, and the magnificent decorative majolica panels adorning the margins of the pediments and the upper part of smooth walls of red brick. The motifs are Malyutin's trademark, derived from *luboks*, decorative painting and woodcarving.

The less prominent architects of the neo-Russian style – Kondratenko, Doroshenko and others – exploit elements inherent in the structure and function of apartment blocks, the rhythms of bow windows and balconies. These are extremely severe, functional projects. The neo-Russian style is evident in the portals at the entrances to the staircases, which allude to old Russian prototypes, and the turrets above the bow windows. In merging with the pre-constructivist phase of *moderne* the neo-Russian style loses many of its distinctive decorative features.

In St Petersburg, quite unlike Moscow, there was little residential building in the neo-Russian style. Again unlike Moscow, the northern or Finnish variety of modernism is much in evidence, reflecting the close cultural and artistic links of the northern capital with Finland and Scandinavia, local traditions, and the orientation of the St Petersburg architectural school which really made an impact on civil architecture only at the beginning of the twentieth century.

Among the greatest works in the neo-Russian style we must include Vasnetsov's masterpiece, the façade of the Tretyakov Gallery. This was designed to house the collection of the

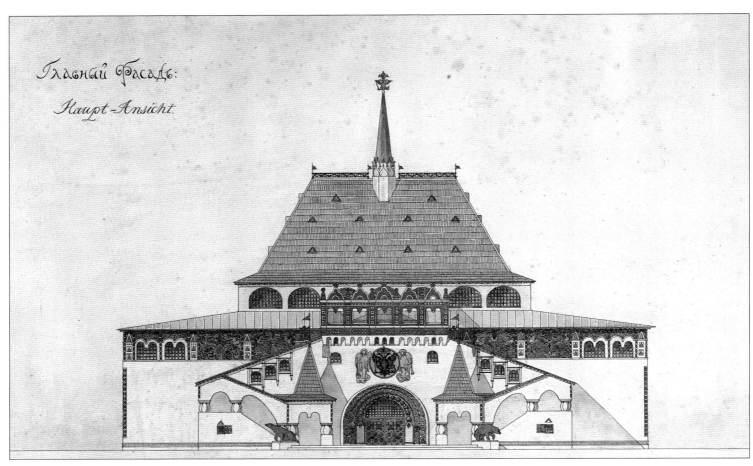

PLATE 180

PLATE 180
Vladimir Pokrovsky, Russian section of the
International Exhibition of Sanitation and
Hygiene, main façade, Dresden, 1910.

PLATE 181

brothers Pavel and Sergei Tretyakov, which they gave to Moscow in 1892. The façade is composed like the title page of an old manuscript. The architect's commission was to reflect in the principal façade the importance of this bequest in the city's cultural history. An inscription running along the top of the central section of the façade relates this in stylized pre-Petrine lettering. A relief of the Moscow coat of arms centrally located above the main entrance asserts the city's ownership of the building. The gallery's social significance is emphasized by the impressive triple entrance. As in the case of the inscription, its importance is enhanced not only by its complex form – particularly noticeable against the smooth wall – but also by colour. It is mainly red, with details picked out in white, a feature commonly found in sixteenth- and seventeenth-century architecture.

In the design of public buildings in the neo-Russian style, multiform structure was the main way of expressing Russianness. The separate identity of each component unit was accentuated not only by the differing heights and prominence or recession of the component sections but also by the diverse form, rhythm and disposition of windows and varieties of roof. Other characteristics were large windows of semi-circular or arched construction, which harked back to the arches in the galleries of Russian churches, and distinctively Russian spreading porches and window frames.

Moscow occupies first place so far as the number of public buildings designed in the neo-Russian style is concerned. Among the noteworthy examples are the Tretyakov Refuge for Widows and Orphans of Russian Artists in Lavrushinsky Lane (designed by N. Kurdyukov, since reconstructed); A.

PLATE 181
Alexei Shchusev, Design for a pavilion at the International Art Exhibition, Venice, 1913. Shchusev was extremely versatile and could – and did – realize anything his patrons demanded. After the revolution he even won the commission to design Lenin's tomb. In this design he plays with the late seventeenth-century forms of Naryshkin baroque which, although the originals are executed in stone and brick, are here presented in wood.

Ostrogradsky's Municipal Primary School at Devichy Pole (now Great Pirogov Street) and the Medvednikov, Rakhmanov and Tretyakov almshouses, the Sergius refuge, and the Museum of Handicrafts, all designed by S. Soloviov.

The variety of the neo-Russian style associated with Soloviov and Ostrogradsky drew on the traditions of Novgorod and Pskov architecture, and became especially popular in the decade or so following 1905. Its popularity resulted from both artistic and ideological considerations. In the first place, these were very ancient centres of Russian architecture, containing the earliest original treatment of Byzantine prototypes. In the second place, they had many well-preserved buildings, not only of religious but, significantly, also of secular architecture. This architecture was congenial to artistic questings and, no less importantly, it was vernacular architecture which genuinely reflected a folk ideal.

The period from 1905 to 1915 saw the neo-Russian style evolve in a number of ways. After 1910 a new phenomenon began to make itself felt in fine art, architecture, and applied art: neoclassicism. Neoclassicism did not leave the neo-Russian style unscathed. A classical influence may be detected – albeit in greatly altered form – in a return, for the first time, to the traditions of the Naryshkin baroque. Pavilions designed for international exhibitions by such prominent exponents of the neo-Russian style as Alexei Shchusev (1873–1949) were modelled on this style.

Naryshkin architecture was a fusion of North European baroque and Russian architecture, the last major stylistic movement of old Russian art before the Petrine reforms. It gives clear evidence of a will to come to terms with the culture of Western Europe. One of the earliest and most striking projects in the spirit of the Naryshkin baroque was by Shekhtel: an unrealized design for the Kazan Station in Moscow. In the same spirit, and manifestly drawing on Shekhtel's new insights, was the station building finally erected to a design by Shchusev in 1913–26.

Another new trend in neo-Russian style was instigated by the government; this was an attempt to harness the neo-Russian style to revive a bizarre variety of official populism. A grandiose neo-Russian-style ensemble to mark the tercentenary of the Romanov dynasty was erected at the Tsarskoe Selo residence of Nicholas II. The most outstanding of the St Petersburg neo-Russian-style architects – Pokrovsky, Krichinsky and Maksimov – took part in creating it. The commemorative Fyodorovsky Church, a regimental church for the Tsar's Lifeguards, was erected, along with a barracks; an assembly house for army officers; a railway station for the Tsar's branch line (designed by Pokrovsky); the Fyodorovsky village, designed by Krichinsky, a complex of buildings of the parish clergy which became a kind of headquarters for the 'Society for the Revival of Old Rus'; and a Museum of Military History designed by Maksimov.

Notwithstanding the inherent conservatism of a large public building, it was in such buildings that the boldest neo-Russian-style innovations in plan and construction were to be found. The use of the latest ferroconcrete vaulting made possible the sense of effortless spaciousness characteristic of some early twentieth-century architecture. In Pokrovsky's State

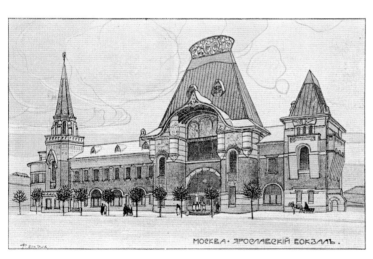

PLATE 182

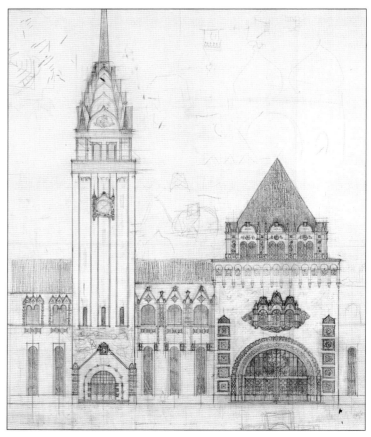

PLATE 183

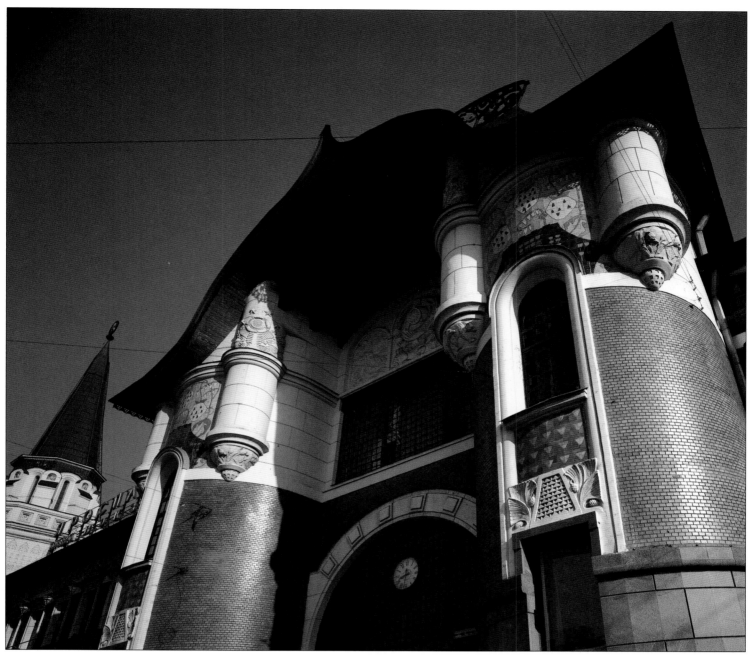

PLATE 184

PLATE 182
Fyodor Shekhtel, Design for the Yaroslavl
Station, Moscow, 1902–4, reproduced on a
contemporary postcard.
The Yaroslavl Station was built as a terminus
when the railway was extended north to
Archangel. The initiative for both the new line
and the station originated with the industrialist
Savva Mamontov, an enthusiastic advocate for
the revitalization of the economy and culture
of the Russian north. The building is a
striking example of the picturesque *khoromy*
style of composition favoured for public
buildings at the turn of the century. The
influence of the international art nouveau style
is likewise strong. The latter was extremely
fashionable in Western Europe and attracted
artists and architects who were working in the
Russian style, but who were anxious to
participate fully in European cultural
movements.

PLATE 183
Fyodor Shekhtel, Design for Kazan Station,
Moscow, front elevation, 1910.
The illustrated design was not used, the
commission being awarded instead to Shchusev
who nevertheless incorporated elements
from Shekhtel's proposal into his work.

PLATE 184
Fyodor Shekhtel, Yaroslavl Station, Moscow,
1902–1904.
Detail of façade. The tiled friezes and
ornamental panels were produced to the
architect's design in the ceramics studio at
Abramtsevo. Flowing curves and faded
colours are combined with the dramatic high-
pitched roofs, which evoke the wooden
architecture of the far north. The northern
theme is also evoked by the low-relief frieze of
polar bears around the building.

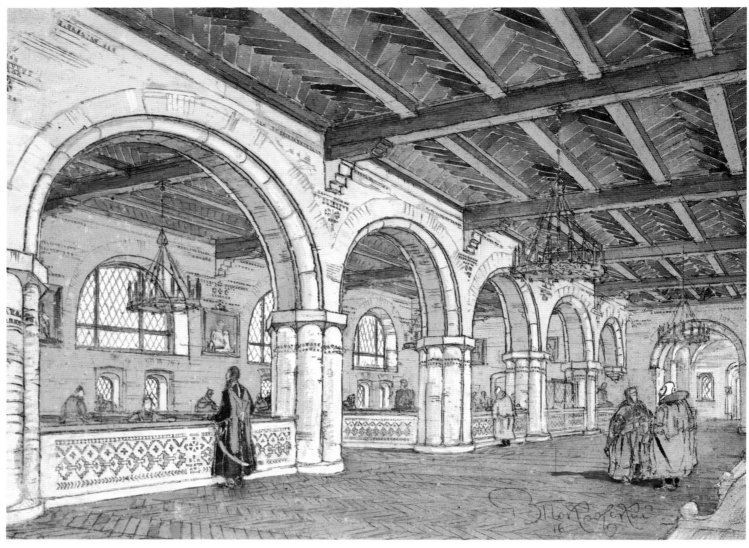

PLATE 185

PLATE 185
Vladimir Pokrovsky, Design for the interior
of a bank, 1916.
Pokrovsky here peoples a design for a modern,
secular interior with figures from the period
that it evokes – the seventeenth century.

PLATES 186 & 187
Vladimir Pokrovsky, Designs for a bank, 1916.
In these illustrations, designs for a bank
executed during the First World War, the
architect looks to the early secular architecture of
Pskov, employing his favoured technique of
exaggerated stylization to emphasize the
shapeliness, solidity and monumental
proportions of the structure.

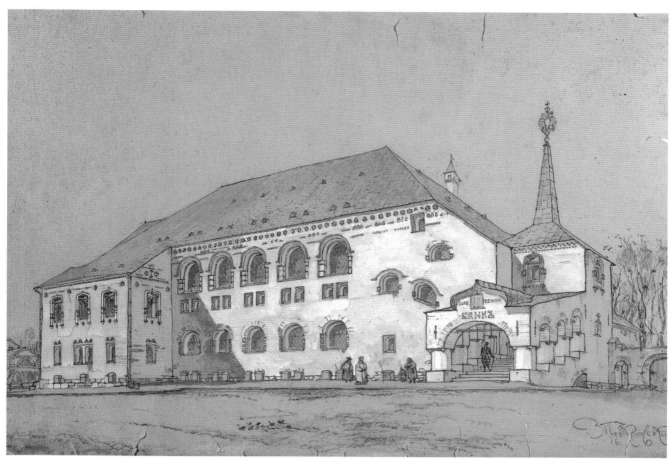

PLATE 186

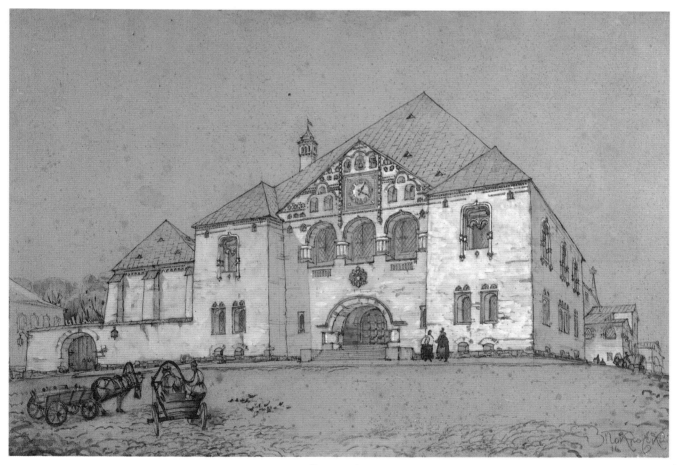

PLATE 187

Bank in Nizhny Novgorod and his Credit Bank in Moscow (designed jointly with B. M. Nilus) great vaulted operations rooms were constructed. The walls were decorated with Russian-style painting, suggesting the vast, columnless refectories of the late seventeenth and early eighteenth centuries, as in the St Simeon's Monastery in Moscow. A grandiose covered platform was designed and built at the Kazan Station in Moscow – its eloquent design and vast, soaring span made possible only by ferroconcrete technology. The station was to be decorated with panels painted by leading artists. In 1913 Roerich began work on two of these: 'The Fray at Kerzhenets' and 'The Subjugation of Kazan'.

Applied art The neo-Russian style in decorative applied art divides into two kinds of product. One is mass-produced everyday objects, such as chocolate boxes, soap wrappers and matchbox labels, as well as various types of commercial graphics, advertisements and posters. Under this heading we may also include such items as Easter eggs and Christmas and Easter greetings cards. At the other end of the spectrum of decorative applied art in the neo-Russian style are gifts and souvenirs: tableware, silver ladles and wine bowls, and jewel-boxes. Items of this latter kind were produced by major firms like those of Olovyanishnikov, Khlebnikov and Postnikov. Specializing mainly in the manufacture of church plate, they nevertheless produced many other applied-art objects. The relatively small firm of O. F. Kurlyukov, which traded from 1884 until 1918, produced high-quality products, mainly tableware, in which modern shapes were combined with colourful enamel-painted inserts on Russian themes. Other kinds of gift tableware in the neo-Russian style continued the traditions of the second half of the nineteenth century, recreating the typical forms of old Russian tableware, and the traditional technique of coloured enamelling with the characteristic plant patterns. Anniversaries produced a rich crop of ceremonial addresses, one of the more rarefied realms of applied art undertaken primarily by silversmiths. The design of these shows the neo-Russian style at its most varied, with the artists demonstrating endless inventiveness and a high level of craftsmanship. The celebrated jewellery firm of Fabergé also drew extensively on Russian tradition, producing items as varied as cigarette boxes in the shape of *izbas* (peasant huts), and ceremonial *kovshes* (the traditional old Russian utensil combining the functions of ladle and cup) which were usually richly ornamented.

PLATE 188

PLATE 188
Cigarette case, gold with cabochon ruby,
Fabergé Workshops, early twentieth century.
The *samorodok* case reproduces the surface of
the metal ore in its natural state, freshly mined.
The tassel attaches to the tinder mechanism, the
other end of which is the wick.

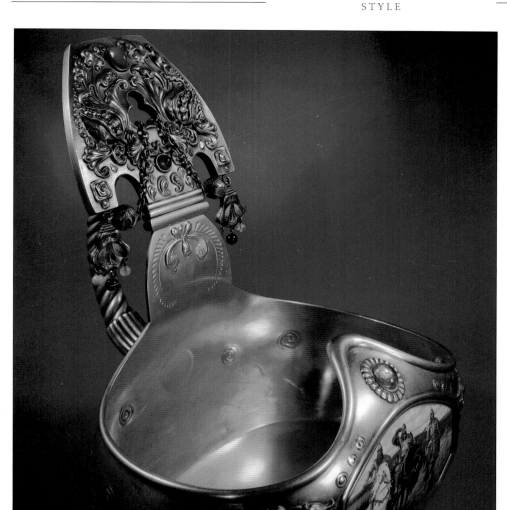

PLATE 189

PLATE 189
Ceremonial *kovsh*, silver, porcelain, enamel and precious stones. Fabergé Workshops, late nineteenth or early twentieth century.
Although made at much the same time as the piece shown in plate 194, this *kovsh* is in marked contrast to it, being more conservative in style. Notice, for instance, the painted enamel plaque which features a reproduction of Vasnetsov's immensely popular painting. Other elements show some modern influence.

PLATE 190
Tea and coffee service, enamelled silver, Kurlyukov Manufactory, early twentieth century.
The pieces are art nouveau in form, with exaggerated curves and angles, but are painted *à la russe* with sentimental images from paintings by (left to right) Elizaveta Bem, Konstantin Makovsky and Viktor Vasnetsov.

PLATE 191

PLATE 191
Cigarette case, cloisonné enamel with decorative plaque, late nineteenth or early twentieth century.

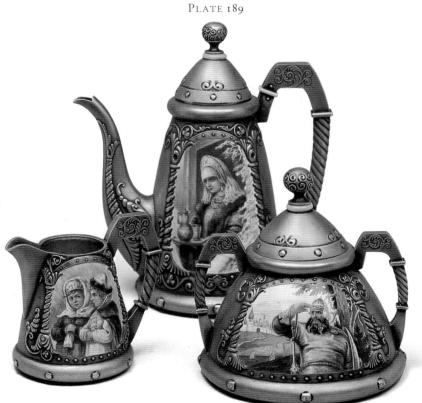

PLATE 190

PLATE 192
Casket, silver and chalcedony, Fabergé
Workshops, 1908–17.
A clear expression of the direction in which
design was moving at the beginning of the
twentieth century – harking back to archaic
forms – this piece may be seen as a reaction to
the awkward juxtaposition of elements
discernible in some earlier pieces. The solid,
blocklike shape and the absence of applied
ornament allow the sculpted forms to blend
organically with the purity of material from
which they emerge.

PLATE 193
Desk set on the historical theme of Boris
Godunov, silver, *pate de verre*, cut rock-
crystal and sapphires, Fabergé Workshops,
1899–1917.
Each piece of the set – which is believed to have
belonged to Nikolai Roerich – illustrates a
different character or scene from the story of
Tsar Boris, who is sculpted on the blotter in the
left foreground. The set was produced in
Fabergé's Moscow workshop. Its pronounced
Russian style contrasts with the products of the
Petersburg workshop, which tended to be more
inspired by classicism.

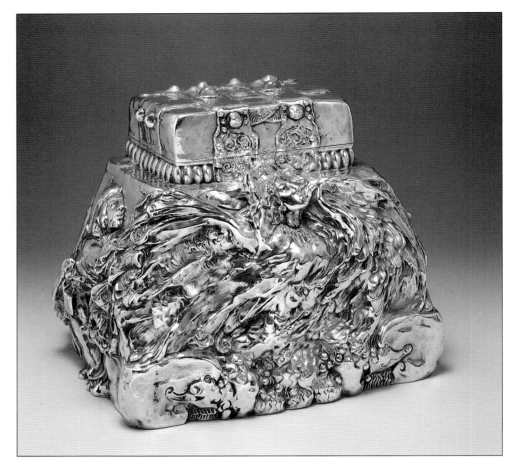

PLATE 192

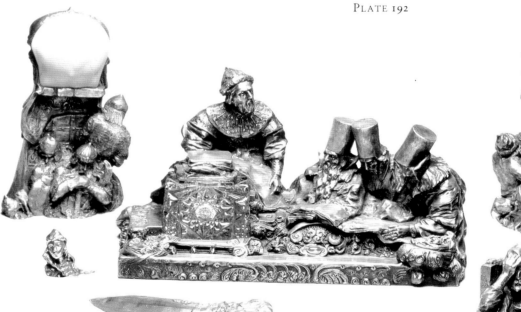

PLATE 193

PLATE 194
'*Bogatyr*' *kovsh*, silver and precious stones,
Fabergé workshops, 1899–1908.
The massive ceremonial *kovsh*, of almost
spherical shape, is cast with the figures of
warriors grouped beneath a standard which
forms the handle. The plain bowl is simply
ornamented with strategically placed cloud-
scrolls offset by the subtle glint of sapphires,
evoking pebbles naturalistically polished.

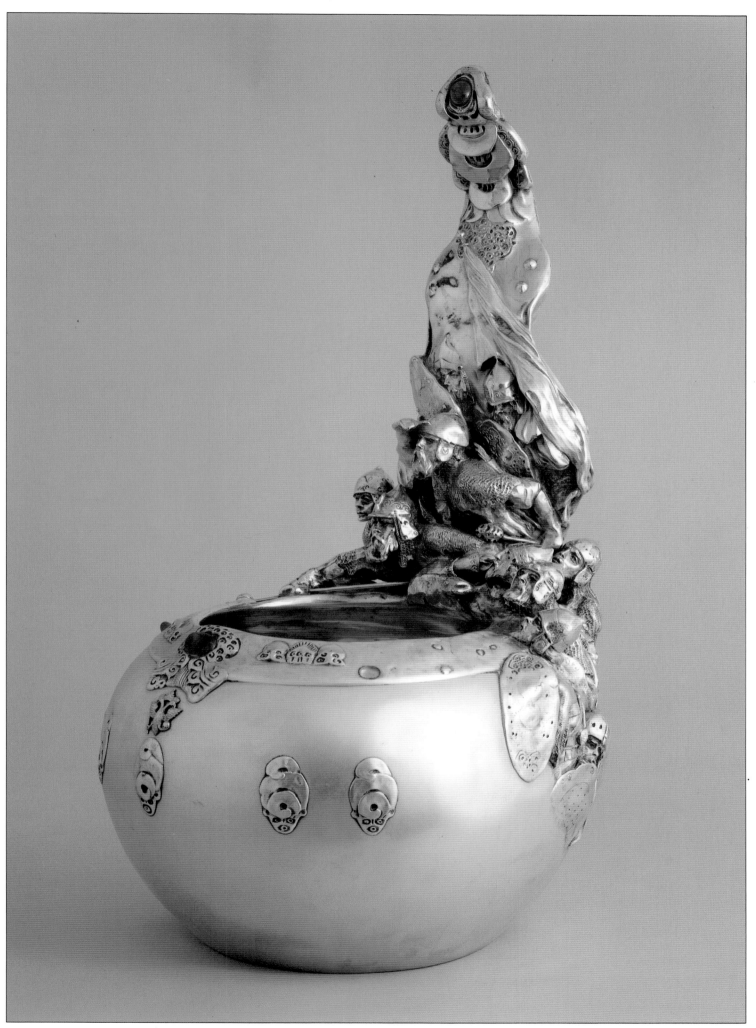

PLATE 194

PLATE 195

PLATE 196

PLATE 197

PLATE 195
The Cathedral Egg, onyx, gold and enamel,
Fabergé Workshops, 1904.
Alexander III commissioned Fabergé to produce
the first Easter egg as a surprise for his consort
Maria Fyodorovna in 1884. After his death a
decade later his son, Nicholas II, continued the
custom, commissioning two eggs every year,
one for his wife and one for the Dowager
Empress. Fabergé was given a free choice in
selecting the materials and the subjects for the
eggs which were a rare indulgence in the
otherwise modest lives of the Imperial couple.
This egg, which celebrates the Cathedral of the
Dormition in the Kremlin, although perhaps not
one of Fabergé's most successful works
aesthetically, nonetheless expresses the affection
of the Imperial family for the ancient Kremlin at
the heart of the old capital. It was made as the
Easter present for Alexandra Fyodorovna in
1904.

PLATES 196 & 197
Leaves from an order book, Fabergé
Workshops, 1909 and 1913.
Fabergé worked for clients with various tastes,
producing designs in a wide range of styles.
While his workmasters were thoroughly at
home making objects in the classical style
admired by the aristocracy, they could also
produce items in a more bourgeois taste.
However, among their most original works
are objects produced to neo-Byzantine and
neo-Russian designs. During the tercentenary
year of 1913 such works were especially
popular, among them the exquisite miniature
stylizations of the Russian eagle seen here.
Many such mementoes were ordered by the
Palace for distribution as gifts. Carefully
worked to appear archaic, these designs are
nevertheless very much of their own time.

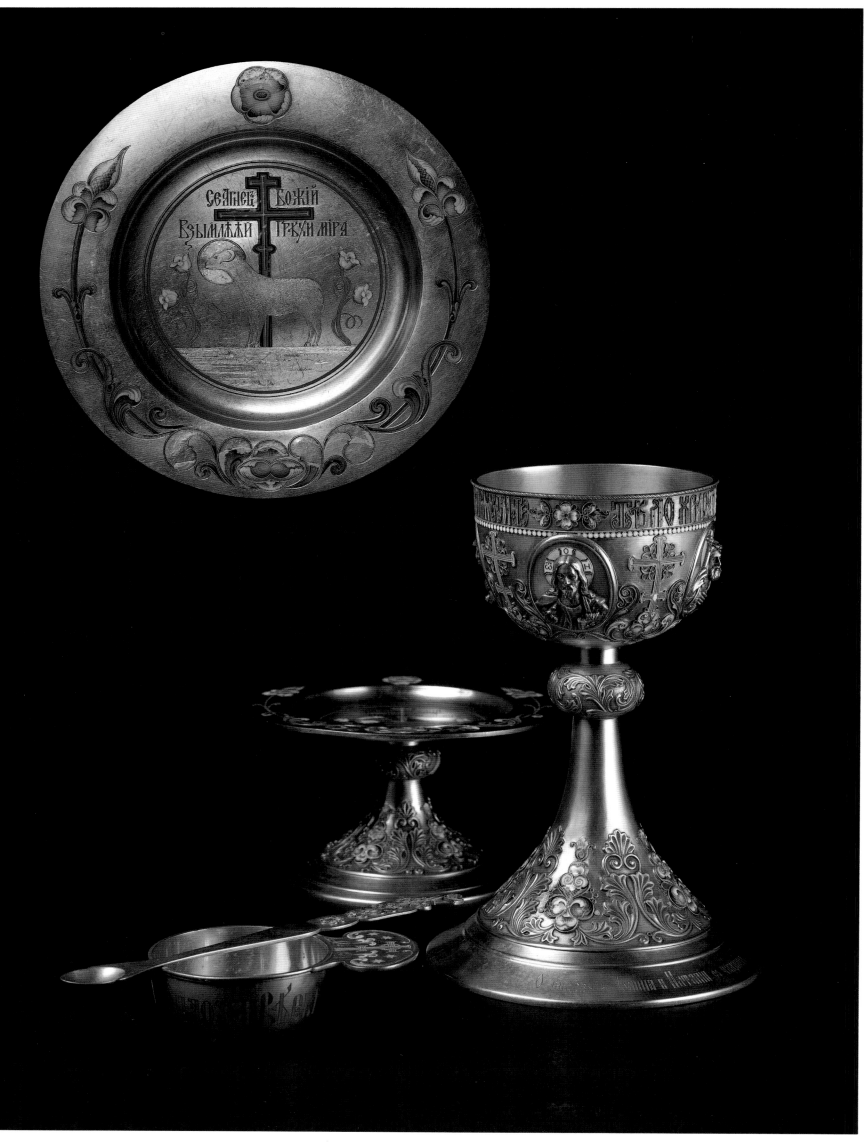

Plate 198

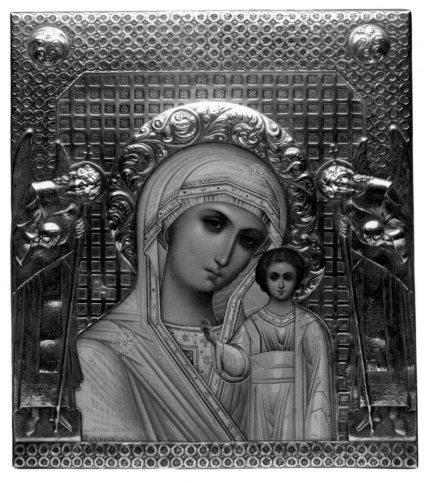

PLATE 199

Religious Art at the Turn of the Century

The markedly prominent role of religious art in Russia at the turn of the century reflects a change of attitude towards religion on the part of the intelligentsia, which in turn resulted in a change of the place religious art occupied in the system of high art. It led not only to a revision of the hierarchy of genres in the fine arts, but also to the closing of the gulf that had divided religious and secular art in their development throughout the post-Petrine period. This restoration of the unity of style of religious and secular art occurred in both the fine and applied arts, and is one of the most striking features of the radical change undergone by Russian art of the end of the century.

Religious architecture differed markedly from religious painting and sculpture in already having a fully fledged Rus-

sian-revival style. Religious painting also had little in common with the mainstream of secular fine art, with its focus on social criticism and the chronicling of everyday life.

As we have noted, the task for all the arts was now seen as the affirmation of the beautiful and the good, and the promotion of beauty as a transfiguring spiritual force. The search for beauty was seen as being closely related to the search for spiritual values, leading to a great heightening of interest in religious questions among the Russian intelligentsia. It had been growing quietly since the Romantic period, its most noticeable manifestation being the philosophical journalism of the Slavophiles, and took on a quite new character at the turn of the century, suddenly becoming a major intellectual movement of the Russian intelligentsia. It brought together the ideas of reform-minded clergy and the artistic intelligentsia, artists, writers, architects, composers, philosophers, and

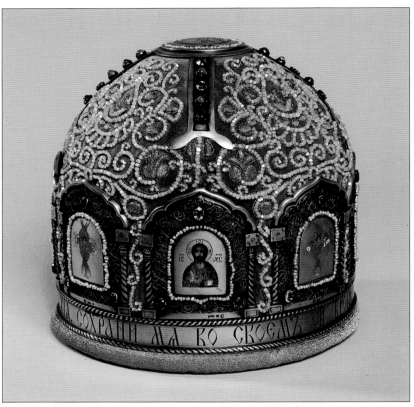

PLATE 200

theoreticians of aesthetics. All the diverse manifestations of this movement, which was given the blanket title of 'God-seeking', were rooted in the conviction that a new religious consciousness must be fostered. The initiative behind this movement came not from the Church, as in pre-Petrine Russia, but from private individuals – often acting in defiance of the Church, which in some cases actually worked against it.

A distinctive feature of Russian idealist philosophy was its nationalist tinge; it saw resolution of Russia's problems as being possible only when primal Russia was reconciled with the principle of enlightenment, when the Russian people was reconciled with the intelligentsia, on the basis of Orthodoxy as Russia's spiritual essence. The sources of Russian idealist philosophy were laid, as we have noted, by Dostoyevsky, Tolstoy, Fyodorov, and Vladimir Soloviov. Soloviov's philosophy of pan-unity, a concept of a united Church and a universal relation between man and God, was fundamental to the brilliant group of Russian philosophers working at the beginning of the century: Sergei Bulgakov, Nikolai Berdyaev, Pavel Florensky and many others. The same con-

ceptual framework is to be found in turn-of-the-century Russian religious art. Although few artists actually drew directly on the propositions of religious philosophers (although this was not unknown, in the works of Nesterov or Roerich, for example) many showed an affinity with their ideas. That these ideas found artistic expression confirms how extensively and deeply they had taken root in the consciousness of the Russian intelligentsia. Russian religious art was an inalienable part of the Russian religious renaissance of the turn of the century as it strove to pass on the shared philosophical ideals to the whole of the people by its own, artistic means. Pan-unity and God-seeking were reflected differently but very markedly in every form of religious art.

A document that gives an insight into the ideals of artistic God-seeking is a catalogue, entitled *Religious Art*, of works created between 1901 and 1911 in the workshops of the Olovyanishnikov Company. It was compiled by the firm's chief designer, Sergei Vashkov, who, like many of his colleagues, was also an architect, and who published a magazine of religious art, *Svetilnik* ('*The Lamp*').

PLATE 200
Mitre, silver, pearl, enamel, gemstones, velvet, Olovyanishnikov Workshops, 1908–17.
During the early twentieth century, when architects were reinterpreting and sometimes exaggerating the shape of the cupola, so likewise workers in precious metals reworked the outline of the mitre. Abandoning the full-blown shape that had dominated throughout the eighteenth and nineteenth centuries, they

revived the simpler form characteristic of the style of the seventeenth century. In this example, the enamelled plaques are clearly of the early twentieth century, and traditional use has been made of a calligraphic frieze. The jeweller combines a wide variety of techniques and materials to produce a sumptuous effect.
PLATE 201
Sash, or *nabedrennik*, gold brocade, early twentieth century.

Sharing the neo-Romantics' conviction that 'art is the soul of the people', Vashkov emphasizes, in his introduction to the catalogue, the fundamental importance of creating works new in form which, 'by their nobility of line, and the relevance of their content, which symbolizes the testament of Christ, would uplift the spirit'.[1] Vashkov's call derives from Tolstoy's proposition that the principal task of the artist is to 'infect' his audience with sublime feelings. Vashkov also writes that in ten years of work as an independent artist he has 'striven within the limitations of my powers only to resurrect the old ideals of religion and morality . . . expressing them according to my own understanding, and thereby clothing them in new artistic forms'. 'Objects produced by the art industry,' he continued, 'find their way into every stratum of society. They are the secret missionaries of pure art, their function being to educate and develop the aesthetic sensibility

of man. For that reason they must be relevant to society . . .'[2] The aims of religious art, then, came together with the aims of the secular neo-Russian style, and with those of *moderne*.

Whereas religious philosophy addressed itself, as always, to the most educated sections of society, religious art could not permit itself the luxury of being élitist. It is typical, however, that in almost the same words as Pavel Florensky, Vashkov points out that the discoveries made by Viktor Vasnetsov and other Russian artists reveal to the educated world 'the forgotten secret places of our national art', and the richness of its treasures.[3]

The new religious philosophy brought with it a fresh revival of Russian messianism. The idea of Moscow as the third Rome had become, in the hands of the Slavophiles and some others, the idea of the Russians as God's chosen people or, as Dostoevsky expressed it, the 'God-bearing people', who

PLATE 201

would save themselves and the rest of the world. This belief imposed a strict code of righteousness. The new religious consciousness, according to the anonymous author of an article published in the periodical *Bogoslovsky Vestnik* (the *Theological Herald*) in 1915, 'has aspirations of universal import', which must be developed '. . . from the religious and moral righteousness of the individual, through the messianic calling of our nation, to the redemption of all'.[4] This orientation of the religious consciousness of the nation obliged it to look to the world as its sphere of activity.

One of the ways in which this secular orientation became evident was in a change in monastery architecture, tying in with a change in the function of the monasteries themselves. There was a new emphasis on enlightenment and charity, helping the suffering, the sick and the poor. The growing unease among educated society on religious and philosophi-

cal questions was reflected in an increasing volume of building which it financed. Side by side with a marked increase in the building of parish churches from the end of the nineteenth century was a marked increase also in the building of churches on country estates, largely inspired by the church at Abramtsevo. There were a variety of reasons for this: the growing desire of ordinary Russians to express their faith and their traditions; the intelligentsia's growing interest in religious questions; and the keenness of the authorities to control the attitudes of workers by setting up a network of Christian workingmen's unions. These heterogeneous and contradictory elements came together to inspire a passion for church and monastery building which has no precedent in the whole history of Russia. In the first seventeen years of the twentieth century alone, 165 new monasteries were founded in Russia.[5] Between 1906 and 1912, 5,500 new churches were built.[6]

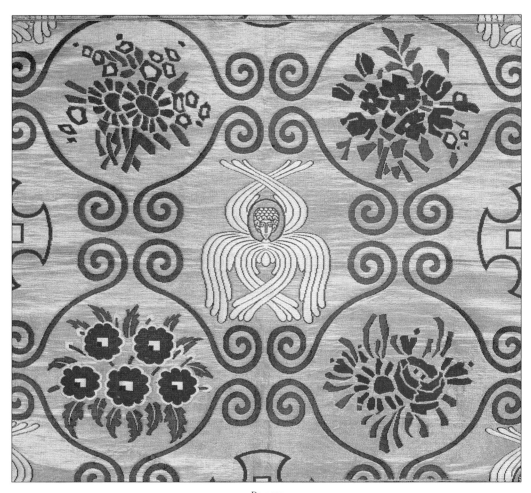

PLATE 202

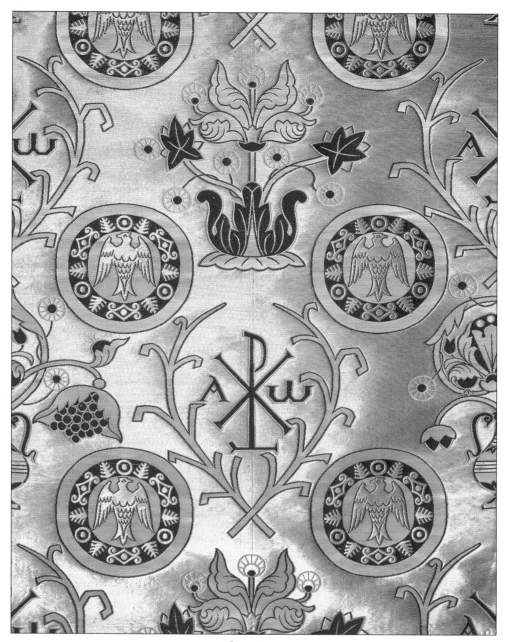

PLATE 203

PLATE 202
Sergei Vashkov, Gold brocade,
Olovyanishnikov Manufactory, early
twentieth century.
Labelled 'Design no. 55, Russian style of the
late seventeenth/early eighteenth centuries'.
The design features seraphim among bouquets
of flowers, the latter a stylization derived from
Dutch Renaissance ornament.
PLATE 203
Sergei Vashkov, Gold satin, Olovyanishnikov
Manufactory, early twentieth century.
PLATE 204
Saccos, rear view, gold brocade, early twentieth
century.
Although the design on the back of the vestment
incorporates a crown over the double heads of
the eagle in the Russian coat of arms, the overall
impression of the fabric s design is Western
European.
PLATE 205
Vestments, rear view, early twentieth century.

PLATE 206

PLATE 206
Sergei Vashkov, Half-silk satin,
Olovyanishnikov Manufactory, early
twentieth century.

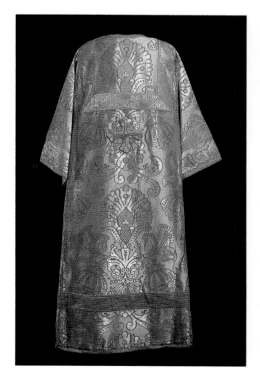

PLATE 204

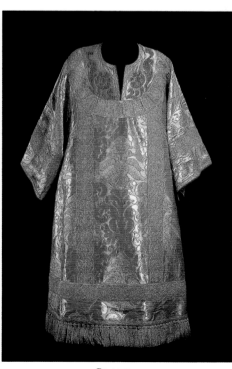

PLATE 205

PLATE 207

PLATE 208

PLATE 209

PLATE 207
Sergei Vashkov, Brocade, Olovyanishnikov
Manufactory, early twentieth century.
PLATE 208
Sergei Vashkov, Half-silk satin,
Olovyanishnikov Manufactory, early
twentieth century.

PLATE 209
Sergei Vashkov, Brocade, Olovyanishnikov
Manufactory, early twentieth century.

PLATE 210

PLATE 211

PLATE 210
Sergei Vashkov, Gold brocade,
Olovyanishnikov Manufactory, early
twentieth century.
Labelled 'Design no. 49, brocade in the old
Russian style of the twelfth and thirteenth
centuries, Vladimir – Suzdal period.'
PLATE 211
Sergei Vashkov, Half-silk satin,
Olovyanishnikov Manufactory, early
twentieth century.
Bold geometrical ornament and a striking
colour contrast here produce a strong new
design, based nonetheless on traditional
geometric patterns. Such combinations of
form and colour were used in a different
context by artists of the avant-garde, who
pillaged both icons and *lubki* for new ideas. It is
often assumed that the avant-garde emerged
from a vacuum and that the traditional
elements which they employed were
primitive, yet closer examination reveals that
pre-Petrine culture provided an inexhaustible
richness of themes and styles from which many
from the avant-garde movements
borrowed freely.
PLATE 212
Sergei Vashkov, Gold satin, Olovyanishnikov
Manufactory, early twentieth century.
Labelled 'Design no. 77, Byzantine style, sixth
century, period of Emperor Justinian'. The
pattern is composed of Christian symbols:
circles, fish and crosses with two palm leaves,
combined with sacred monograms. Before
seventeenth-century Westernization, East
Christian vestments were distinguished by
their dignity. Textiles were frequently worked
with geometric patterns, conveying a
symbolism which could be read and
understood by the congregation. Here,
Vashkov rejects the flower and foliage motifs
in common use since the seventeenth century
and recovers a Byzantine simplicity.

PLATE 212

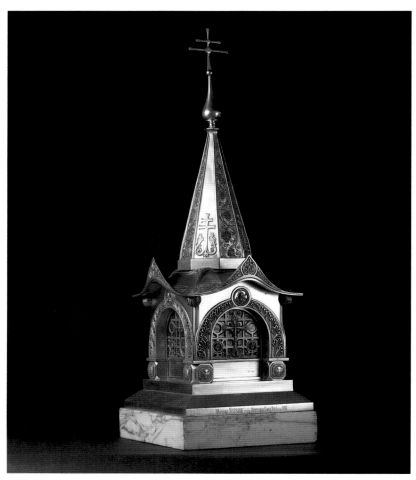

PLATE 213

Religious Architecture

Religious architecture was one of the most flourishing areas of artistic creativity and innovation at the turn of the century. It looked to a new set of prototypes, and shared a characteristic of all building in the neo-Russian style in adapting them in new ways.

The neo-Russian style was seen, justifiably, as having originated with the church at Abramtsevo. That project had initiated a trend for references to the eleventh- and twelfth-century architecture of Novgorod and Pskov, and to the architecture of the fourteenth and fifteenth centuries in the same region. Another fruitful source was fifteenth- and sixteenth-century Muscovite architecture. This particular heritage had already attracted the attention of Russian-style architects, although then it had been viewed through the

prism, so to speak, of the ornate architecture of the seventeenth century. At the turn of the twentieth century, attention centred principally on tent-roofed, pyramid-form churches, and among the most popular models were such masterpieces of old Russian architecture as the churches of Kolomenskoe, Besedy and Ostrov – all in the vicinity of Moscow. Architects turning their attention to seventeenth-century buildings concentrated primarily on those which had retained the monumental and strict outline of the main body of the building, and the laconic forms of sixteenth-century architecture.

There is in all this a thoroughly consistent set of preferences, and at the same time an unprecedented catholicity in the use made of the heritage. While the architecture of Novgorod, Pskov and Moscow was indubitably dominant, there was also a re-discovery of the architecture of Kiev, and that of Vladimir and Suzdal. Along with the sixteenth-century

PLATE 213
Silver, enamel and marble ciborium for a
church at Petushki, Vladimir Province,
Kurlyukov Company, 1910.
An altar ciborium that replicates the form of a
shrine.

PLATE 214
P. Tolstykh, Church of the Resurrection of
Christ, Sokolniki, Moscow, 1909.
In designing this church, Tolstykh combined
two common forms of sixteenth-century
stone architecture, the *shatyor* tower and
hipped roof, and the multi-domed church
with annexes.

PLATE 214

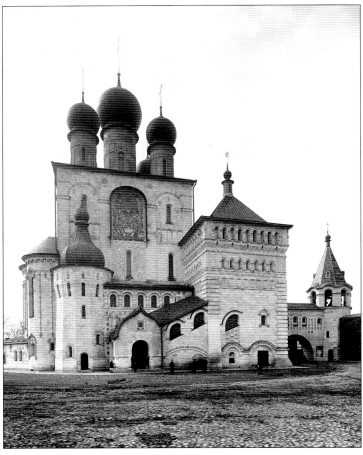

PLATE 215

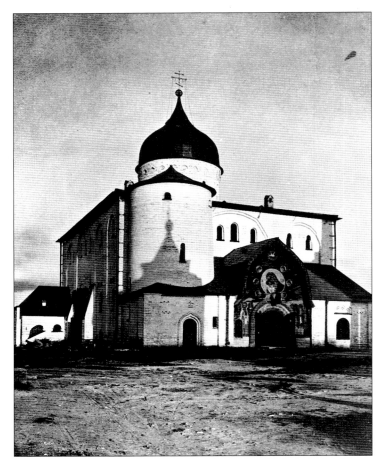

· PLATE 216

hipped-roof buildings, interest focused on the use to be made of Muscovite single-domed and five-domed churches as prototypes. This period saw yet another upsurge in interest in Byzantine architecture – not in its own right, but as the source of Russian architecture, as something that could provide new solutions to architectural problems. Finally, the tradition of folk wooden architecture was again widely recognized as relevant to church, and indeed also secular, architecture. Its attraction lay in its individuality and in its exemplification of the distinctively Russian sense of beauty and form.

The neo-Russian style continued the Russian style's love of varied materials, if in a much revised form. First and foremost this continued to apply to such 'Russian' materials as brick, the combination of red brick with white stone, or with majolica. From the Russian style the new religious architecture adopted an enthusiasm for multiform buildings. These features found support in the understanding of the Russian

Church as the heavenly Jerusalem and invisible city, popularized by the philosophy of pan-unity. In this, two contrasting but complementary concepts found expression: the universal (Christianity in general), and the national and ethnic (embodied specifically in Russian Orthodoxy).[1] These philosophical concepts merit mention in this context because they were reflected in the very structure of churches.

No matter which prototype the architect of a particular building took as his model, neo-Russian-style churches strove consistently to represent the church as the likeness and symbol of the invisible city. A sense of great complexity and multiplicity in the composition was strengthened by the asymmetry and irregularity which became the hallmark of church architecture in this period.

The iconography of neo-Russian-style churches was just as diverse as the traditions they drew on. As well as the tent-roofed church we encounter single-domed and five-domed

PLATE 215
Stepan Krichinsky, Church on Poltava Street, St Petersburg, 1913.
This memorial church was built in honour of the tercentenary of the Romanov dynasty.

PLATE 216
Alexei Shchusev, Cathedral of the Trinity, Pochaev Monastery, 1912.
The mosaic over the entrance to the cathedral is by Nikolai Roerich.
PLATE 217
Alexei Shchusev, Interior of the Cathedral of the Trinity, Pochaev Monastery, 1912.
The murals which cover all the interior walls were painted by Shcherbakov.

churches. These were the three basic types. We also meet, although rarely, three-, seven-, nine-, and even thirteen-domed churches. All of them share not only a common stylistic, but also a common compositional feature: verticalism. This shows itself in the stepping of the component building sections in the pyramidal composition, a gradual, smooth lightening of weight the higher the building rises.

Another common feature of neo-Russian-style churches is the complication and enlargement of the initial prototype, in both a literal and a figurative sense: literally, where an initial design is in itself quite simple, but is doubled or even trebled by being combined with others, and when the relatively modest dimensions of the prototype are markedly increased; figuratively, when, thanks to the accentuation or exaggeration of the features of the prototype, the effect becomes larger than life. A method of producing this kind of purely optical enlargement is the blurring of divisions between the separate parts of a building, the predominance of large elements or

frugal use of ornament – compensated for by the decorativeness of the treatment of the building as a whole.

These approaches are interrelated; indeed, we rarely encounter one without the other, but there is almost always a third present: a ceaseless creation of form on the level of the building as a whole. The design process becomes a constant search for new combinations of forms and volumes within the limits of a relatively restricted number of traditional types of church building.

In the Porokhovshchikovs' chapel in the Novodevichy Convent in Moscow (designed by Pokrovsky in the second decade of the twentieth century), the initial plan of the Novgorod–Pskov type of church, with its octuple, gabled roofing, is enriched and complicated not only by doubling it into two tiers, but also by further elaborating the outline of the exterior, giving the decorative *kokoshnik* pediment crowning each section of the wall an ogival shape. The diminishing ogival pediments, ranged in tiers one above the

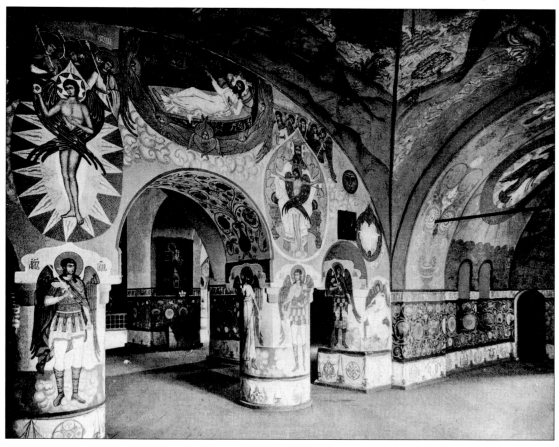

PLATE 217

other, are a technique characteristic not of Novgorod and Pskov, but of tent-roofed Muscovite churches. In Morozova's chapel (designed by Apollinary Vasnetsov), we find an analogous complication and doubling of the original plan of an octuple pitched roof. It, too, received not the gable or three-arched outline of Novgorod and Pskov architecture, but an ogive, typical of Moscow. The initial design was doubled in size, but along the horizontal. Two buildings adjoin along an east–west axis to produce an unusual two-domed structure with a sextuple pitched roof.

This treatment is typical of neo-Russian churches. Whatever model is taken as the starting point, the initial plan is invariably made more complex and adapted until it retains only a distant associative similarity with its prototype. Pokrovsky was one of the most consistent exponents of the neo-Russian style. It is in his work that we can trace the greatest number of methods of elaborating on prototypes, and indeed also the greatest variety of prototypes. Unlike most of his contemporaries, he showed little bias towards a particular tradition. For the Fyodorovsky church in Tsarskoe

Selo he developed the type of the fifteenth and sixteenth-century single-domed Muscovite church. At the same time there are echoes of the multi-domed Cathedral of the Annunciation in the Moscow Kremlin. On the Fyodorovsky church's western façade, above the vestibule, there is a horizontal belfry with a peal of bells. Never used in Muscovite building, this *zvonnitsa* gives a sense of place, pointing to the roots of the architecture of the St Petersburg region in the culture of Novgorod and Pskov. The pyramidal outline of the building is emphasized by a roofed gallery with two porches, one specially for the use of the imperial family.

The same principle of elaborating on the initial design was applied to churches designed from Novgorod and Pskov prototypes or from hipped-roof churches. This can be seen in the memorial church in honour of the Battle of the Peoples of 1813, during the Napoleonic Wars, near Leipzig, and the Church at the Powder Factories, near Schlisselburg. The model for the Leipzig church was the Church of the Ascension in Kolomenskoe, the eight-faceted tent roof becoming sixteen-faceted, with a resulting enhancement of its elegance.

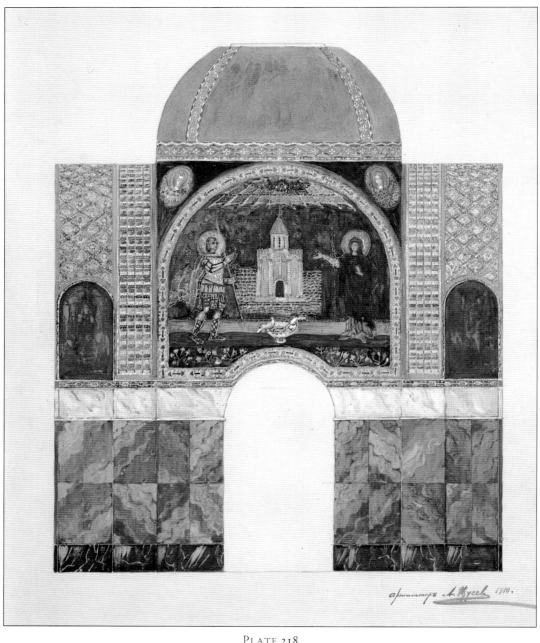

PLATE 218

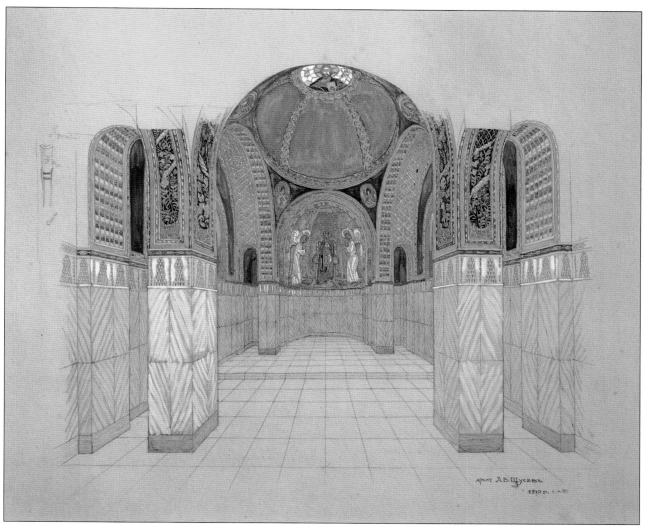

PLATE 219

To the west a monumental porch and *zvonnitsa* belfry was built on to it in the shape of a miniature single-domed church in the Novgorod and Pskov tradition, with an octuple pitched roof. To the east, three apses abut the basically columnar body of the church. The Kolomenskoe prototype had neither the belfry nor the apses.

In the Church at the Powder Factories, rectangular ancillary sections were built on four sides, adjoining the main tent-roofed, tower-shaped body of the church. These were crowned with domes, and resembled the fourteenth- and fifteenth-century churches of Novgorod and Pskov. A *zvonnitsa* adjoins the church. This complicated hybrid of the tent roof and multi-domed churches became fairly widespread.

Shchusev and Krichinsky Alexei Shchusev was another church architect working mainly in the neo-Russian style. Unlike Pokrovsky, but like Vasnetsov and Polenov, he displayed a consistent bias in favour of Novgorod and Pskov prototypes. If stylization was barely discernible in the architectural designs of Vasnetsov, in Shchusev it emerged triumphant. Shchusev's churches combine a love of simple prototypes with a complex development to express the idea of the church as the invisible city. For example, in the memorial church on the Field of Kulikovo, he adapted the type of the fortress church, with two towers flanking the western façade. This was to be found in a number of twelfth-century buildings – in particular the Cathedral of St Vasily in Ovruch. Shchusev

PLATES 218 & 219
Alexei Shchusev, Designs for a church
interior, early twentieth century.
For the design of a church to be built on the
estate of a client, Shchusev works with a
Byzantine vocabulary. He uses rich materials
– marble, gold and mosaic.

made dazzling use of asymmetrical compositions of churches with towers, which also became popular at the beginning of the twentieth century. The prototypes here were the buildings of the most ancient, Kievan, period of Russian history; in Kiev, St Sophia's Cathedral; and in Novgorod, the churches of St Antony's and St George's Monasteries. A prototype particularly beloved and often used by Shchusev was the church of the Mirozhsky Monastery in Pskov, with its asymmetry, its ground-hugging component sections, its massive dome and the *zvonnitsa* added later to the main part of the cathedral.

In one of his most successful buildings, the Church of the Convent of Saints Martha and Mary in Moscow, Shchusev took as his starting point the octuple pitched-roof churches of Novgorod and Pskov, complicating the original and, at the same time, making it seem even more archaic. The church was created for an order whose rule typified the urge of contemporary Russian religious philosophy and monasticism to participate directly in building a better world. The name of the community, which was created by Grand Duchess Yelizaveta Fyodorovna for the purpose of spreading goodwill, summarized this, Saints Martha and Mary combining good works with spirituality.

Stepan Krichinsky, who practised in St Petersburg, also consistently championed the neo-Russian style. His memorial church in honour of the tercentenary of the Romanov dynasty was a sophisticated composition built on Poltava Street in St Petersburg. It played a leading role in the compositional scheme of a new region of the capital which was being vigorously developed. In allusion to the ruling dynasty, he incorporated features of the fifteenth-century cathedrals of the Moscow Kremlin, and certain features of the renowned Rostov Kremlin, residence of the Metropolitan Iona Sysoevich, which dated from the seventeenth century when the Romanovs first came to power. The arched band on the façades was a characteristic of the twelfth-century cathedrals of Vladimir, repeated on the fifteenth-century

Cathedral of the Assumption in the Moscow Kremlin, and regarded from that time as symbolic of the state. The houses of the clergy, the bell tower and wall, and the church form a unity. The church is situated in the centre of a crossroads, and is seen at the end of the perspective of the streets leading to it.

In his 1915 St Petersburg church, named after one of the early twentieth century's favourite saints, Nicholas Mirlikiisky, Krichinsky re-created the equally popular prototype of the fourteenth, to fifteenth, century Novgorod and Pskov-style church with octuple pitched gable roof.

Bondarenko A major and original architect, who had a considerable impact on Russian church design in the immediate pre-revolutionary decades, was Ilya Bondarenko (1870–1946). Bondarenko was a Moscow architect who built mainly for Old Believers, an ultra-conservative Orthodox sect. Despite the stereotype which portrayed them as obsessively tied to old ways, the Old Believers – who included most of the important industrialists – proved one of the most dynamic and innovative sections of Russian society. They were enthusiastic patrons of the arts, gatherers and collectors of old Russian art, and, as in the case of S. Ryabushinsky, great organizers of exhibitions. His brother N. Ryabushinsky provided the capital to publish the celebrated magazine *Zolotoye Runo* ('*The Golden Fleece*'), which brought together the symbolists in literature and the modernists in the fine arts. The Old Believers were the most active section of the community in commissioning up-to-the-minute buildings, both secular and religious. In particular, they were to the forefront in commissioning neo-Russian-style churches at a time when the Russian style still dominated ecclesiastical architecture.

Among Bondarenko's religious buildings are the church, house for the clergy, and blocks of almshouses in Bogorodsk, the church at the Bogorodsk-Glukhov Manufacturers (both now part of the town of Noginsk), and the Old Believer churches in Great Perevedenov, Gavrik and Tokmakov Lanes. Bondarenko himself characterized his buildings as

PLATE 220

Alexei Shchusev, Convent Church of Saints Martha and Mary, Moscow, 1912.
Shchusev was a key figure among architects of the early twentieth century. His close study of medieval Russian architecture allowed him to reach a clear appraisal of its significance and to rework the old forms in a startling new way. The effect here is highly expressive, suggestive of something ancient and yet unmistakably of its period. Detailing is of a high standard and the effect of the effortlessly soaring interior space is exhilarating. While his buildings belong to the philosophical climate of the early twentieth century, spiritually they are the heirs of a much earlier period – the architecture of Pskov and early Muscovy. Inside, the walls narrow slightly towards the vaults, creating the impression that they are being pressed inwards. The austerity of

the building is offset by asymmetrically but carefully placed details: windows and decorative plaques are precisely laid across the surface of the façades. The convent was founded by the Grand Duchess Elizabeth, at whose instigation the church was also built. The Grand Duchess was the sister of the Empress. Her husband, the Governor of Moscow, was killed by terrorists, and she subsequently came to terms with this tragedy through her extensive work with her order of nursing sisters among the Moscow poor. The absence of the cross above the cupola of the church produces a disturbingly unfinished effect in this modern photograph. Such churches were fated to be among the last significant achievements of Orthodox ecclesiastical architecture anywhere in the world.

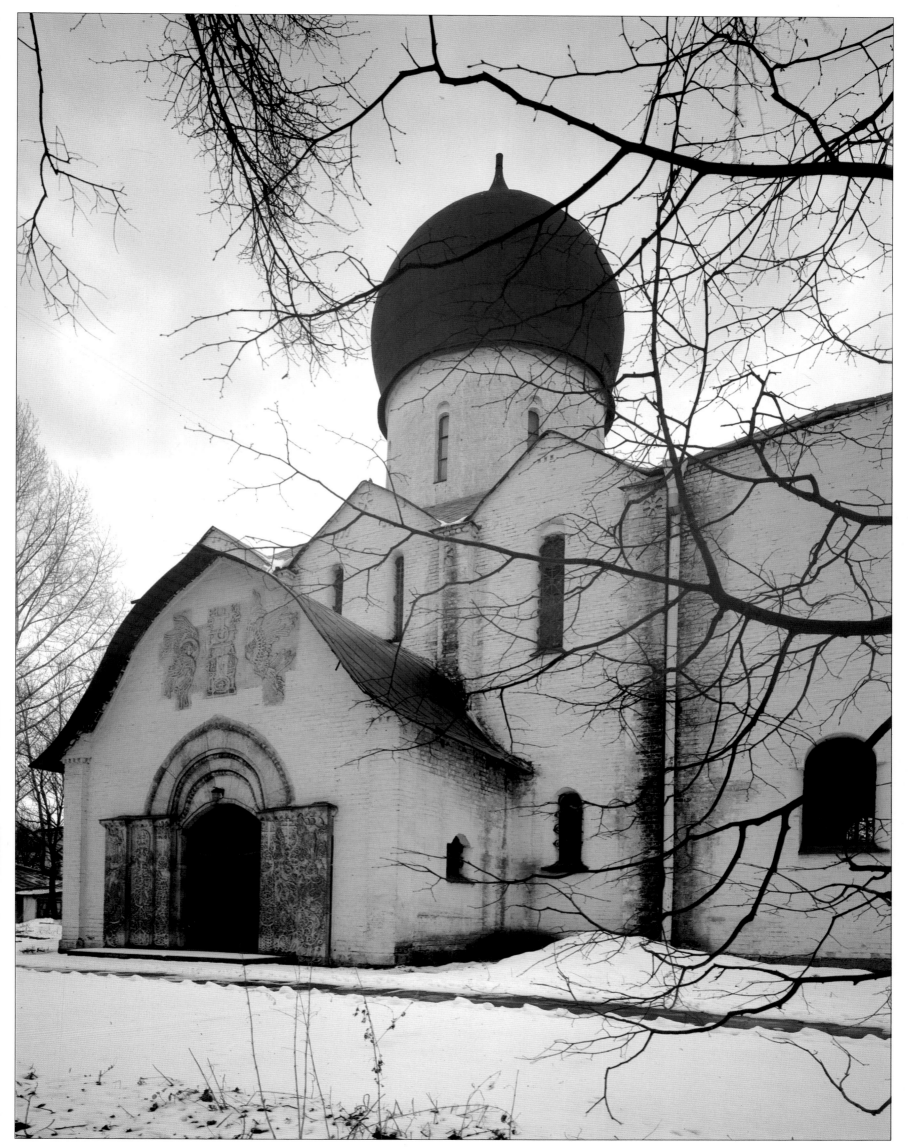

PLATE 220

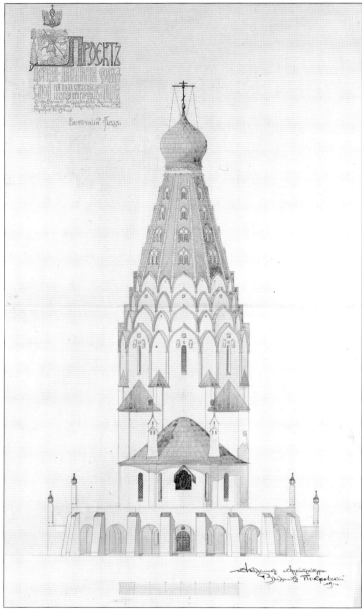

PLATE 221

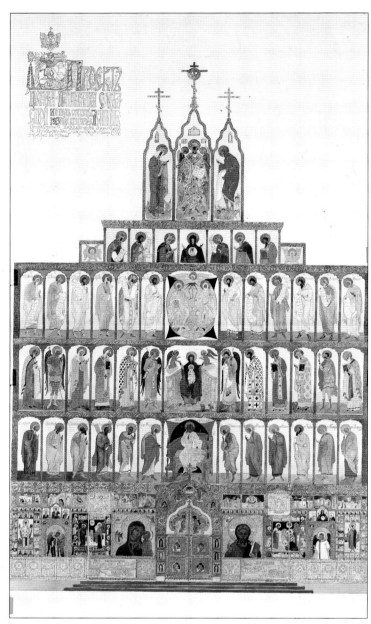

PLATE 222

PLATE 221

Vladimir Pokrovsky, design for a memorial church in Leipzig, east façade, 1911.
Early in the twentieth century a new generation of artists, having closely studied the principles of old Russian architecture, consolidated their work into a valid architectural style. Vladimir Pokrovsky takes his place among the exponents of this mature phase. This church was built to commemorate a battle near Leipzig in which the Russians fought the army of Napoleon. Here, the Russian style is not conceived as ornament superimposed on every surface of the building. Form is simplified and contributes towards a sense of volume. The inspiration for the building is provided by the Church of the Resurrection at Kolomenskoe which dates from 1532 and which repeats and reinterprets in brick an earlier wooden prototype. The Kolomenskoe church ranks as one of the most original creative achievements of old Russian architecture. Pokrovsky's interpretation for Leipzig is its natural descendant.

PLATE 222

Vladimir Pokrovsky, Design for the iconostasis of the memorial church in Leipzig, 1911.
The religious revival at the turn of the century led to a rediscovery of the real quality of old Russian icon painting. As the ancient masterpieces were cleaned and their images began to emerge from the accumulation of soot and darkened varnish, a growing awareness of their aesthetic qualities developed and the revelation had a profound effect on an entire generation of artists. Meanwhile the spiritual content of the icon was reinterpreted by such contemporary writers and thinkers as Prince Evgeny Trubetskoy and Pavel Florensky. Pokrovsky's design for the iconostasis for Leipzig reflects a sensitive understanding of the nature and meaning of the icon and also attests to his perception of the way in which all the elements of the church are subordinate to the overall plan.

being mainly in the spirit of Muscovy. The basis for this is doubtless his ready use of colour and roof tiles, his love of tent- and hipped-roof shapes and onion domes, his utilization of ogival forms for crowning walls, and such features as recessed decorative panels (*shirinki*), typically seventeenth-century motifs. In Bondarenko's designs these recessed panels are radically adapted and used to quite opposite effect to that seen in their prototype, emphasizing the expressiveness of the large surfaces of smooth undecorated walls.

In his work Bondarenko embodied the more striking features of Muscovite architecture, most evident in religious buildings. In his churches the combination of multiple sections of a building is largely illusory. It is created by emphasizing the diversity of the roofs of sections traditionally separate in Russian Orthodox churches: vestibules, refectories, bell towers, apses, galleries; and also by the original device of drawing an imaginary building endowed with an elaborate 'outline' on the wall surface of a real façade.

The nexus with the national tradition and conscious repeated reference back to it are inseparable in Bondarenko's work from the equally deliberate struggle to create modern, wholly original works. In his designs the old Russian prototypes are adapted radically and systematically, whether in respect of individual details or of the composition as a whole. He made highly expressive use of contrasting material types and colours, of the rhythm of forms and planes, of different-coloured and textured surfaces, of the major sections of the buildings, and the forms of minor aspects of his larger compositions. In his expressiveness and the exuberance he conveys through the complex composition of his buildings he is rivalled only by Shekhtel. In identifying his innovations with the national heritage, he compares also with Antoni Gaudí.

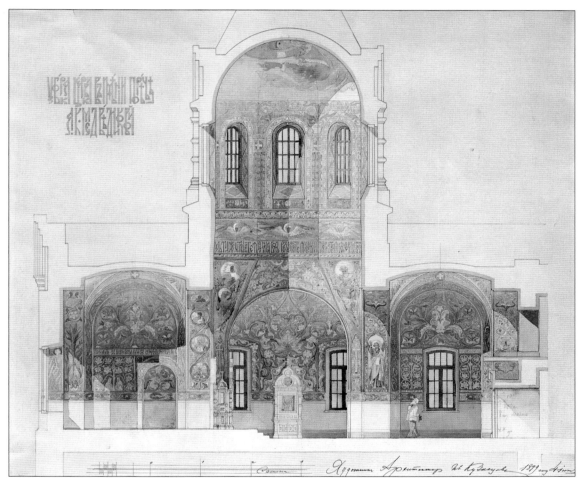

PLATE 223

PLATE 223
Ivan Kuznetsov, Design for a church on the
Medvednikova estate, 1899.

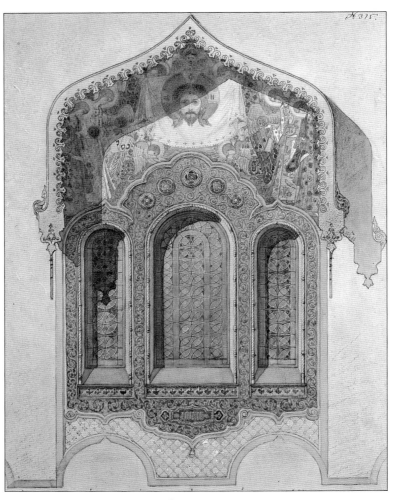

PLATE 224

Shekhtel Fyodor Shekhtel hailed from the same part of Russia as Bondarenko, but his church architecture is sparse and uneven. It relates in the main to the early period of his creative work, and to the years immediately before the Revolution, and it was not this that secured him a place in the history of Russian architecture. The churches Shekhtel designed in the first two decades of the century are associated with the growth of neoclassical tendencies within the neo-Russian style. This showed itself in a spare, geometrically precise, rather arid shape, a struggle for visual rationality in lucidly constructed compositions combining a variety of forms. As regards first principles, however, Shekhtel was not merely competent, but one of the pioneers in matters such as the design of churches symbolic of the 'invisible city', with their complex, picturesque composition, their wealth of

rhythmic correspondences of segments of the building and elements of different shapes, their many and varied combinations of materials of different colours, their extensive use of colour, and frescoes and wall paintings utilizing such highly durable materials as majolica and mosaics (which became popular in church architecture precisely at the turn of the century). Shekhtel had a hand in the move towards new sources, and the discovery of new techniques. He was one of the first to rediscover the compact cuboid form of the Vladimir-Suzdal and early Muscovite churches, using it in his design for an Old Believer church for the Ryabushinsky brothers in 1907.

The new ferroconcrete vaulting technology was widely used in religious as well as secular buildings. Bondarenko himself drew attention to the fact that he made use of it in all his own designs. He invariably worked in partnership with

PLATE 224
Mikhail Preobrazhensky, Design for a
ceramic tile window surround for the Russian
Church at Nice, 1904.

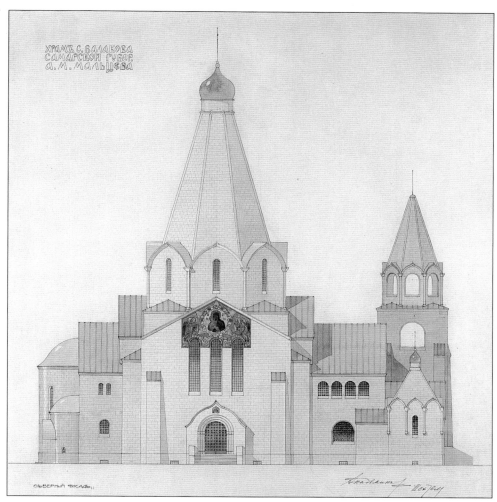

PLATE 225

PLATE 227

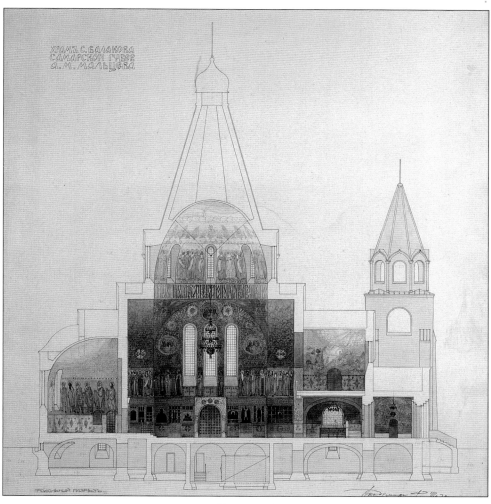

PLATE 226

PLATE 225
Fyodor Shekhtel, Design for the church of
Balakovo, 1908 (longitudinal section).
Shekhtel ranks among the most gifted Russian
architects at the beginning of the twentieth
century. His buildings consistently combine
elements derived from art nouveau with an
appreciative knowledge of old Russian
architecture. The design here is an
interpretation of the traditional old Russian
church with a hipped roof and a *shatyor*.
PLATE 226
Fyodor Shekhtel, Design for the church of
Balakovo, interior view, 1908.
PLATE 227
Fyodor Shekhtel, Design for a mural painting,
1890s.

A watercolour for a church mural, the cursive
lines of this design owe much to seventeenth-
century applied ornament.

PLATE 228
Fyodor Shekhtel, Invitation card to attend the
consecration of the Church of the Merciful
Saviour, Ivanovo-Voznesensk.
In this invitation Shekhtel uses the image of an
archangel holding a church and a disc with the
Christic monogram, derived from Byzantine art.

PLATE 229
Fyodor Shekhtel, Design for the bell tower of
the Church of Basil the Great, 1899.

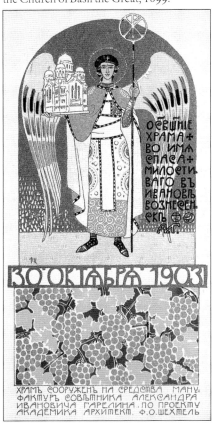

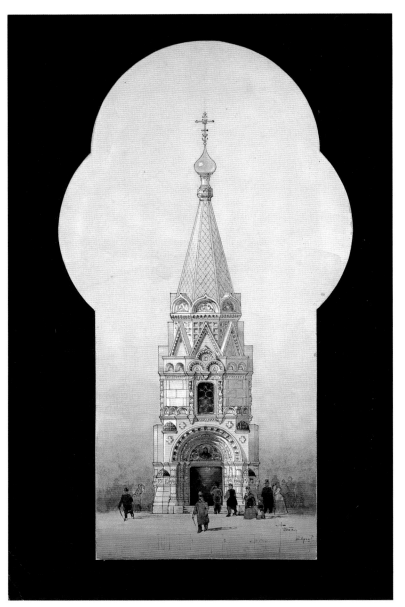

PLATE 228

PLATE 229

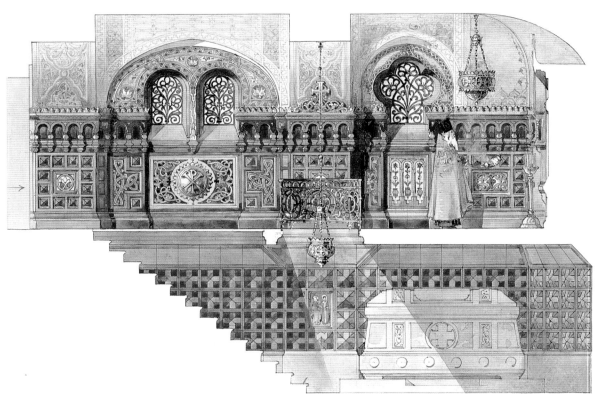

PLATE 230

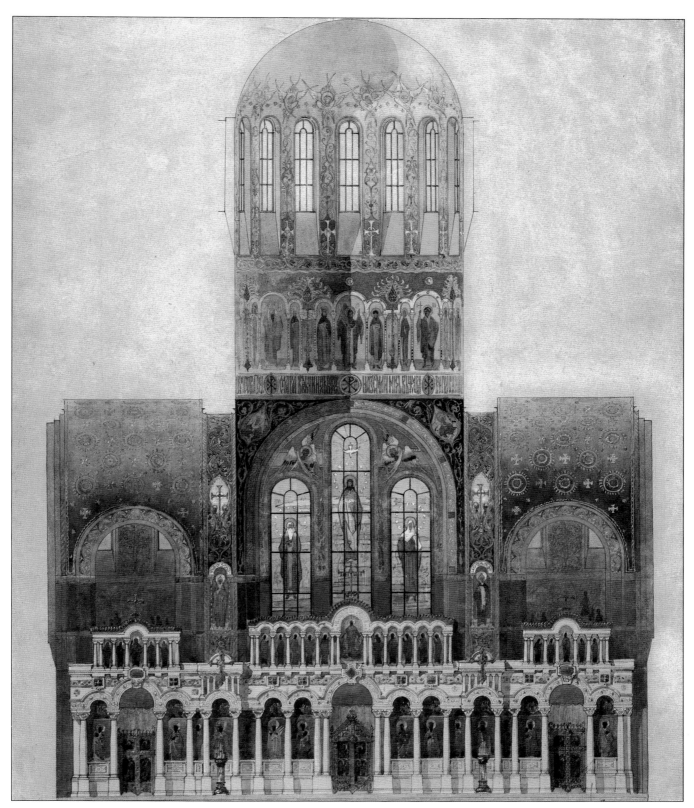

PLATE 231

PLATE 230
Fyodor Shekhtel, Design for the Lapin family
vault, Danilov Monastery, Moscow, 1897.
Shekhtel here draws upon Byzantine motifs, in
particular in the roundel under the left-hand
windows, and the patterns of the window
grilles.

PLATE 231
Fyodor Shekhtel, Design for the Church of
the Merciful Saviour, Ivanovo-Voznesensk,
1898 (section).
This church represents Shekhtel's quest for
innovative design. The marble sanctuary screen
recalls the neo-Byzantine version in the Church
of St Vladimir in Kiev.

one of Russia's best engineers of the period, Loleyt. All Bondarenko's churches dispense with internal pillars and have a great hall-like spaciousness. The immense columnless refectory built onto the cathedral in Shuya reflects the early twentieth-century's delight at the freedom and spaciousness of great vaulted structures. There had been a discernible tendency in this direction in nineteenth-century church building, with a move towards merging the space of refectory and church into a single, although not homogeneous, hall-like space. The ground was prepared for innovation at the turn of the century as ferroconcrete technology became available for use in church architecture.

Church Interiors: Painting and Applied Arts

In the decoration of church interiors, in the subject matter, iconography and disposition of mural painting, we find the same synthesis of opposites, the same will to innovation, opposing and complementing the urge to go back to tradition, which was to be seen in the church architecture. We have noted the trend to create a hall-like space. Equally typical was the tendency to verticality. This was true not only of tent-roofed churches, where it was virtually unavoidable, given the columnar shape of the central space of the church, or of churches with domes which let in the light, but also in the new kind of hall-like church. This was a strange hybrid of the great four-columned refectory, which served also as a winter church, and the four-columned church proper. From the former, the hall-like church adopted the features of spatial organization, with naves of equal height; from the second, the pre-eminence of the central space beneath the dome. In hall-like churches the dome is false. The illusion of a dome is achieved by arranging a dome-shaped vault in the centre of the church, but the important thing is the prominence given to the space below the dome in the interior of the church. The majestic impression produced by the interior and false dome in the church in Petushki (1910) in the Vladimir region is enhanced by successful innovations in the system of the mural painting. The vaults of the side sections are painted grey-blue, and this abstract colouring creates an impression of primal chaos, against which the cosmos of the central dome-like vault, given order by the mural painting, stands opposed. The murals, too, are far from the traditional iconography. In place of the canonical Evangelists, four hovering angels bearing spheres are depicted on the pendentives. They appear to be supporting a sky from which the golden light of God's wisdom floods forth. The colour contrast makes the height and dimensions of the space beneath the dome seem greater than they are, and corresponds to the architectural semantics of Orthodox churches, in which the cupola is the visible symbol of the invisible God and the grace that flows from Him.

One more feature typical of many churches of the turn of the century is a reduction in the amount of mural painting. In the church in Petushki, paintings occupy only the west wall and the lower part of the pillars. On the west wall there are copies of paintings (not icons, not church murals, but easel paintings) on religious subjects: in the southern part a copy of Polenov's picture 'Christ and the Fallen Woman'; in the northern, 'Christ at the House of Martha and Mary' by Semiradsky. This substitution for church murals of copies of pictures on religious themes is by no means unique. Nesterov's painting 'The Vision of Bartholomew' is reproduced on the west wall of the church at Lopasnya Station, near Moscow (now the town of Chekhov). The extent of the practice indicates a closing of the gap between religious and secular painting.

Equally widespread was the practice of copying murals of outstanding artists in local churches. Vasnetsov's murals were especially popular. They might be reproduced in their entirety, or details might be taken from them. The Petushki church has copies of Vasnetsov's murals in St Vladimir's Cathedral in Kiev in its apse, on the lower part of its columns, and on the west wall of the refectory.

Vasnetsov's murals in St Vladimir's Cathedral marked a turning point in the development of Russian religious painting. Their popularity derived not only from their innovations, or their consonance with the spirit of the times, but also from the significance of the event commemorated by the building and decorating of the cathedral: the 900th anniversary of the Christianization of Rus.

The work was under the direction of Adrian Prakhov. Prakhov's role in the revival of monumental art on the basis of Byzantine and old Russian traditions was crucial. In many ways it was thanks to him that the reforming genius of such artists as Vasnetsov, Vrubel, Nesterov and Roerich was able to affect religious painting. Given that both Prakhov and Vasnetsov belonged to the Mamontov circle, the link between the circle's ideals and the revival of Russian religious art is evident. The originality of Prakhov's programme for

PLATE 232
Marble iconostasis, Cathedral of St Vladimir, Kiev, completed 1895.

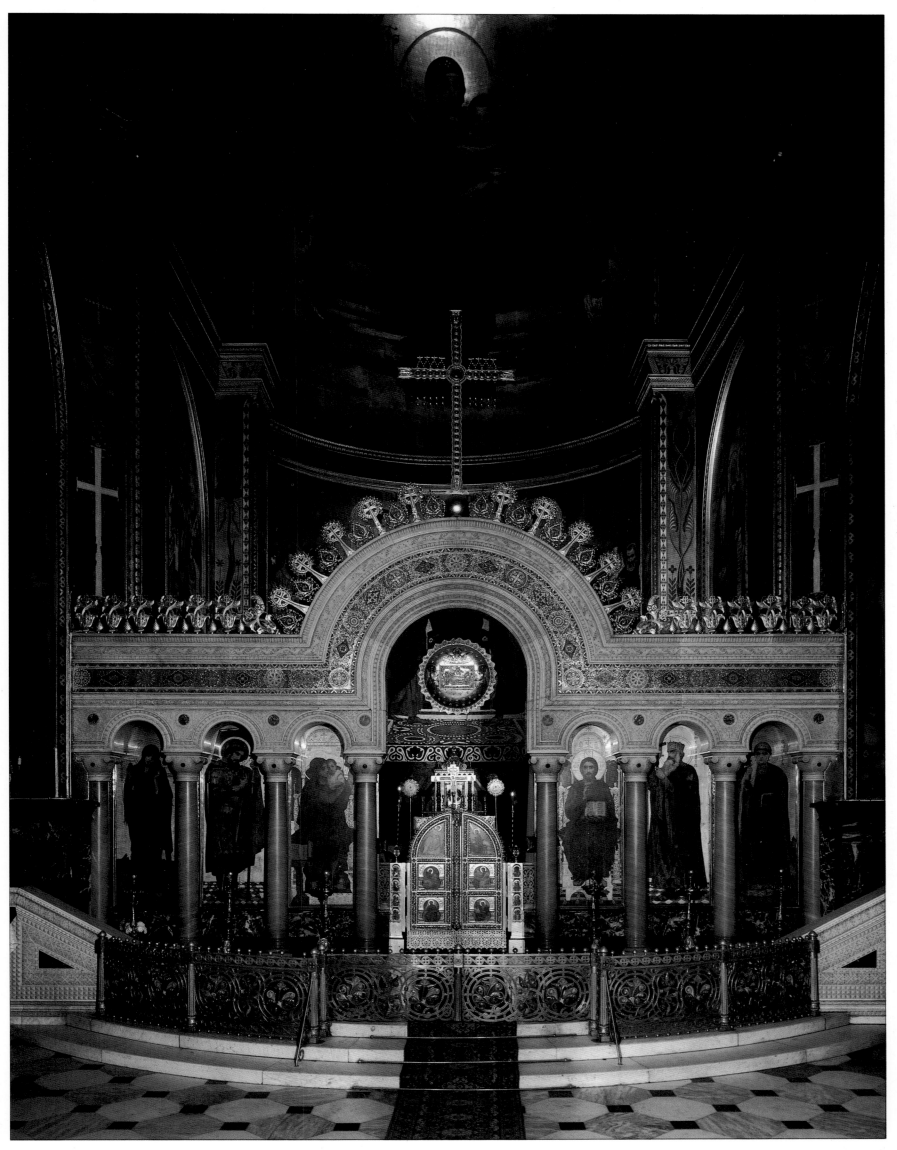

PLATE 232

PLATE 233
Viktor Vasnetsov, *The Baptism of Rus*,
painting in the nave of the Cathedral of St
Vladimir, Kiev, completed 1895.
An unforgettably dramatic representation of
the event that the Cathedral was built to
commemorate – the Christianization of
Russia, nine hundred years earlier.
PLATE 234
Mikhail Nesterov, *The Evangelists*, painting
from the sanctuary gate, Cathedral of St
Vladimir, Kiev.
PLATE 235
Viktor Vasnetsov, *The Mother of God with the
Infant Christ*, apse painting of the Cathedral of
St Vladimir, Kiev.

Vasnetsov's investigations into Russia's past
inevitably awoke in him a response to icon
painting. He designed a wooden house for
himself in the old Russian style, which he filled
with a collection of icons from the sixteenth
and seventeenth centuries. He was, however,
limited by the perspective of his generation.
He could not perceive the relationship
between the spiritual vision of the icon painter
and the technique he used. It was not his aim to
find a way of reinterpreting old techniques to
rediscover the abstract timelessness central to
icon painting. All his success was derived from
the skilful use he made of the 'realism' which
was one of the aims of painting no less than of
literature during the second half of the
nineteenth century. There is, however, some
shift of emphasis discernible between the small
painting of the Virgin executed for the
Abramtsevo Church and the image in the apse
at Kiev. In the latter, Vasnetsov exaggerates
the large oval eyes and straight nose of
Byzantine tradition and seeks to sanctify the
image with the Greek monogram denoting the
Mother of God. The result remains
sentimental and, in the words of Heard
Hamilton, 'mournful rather than majestic'.
Vasnetsov's imagery was enthusiastically
received by the educated Russian public. Rosa
Newmarch, an early Western critic to write on
Russian art, enthuses in 1906 that 'Here we
have the Slavonic Madonna realised for the
first time in Russian art', but adds, 'A friend
told me that, while in the Cathedral, he asked
peasants who were gazing around, "Are you
not proud of your splendid church and the
wonderful pictures?", to which he was
answered, "We like the old icons best, these
have too much life in them."' Ironically, it was
Vasnetsov's painting that reconciled the
conservative peasantry to the invasion of
naturalism into traditional imagery. A host of
imitators spread his style inexorably
throughout the Empire.

PLATE 233

PLATE 234

PLATE 235

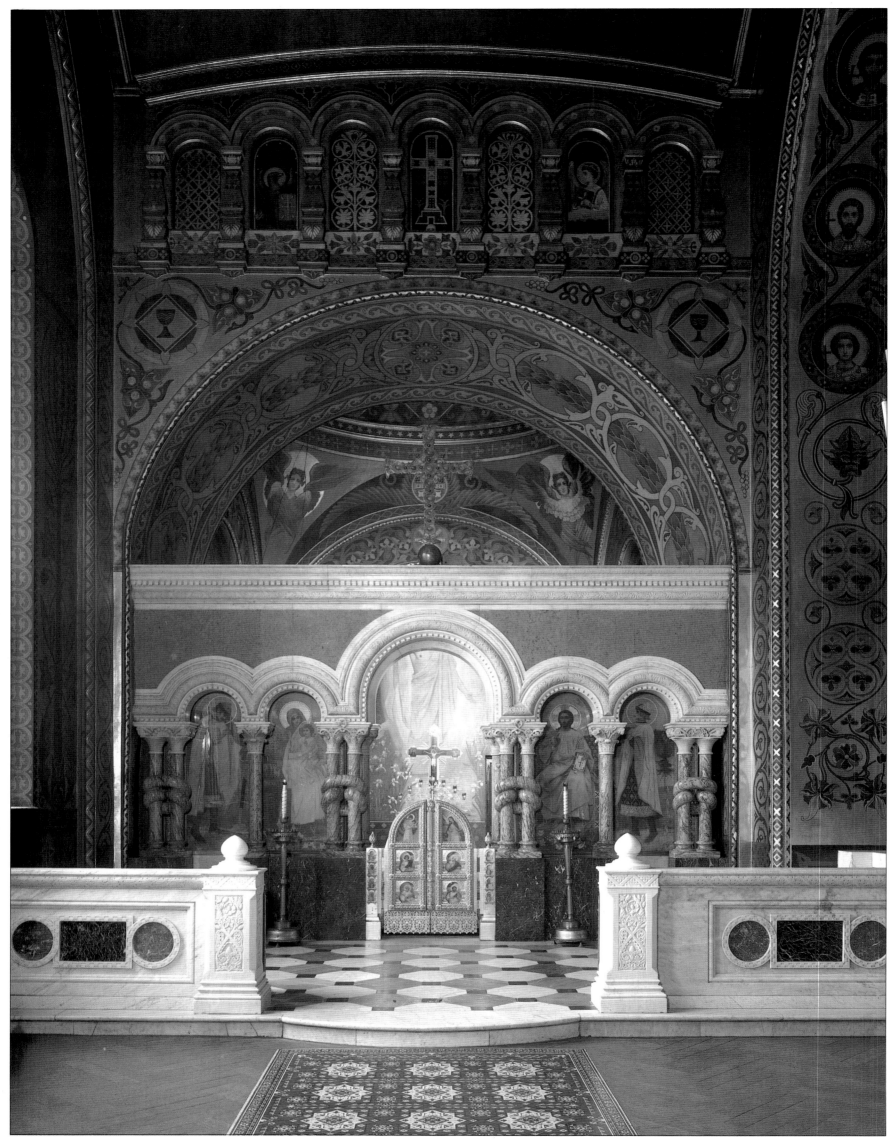

PLATE 236

decorating the interiors of St Vladimir's Cathedral lay in his attempt to use this project as a means of interpreting the religious history and culture of Russia, including the way in which it related to world history and culture through Byzantium, and of reviving the national character of Russian religious art. For the first time, not only the structure of a church but also its scheme of interior decoration was to mirror the earliest period of Russian Christian art. Of particular significance was the deliberate modelling of the work on the Cathedral of St Sophia, Kiev.

The important eastern part of St Vladimir's Cathedral followed the iconography and positioned the representational images in accordance with the scheme of St Sophia's. The symbolic and artistic centre of both interiors was the huge image of the Mother of God with the infant Christ, more than 10 metres (33 feet) high, in the central apse. Vasnetsov took as his proto-image not only the Kiev Mother of God, but also Raphael's Sistine Madonna. This derived not only from the familiar Romantic enthusiasm for trying to unify Eastern and Western artistic traditions, but also from the symbolic value of the image. Vasnetsov wished to convey the sense of boundless clemency and sacrifice of the Mother of God, bringing Christ to the world in order to save the human race and interceding mercifully for mankind, expressed more eloquently in the Raphael Madonna than in the awe-inspiring Madonna of Orthodox art. On the wall of the principal apse, beneath the Mother of God, was a depiction of the Eucharist, a symbol of Christ's sacrifice, in the form of the communion of the Apostles serving him at his throne. On the walls of the apse, looking to the nave, was a representation of the Annunciation; in the pendentives, the four Evangelists; and in the main dome, Christ Pantokrator.

For Prakhov, however, the visual representation of dogma took second place to presenting the most important historiosophical ideas of the time. The positioning, composition and style of the paintings were the vehicles for the expression of the direct descent of Russian art not only from Byzantine, but also from early Christian art, as well as its link with the classical tradition. The desire to convey a Slavophile-derived concept of the Russian people as sole bearer of the unsullied Christian faith, and to represent the loftiness of the ethical message of Christianity as a religion of love and mercy was entwined with the desire to turn the cathedral into a monument to Russian history and culture. This resulted in com-

pletely uncanonical, historically ordered arrangements, a change in the way canonical subjects were presented, with early Christian iconography juxtaposed with later styles. In terms purely of the amount of wall space allocated to them, Russian saints and subjects from Russian history enjoyed exceptional prominence.

A large part of the nave was given over to paintings by Vasnetsov on Russian themes. On each side of the pillars a Russian saint was represented: the first royal Christians, Princess Olga and Prince Vladimir; their descendants, the first saints canonized by the Russian Church, Princes Boris and Gleb, Andrei Bogolyubsky and Alexander Nevsky; Mikhail of Tver and Mikhail of Chernigov; the chronicler Nestor; the painter Alepy; Kukshi, enlightener of the Vyatichi; St Nikita, Bishop of Novgorod. The visitor entering the cathedral was met by scenes of the christening of Vladimir and the Kievans painted by Vasnetsov. The northern wall of the nave was taken up by a picture of 'The Christianization of Rus'. Scenes from the Bible and the life of Christ were relegated to the side aisles.

In decorating St Vladimir's Cathedral Vasnetsov abandoned verisimilitude and realism in favour of using his medium to convey the beauty of Christian morality. This showed in his revival of the decorative and abstract idiom of ancient painting. The gold backgrounds common in the Kievan period reappeared, along with silver backgrounds introduced by Vasnetsov, which retained the abstraction of the gold while imparting a lightness and airiness to the murals. With the rediscovery of the tradition of frescoes and mosaics went a revival of the traditions of icon painting, notably in the shape and whiteness of the angels' wings. Landscape and interiors were treated in accordance with the rules of iconography, disproportionate in relation to the dimensions of the human body. Figures were flat and elongated, outlines linear; faces were given large, exaggerated eyes, narrow, elongated noses and small mouths. Vasnetsov drew on the latest research into the history of Christianity as well as on medieval tradition. In appearance and dress his saints are treated with ethnographical meticulousness, and there is an evident attempt to individualize the faces. The murals' naturalistic quality marks a transitional stage in the work of Vasnetsov, whose mature style was to be considerably more stylized.

Decorative painting Ornament played an important

PLATE 236
View of the iconostasis in the side aisle,
Cathedral of St Vladimir, Kiev, completed 1895.

part in the interior of St Vladimir's. Even as he invited Vasily Polenov to take part in the painting, Prakhov emphasized the importance of creating a unified whole, in which the decorative painting would have a role of equal significance to the depiction of religious scenes: 'Your talent is needed to create not a part, but a poetic whole, not a separate picture out of context, but a series of pictures and scenes integrated by the aesthetic atmosphere of elegant and symbolic decorations inspired by great ideals.'[1] Vasnetsov reinterpreted the traditions of early Christian and Byzantine art in the light of the mural painting of Russian Orthodox churches of the modern period. Decoration provided the background against which the religious pictures were seen, with Christian symbols supplying the main motifs. In the vibrant intensity of its colours,

the decorative painting was close to Byzantine mosaics and enamels. Decoration played a large part in the creation of an atmosphere suffused with beauty, and the heightened excitement of the great feasts, a 'heaven on earth', as Orthodox theologians called the Church. There is an essential parallel here with modernism's high opinion of the role of decoration in communicating the values of beauty and spirituality.

Vasnetsov's work on St Vladimir's Cathedral was the beginning of a great labour of love by the painter, which continued uninterrupted right up to the Revolution. He was trying to renew the heritage of ancient Russia and, at the same time, to find the perfect idiom for the art of Russian Orthodoxy. In the early 1900s, he painted icons and murals for a suburban church near Nechaev-Maltsev's Glass Fac-

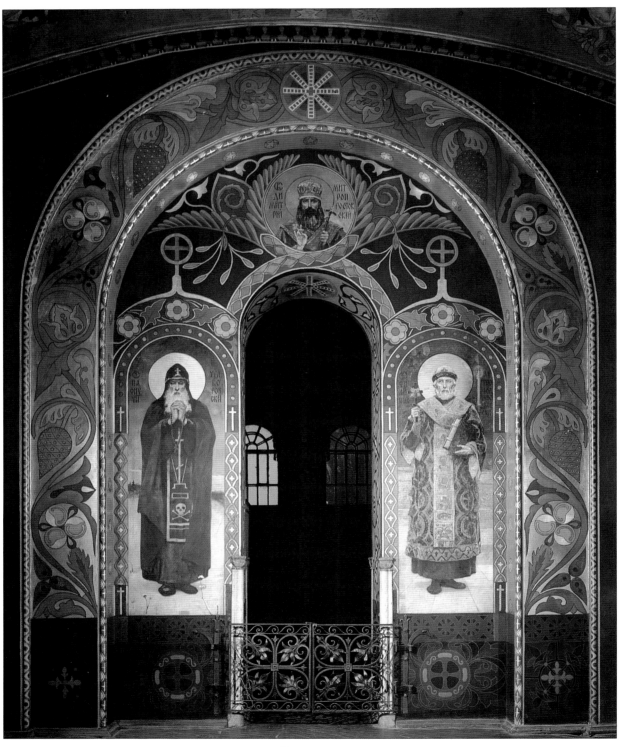

PLATE 237

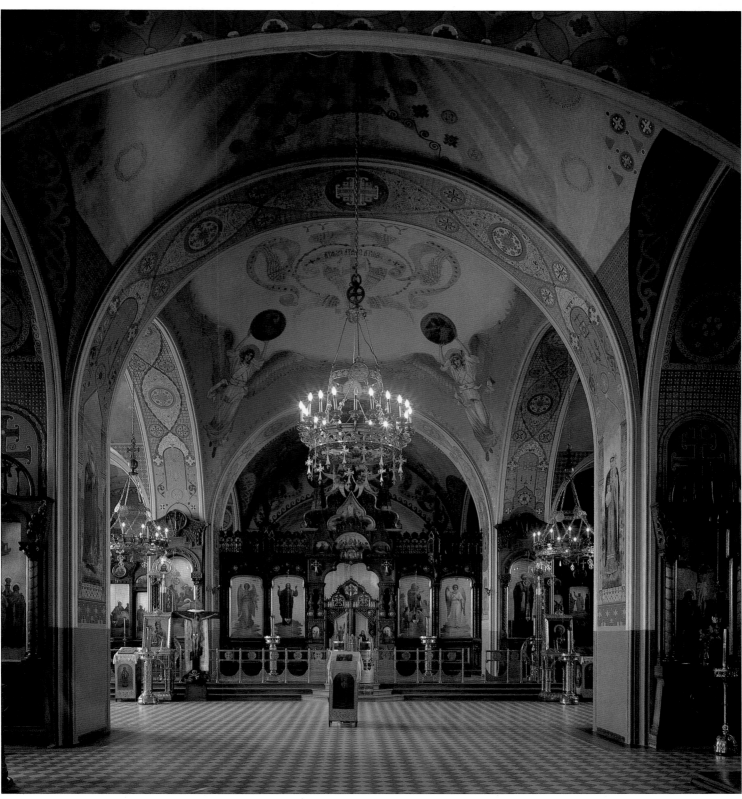

PLATE 238

PLATE 237
Gallery of the Cathedral of St Vladimir, Kiev.
PLATE 238
Church of the Dormition, Petushki, Vladimir
Province, 1910.
An early twentieth-century church interior that
has been preserved intact.

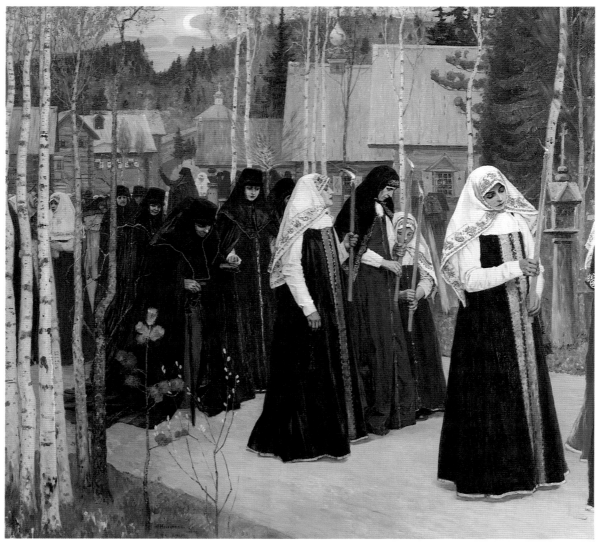

PLATE 239

tory, in the town of Gus-Khrustalny ('Crystal Goose'). In the church in Gus-Khrustalny Vasnetsov painted a mural on the theme 'In Whom the World Rejoiceth'. Here the iconography of the St Sophia Mother of God was combined with that of sixteenth-century Muscovite icons, in which the Madonna was depicted surrounded by a host of angels. In all the new paintings for the church – 'The Last Judgment', 'The Crucifixion', 'The Descent into Hell', 'The Eucharist', and others – the Byzantine, pre-Mongol tradition and that of the Muscovite icons were reinterpreted in the light of modern techniques of linearity, flatness and accentuated outline. In these works the transitional naturalism of the St Vladimir paintings is finally surpassed. Other major religious works by

Vasnetsov are the design of the interior of the Russian church in Darmstadt – notably the frescoes – and designs for mosaics for the Church of the Resurrection of the Holy Blood in St Petersburg, erected over the spot where Alexander II was assassinated.

Nesterov Work on St Vladimir's Cathedral in 1890–95 also had a decisive effect on the subsequent career of Mikhail Nesterov (1862–1942). It was followed by a succession of similar commissions. From 1894 Nesterov worked on mosaics for the Church of the Resurrection in St Petersburg; from 1898, on painting for the Church of Alexander Nevsky in Abastuman. Between 1898 and 1900, he painted icons for the von Mecks' family mausoleum in the Novodevichy

PLATE 239
Mikhail Nesterov, *Taking the Veil*, 1898.
Like many of his generation, Nesterov revered the Old Believers as custodians of an ancient spiritual inheritance that had assumed an indigenous Russian form. Monasticism was central to their religious system. The painter depicts an ideal type of spiritual beauty, quiet and iconic, which is reflected in such details as the graceful folds of the dresses.

PLATE 240
Mikhail Nesterov, *Prince Dmitri Slain*, 1899.
Nesterov displayed a profound feeling for the Russian landscape, which he imbues with a quality of tenderness. The martyr Prince Dmitri is remembered for his innocent suffering, and the stillness of the landscape supports the theme. Benois said of Nesterov that he discovered 'the gloomy solemnity . . . as well as the pensive, religious aspect of our landscape'.

Cemetery in Moscow. Nesterov painted icons for the old church in Gagry; in 1908–11, murals for the church of the Convent of Saints Martha and Mary in Moscow; and from 1913 he was commissioned to paint murals for the Cathedral of the Trinity in Sumy.

Nesterov's early works show that the main features of his spiritual concerns as an artist were already established: the search for God and affirmation of Him as kindness, compassion and man's link with creation. These features are equally characteristic of his ecclesiastical and easel works. Nesterov draws on the Russian cultural tradition, for which 'The Soul of the People' (as one of his programmatic canvases is called) is 'Holy Rus' (the title of another painting), seeking God. He stated that in his works he 'quite deliberately' gives 'the principal role to the people, the God-seeker, and to nature which created the people'.[2] His ideology determined Nesterov's creative preferences – his admiration for Jules Bastien-Lepage, Puvis de Chavannes, the Pre-Raphaelites, Fra Angelico and Botticelli, and for Russian painters such as Alexander Ivanov, whose 'Appearance of the Messiah' and 'Bible Sketches' he especially admired, and Vasnetsov, of whose works in St Vladimir's Cathedral he said, 'The dream comes alive in them, the dream of a Russian Renaissance.'[3] Nesterov also showed intense interest in the artists of the German and Austrian secession, attracted by a quest akin to his own for 'the living soul of living forms, of living beauty in nature, in thoughts, the heart, and everywhere'.[4]

Nesterov's desire to communicate 'my own feeling, my own faith' as accurately as possible on canvas made him reluctant to make direct use of the traditions of old Russian and Byzantine painting. He was afraid that concern for style might take over, muting the intensity of the religious mood. 'The Byzantine style is closest to us . . . but may serve as a model only with severe reservations . . . in itself no one style, artificially evinced, can fully satisfy the aesthetic sense, and even less can it satisfy the seeking for faith itself.'[5] 'What fascinates me in Byzantium,' Nesterov wrote, 'is not what is not there, or was there once upon a time, but what is there, and has survived to our day in all its pristine purity. I am fascinated by the life force in it'[6]

Nesterov's concerns and his artistic language became more precisely defined in his works of the late 1880s and early 1890s, such as 'The Vision of Bartholomew', 'Taking the Veil' and 'Prince Dmitri Slain'. He sought to create works symbolic of the Russian soul, and the role of Christianity in Russian life and history.

Nesterov's subjective, lyrical treatment of a topic – whether overtly religious or a reworking of a purely realistic kind of representation of common people – blurs the distinction between his easel works and his religious painting. The kin-

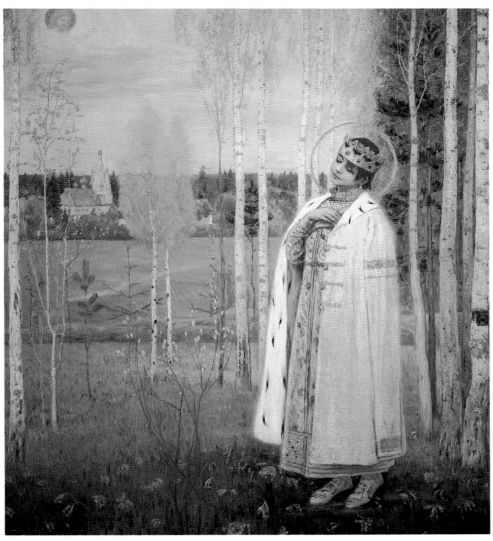

PLATE 240

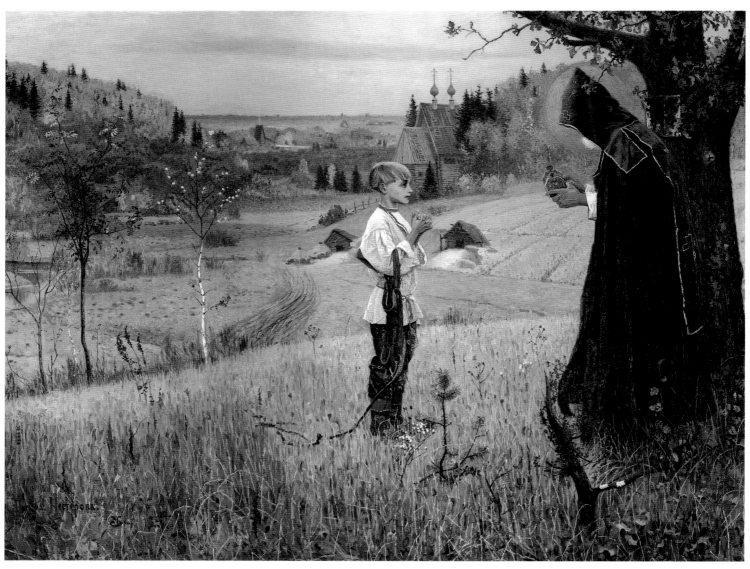

PLATE 241

ship is particularly noticeable when he is treating non-canonical subjects. Murals depicting scenes from the life of Alexander Nevsky on the walls of the church in Abastuman might, if transferred to an exhibition hall, quite easily be taken for a studio panel painting on a subject from the life of old Rus. In some cases this kinship led to an easel picture being directly reproduced in a church mural. Between 1901 and 1905 Nesterov painted 'Holy Rus', which, in the artist's words, depicts people seeking 'their God, seekers after the ideal such as fill our Holy Rus'. Another title for the picture is taken from the Sermon on the Mount: 'Come unto me all you who labour and are heavy laden, and I shall give you rest'.[7]

Nesterov repeated the theme of the seeking of God in his overtly religious painting. In the Convent of Saints Mary and Martha in Moscow he painted a mural on the east wall of the refectory which was very close in composition to 'Holy Rus'. Nesterov himself suggested the subject, 'The Way to Christ', to his patron. 'The sisters of the community of Martha and Mary in their white habits are leading people, and showing them Christ, who is made manifest to them among all their sorrows and afflictions, spiritual and physical. This is occurring in the midst of bright, vernal nature.'[8]

PLATE 241
Mikhail Nesterov, *The Vision of Bartholomew*, 1890.
The subject of the work is the appearance of the mysterious figure of a monk to the boy Bartholomew as he was out searching for runaway horses. As a result of the encounter the boy, unable to learn, was granted the ability to read the scriptures. He grew up to become St Sergius Radonezhsky, founder of the Trinity Monastery, a great centre of

spiritual and cultural renewal and the model for more than a hundred other monasteries founded through the work of his disciples. The muted landscape of the painting lends it a stillness and calm characteristic of the artist's work. It was painted from the countryside near Abramtsevo.

A direct link exists between Nesterov's paintings and the writings of contemporary Russian idealist philosophers, of whom Sergei Bulgakov and Pavel Florensky were his friends. There are also textual coincidences. Bulgakov's words in his article 'The Intelligentsia and Revolution' (1908), a meditation on the results of the first Russian revolution in 1905, are amazingly close to the idea of 'The Way to Christ' as Nesterov himself formulated it. 'Now the twilight again descends upon humankind, as it goes off into a suffocating underground place and languishes there under the yoke of life; but the star of Bethlehem shines even now, and sends forth its gentle ray, opening the heart of each one of us with its still call: come unto me all you who labour and are heavy laden, and I shall give you rest'.[9]

'The Way to Christ' is the only mural in the refectory of the cloister. Placing a single mural, usually on the east wall of a church, or in the case of the Convent of Saints Martha and Mary, in church and refectory, was common practice at the turn of the century. The device makes the iconostasis much more prominent. The low height of iconostases built at the turn of the century result in a prominent role for the mural painting of the chancel, which now took on some of the functions of the iconostasis itself.

Nesterov is at variance with the *peredvizhniki* in his conception of the people. His 'pilgrimages' are an implicit rebuke to their paintings on similar subjects, and in particular take exception to Repin's famous 'Religious Procession in Kursk Province', with its aspiration to give a generalized, objective picture of the whole of Russia. Nesterov's approach is much more in sympathy with the spirit behind Alexander Ivanov's masterpiece 'The Appearance of Christ to the People'. In Nesterov's paintings, however, corresponding to the changed emphasis of the times, it is not Christ who is coming to the people – as in Ivanov's painting – but the people who are coming to Christ. This is strikingly evident in his last great 'God-seeking' painting, 'In Rus', known also as 'The Christians', which he completed in 1916, just before the Revolution. Here, the whole Russian people – both great and small; princes, boyars and tsars of medieval Rus; representatives of every class of contemporary society, of all ages: priests and monks, the leaders of the intelligentsia, Tolstoy, Dostoyevsky, Soloviov and more; a wounded officer and a nurse, led by an innocent boy – advance slowly but purposefully towards Christ. The painting is almost a mirror image of Ivanov's canvas, in which the expectant crowd is disposed over the foreground, with Christ positioned in the distance and moving towards it. Nesterov's painting reverses this, placing·the crowd in the background, moving towards the viewer. The foreground is empty, the way open.

Vrubel Mikhail Vrubel's religious works, indeed his very acquaintance with old Russian art, are closely associated with Kiev. He arrived in Kiev, ahead of both Vasnetsov and Nesterov, in April 1884, to restore and, where necessary, repaint the murals of the eleventh-century church in St Kiril's Monastery. Towards autumn the main restoration work was complete, and he had painted 'The Descent of the Holy Spirit', 'The Annunciation' and 'The Lamentation at the Tomb'.

Unlike those artists who were practising Christians and saw the creation of religious art as a duty, Vrubel, who was indifferent to religion, considered this work to be simply another job – albeit a most important one. He saw the eternal as separate from Christianity, and only partly associated with Russia. It was, however, his work in Kiev, his study there of mosaics and frescoes, and his later journey to Italy to study the old Christian monuments and Renaissance art, which shaped his artistic idiom. With the exception, perhaps, of his first works in the St Kiril Monastery, he did not draw directly on Byzantine art sources. The exceptional power of his creative imagination, and his ability to penetrate into the essence of the artistic structure of past works, enabled Vrubel to recreate the inner conventions of both Italian and old Russian art. His aim was not to reproduce the stylistic features of his prototypes but to create his own original work based on their conventions.

In restoring the murals of St Kiril's Church, Vrubel's technique was to simplify, and make archaic, examples of art dating from before the Mongol invasion of Russia in the thirteenth century. One of the sources was the Eucharist in the apse of St Sophia's, Kiev. Vrubel hyperbolized the angularity of the forms and abruptness of the rhythms. In order to increase dramatic tension and expressiveness, he exaggerated proportions – weighting and enlarging hands and legs.[10] Going further in this direction, Vrubel turned also to examples of Carolingian art and the frescoes of the Church of the Saviour at Nereditsa, near Novgorod (the prototype for the Abramtsevo church), and of St George's Church in Old Ladoga. His interest was in the archaic quality of their drawing, and their expressive use of space.

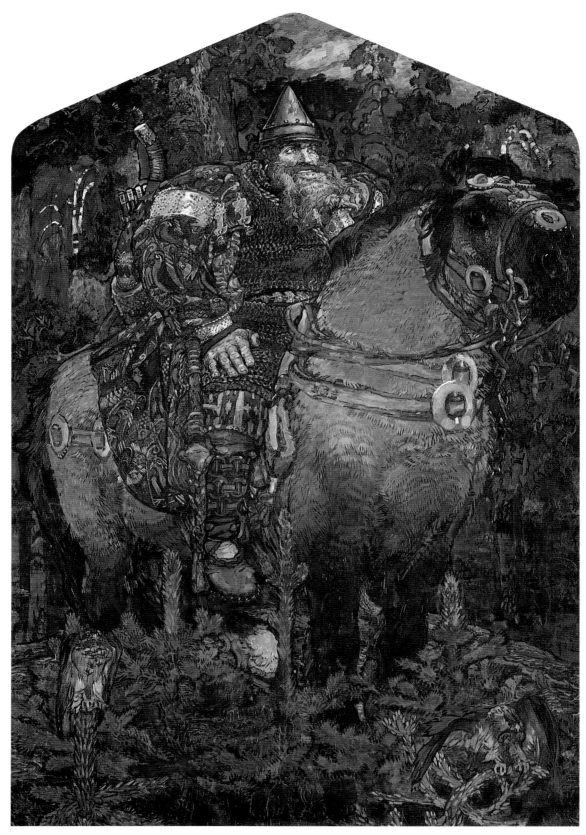

PLATE 242

PLATE 242

Mikhail Vrubel, *The Bogatyr*, 1898.
In this decorative panel, Vrubel tackles the
theme of the ancient Russian epic hero, a
symbol of elemental strength, which had
already been made famous by Vasnetsov.
Vrubel's version reflects the gap between the
generations. His aim was to emphasize the
nature and power of the subject. Here, the
massive figure seems almost to overflow the
space, while trees scarcely reach the rider's

stirrups. His figure, as Vrubel described it,
quoting the legend of the bogatyr, is 'a bit
higher than the forest, a bit lower than the
moving clouds'. The synthesis of dynamic
shapes owes much to art nouveau but the
reworking of the style is entirely Russian.
At the time of its completion, Vrubel's painting
was so new as to inspire some controversy. It is
significant that Diaghilev rejected it as an
exhibit for the exhibition of Russian art that he

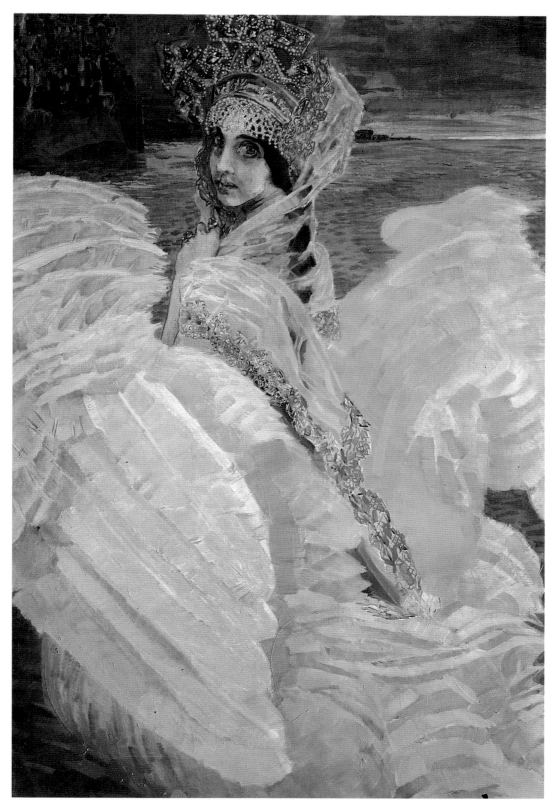

PLATE 243

PLATE 243
Mikhail Vrubel, *The Swan Tsarevna*, 1900.
A painting inspired by Pushkin's fairy tale and
celebrated in Rimsky-Korsakov's opera, in
which Vrubel's wife, of whom this painting is
also a portrait, played the leading role.

was arranging in Paris. Among those who
never doubted Vrubel's great talents were
Tenisheva and Mamontov. The latter
commissioned another version of this work for
the All-Russian Exhibition at
Nizhny-Novgorod.

The icon of the Madonna and Child which Vrubel painted in 1885 for St Kiril's iconostasis shows a characteristically free attitude to traditional iconography. This masterpiece bears hardly any relation to the Byzantine and old Russian traditions, being closer, even in its iconography, to Italian Renaissance models.

In 1887 Vrubel created a series of remarkable designs for murals in St Vladimir's Cathedral which were never realized because of their audacity. There are several variants of the pictures 'The Lamentation at the Tomb', and 'The Resurrection' which demonstrate a profound mastery and adaptation of the tradition of Byzantine and old Russian monumental art that had already been hinted at in the St Kiril murals. Rhythm becomes an independent, powerful means of emotional, artistic and symbolic expression, the composition based on a clear, simple correlation of verticals and horizontals. Vrubel's medieval prototypes were not, however, his only source. He drew also on Alexander Ivanov's 'Bible sketches', and some

of the variants of 'The Resurrection' are noticeably influenced by Michelangelo's version of the Last Judgment in the Sistine Chapel.

Vrubel's work on the murals of St Kiril's Church and St Vladimir's Cathedral, and his study of Byzantine mosaic technique, resulted in his evolving the highly individual technique of the separated, blurring brush stroke. This enabled him to achieve precisely the opposite effect from that sought after in the mosaics: destruction of the unity of form, and creation of an impression of unity between the figure and space. Vrubel went further than Nesterov and Vasnetsov in his transformation of the academic canons and of the principles of direct perspective and three-dimensionality, which derived from the Renaissance. Where Nesterov and Vasnetsov mitigate perspective and three-dimensionality by reducing the autonomy of the background, Vrubel achieves this by giving the background an artistic force and character of its own. The mosaics of Kiev and Ravenna helped him to develop a palette

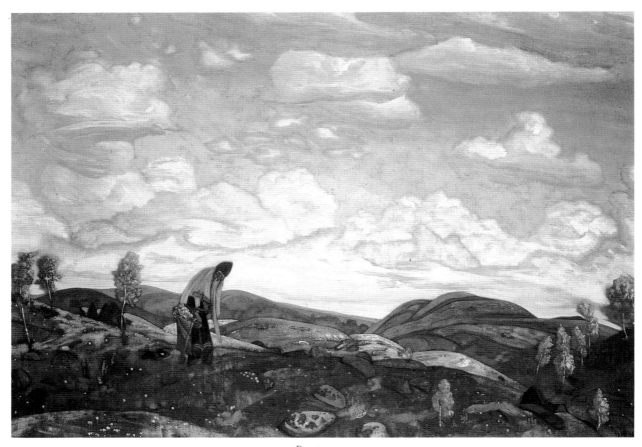

PLATE 244

PLATE 244
Nikolai Roerich, *Pantelymon the Healer*,
1916.
The solitary figure gathering healing herbs is
contrasted with the mystic landscape,
demonstrating another aspect of Roerich's
preoccupation with old Russia –
a philosophical attitude towards a romantically
perceived past.

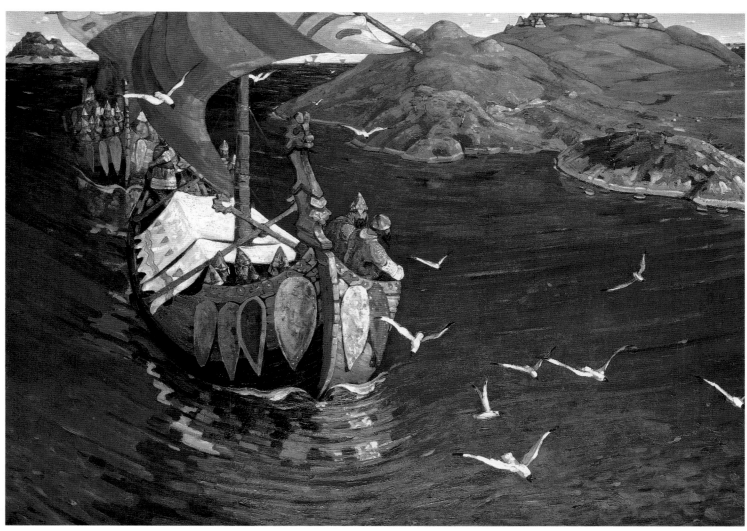

PLATE 245

of exceptional richness and saturation. Having discovered the richness of colour, the beauty, and the organic fusion of decoration and spirituality of medieval art, Vrubel created a synthesis of the pictorial quality of modern European art and medieval monumentalism.

Roerich In the case of Nikolai Roerich (1874–1947) the contemporary belief in beauty as an end in itself and as the most potent factor in the reconstruction of life is linked with the conviction that the folk-art tradition must be revived. Both were central to his religious philosophy. Like many idealist philosophers, writers and artists, including Nesterov and Vasnetsov, Roerich found his way to religious painting indirectly. His work shows other features characteristic of the

turn of the century. Stylistic distinctions between different kinds of visual art, religious and secular in particular, disappear; and there is a tendency to go beyond seeking out new sources as a means of renewing the artistic idiom, and to create iconographical schemes.

At the same time, Roerich's interests differed significantly from those of Nesterov, Vasnetsov and Vrubel. Roerich was from St Petersburg, and from 1910 was the leader of *Mir Iskusstva*. The main artistic and philosophical concept underlying all his creative work was his own interpretation of the philosophy of pan-unity. He dreamed of creating a realm of harmony, spirituality and beauty, in which the ancient foundations of Russian culture would be reborn, and this

PLATE 245
Nikolai Roerich, *Visitors from over the Sea*,
1901.
Roerich's well-known canvas depicts the
arrival of the Varengians, who were credited
with the organization of the earliest Russian
state. Thickly applied paint contrasts with rich
colour, producing a carpet-like effect which is
characteristic of Roerich's retrospective
search. The work can be seen *in situ* in the
Pertsov House in plate 168.

made him a deliberate archaist. In his work he turned to themes and sources which his colleagues ignored such as proto-Slavonic and early Slavonic culture, archaeology, and the Stone Age.

Roerich dreamed of creating a gallery of early Russian history. In his own words: 'I am tormented by a dream which can never come true. Someone will put at my disposal the hall of a museum, and there I shall paint "The Beginning of Rus", painting all the walls from floor to ceiling, making sense of a

Russian history, and looking towards a rebirth of the style of early Russian art.

Roerich also drew heavily on Oriental sources. His belief in the Indian origins of Russian culture show him as a typical neo-Romantic, subscribing to a deeply rooted belief widely held in the Romantic period.

The urge to participate directly in spiritual renewal brought Roerich predictably to religious art – especially in the form of mosaics. Between 1906 and 1914 he completed a number of

PLATE 246

whole period, so that a visitor entering immediately finds himself transported to that age. . . . It would deserve to be the work of a lifetime, so much new insight could it bring to art and science.'[11] This underlying idea matured in Roerich's mind in 1897, and the works he created over the course of the next two decades, right up until the Revolution, derive from it. His global orientation and his efforts to break down the fundamental questions of existence through the medium of art, brought Roerich to the work of Alexander Ivanov (1806–58). A conscious move towards Ivanov's painting and a sense of common cause with his underlying aims was typical enough for an artist in this period, but Roerich had his own interest. Ivanov had created his 'Bible sketches' in the hope of someday decorating a church of the spiritual history of mankind. Roerich had a similar aspiration towards the spiritual enlightment of mankind, but utilizing the material of

murals, many in mosaic, for monasteries and churches. After becoming principal of the College of the Society for the Encouragement of the Arts in St Petersburg in 1906, he established a class of icon painting, whose main purpose was to study ancient techniques and iconography. There was a general trend towards the creation of new iconographical schemes derived from reinterpretation of traditional subjects. In Roerich's work this led to very individual results. While seeking to communicate some of the key concepts of Indian philosophy, he had, as his primary interest, the most ancient strata of Russian medieval art: the Kievan mosaics and frescoes, and icons and frescoes of Novgorod and Pskov. The fusion of these two influences produced some unconventional results.

In the apse of the Church of the Holy Spirit at Talashkino, Roerich depicted the Mother of God as the Queen of Heaven

PLATE 246
Nikolai Roerich, *Mikula Selyaninovich*, 1909.
This decorative panel formed part of a frieze painted in tempera for the dining room of a flat in Bazhenov House, an apartment block in St Petersburg. The frieze ran in a continuous band around the walls, consisting of eight paired panels depicting *bogatyrs*. The legendary Mikula Selyaninovich shown here was a ploughman who defeated the son of a Varengian prince in single combat.

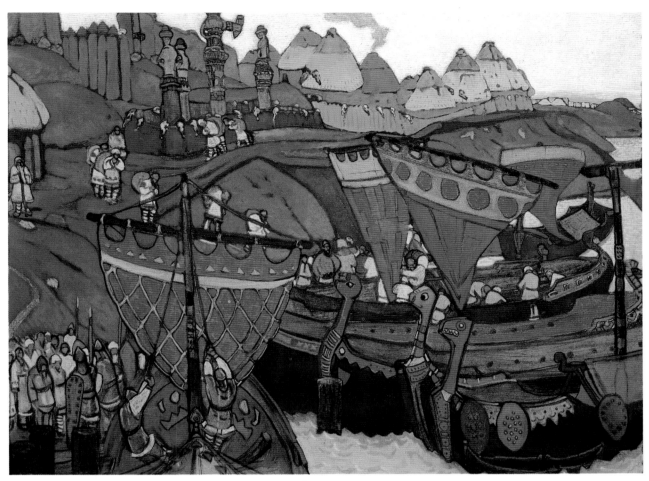

PLATE 247

above the River of Life. She has brought her hands together in prayer for the human race, which is struggling in the turbulent river. To the sides are cities guarded by angels. This pantheistic rendering of the Mother of God is tinged with the religions of the East, and reveals at the same time an affinity with the idea often encountered in Russian religious art, and consistently propounded by Roerich, of the popular nature of religion, the direct participation of the saints in the life of the people. Roerich wrote of the Queen of Heaven, who helps 'the wanderers, the blunderers, those who cannot tell good from evil'.[12]

This idea of the active intercession of the Mother of God goes some way to explaining why, in the tense atmosphere of the early twentieth century, as people sensed the lull before the coming storm, the traditional Russian symbol of the enfolding mantle of the Mother of God should have become so popular. In Parkhomovka an enormous mosaic icon of the mantle was located above the main entrance to the church on the western façade of the bell tower. The belief in the intercession of heavenly powers is evident in the frequent depiction of symbols of earthly life in religious pictures. The Mother of God extends her mantle, supported by the host of the angels, over the city, by whose walls its righteous men pray to her for mercy. In the Church at the Powder Factories in Schlisselburg saints especially popular in Russia are also depicted above the city – 'the invisible city' become visible, the heavenly Jerusalem, a highly allusive symbol of Russia and the Russian Church. The first Russian saints, Boris and Gleb, on their mighty steeds, are depicted, traditional iconography notwithstanding, above the city. The saints Nicholas Mirlikiisky and Alexander Nevsky stand before Christ holding a church which seems to become part of the body of Chr-

PLATE 247
Nikolai Roerich, *Slavs on the Dnieper*, 1905.
Roerich's evocation of pre-Christian Rus
shows Norse Varengians among the
indigenous Slavs. The pagan idols, which
resemble totem poles, are set up outside the
town stockade.

ist, while at the feet of the saints there is representation of the city, again with the idea of intercession.

Roerich brought a profoundly dramatic treatment to the severe painting of Novgorod and Pskov. His art is splendidly integrated with the architecture. The compositional rhythms and features of the mosaics and murals are subordinated to the architectural structure of the church, repeating and emphasizing them.

Roerich's easel paintings, created in an age of revolution and war, differ little in subject matter from the work he did for churches. The two dominant themes are the intercession of the saints for the land of Russia and a terrible foreboding of impending cataclysm. Intercession is represented in pictures such as 'Prokopy the Righteous Deflects the Thundercloud of Stone from Great Ustyug', 'Prokopy the Righteous Prays for Those on the Seas', 'Panteleymon the Healer', 'St Nikola' and 'Three Joys'. Roerich's sense of foreboding is evident in the pictures 'Dusk', 'The Cry of the Serpent', 'The Doomed City' and 'The Seers of Evil'.

The same may be said even of Roerich's works for the theatre. He painted a front curtain for Sergei Diaghilev's third Russian season in Paris in 1911, for the musical entr'acte 'The Fray at Kerzhenets', in Rimsky-Korsakov's opera, originally named *The Tale of the Invisible City of Kitezh and the Fair Maid Fevroniya*. The fray is depicted in a populous battle piece, its dynamic rhythm, vivid colour, and indeed its whole structure looking much like a replica of his previous compositions for Talashkino. So far as its iconography is concerned, the curtain is a reworking of such grandiose sixteenth-century compositions as the iconographic scheme known as 'The Church Militant'. Here again, the style and idiom of religious art invade Roerich's secular painting. We may see in this interpenetration the realization, if only partial, of the philosophy of pan-unity, and a manifestation of the idea of the Church as the 'invisible city'. That Rimsky-Korsakov should have created an opera on such a subject, the fact of its production in Russia and Paris, and its stage design all testify to the extent to which the ideas of the religious thinkers had taken root in the minds of educated Russian society.

Folk traditions in religious art　Roerich's art represents the archaic tendency in Russian religious art. It exists alongside the art of Nesterov and Vasnetsov, which had not entirely broken with academicism and the artistic conventions of the day. Simultaneously with these two movements, which were developing within the general context of European art, there suddenly reappeared Russia's native religious art, which had preserved an unbroken tradition since before the age of Peter the Great and which, for two centuries, had been developing outside professional art. The creators of this art were the unknown artists working in such centres of icon painting as Palekh, Mstera and Kholuy. Now, for the first time, their icons were taken up, if not by all of educated society, at least by Court society. These folk craftsmen were invited to work in many important buildings, such as the St Petersburg church built in honour of the tercentenary of the Romanovs. In the church of the Pochaev Monastery in the Ternopol region we find Vasily Shcherbakov, an artist schooled in the folk tradition, working with Shchusev and Roerich.

Every item required for the conduct of religious services was conceived as an integral part of the church ensemble: the furniture, the liturgical vessels, even the light fittings. Many a major artist was to be found working in factories and workshops manufacturing religious objects. Among them was Sergei Vashkov, chief designer of the firm of Olovyanishnikov, whom we have already mentioned. The great resurgence of Russia's Silver Age – the explosion of creativity at the close of the nineteenth century – took in every branch of applied art. The same stylistic movements were to be found in it as in other art forms.

We can see this in textiles – for example in the fabrics created to Vashkov's designs for church vestments. Alongside relatively traditional designs, which drew on the plant-like ornamentation of manuscripts or the patterning of silver items, we find fabrics with patterns derived from folk-printed textiles, or a reinterpretation of traditional motifs like sunflowers, or the characteristically Russian pattern of stylized burdock leaves. In these patterns the rhythmic element is more pronounced. Innovation and the link with the latest artistic ideals show themselves most clearly in two types of design: those based on early Christian symbols and those derived from the cross-patterned chasubles of the saints and patriarchs.

This division into fabrics patterned on early Christian sources and old Russian and folk examples is far from rigid. Often we find early Christian symbols happily coexisting with floral motifs from folk painting, printed fabrics and multi-coloured ceramic tiles. The reworked sources do not remain compartmentalized, but are fitted into new, original fabric

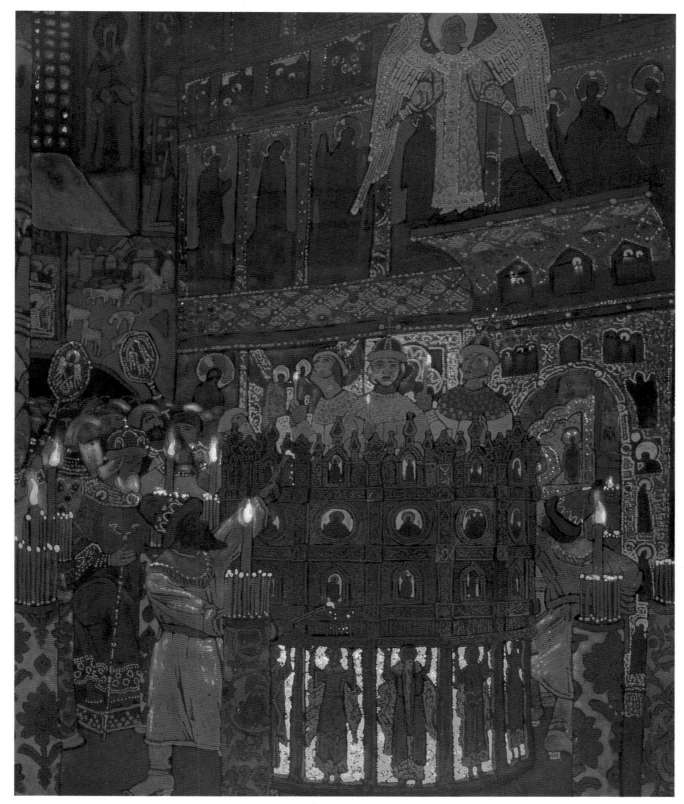

PLATE 248

PLATE 248
Nikolai Roerich, *Mystery Play in Medieval Novgorod*.
The play celebrates the three youths, Shadrach, Meshach and Abednego, consigned by Nebuchadnezzar to the fiery furnace. A sense of mystery is imparted in the painting by the backdrop formed by the iconostasis – an essential cosmological backdrop for liturgic drama. In the medieval world, as in living orthodox tradition, musical incantation had a 'magical' property. One Byzantine commentator has written that the boys' angelic song transmuted the furnace into a sacred space in which the fire could not burn. Roerich's rendering of the interior, dimly lit, is strongly atmospheric.

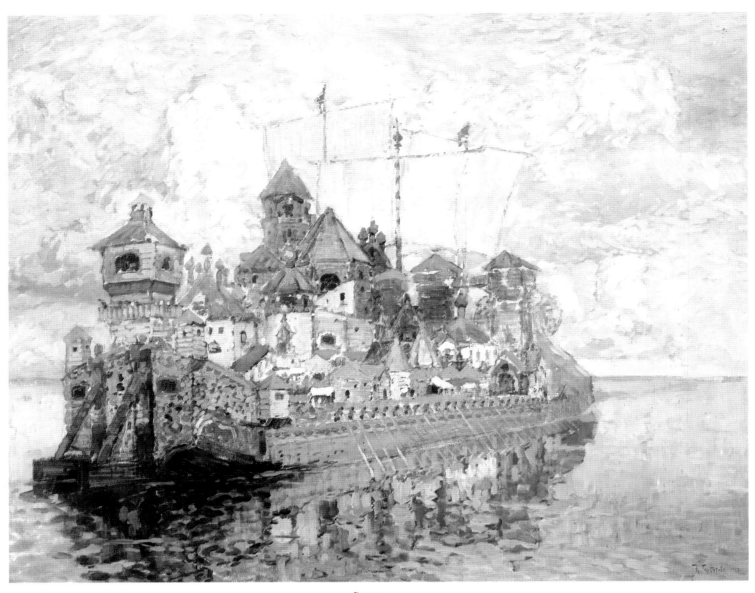

PLATE 249

patterns. The decorative element is heightened, rhythm becoming more complex and prominent, patterns becoming enlarged and colours more saturated.

The range of colours employed also changed at this time. Use was made of colour symbolism, with violet – a favourite with the symbolists and with followers of *moderne* – being especially popular. On the other hand, we must note an interesting revival of national colours. Red became exceptionally popular (in old Russian, 'red' is a synonym for 'beautiful'). Red backgrounds are widespread in icons of the medieval

Novgorod school. In church fabrics, another much-used colour is gold, the colour of divine grace and of the sun, of the background of ancient mosaics and of the frames of Russian icons. This tradition made an unexpected comeback in Russian icon painting at the turn of the century, with gold backgrounds in icons again becoming common.

Special mention should be made of those fabrics that Vashkov created in imitation of the cross-patterned chasubles seen in icons and frescoes. The clarity and purity of form of the expressive rhythmic patterns, and their significance, invite

PLATE 249
Konstantin Gorbatov, *The Invisible City of Kitezh*, 1913.
A legend with an abiding influence on Russia's view of her past was that of a city of unforgettable beauty which escaped the Mongol invasion through submersion at the bottom of a lake. It was said that sometimes the golden domes and brightly coloured rooftops of its churches, terems and palaces could faintly be discerned through the water,

while the pealing of bells reverberated to the surface of the lake. For a country with a history punctuated by invasion and schism, Kitezh signifies the value of an ideal past which endures in the memory of her people. Gorbatov uses spots of colour to create a dense, decorative surface.
PLATE 250
Andrei Ryabushkin, *Seventeenth-Century Women in Church*, 1899.

comparison with the later works of Suprematism and the aims of the avant-garde. They show, too, how extensive Vashkov's searching was, how deep were the semantic roots of these designs and how accessible they become through the use of universal symbols.

Russian Folk and Medieval Themes in Secular, Fine and Graphic Arts

By the end of the nineteenth century the decorative style associated with murals and other *in situ* painting was influencing easel works. This was one more result (along with the convergence of religious and secular art, fine art and architecture) of the search for synthesis and a single overall style.

Ryabushkin The artist who most clearly exemplified the new trend was Andrei Ryabushkin (1861–1904), who painted mainly scenes from bygone Russian life. In Ryabushkin's mature works of the mid-1890s, conflict disappears from the subject matter, as does close attention to commonplace detail. The main purpose of such historical scenes as 'Holy-Day Street Scene in Seventeenth-century Moscow', 'Seventeenth-century Russian Women in Church', or 'A Wedding Procession in Seventeenth-century Moscow', is to evoke and celebrate the solid, patriarchal features of Russian life. The old *peredvizhnik* approach of the social chronicler disappears. For Ryabushkin Russian culture and life became an

end in themselves. The revival of traditional forms became a means of expressing the new approach in its own right.

Ryabushkin saw history as inseparable from the life of the people. What attracted him in the life of the people was what interested him in history: the elements of stability, the things that are important and recurrent. He painted ceremonial, ritual or ritualized action: folk dancing, celebrations, tea-drinking. In his paintings the solemnity of the moment and the patriarchal nature of the custom bring the past into the present. The only things that seem worthwhile in the present are those rooted in the distant past. In both his pictures on folk and on historical subjects what interests him are the important moments in the lives of ordinary people. For him, as for earlier historical painters, the main vehicle of the sense of history is costume and the objects of the environment. These are painted realistically, but without the earlier documentary emphasis. Ryabushkin's ideal of beauty is inseparable from the ideal representation of Russia, which he most consistently embodies in female figures. This can be seen as a different perspective on Nesterov's thinking on the Russian ideal, less ethically based, but clearly enough expressed in aesthetic terms, sometimes with a touch of irony.

Ryabushkin's desire to show the beautiful and the poetic in the everyday sent him back to the seventeenth century, which he found aesthetically congenial. Although he did not turn

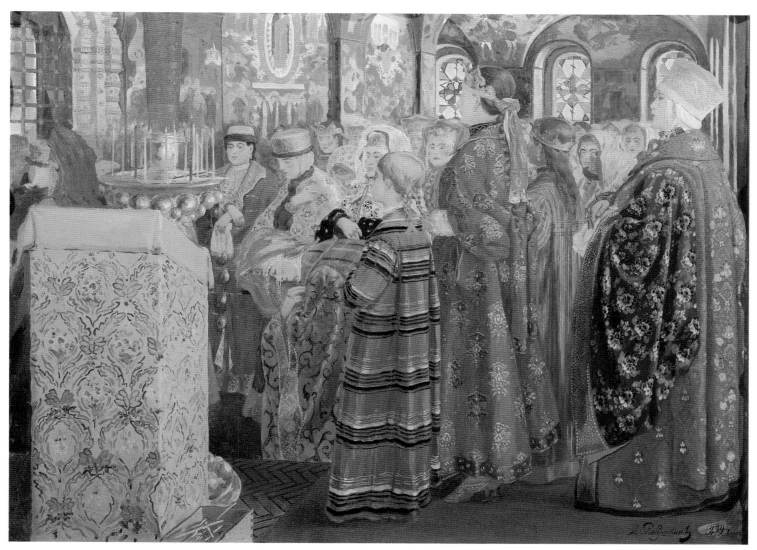

PLATE 250

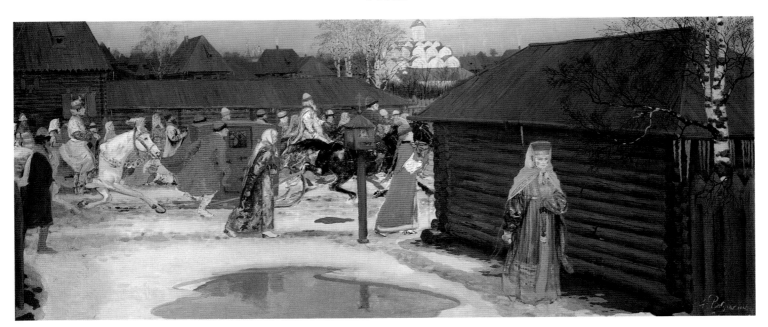

PLATE 251

directly to folk art or old Russian art, they greatly influenced his style. He moved beyond the nature and *plein air* approach of his early works to create a consistently decorative idiom. He worked with vivid patches of pure colour, treating figures two-dimensionally, with sophistication of line and expressive rhythms.

Colour was the most important of Ryabushkin's means for characterizing his image of Russia. His palette has the vitality of the hues of icon painting and frescoes. Red – with its connotations of Russian patriotism – has a special place in his work; sometimes a whole picture is constructed in different shades of red, as in 'Seventeenth-century Russian Women in Church', or 'Young Girl in Seventeenth-century Moscow'.

Ryabushkin's experimentation was anticipated by a picture that Konstantin Korovin (1861–1939) painted in the 1880s. Although only an episode in the career of the greatest of Russia's small number of impressionists, it is of great significance for the evolution of the peasant genre. Like historical painting, the peasant genre lost its anthropological dimension in the late 1800s. The main theme of Korovin's 'Northern Idyll' is the beauty of the spiritual world conveyed through the tangible beauty of landscape and of the peasant-girls' costume, as they sing to the accompaniment of a boy playing on his pipes. Korovin's painting is a manifestly transitional piece. The landscape and costumes are accurately depicted, but with a

tendency towards surface composition. The contrast of the vibrant sarafan gowns against the green of the meadows and woods is frankly decorative, the scene perceived symbolically as a poetic image of Russia.

Malyavin Until the second decade of the twentieth century the influence of folk art in Russian painting was principally indirect – implicit in a joyous perception of the world, in the showy, vibrant range of colours, in the prominence of red and, finally, in the subject matter. Festive scenes predominate: tea-drinking, holiday scenes and folk-dancing. The same is true also of the painting of Filip Malyavin (1869–1940).

Malyavin earned his place in art history as an artist of the peasant theme, generally following in the footsteps of Korovin and Ryabushkin. His mature work illustrates the liberation of easel painting from social relevance and chronicling of the everyday. He embodies Russianness in his figures of peasant women in their festive costumes, often dancing with feverish abandon. One such work in this vein is aptly entitled 'Whirlwind'.

Kustodiev Yet another vision of Russia is offered in the work of Boris Kustodiev (1878–1927). His paintings divide into those on peasant themes and those depicting the life of a provincial Russian town. Kustodiev's subject matter is the same as that found in the rural and urban genres of the

PLATE 251
Andrei Ryabushkin, *Wedding Procession in Seventeenth-Century Moscow*, 1901.
The work of Ryabushkin reflects the subtle shift in the way in which ancient Russia was perceived at the turn of the century. As a result of continuing historical research, he and his contemporaries were better informed about the past. The new generation moved decisively

away from subjects inspired by social commentary and moral issues, and instead portrayed the enduring qualities of Russia and the patriarchal customs of the people.

peredvizhniki, but in terms of style and meaning they are far apart. He turned to depicting Russian folk life in the middle of the 1900s. Chronologically, peasant subjects preceded urban ones, but both of them present Russian life as a joyous, self-contained world of traditional customs which contemporary life has discarded.

Kustodiev constructed his peasant paintings on the principles of a decorative panel. All are painted in a stylized manner. This is not the real Russia but an idealized Russia of annual fairs, rustic holy days and harvesting of fields of grain. There is no place for anything gloomy, sad or depressing.

The paintings are sparklingly alive with vivid colours and an abundance of detail, crowded with figures, grouped into numerous individual scenes. By contrast, his paintings of the life of provincial towns generally have few figures. Often they depict merchants' wives. The main figure has a monumental quality, and the dimensions of the picture are correspondingly large. The women may be represented against an urban landscape or in an interior. Fine, ample women, dressed in magnificent silks, they drink their tea, make conversation or simply pose. 'What I find really attractive,' Kustodiev emphasized, 'is decorativeness. A painting composed and

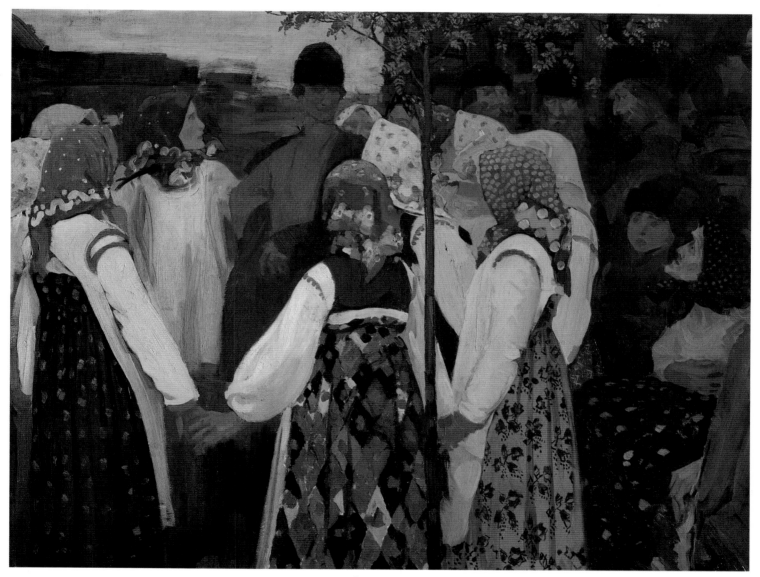

PLATE 252

PLATE 252
Andrei Ryabushkin, *The Round Dance:*
A Youth Steps In, 1902.
At the beginning of the twentieth century the customs of the countryside were still vigorous and were affectionately celebrated by such painters as Ryabushkin and Kustodiev. The ancient round dance, of which variants exist throughout the Near East, reserves a key role for the male dancer; Bilibin writes: 'the man dances like a demon, performing every

possible trick at dizzy speed. In contrast, the women dancers preserve a serene tranquillity, making only small movements of their shoulders.' The painting shows the moment at which the youth takes his place at the centre of the circle.

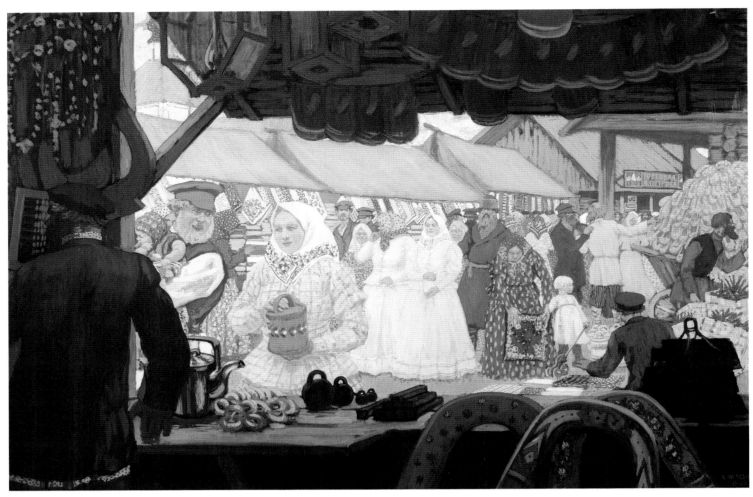

PLATE 253

painted not in a coarse, straightforward way, but stylized – that is beautiful.'[1]

In Kustodiev's work, as in that of any other major artist, meaning and style are interdependent. His move from working in oils to painting in tempera is an oblique reflection of the icon and fresco tradition. This was a technique used by the great icon painters, and one adopted by many of Kustodiev's colleagues, including Roerich. Other media and sources that fed his creative imagination included Lukutin lacquers (decorative papier-mâché objects decorated with lacquer); the painted decoration of distaffs; wooden and clay toys; folk costumes and fabrics; old Russian *parsuna* painting; and the formal portrait refracted through a folk-art style. Yet another source was the signboard, a form of advertisement for the illiterate. Signboards figure in Kustodiev's paintings both as subject matter and a source influencing his manner.

Kustodiev's work demonstrates clearly the difference between easel painters working in what may be called the domestic genre and those other artists, like Roerich, Nesterov and Vasnetsov, who were identified with religious and moral concerns. The artists of the Russian domestic genre were closer to the 'westernizing' wing of the *Mir Iskusstva* in their attitude towards an ethical dimension in art, seeing it as separate or irrelevant. Kustodiev's presentation of beauty as a self-sufficient absolute could not conceal an inner dissonance in the beautiful world he created. There is an irony which can tip over into the grotesque, a sense of aloofness and a lack of straightforwardness which the world of his images might seem to demand, which put Kustodiev in the *Mir Iskusstva* camp – not formally, but in terms of his artistic vision.

PLATE 253
Boris Kustodiev, *The Fair*, 1908.
Kustodiev is renowned for his celebration of
the patriarchal lifestyle of the provincial towns
and villages and their colourful festivals. Here
we see a vivid depiction of village life on the eve
of its destruction.

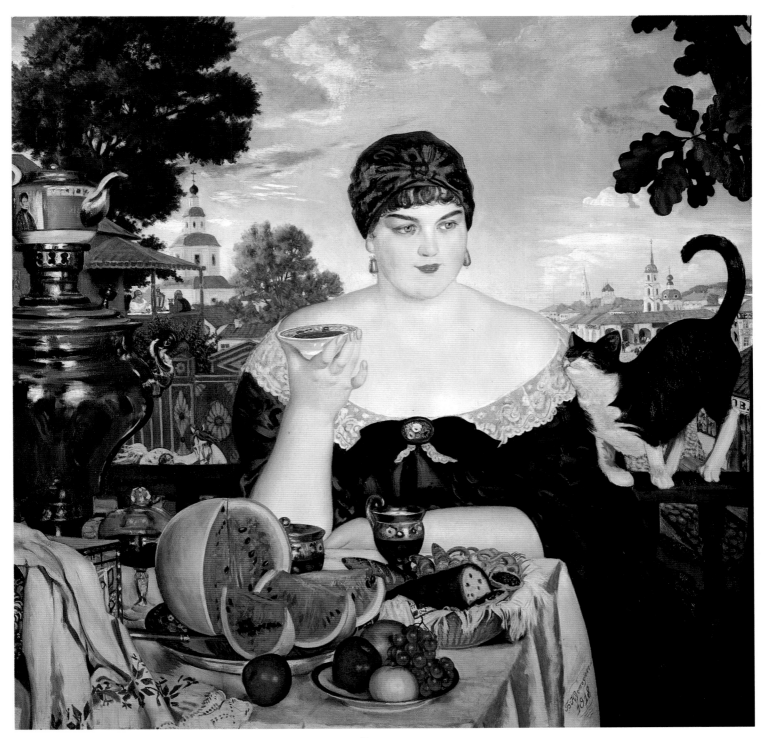

PLATE 254

PLATE 254
Boris Kustodiev, *The Merchant's Wife*, 1918.
The welcoming samovar suggests an invitation
to the well-spread table, which is set with
prized Gardner porcelain from the period of
Nicholas I. Beyond the balcony a boundary
fence of Russian blue encloses house and yard,
while in the distance domes and bell towers of
the early nineteenth century rise against the
sky. The merchant's wife, replete and
welcoming, is a true product of provincial life,
affectionately observed.

PLATE 255

Like Malyutin and Malyavin, Kustodiev worked extensively as a portraitist, and his portraits, like theirs, adhere to the realist tradition. They give no hint that their creator was a master of the idiom of folk art – their style being entirely in harmony with mainstream eighteenth- and nineteenth-century portraiture.

Bilibin Ivan Bilibin (1876–1942) had in common with Kustodiev the fact that his primary source of inspiration was the tradition of folk art, both peasant and urban, although in other respects they were opposites. Bilibin worked mainly in the realm of graphic art, with a special interest in folk tales and legends. Besides illustrating folk tales, he designed the covers of books, magazines, calendars and collections of music. He also designed furniture and theatre sets. Above all, Bilibin is associated with Russian folk tales and the transformation of book design into a true art form.

Book design had always been accepted as an art, but it was one that the nineteenth century had regarded as subordinate, dependent on popular taste. As we have seen, by the turn of the century applied art generally had been promoted from being regarded as non-art to having equal status with easel art. This trend, inaugurated by the works of Polenova, was continued by the artists of *Mir Iskusstva*, including Bilibin. It was Bilibin who brought the Neo-Russian style to book design, initiating a tradition, which lasted into the 1930s, of outstanding artists working in graphic arts. It was he, more than any other artist, who determined the way in which Russians visualize the world of their folk tales. Even the most brilliant and individual of the artists who came after him drew in one way or another on his work.

Bilibin's enthusiasm for Russian folk tales and his first major commission, received in 1899 from the Imperial Stationery Office, to illustrate a series of folk tales, determined his subsequent career. The series consisted of six folios, for which Bilibin designed a cover and a standard sheet layout. The design of the cover was suggested by the form of the hagiographical icon. The central part of the cover was given over to the main title, while a decorative frame around

PLATE 255
Ivan Bilibin, Cover design for Pushkin's *Tale of Tsar Saltan*, 1905.

PLATE 256
Ivan Bilibin, 'Tsar Dadon stands before the Shemakha Queen', illustration for Pushkin's *Tale of the Golden Cockerel*, 1906.

PLATE 257
Ivan Bilibin, 'The punishment of Tsar Dadon by the astrologer', illustration for Pushkin's *Tale of the Golden Cockerel*, 1907.

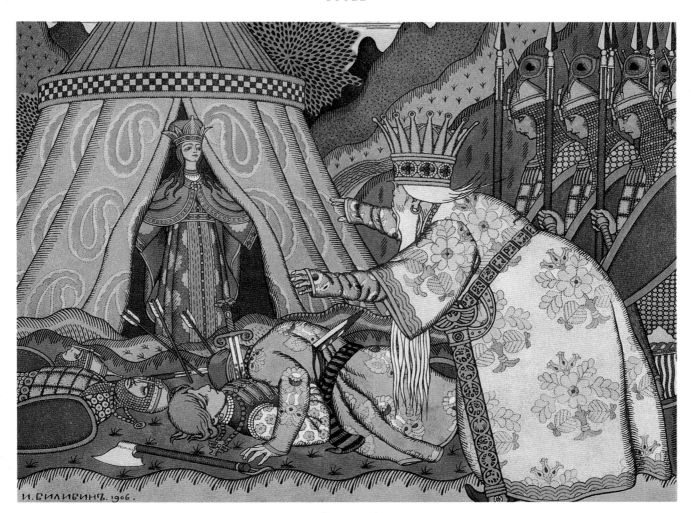

PLATE 256

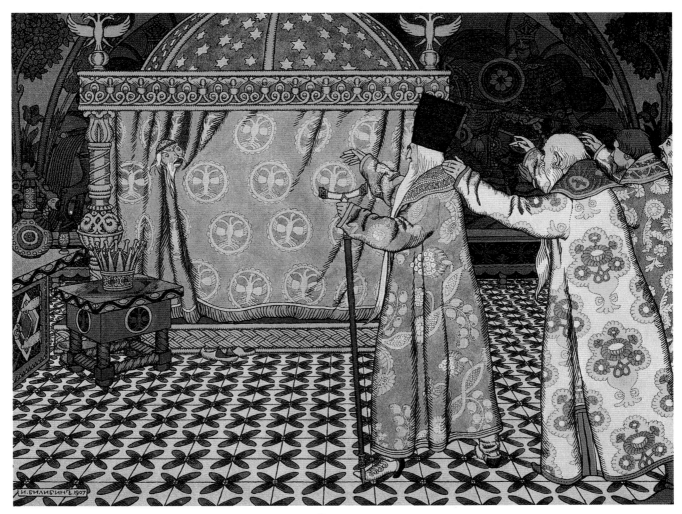

PLATE 257

the edges consisted of a series of separate illustrations unified by a single underlying concept. The vivid and colourful frame only serves to make the title more prominent.

We can discern in this first major undertaking the sources on which Bilibin drew throughout his career. His Russian sources included the epic paintings of Viktor Vasnetsov and the illustrations of Yelena Polenova and Alexander Afanasiev for Russian folk tales. His Western European sources included the work of such artists as Axel Gallen-Kallela, Boutet de Monvel, Arnold Böcklin, Moritz von Schwind, Aubrey Beardsley and Charles Dudley.[2] His illustrations are decoratively coloured, with strong outlines that determine the shape and positioning of the patches of colour. Extensive use is made in the ornamental designs of motifs from *lubok* woodcuts, peasant embroideries, printed fabrics, and carved and painted wooden utensils.

In a series of folk tales dating from the first decade of the 1900s, Bilibin attempted to create illustrations that were graphic in the narrower sense of the word – that is, in which the line is all-important. As Bilibin himself put it: 'Our understanding of the term "graphics" as that branch of line and book illustration in which the centre of gravity devolves on the processing of the line itself (the art of the "elegant line", as Bakst put it) is primarily a Russian concept'[3]

A significant role in the evolution of Bilibin's mature style was played by his excursions to the Russian North between 1902 and 1904. The influence of the North on his work was analogous to that which the rediscovery of the wooden folk architecture of that region exerted on the neo-Russian style. The clean, sharp outlines found in Japanese engravings were another source of inspiration. Using old Russian and folk architecture, stylizing and simplifying the figures of his characters, Bilibin constructed a world of Russian folk tale and legend which became virtually definitive. This was the scale of his achievement with his illustrations for the legend 'Volga', and Pushkin's poem, 'The Tale of Tsar Saltan' in 1904–5; and for 'The Tale of the Golden Cockerel', drawn between 1906 and 1910.

Bilibin saw stylization and fantasy as fundamental to the language of Russian folk art. 'In folk ornamentation we simply do not encounter any desire to represent what is present in everyday life. The Russian people, oppressed by their joyless reality, sought consolation in fabulous dreams of far-off unknown kingdoms with extraordinary birds, wooden churches and animals'[4] He envisaged Russian folk art as all of a piece: 'Folk tales, legends, religious verses are all part of the same thing as embroideries, printed fabrics, woodcarving, folk architecture and folk pictures.'

Traits characteristic of Bilibin's mature work – the all-pervading ornamental quality, 'wire-like' lines, the 'iron hand', their succinct and graphic quality – were reinforced after 1910, when to the influence of the woodcut was added the influence of icon painting. Bilibin's work also duly reflected the influence of the new, resurrected neoclassicism which was having an impact on the artists of the neo-Russian style, with its characteristic attempt to revive universal artistic devices. Bilibin's colour range became more vibrant and saturated.

Bilibin produced many designs for mass-circulation printed graphics: magazine covers, Christmas and Easter cards, advertising posters, calendars, playing-cards and postcards – including series of 'The Sirin, Bird of Good Omen' and 'The Alkonost, Bird of Ill Omen', reminiscent of *lubok* depictions of the same subjects. In these works he naturally drew on his experience of book design, but necessarily simplified the graphics, making it all more schematic, and the illustrations more decorative.

Among Bilibin's contemporaries were several other artists who worked extensively in book illustration, and were also associated with renewal of the old Russian heritage, including Sergei Chekhonin (1878–1936), Dmitri Mitrokhin (1883–1973) and Georgi Narbut (1888–1920). More important than any of these, however, was Dmitri Stelletsky. The object of Stelletsky's unwavering admiration and emulation was old Russian and folk art. His adherence to tradition is evident not only in his book illustrations but also in a variety of other art forms: ceramic figurines, theatre design and easel painting (particularly portraits). Towards 1910, his traditionalism became ever more precise and literal. In his early majolica female figurines it is expressed only in the national costume. Later, to costume and characters, were added features of Russian wooden sculpture, with its particular sense of constraint, its frozen poses and a generalized flatness of form and lapidary outline.

When illustrating books, Stelletsky made use of the miniatures of the *Collection of Illuminations*, a sumptuous sixteenth-century illustrated history of the Russian state. These also provided Stelletsky with prototypes for illustrating

PLATE 258
Ivan Bilibin, Calendar designed for the Charitable Community of St Evgenia, 1911.
PLATE 259
Ivan Bilibin, Calendar designed as a supplement to *The Cornfield* magazine, 1913. The illustration takes the tercentenary of the dynasty as its theme. The boy Tsar, Mikhail Romanov, appears in a procession to which the Kremlin walls form the background.

Reminiscent of a *lubok*, the style is characteristic of Bilibin's graphic design.
PLATE 260
Ivan Bilibin, Invitation to a reception at the town hall for the President of France, St Petersburg, 1902.

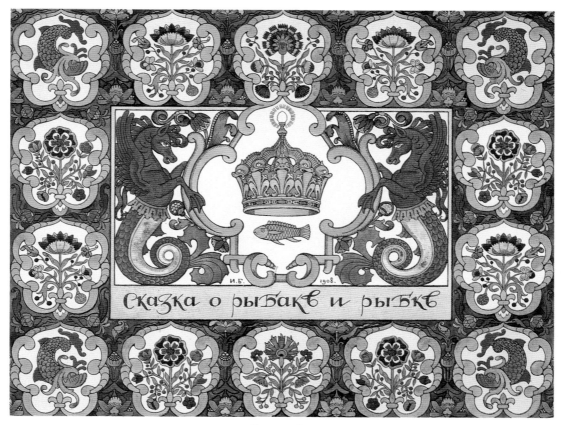

the twelfth-century epic *The Lay of the Host of Igor*. For the stage production of Alexei Tolstoy's tragedy *Tsar Fyodor Ioannovich*, Stelletsky re-created the environment of a late sixteenth-century Russian palace from architectural motifs and shapes of furniture copied from Russian icons. His work parallels those consistently retrospective tendencies evident in early-twentieth-century icon painting and church murals with its copying of sixteenth- and seventeenth-century prototypes.

Minor graphic design We have already mentioned Bilibin's work in mass-produced graphics such as calendars and advertisements. He was not alone in this respect: many other major artists and architects occasionally turned their talents to such media. Among their output we find announcements of ceremonial events, illuminated addresses, menu cards, invitations and theatre programmes.

In these items certain allusive motifs continually recur: townscapes, particular buildings, coats of arms. They specify a whole complex of concepts, the time and place of the event,

the institution or society involved, and much else besides. A great torrent of menu cards, programmes and invitations resulted from the 1913 celebrations of the tercentenary of the Romanov dynasty. Prominent among the souvenirs of the event were calendars with illustrations of the coronation of the first Romanov tsar, the double-headed eagle, and the coats of arms of Russia and of Moscow.

St George and the dragon, in a style and iconography derived from fifteenth- and sixteenth-century Muscovite icons, was one of the most popular subjects. He graced menu cards, diplomas and the covers of books about Moscow. St George was the patron saint of the Russian army, and the Cross of St George was the highest military medal in Russia. Because of its patriotic connotations, the image of St George and the dragon was much used in political posters, a genre that began to develop in the period of the First World War and the Revolution.

On the whole, run-of-the-mill printed graphics – posters, bills, programmes and the like – followed the general trends

PLATE 261
Ivan Bilibin, Menu for a banquet, 1910.
PLATE 262
Ivan Bilibin, Menu for the *Medved* (Bear)
Restaurant, St Petersburg, 1912.
PLATE 263
Ivan Bilibin, Vignette from *The Tale of Tsar
Saltan*, 1907.

PLATE 264
Ivan Bilibin, Jacket design for Pushkin's *Tale
of the Fisherman and the Fish*, 1908.
Such illustrations are among Bilibin's finest
achievements as a graphic artist. He relied a
great deal on the conventions of manuscripts,
but produced results that are fresh and
contemporary.

PLATE 265

PLATE 266

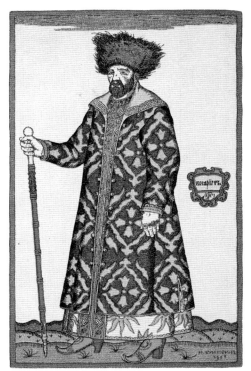

PLATE 267

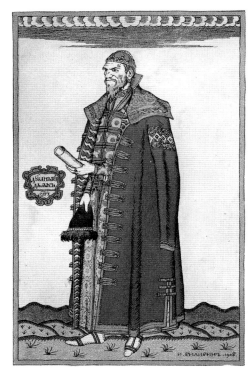

PLATE 268

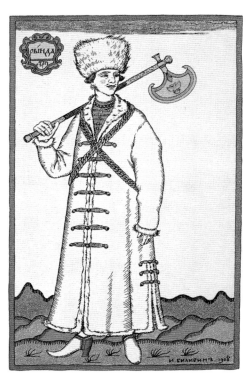

PLATE 269

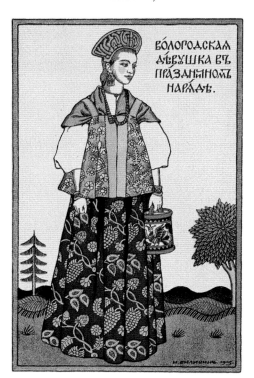

PLATE 270

PLATES 265–272

Ivan Bilibin, Designs reproduced as postcards.
Plate 270 (1905) shows a young woman from the
Vologda Province in feastday costume and plate
271 is titled 'The Walled City of Ledenets' and
dated 1911. The remaining five images show
boyars, a local government official and one of
the Tsar's bodyguard, in costumes from the
seventeenth century. Bilibin was fascinated by
the dress of Russia before her Westernization
and returns to it again and again. He wrote 'Was
this dress attractive? It was splendid. There is
such a thing as beauty of movement and there is

also a beauty of serenity. Russian national dress
is a dress of serenity.'

PLATE 271

PLATE 272

PLATE 273

PLATE 273
Dmitri Stelletsky, *Portrait of Count M. Yu. Olsufiev*, 1913.
Stelletsky shared the Slavophile conviction that Peter's drastic Westernization had dealt a fatal blow to the organic development of Russian culture. He found inspiration in icons, which he used for secular painting as though the Westernization of Russia had never happened. Skilfully weaving elements of architecture and landscape into a formal pattern, he went a long way towards recovering the flattened surfaces and stylization of earlier times. The boy is the son of Prince Yuri Olsufiev, who had made a special study of icon painting and wrote many books on the theme, and who was also the curator of the Trinity Monastery Museum. The portrait was executed in 1913, the year of the first major exhibition of cleaned icons, which proved a revelation to the public and had a strong influence on artists. Of Stelletsky's work, the critic Sergei Makovsky wrote that 'here shines a light of a truth of the age to come'.

PLATE 274

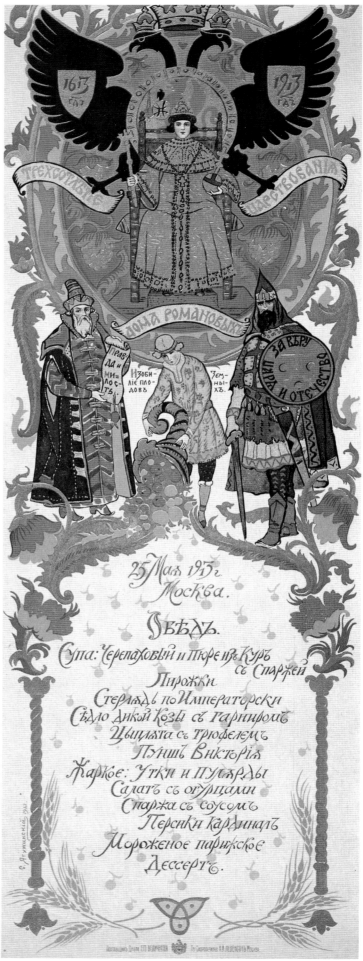

PLATE 275

PLATE 276

PLATE 274
B. Zvorykin, Theatre programme cover for the
Imperial Alexander Theatre, Moscow, 1913.
Both this and plate 275 were designed on the
theme of the commemoration of the
tercentenary of the Romanov dynasty.

PLATE 275
S. Yaguzhinsky, Menu for a dinner, 1913.

PLATE 276
Mikhail Vrubel, Poster for an exhibition, 1901.
The poster includes the names of all thirty-six of
the artists exhibiting. Vrubel has borrowed the
forms of archaic calligraphy, but has combined
and interpreted them in a thoroughly
contemporary manner.

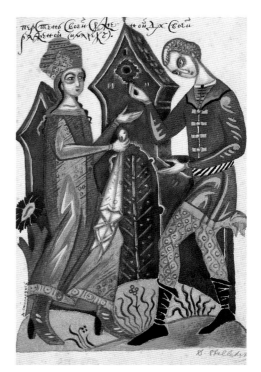

PLATE 277

PLATE 278

PLATE 279

PLATES 280–281

of fine art. There were, however, exceptions. The commercial poster tended to conservatism and a pandering to popular taste. Such works often featured beautiful girls in Russian dress who have a salon-art prettiness. Alternatively, there are the refined, languid beauties in the *style moderne*. Their images are wholly integrated into whimsically billowing, curvilinear plant ornamentation, which might include ornamental flower motifs taken from old Russian manuscripts, and motifs from Russian architecture. Always fashionable rather than innovative, the graphic art of everyday avoided the latest artistic experimentation. The avant-garde tendencies to be found throughout the fine arts and theatre decoration are absent.

Sculpture In the early twentieth century, for the first time in the entire history of post-Petrine art, the search for Russianness was expressed in statuary. This took the form of funerary monuments and in designs submitted for a competition to design a monument to SS Dionysius and Hermogen, priests who refused to take the oath of allegiance to the False Dmitri, pretender to the throne of Russia, during the Polish–Lithuanian invasion of 1612. Executed for their stand, they were subsequently declared national heroes. In the designs submitted by various sculptors, including Nikolai Andreev, Dmitri Sukhov, Leopold Ditrikh and Vasily Kozlov, we find traits of Russian folk wooden sculpture.

Concluding our look at the use made of the tradition of folk and national art in the fine arts before the age of the avant-garde, we should note one striking feature. We have already spoken of the impossibility of separating Nesterov's and Roerich's religious mural painting from their easel painting on religious subjects. We have spoken too of how Bilibin's book illustrations relate to the images of everyday graphic design such as posters, calendars and postcards. Roerich's paintings on subjects from old Russian history closely resemble his theatre designs, theatre curtains and murals. It is difficult to differentiate Apollinary Vasnetsov's theatre décor from his watercolours, drawings and pictures of old Moscow. There is indubitably a shared quality, but one which has deep roots and a universality about it which relate the creative work of different artists working in different genres.

Suslov's architectural fantasies closely resemble not only the designs of Korovin, Fyodorovsky and Roerich for the contemporary theatre, but actual architectural projects in the neo-Russian style. Theatre settings for opera productions on themes from Russian history and folk tales barely differ from real architectural designs, particularly those for churches. Architectural plans, for their part, are startlingly reminiscent of paintings of architectural landscapes, where ancient stone and wooden architecture is depicted by artists like Roerich and Konstantin Yuon, who had made a special study of Russian architecture. The turn of the century has a characteristic perception which predetermines the way ancient buildings are depicted. Just as artists of different ages depicted the same building in quite different ways, so a shared perception explains the formal similarity between the ancient buildings depicted in turn-of-the-century paintings and the new churches designed at the same time. The whole phenomenon shows not only how widespread was the dissemination of the neo-Russian style, but also how deeply rooted and organic a development it was.

The Russian Avant-Garde and Russian Tradition

The end of the first decade of the twentieth century saw yet another approach to reviving the national heritage. Artists now began turning to simple forms of urban folk art and meting out unconventional treatment to traditional sources. These became the salient characteristics of Russian neo-primitivism, an offshoot of modernism, and a relation of such European phenomena as Fauvism and Expressionism.

Not all works of neo-primitivism can be identified with the national tradition, and hence included under the heading of the neo-Russian style. It is not the widening of sources that results in this exclusion but the fact that, in these works, expressing the national ideal ceased to be a separate aim. The national heritage was prized not for itself, but more as a means to an end. The addressing of the national tradition and the accentuation of its archaic features stem from the same aim of finding ways forward, beyond realistic depiction, and striving to create an artistic idiom different not only from that of the nineteenth century, but from that of the post-medieval period altogether.

A decisive break with what the avant-garde considered traditional art was accompanied by a no less decisive break with the methods accepted at the turn of the century for making use of the national heritage and rediscovering new sources. It was as if history were repeating itself. The innovators at the turn of the century, from Vasnetsov to Bilibin

PLATES 282 & 283
Ball held at the Winter Palace to mark the
bicentenary of the founding of St Petersburg,
1903.

The ball was planned not merely as a splendid
spectacle, but also to reflect the Slavophile
convictions of Nicholas II, shown in plate 283 in
the costume of his ancestor, Tsar Alexei
Mikhailovich. That the theme of the ball evoked
not the time of Peter but that of his father was
symptomatic of the increasing fascination with
pre-Petrine culture and of Imperial support for

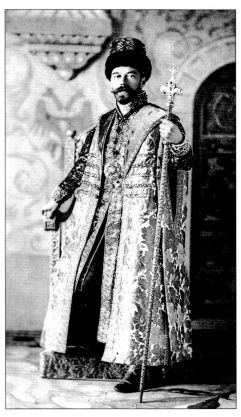

PLATE 283

the revivalist movement of the first decade of the
twentieth century. Nicholas believed that Peter's
'enlightened despotism' cut at the roots of the
sacred concept of the tsardom. Many of the
costumes were extremely rich; some were
copied from period originals, others sewn with
jewels or ornaments by Fabergé.

and Kustodiev, had affirmed the new, discovering for themselves traditions that their predecessors had ignored, utilizing and adapting them in a new, alternative, way. So it was now. At the All-Russian Congress of Artists in 1911–12, one of the ideologists of the new art, S. Bobrov, propounded the avant-garde's credo. 'At the present time,' he declared, 'we believe Russian purists have ceased to study in France. Having mastered what France has to offer, they have realized that there is so much in their own country as yet untouched and unstudied: our amazing icons, which are the peak of the world's Christian art, our old *luboks*, our northern embroideries, our stone figures. . . . From this day forward our own material heritage, and our archaism, lead us towards unknown horizons.'[1]

The avant-garde's position was most fully formulated by the artist Alexander Shevchenko in his books *Neo-primitivism: its Potential and its Achievements*, and *Principles of Cubism and Other Contemporary Trends, in the Art of All Times and Peoples*, both published in 1913. In the first, the artist's right to free creativity and his rejection of naturalism were justified by the fact that, seeing 'around himself nature remade and improved by the hand of man the creator, we cannot but demand the same thing of Art'. In the search for new ways forward Shevchenko considers it essential to look primarily to 'primitives, icons, *luboks*, trays, signboards, fabrics of the Orient, etc. . . . examples of real art'.

In Shevchenko's opinion, the term neo-primitivism expressed the dialectical nature of his programme, a simultaneous orientation towards national tradition (the primitive) and 'partaking of the artistic traditions of our age'. For Shevchenko the concept of the national tradition also embraced Oriental culture. Russian 'icons are permeated through and through by the Orient and Byzantium, even as

they remain profoundly original . . . Russia and the Orient have been inextricably linked since the Tatar invasions'[2]

Learning from the Orient – in particular from Japan – and from Russian medieval and folk art was a principle which had already been espoused by art nouveau elsewhere in Europe. Modernist manifestos had also formulated the view that the underlying artistic principles of the modern period were obsolete. The views and practice of the avant-garde, Russian and Western European, are obviously related to art nouveau, but equally obvious is the fact that the avant-garde comes later. Art nouveau was insufficiently radical for the neo-primitivists, still too dependent on fixed sets of artistic principles.

Shevchenko's second book on Cubism is devoted to trying to prove the universal applicability of the rules of avant-garde art. Even as they affirmed national originality, artists of the Russian avant-garde claimed to derive their pedigree from the earliest civilizations: Assyria, Babylon and Egypt. In the process they hoped to prove the comprehensive and universally applicable nature of the new movement. Like the artists of the Academy, they did not simply turn to the past, but strove to work out eternal, absolute canons.

Shevchenko proclaimed that the bases of art are eternal: 'they are eternally the same for the arts of all times and of all peoples . . . there is no old art, no new art, no art which is fashionable, or unfashionable, or passé. Art is outside of time and space.'[3] The paradox here is that an art which is non-canonical on principle was attempting to define itself by drawing on and appealing to artistic traditions that were consistently and rigorously canonical; an art profoundly subjective and individualized sought to derive itself from an art to which the concept of individuality as understood in post-Renaissance Europe was quite alien.

PLATE 284

PLATE 285

A further paradox of the new movements in Russia is that, even as their birth and development took place, associated with the national tradition, the search for national character, whether on a theoretical or a practical, creative level, was becoming obsolete. Even as they turned to the national tradition, artists were seeking something akin to the eternal laws of art. Expression of national originality gave ground before the new task of expressing the universally human. This is brilliantly confirmed by the art they produced.

It is impossible to single out the old Russian or folk sources among all the others on which artists of the radical movements drew, but we can certainly identify those sources that were most popular. All the painters were to some degree influenced by the archaizing movement of thirteenth- to fourteenth-century Russian icon painting, with its characteristic hypertrophied powerfulness, immobility, disproportions and taste for decorative effect. Painting from the North came in for particular scrutiny, as did seventeenth-century icons, especially those from South Russia, and old Russian wooden sculpture. At the same time, neo-primitivists were fascinated by urban folk art: signboards, the stage sets of the popular theatres, photographers' backdrops, the genre portraits of merchants or burghers, the painted decoration on trays and the boisterous aesthetics of the fairground.[4] Often the historical and folk influences merged, or one or other might predominate; but no matter how diverse the sources might be, the crucial point was the rejection of any overt similarity, the deeply structural character of the reinterpretation.

Only a few of the many Russian neo-primitivists were associated with the late neo-Russian style. Among them were those who belonged to the expressly 'negativist' 'Jack of Diamonds' group, founded in 1910 with the aim of founding a completely new art. Members included Aristarkh Lentulov and Natalia Goncharova. When she left 'The Jack of Diamonds', Goncharova joined 'The Donkey's Tail',

PLATE 284
Boris Kustodiev, Stage design for *From Rags to Riches*, 1925.
The design is for a comedy by Alexander Ostrovsky, produced in Leningrad in 1925. Kustodiev has combined a neoprimitivist energy with an atmospheric reproduction of the distinct character of Russian provincial life. The scale and proportions recall the flexible perspective and vision of much earlier painters.

PLATE 285
Silver ewer and basin, early twentieth century. The new trends are well expressed in these items, which were made as a wedding gift for the marriage of Grand Duchess Elena Vladimirovna, favourite daughter of Vladimir Alexandrovich, to Prince Nicholas of Greece in 1902. The pristine forms are exquisitely ornamented with calligraphic roundels composing the name and style of the Grand Duchess.

PLATE 286

founded in 1912 by Mikhail Larionov, which was more
thoroughly neo-primitive. Also included were the pioneers of
abstract art, Vasily Kandinsky and Kasimir Malevich. This is
not to say that other artists were not drawing on the national
tradition; but either it was so radically transformed in their
work that we cannot discern it or it was so intermingled with
other folk traditions that the work cannot be defined as
belonging particularly to the Russian artistic tradition.

Lentulov An interest in tradition could, and often did,
harmonize with the ideal of reflecting life and the norms of art
of the modern period. The use that Aristarkh Lentulov
(1882–1943), for example, a prominent member of 'The Jack
of Diamonds', made of the Russian tradition resulted in
works far from conventional verisimilitude. Lentulov was

attracted by aspects of old Russian art that went unnoticed by
Nesterov, Vasnetsov and even Roerich. Behind the restraint
and tension of the primitive icon he sensed features of the
Russian character similar to those captured in Malyavin's
paintings – exuberance, turbulence, even frenzy – and from
about 1910 embodied them in works on evangelical themes.
He is better known, however, for his large-format decorative
panel pictures which transformed motifs derived from
Muscovite architecture (St Basil's, the Ivan the Great Tower,
Red Square) on the basis of Cubo-Futurist principles. Len-
tulov was primarily interested in the architectural forms of six-
teenth- and seventeenth-century icons and frescoes, but
reinterpreted them through the gaudy, boisterous idiom of
fairground art, which he rendered with great gusto. In these

PLATE 286
Mikhail Larionov, Stage design for *Chout* (The
Buffoon), 1915.
Design for a production by Diaghilev's Ballets
Russes, a Russian legend in six scenes with
music by Prokofiev. The designs were made in
1915, but the ballet – performed in the manner
of pantomime – was not produced until 1921.
It was not a success: the discrepancy between
Prokofiev's music and the expressive

primitivism of the decor disgusted Paris
audiences, and Diaghilev had to fine the dancers
to persuade them to appear in heavy costumes
which restricted their movement. Larionov had
looked towards vernacular sources to design
something vibrant and new. Flat imagery, bright
colours and bold decoration are all characteristic
of Larionov's work and evoke his desire to
charge stage design with a new popular energy.

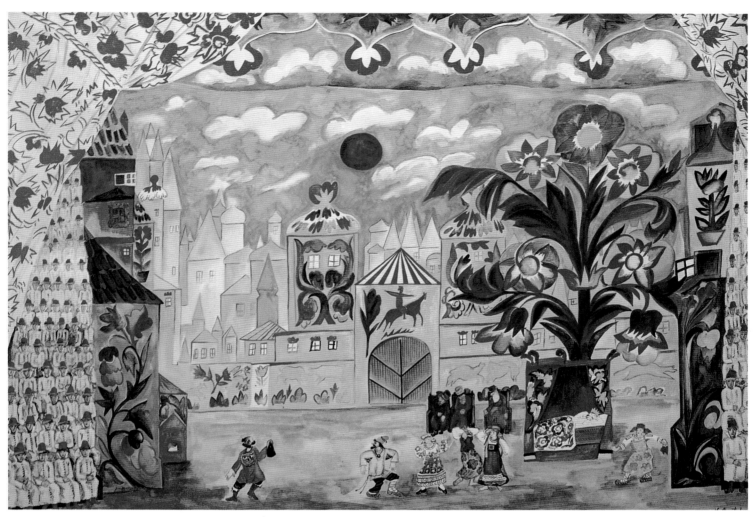

PLATE 287

paintings – such as 'Moscow, 1913', 'Decorative Moscow', 'Nizhny Novgorod', 'Peal of Bells: Bell Tower of Ivan the Great', 'By the Iverian Mother of God' – he employed startling foreshortenings and pitches, and angular and abrupt forms which collide and cut across each other. An impression of material solidity, of crowdedness, movement, even noise in some extraordinary way, evokes the actual image of Moscow, despite the total lack of realism. The harsh rhythms of these paintings are remarkably convincing and modern. There are parallels to a similar city depicted in the ceramic tiles of Gzhel, in the art of the craftsmen of Palekh and in some *lubok* pictures. We recognize an affinity with folk art in the idea of representing St Basil's Cathedral from all sides at once.[5] Similarities to the effects of collage and appliqué,

notably in the multi-layered Russian folk costume, can be detected, while the simultaneous use of different viewpoints is a common technique in old Russian art.

Goncharova Of all the avant-garde artists, only Natalia Goncharova (1881–1962) can be compared with Lentulov in terms of the active and fruitful way in which her works revive Russian tradition. They also have in common their attempt to synthesize the old Russian icon tradition with the purely decorative aspect of the *lubok*. The two artists sought this synthesis, however, in quite different ways. Lentulov reinterpreted the forms, composition, and structure of imagery of old Russian architecture through the techniques and imagery of the *lubok*. Goncharova, in her compositions on various religious subjects such as 'The Madonna and Child',

PLATE 287
Natalia Goncharova, Design for Act I of *Le Coq d'Or*, 1914.
The first performance of Rimsky-Korsakov's *Coq d'Or* took place in 1914. The action was presented as a ballet with mime, accompanied by off-stage singing. Goncharova's brilliant colours reflected the energy of the music and were received with enthusiasm. One of the aims of the World of Art movement was that the West should come to know Russia better and

this was one of the principal motives behind Diaghilev's determination to bring his productions to Paris and London, where they had an unprecedented success.

PLATE 288
Natalia Goncharova, Stage design for a costume
for the Virgin for *Liturgy*, gouache with foil
appliqué, 1915.
During the early months of the First World
War Diaghilev, in isolation abroad, conceived a
new ballet, *Liturgy*, in the form of

performed. Only Goncharova's designs, many
with applied collage, survive. The most
ambitious and fantastic projects at this period
were for the theatre. In 1915 the composer
Scriabin was working on a mystery 'play' for
two thousand performers, conceived as a ritual

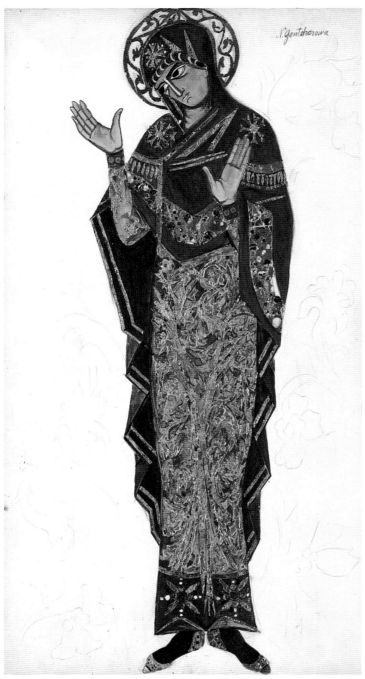

PLATE 288

PLATE 289

a choreographed mystery play with music,
sung in intervals rather than to accompany the
dancing, based on traditional liturgic song.
The artist Larionov, who was an enthusiast for
folk art and dance, worked on a formalized
choreography, while Goncharova immersed
herself in the study of medieval icons and
mosaics in order to imitate the effects of the
painted drapery. When the cost of the
performance was estimated even Diaghilev
became alarmed, and *Liturgy* was never

fusion of dance, music and rhetoric. The action
was planned to take the form of a
journey, starting in Tibet and finishing in
England. There would be no spectators. The
project was never realized.
PLATES 289–292
Natalia Goncharova, Four panels depicting
the Evangelists, 1910–11.
These paintings were shown at the exhibition
organized by Russians of a younger
generation, calling themselves the Donkey's

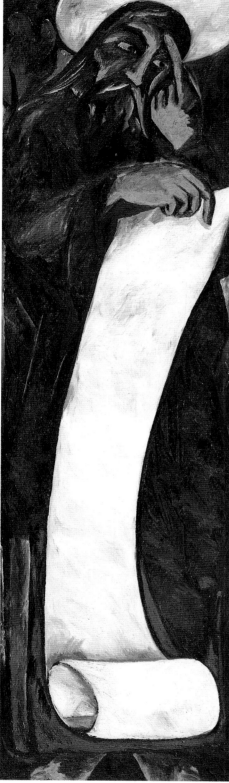

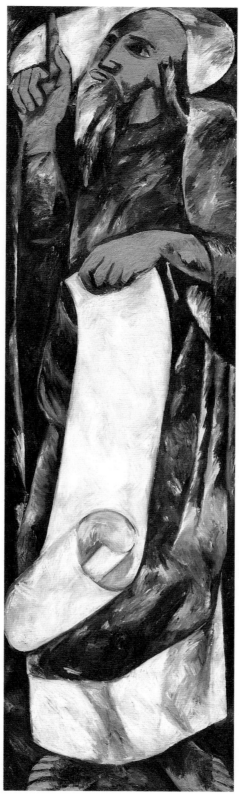

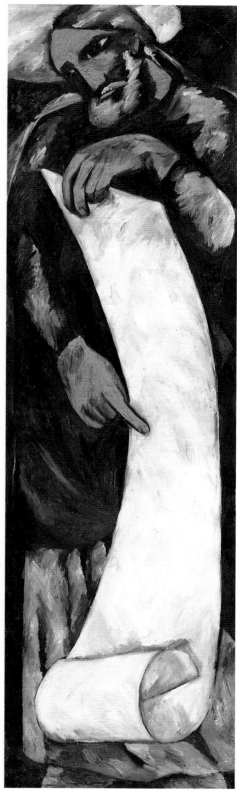

PLATE 290

PLATE 291

PLATE 292

Tail Group, which opened on 11 March 1912. Larionov, Goncharova, Tatlin and Malevich all contributed, as did Chagall who sent work from Paris. The press and public responded to Goncharova's works with outrage: that paintings on a religious theme should be included under such an irreverent title was considered blasphemous, nor were the public accustomed to see sacred forms reworked as an expression of the artist's individuality. Goncharova's Evangelists evoke the standing figures of saints from an icon screen, where emphasis is given to a silhouette and to the rhythmic consonance of gesture. Nevertheless it would seem that the works owe as much to the conventions of stained glass as to icon painting.

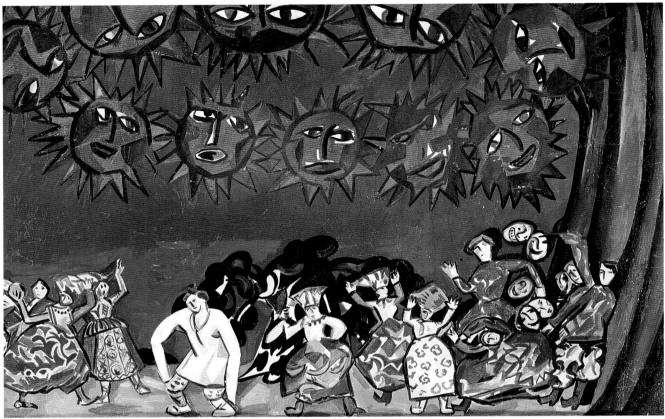

PLATE 293

and 'The Flight into Egypt'; and in costumes for the ballet *Liturgy*, combined the iconographical scheme of Byzantine art with the decoratively treated motifs from the *lubok* and printed fabrics.[6] In a number of Goncharova's works these two major components of the Russian tradition, rich, thickly applied decoration and traditional iconography, take on a separate existence, independent of each other. In her celebrated stage designs for Rimsky-Korsakov's opera *The Golden Cockerel* for the 1914 Russian Seasons in Paris, the decorative element triumphs. Fabulous plants cover the walls of fantastical architecture. The flower and plant decoration beloved of Russian folk art is treated in a markedly primitive way, taking on gigantic, dimensions. Reds blaze out intensely.

The traditions of old Russian art are reflected in Goncharova's work in several ways. The thirteenth- and fourteenth-century icons and frescoes of Novgorod and Pskov have a dramatic view of the world, reflecting the turbulent events of that epoch. Goncharova drew also on the

traditional depiction of the saints in the *lubok*. She was attracted by the more overtly expressive trends in old Russian art. The abrupt rhythms, the movement of draperies in old icons and frescoes, come to life in the abrupt rhythms of the folds in the clothes of her saints. In her quest for expressiveness and the ever-present sense of drama, Goncharova also turned to the ancient stone figures standing on the tumuli of the South Russian steppes.

It was the deeply philosophical idiom of old Russian art which helped Goncharova to give 'clarity and definition'[7] to the biblical images she treated so profoundly and allusively. She introduced a new dimension of unconventionality into the adaptation of medieval religious art to the needs of contemporary secular and religious art through a reinterpretation of the genre picture. Goncharova created an unusual hybrid kind of painting which combined New Testament symbolism and subject matter with the cult of labour and nature. Her paintings in this vein include 'The Angels Cast Stones at the City', 'The Peacock', 'The Phoenix', 'The Tsar', 'The Maid

PLATE 293
Mikhail Larionov, Stage design for *Midnight Sun*, 1915.
In 1915, having given up his plans to produce *Liturgy*, Diaghilev put together a ballet which was provisionally entitled *Midnight Sun*, later *Night Sun*. It had no formal plot, consisting of a sequence of Russian folk dances, taken from the scene of the returning sun in *Snegurochka*. Larionov had already been closely involved with Goncharova on *Liturgy* and was an expert on folk dance. He restored the element of farce and the ridiculous to the contemporary stage and

introduced a search for simplicity and for uninhibited energy, combined with strong primary colours and mime, all of which were new and experimental at this time.

PLATES 294 & 295
Liubov Popova, Marionette designs for a servant and a priest's wife from Pushkin's *Tale of a Country Priest and his Simpleton Servant*, 1919.
These designs were produced for a performance of Pushkin's story in the Moscow Theatre of Marionettes.

Riding on a Beast', 'The Prophet', 'Feet Pressing Wine', 'The City Inundated' and 'The Harvest'.[8] In 'The Evangelists' she demonstrated a trait characteristic of the period, with her relaxed attitude towards the established iconographical canons. The Evangelists are depicted with scrolls, something traditionally reserved for the prophets or the angels of the Last Judgment. This merging of the Evangelists' labours with the symbolism of prophecy and apocalypse bears eloquent testimony to the intelligentsia's acute sense of the end of an era and a presentiment of impending disaster. Intense colour, charged with emotion, along with spiritual tension are also characteristic of Goncharova's works associated with the theme of labour, such as 'Washing the Linens', 'Laundering Clothes', 'The Laundresses', 'Gathering Firewood' and 'Picking Apples'.

Petrov-Vodkin Standing somewhat apart from the general drift of the Russian avant-garde is the work of Kuzma Petrov-Vodkin (1878–1939). Not only representational, his paintings deliberately revived the classical tradition. They belong to a movement in painting which is related to turn-of-the-century neoclassicism in architecture. In Petrov-Vodkin's paintings there is a fusion of the modern classical and the old Russian traditions. Both factors are of equal significance. It is this synthesis which determines the originality of Petrov-Vodkin's artistic language.

In his moral seriousness and the areas in which he worked, Petrov-Vodkin is close to Vasnetsov, Nesterov, Roerich and others who also worked extensively in the area of religious art. He made a major impact with both his religious murals and mosaics – for the Church of Vasily the Great in Ovruch, for St Nicholas's Church in Bari and for the mausoleum of the Erlanger family in the German cemetery in Moscow – and with such secular easel paintings as 'Boys Playing', 'The Dipping of the Red Horse', 'Girls on the Volga', 'Mother' and 'Morning, Girls Bathing'. Petrov-Vodkin believed that art should elevate people spiritually and morally: 'We are called not to teach or to entertain, but to shine.' He had boundless faith in the ability of art to exercise a direct influence on the course of history. 'I used to say to myself, if I were not so hopelessly untalented, I could stop this dreadful war with a painting.'[12] For Petrov-Vodkin, as for many artists of the turn of the century who harnessed their art to the expression of a moral idea, Alexander Ivanov, with his 'Appearance of Christ to the People' and his 'Bible sketches', was a great inspiration. Another of his heroes was Mikhail Vrubel. Petrov-Vodkin saw both of them as 'representing the people's intellect'; both, in accordance with the needs of their time, synthesized two traditions of crucial importance for Russian art: the Byzantine and the Italian. 'They checked the tradition of religious painting against nature.'[13]

PLATE 294

PLATE 295

After passing through an early period of enthusiasm for French and German symbolism, Petrov-Vodkin emerged after about 1910 as both a confident and consistent innovator and an equally faithful conserver of tradition. The images he produced were of such deep and universal applicability because they were grounded in the European academic and classicist tradition. As one critic put it, 'His new system of form and painting serves one purpose. Petrov-Vodkin gives not a fact, but a concept, not an incident, but a rule . . .'[14] The classicist tradition, however, he reinterpreted and adapted with reference to his profound understanding of the tradition of Russian icons and frescoes. In old Russian art he was attracted by the most harmonious and inspired images, the gentlest and most lyrical in all of Russian art: the painting of Andrei Rublev (c. 1370–1430) and Dionysius (c. 1440–1508), particularly Rublev's 'Trinity', and Dionysius's frescoes in St Ferapont's Monastery, in the northeastern territory of Novgorod.

In his painting Petrov-Vodkin observed the general rules of medieval Russian art: an abstract underlying idea and emotional image, a generalization of form and patches of colour, the monumentality of a grand style and the quality of a fresco, depersonalization of his heroes, icon-like countenances, frozen poses, and rhythmical repetition of movement, outline, line, and figures. All these qualities he combined in an amazingly natural and unconstrained manner. His painting 'Girls on the Volga' derives from 'The Meeting of Mary and Elizabeth'; 'Morning, Girls Bathing' goes back to icons of the holy-day cycle on 'The Baptism of Christ'. In the outline of the girls' heads, the way they are leaning, there are unmistakable echoes of the icons of the fifteenth century, and of the angels in Rublev's 'Trinity' in particular.[15] Petrov-Vodkin also derives his use of colour from Rublev and Dionysius. He adapts – but not to the point of losing its symbolic significance – the charged three-colour combination of the Russian icon: red, yellow and blue. Red is the colour of the clay of which mortal man is made, of blood and emotion; yellow is the colour of the sun and of the radiance of God, the royal colour; blue is the colour of the sky, symbolizing infinity and the immortal nature of the soul. Sometimes this basic palette is augmented with green, the colour of consolation and hope.[16] Also from the icon, Petrov-Vodkin derived his characteristic positioning of major figures in the foreground, his vertical construction of the composition, and his combination of two viewpoints, from above and below.

The techniques of icon painting are strongly present in Petrov-Vodkin's portrayals of motherhood. The Madonna-like mother with her child in her arms is one of his favourite subjects. These mothers do not have faces in the ordinary sense, but countenances, such as are found in icons – the features of simple people, but generalized rather than individual.

One of the greatest of Petrov-Vodkin's paintings, and a landmark in the art of the pre-revolutionary period, is 'The Dipping of the Red Horse' (1912). This picture is so allusive as to defeat any attempt at putting its meaning into words. Its significance can be understood only by reference to old Russian art and the images and metaphors current in Russian art at the time. At the time it was painted the picture was seen as an expression of the disturbed character of the period, and of foreboding. When, two years later, the First World War broke out, Petrov-Vodkin saw his picture as a presentiment of the catastrophe.[17]

The symbolism of the picture has something in common with Alexander Blok's poem 'The Mare of the Steppes', which the poet saw as an image of Russia's past, her difficult present and her unchanging features.[18] The horse was a recurring symbol in Russian culture. To enumerate only some of the best-known examples: Saltykov-Shchedrin's story 'Konyaga'; Leo Tolstoy's 'Kholstomer'; Gogol's image in *Dead Souls* of Rus as a troika; the poet Valery Bryusov's apocalyptic 'Pale Horse' and fiery-faced horseman; the horse Savrasushka in Nikolai Nekrasov's poem 'Red-nosed Jack Frost'; and Vasily Perov's painting 'The Peasant's Send-off'. The hero of Russian art is the mighty epic warrior on horseback, who appears in the work of Viktor Vasnetsov and Mikhail Vrubel. Pushkin's 'The Song of Oleg the Seer' tells how the fate of the warrior is inseparable from that of his faithful horse. When deciding the fate of a tribe, the ancient Slavs consulted a 'prophetic horse'.

Only in this context can we begin to understand the symbolism of 'The Red Horse', a picture with no visible signs of contemporary significance, yet profoundly contemporary in spirit, full of foreboding of the imminent wars and social upheavals, expressed in the contrast between the mighty, fiery-red stallion, with its searing gaze, and the vulnerable, naked boy on its back. The characteristics of icon painting are very pronounced in this picture. The central figure cor-

PLATE 296

PLATE 296
Kuzma Petrov-Vodkin, *The Dipping of the
Red Horse*, 1912.
On the feast-day of Flor and Lavr, patron
saints of horses, it was customary in the
Russian countryside to drive the horses to
bathe in the river, in waters which had first
been blessed by a priest. The bathing process
was seen as curative and protective to the horses,
and the picture is imbued with vague references
and symbolism which are not explicit.

responds in significance to the central image of an icon; there is, too, a typical contrast in dimensions, as in the enhancement of a saint's monumental status by means of diminishing the size of flat landscape features and secondary figures.

Malevich The tradition of old Russian and folk art is mirrored in two periods of the art of Kazimir Malevich (1878–1935): the neo-primitivist, and the Suprematist. In his neo-primitivist work it is readily identifiable. At the end of the 1900s Malevich became close to Mikhail Larionov and Goncharova. Malevich's neo-primitivism relates to peasant genres created under the influence of Goncharova. In his paintings of 1910–12 we find the same expressiveness as in Goncharova – the same tension, the same symbolic and metaphorical treatment of the Russian landscape. The Russian icon tradition can be discerned in the articulate rhythms and overall sense of monumentality of the figures, and a much transformed echo of the archaic style of the Northern icons and of the frescoes of Novgorod and Pskov in the treatment of the faces.[9]

From about 1910 Malevich was exploring wholly new ways of making sense of the world, by creating the style known as Suprematism. His first Suprematist canvases date from 1913–15, and include the celebrated 'Black Square', whose title describes it completely. 'Black Square' is only one of thirty-five pictures which Malevich exhibited in December 1915 – January 1916. Taken together they constituted an art free from representationalism, an art of pure being. The language of simple geometrical figures (the square, the circle, the cross, the rectangle) and a highly abstract background (a pure, smooth, light surface) was, in Malevich's opinion, to express 'a whole system of world building'.[10] In Suprematism we can see painting aspiring to take over the functions of the icon, to symbolize the world, to reflect the essence of being in form and colour, to represent the highest spiritual reality in pure and absolute form. For so bold and immense an undertaking, Malevich could make use only of the most abstract forms and expressive techniques capable of bearing symbolic meaning. He borrowed the icon's abstract, light background, its smooth manner of painting and its ethereal quality. As to Malevich's representational, 'figural' foundations, we seem to recognize Christian symbols and the architectural backgrounds of icons, much transformed, highly schematized, and curiously reduced to primary geometrical shapes. Malevich is seeking a way of expressing a higher sense, immeasurably more significant than the meaning of the visible world. A Suprematist painting depicts everything,

PLATE 297

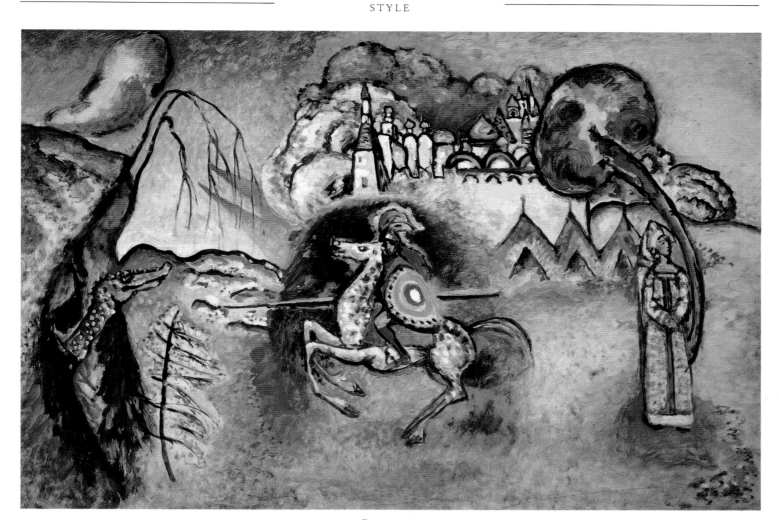

PLATE 298

PLATE 299

PLATE 297
Vasily Kandinsky, *Russian Woman in a Landscape*, 1906.
PLATE 298
Vasily Kandinsky, *St George and the Dragon*, 1914–15.
PLATE 299
Vasily Kandinsky, *The Psaltery Player*, 1907.
Plate 297 is an early gouache, incorporating stylistic idioms reminiscent of folk art in an innovative composition. The dominant black outlines in the painting cannot quite contain the diffused spots of colour. *The Psaltery Player* also possesses stylized pictorial elements, but is still essentially a figurative painting. *St George and the Dragon*, however, seems to represent a state of transition between the figurative and abstract, making even more use of vibrant colour and shape. The fresh, bright colours contrast sharply with the oppressive shades of Vasnetsov's melodramatic treatments of similar subject matter.

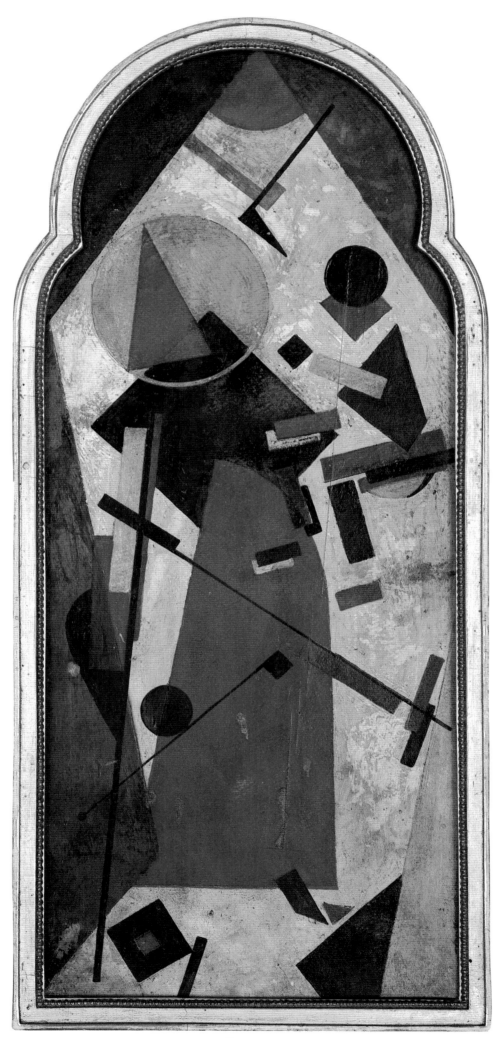

PLATE 300

even as it depicts nobody and nothing. Similarly, it is the essence of an icon to make visible the invisible, and perceptible that which is not amenable to perception by the senses. The abandonment of the representational styles of medieval and folk art in favour of mastering and exploiting its underlying artistic principles led, in a number of cases, to abstract art. The paintings created were highly abstract symbols of the order of the world, free of representationalism of any sort. In terms of meaning, they moved from the universality of what was generally comprehensible, to the subjective or what was accessible only to a narrow circle of initiates.

Kandinsky Malevich's expressed urge to 'tear ourselves free of the arms of nature and build a new world' was felt by other artists. Larionov, too, aimed to create a world of his own with no analogies in the world of nature, founding one of the varieties of non-representational art known as rayism. Vasily Kandinsky (1866–1944) was, like Malevich, Larionov and Goncharova, not only a great pioneer, but the creator of a new aesthetic. This affirmed the purpose of art as the expression of a supreme spiritual reality and exalted the artist as the creator of a new world representing that unseen reality in visible images. Artistic searching was a means of expressing equally intensive spiritual searching.

Kandinsky's path to abstract art was unlike that of either Goncharova or Malevich. The results, too, were different. Malevich represents a rational tendency in abstract art; Kandinsky, the subjectively expressive. The way by which they came to abstract art had some similarities, nevertheless: it came about through modernism, through study and adaptation of the heritage of medieval and folk art, by way of the primitive and archaization. There is, too, an undoubted kinship of outlook. Kandinsky, like Malevich, was an adept of theosophy, the ideas of Yelena Blavatskaya (known in the West as Madame Blavatsky) and Rudolf Steiner, and of Oriental philosophy.

Within Kandinsky's *oeuvre* – and particularly in terms of his contribution to world art – his specifically 'Russian' works are of secondary importance. Mastery of the national heritage was nevertheless an essential stage on the path to expression of *The Spiritual in Art*, as his book of 1910 (published in 1911–12) is entitled. Here he articulated new methods of 'expressing the spiritual, liberated from the material, which in the artist's mind was identified with representationalism'. He also mastered the art of medieval Western Europe. In particular, he adopted the technique of painting on glass from primi-

tive German medieval icon painting. Unlike Lentulov, Goncharova and Malevich, Kandinsky tended towards the Russo-European rather than the Russo-Oriental heritage.

Simplification, primitivization and abstraction of the underlying structures found in traditional Russian and medieval Western European art were an essential stage on Kandinsky's path to abstract art. The link with old Russian tradition is still to be found in his works of 1910 onwards when he created his major masterpieces of wholly abstract art. Representational and abstract art coexist as separate trends within his work, and within his representational work the Russian theme occupies a significant place.

By the early 1900s Russian art of the eighteenth and early nineteenth century had come to be regarded as a part of Russian, rather than of Western European, culture. This is reflected in Kandinsky's work by depiction of gallant scenes in his highly original interpretation. Kandinsky depicts ladies in wide skirts, reminiscent of crinolines, against a background of a stylized Russian town or landscape. The aristocratic subject matter of these images of a culture on the eve of its extinction lives paradoxically side by side with the archaization and openly ornamental style of decorative folk painting.

A second variety of Kandinsky's works makes use of the true national heritage. These include his paintings on subjects from Russian folk tales such as 'The Golden Cloud' and 'The Psaltery Player', his pictures of St George and the dragon, and of horsemen and amazons on horseback flying over the earth. In his own way Kandinsky was continuing the trend of fusing the national secular and religious fine art traditions. 'St George and the Dragon' (1914–15) and 'The Horseman in Pink' (1918) combined features of the iconography of icon painting and decorative folk art. Kandinsky used the same iconography for his numerous paintings of amazons.

Kandinsky set no store by the uniqueness of the national tradition as such, but that it contributed significantly to his art is beyond dispute. Quite apart from his representational work – the large number of horsemen he takes from pagan mythology, his liking for St George and the dragon, the iconography of his amazons and various Russian themes – a number of Kandinsky's abstract paintings of the 1910s and 1920s encourage this idea. In complex interwoven lines and patches we can discern a schematic representation of St George and the Dragon, a horseman destroying a dragon with a lance, or rather more rarely, a historic Russian town, transfigured in the manner of Lentulov.

PLATE 300
Attributed to Kazimir Malevich, *Suprematist Madonna*, early twentieth century.
This painting has been attributed to Malevich by his daughter. It is notable as much for its title as for its style, both of which mirror the link between the experimentation of the leaders of the artistic avant garde and the heritage of old Russia.

AFTERWORD

In summarizing our history of the old Russian and folk tradition in art from the eighteenth century to the beginning of the twentieth, we must return to the generalizations we formulated initially, and which we have seen confirmed as we traced its journey to this point.

Let us begin by noting the significance of the very fact that people turned to national tradition at all. The desire to give expression to national identity and the use of the visual arts for the purpose became a central preoccupation of Russians in the mid-eighteenth century. It resulted from Russia's unique history, in which the transition from the Middle Ages to the modern period took on the character of Europeanization, and very soon engendered a countervailing urge to assert her national identity.

During the eighteenth century and the first quarter of the nineteenth, only architecture drew upon the national tradition. The second quarter of the nineteenth century saw this extend to applied art, and in the latter part of the nineteenth century, church art and graphic design were added. This was the period when the influence of the national tradition expanded dramatically in architecture and applied art. The last to follow suit were easel painting and monumental sculpture. Along with the expansion of the national tradition's influence on different art forms went an expansion of the periods, styles and art forms that were regarded as a potential source.

If exploitation of the national tradition varied greatly between different periods and different art forms, there was also great unevenness in the extent to which it was drawn on in different genres within particular arts. There was a tendency nevertheless for the process to broaden out into new art forms, and also into new genres.

Russianness and the Russian style in Russian art are not the same thing. The former is always present and will be expressed whether the artist wills it or no; the latter is expressed deliberately, in periods when the issue seems particularly crucial. In this book we have tried to give as accurate an idea as possible of what it was that Russians themselves, over a period of almost two centuries, saw as expressing the Russianness of Russian art.

NOTES

CHAPTER I

First Attempts to Express National Identity 1750–1825

New Trends in Architecture

1
T. P. Fedotova, 'K probleme piatiglavia v arkhitekture barokko pervoi poloviny XVII veka', in *Russkoe iskusstvo barokko, Nauka*, Moscow, 1977:7

2
Noted on the plans for the church in the Bergholz collection of drawings in Stockholm. Quoted by Fedotova:73

3
Statistics relating to the St Petersburg diocese, 1876

4
P. N. Petrov, *Istoriia Sankt-Peterburga s osnovaniia goroda do vvedeniia v deistvie vybornogo gorodskogo upravleniia po uchrezhdeniiam o guberniiakh, 1703–1782*, St Petersburg, 1885:505

5
I. E. Grabar (ed), *Russkaya arkhitektura pervoi poloviny XVIII veka. Issledovaniia i materialy*, Moscow, 1954:287

6
A. I. Mikhailov, 'Iz novykh materialov o russkoi arkhitekture XVIII veka', *Arkhitekturnoe nasledstvo*, volume I, Moscow, 1951:63

7
Grabar (ed), *op. cit.*:350; A. Titov, *Dopolnenie k istoricheskomu geograficheskomu po 1762 g. sochinennomu A. Bogdanovym s risunkami prezhnikh zdanii*, St Petersburg, 1903:62

8
P. N. Petrov, *op. cit.*:505

9
O. P. Markova, 'O proiskhozhdenii t. naz. grecheskogo proekta (80-e go. XVIII v.)', *Istoriia SSSR*, volume IV, 1958:70

10
V. I. Piliavskii, *Stasov – arkhitektor*, Moscow, 1958:57–8, 245

11
From A. I. Venediktov, 'XVIII vek. Arkhitektura', in *Istoriia evropeiskia*, volume I (*Ot antichnosti do kontsa XVIII veka*), Moscow, 1963:314

12
A. V. Pozdnukov, 'Ob avtorstve rannikh psevdogoticheskikh sooruzhenii' in *Istoria i teoria arkhitektury i gradostroitelstva. Mezkhvuzovskii tematicheskii sbornik*, Leningrad, 1980:167–8

Russian Art and the Historical Events of the Nineteenth Century

1
N. M. Karamzin, *Zapiska o drevnei i novoi Rossii*, St Petersburg, 1914:28

2
Syn otechestva, part 51, volume I, 1819:14

3
A. S. Kurilov, 'Poniatie narodnosti i printsip istorizma' in *Metodologia sovremennogo literaturovedenia. Problemy istorizma*, Moscow, 1978:134–5

4
Istoria romantizma v russkoi literature, 1790–1825, Moscow, 1979:106–7.

5
N. I. Turgenev, *Rossia i russkie*, part I (letter from Herzen to the Emperor Alexander II), Moscow, 1907:3, 9

Venetsianov and his School

I

M. M. Allenov, 'Obraz prostranstva v zhivopisi a la natura: k voprosu o prirode Venetsianovskogo zhanrizma', *Sovetskoe iskusstvoznanie*, part 83, volume I, Moscow, 1984:125–6

2

Ibid:132

3

M. A. Nekrasova, *Narodnoe iskusstvo kak chast kultury, Teoria i praktika*, Moscow, 1983:33–4

4

Mastera iskusstva ob iskusstve, volume VI (Venetsianov's letter to the publisher of the literary supplements to *Russkii invalid*):187

5

T. V. Alekseeva, *Istoria russkogo iskusstva*, volume VIII, Moscow, 1963:20

The Russian Costume Portrait

I

T. T. Korshunova, *Kostium v Rossii XVIII–nachala XX veka. Iz sobrania Ermitazha*, Leningrad, 1978:7

2

Loc. cit.

3

N. G. Platonova, 'XVIII vek' in *Russkie iuvelirnye ukrashenia XVI–XX vekov. Iz sobrania Gosudarstevennogo Istoricheskogo muzeia*, Moscow, 1987:72

4

Ibid:75

5

N. M. Kaminskaya, *Istoria kostiuma*, Moscow, 1977:101

6

'Cherty Ekateriny Velikoi', *Russkii arkhiv*, 1870:columns 2112 & 2113

7

T. Gautier, *Puteshestvie v Rossiiu (Journey into Russia)*, Moscow, 1988:46

The Byzantine Style
1825–1850

The Emergence of the Byzantine Style

I

A. S. Khomiakov, 'O vozmozhnosti russkoi khudozhestvennoi shkoly', *Moskovskii Literaturnyi i uchenyi sbornik na 1847 god*, Moscow, 1847:323

2

V. I. Plotnikov, *Folklor i russkoe izobrazitelnoe iskusstvo vtoroi poloviny XIX veka*, Leningrad, 1987:26

3

A. Grigoriev, *Sobranie sochinenii*, volume XIII, Moscow, 1915:35

Ton and the Cathedral of Christ the Redeemer

I

T. A. Slavina, *Konstantin Ton*, Leningrad, 1982:91

The Byzantine Style and Town Planning

I

T. Gautier, *op. cit.*:221, 242

2

V. G. Lisovsky, *Natsionalnye traditsii v russkoi arkhitekture XIX–nachala XX veka*, Leningrad, 1988:14

3

Pamiatniki arkhitektury Moskvy. Kreml, Kitai-gorod, Tsentralnye ploshchadi (2nd edition), Moscow, 1983:326–8

4

S. P. Bartenev, *Bolshoi Kremlevskii dvorets. Dvortsovye tserkvi i pridvornye sobory*, Moscow, 1916:28

The Byzantine Style in the Fine and Applied Arts

I

TsGIA, f. 1789, *op.* 14, d. 108, l. 7.

2

F. G. Solntsev, 'Moia zhizn i khudozhestvenno-arkheologicheskie trudy', *Russkaya starina*, no. 3, 1876:634

3

Russkaya starina, no. 5, 1876:159

4

Russkaya starina, no. 1, 1876:109–11

5

Russkaya starina, no. 6, 1876:305

6

'Restavratsii russkikh khudozhnikov. O restavratsii
voobshche', Khudozhestvennaya gazeta, no. 10, 1840:7

7

F. G. Solntsev, op. cit., Russkaya starina, no. 1:110; no. 2:273

8

M. V. Davidova, Ocherki istorii russkogo teatralno-
dekorativnogo iskusstva, Moscow, 1974:48

9

V. G. Lisovsky, Akademiia Khudozhestv, Leningrad,
1982:103

10

A. N. Savinov, 'Gagarin', Russkoe iskusstvo. Ocherki o
zhizni i tvorchestve russkikh khudozhnikov pervoi
poloviny XIX veka, Moscow, 1954:432, 534, 535

11

P. N. Petrov, Sbornik materialov dlia istorii Akademii
Khudozhestv za sto let ee sushchestvovaniia, part III,
St Petersburg, 1866:258–9

12

I. N. Kramskoi, Stati, volume I, Moscow, 1964:46

13

'Proekt khrama v pamiat kreshcheniia sv. Vladimira v
Khersonese', Arkhitekturnyi vestnik, no. 4:345

CHAPTER III

The Russian Style
1850–1900

The Folk Variety of the Russian Style

1

V. V. Stasov, Izbrannye sochineniia, volume II,
Moscow/Leningrad, 1937:206

2

Y. A. Soloviev, 'Literaturnoe dvizhenie XIX veka v Rossii'
in XIX vek. Illiustrirovannyi obzor, St Petersburg, 1901:191

3

Stasov, op. cit.:214

4

Ibid:215

Peasant Architecture in Russian Towns

1

Plany dlia ustroeniia selenii 1831 goda, Izdanie Ministerstva
vnutrennikh del., St Petersburg, 1831

2

Atlas normalnykh chertezhei sooruzheniiam po
vedomstvu Ministerstva gosudarstvennykh imushchestv,
St Petersburg, 1842; Atlas fasadov domov po
krestianskomu obraztsu s planami raspolozheniia selenii
na shosse, St Petersburg, 1851; Atlas proektov i chertezhei
selskikh postroek, izdannyi ot departamenta selskogo
khoziastva Ministerstva gosudarstvennykh imushchestv,
St Petersburg, 1853.

3

PsZRI, sobr. 2, volume XXXI, no. 31251, 1858

4

N. K. Shaikhdinova, Dereviannaia rezba Tyumeni,
Sverdlovsk, 1984:32

Interiors and Applied Art

1

V. V. Stasov, Obraztsy russkogo ornamenta, published by
Viktor Gartman, Moscow, 1872, unpaginated

2

Opisanie risunkov pomeshchennykh v albome 'Risunki
modnoi mebeli', published by K. Kun, St Petersburg, 1869

3

A. P. Chekhov, Izbrannye sochineniia, Moscow, 1946:162

4

V. I. Konashevich, 'O sebe i svoem dele', Novy mir,
no. 10, 1965:10

5

Z. P. Popova, 'Duga, topor i rukavitsy', Nauka i zhizn,
no. 8, 1965:82

6

F. I. Buslaev, Moi dosugi, volume II, Moscow, 1886:207–8

7

Stroitel, no. 1–2, 1899:43–4

CHAPTER IV

The Neo-Russian Style

The Birth of the Neo-Russian Style

1

'Khudozhestvennost promyshlennosti', Iskusstvo i
khudozhestvennaya promyshlennost, no. 20, 1900:440

2

'E. Makovskii', Peterburgskaya gazeta, no. 268,
St Petersburg, 30 September 1902

3
A. N. Benois, *Istoria russkoi zhivopisi*, St Petersburg, 1902:252

4
L. Bakst, 'Vystavka v redaktsii "Apollona"', *Apollon*, no. 8, 1910:45–6

5
I. E. Repin, *Dalekoe blizkoe*, Moscow/Leningrad, 1949:338

6
N. K. Roerich, 'Obedneli my', quoted in V. P. Kniazeva, *Roerich*, Moscow/Leningrad, 1963:36

7
N. K. Roerich, 'Glaz dobryi', quoted in Kniazeva, *op. cit.*:38

8
P. Muratov, 'O vysokom khudozhestve', *Zolotoe runo*, no. 11–12, 1907:82

Abramtsevo

1
G. I. Stepnin's expression; see *Tip zhizni i tip iskusstva* in *Abramtsevo*, Leningrad, 1988:11

2
V. S. Mamontov, *Vospominaniia o russkikh khudozhnikakh*, Moscow, 1951:108–9

3
Ibid.:94, 99

4
N. V. Polenova, *Vospominaniia*, Moscow, 1922:21

5
A. Bely, *Simvolizm. Kniga statei*, Moscow:3, 10

6
TsGALI (Central State Archive of Literature and Art), f. 799, op. 1, d. 17, l. 171; quoted by V. I. Plotnikov, *op. cit.*:113

7
V. I. Plotnikov, *op. cit.*:111–12

8
E. R. Arenzon, *op. cit.*:31–3

Vasnetsov and Russian Art

1
E. V. Paston, 'On pervyi sredi khudozhnikov obratilsia k ukrasheniiu zhizni', *Decorativnoye iskusstvo SSSR*, no. 2, 1984:38

2
E. V. Paston, *op. cit.*:41

3
N. D. Morgunov and N. D. Morgunova-Rudnitskaya, *Viktor Mikhailovich Vasnetsov. Zhizn i tvorchestvo*, Moscow, 1960:96, 97, 148

4
D. S. Likhachev, *Poetika drevnerusskoi literatury*, Leningrad, 1967:243

5
V. I. Plotnikov, *Folklor i russkoe izobrazitelnoe iskusstvo vtoroi poloviny XIX veka*, Leningrad, 1987:15–20

6
N. D. Morgunov and N. D. Morgunova-Rudnitskaya, *op. cit.*:188

Neo-Russian Stage Design for the Mamontov Circle and the Russian Private Opera

1
V. M. Vasnetsov, 'Pamiati Sergeia Ivanovicha Vashkova', *Svetilnik*, no. 10, 1914:9

The Abramtsevo Church and the Carpentry Workshop

1
E. V. Sakharova, 'Elena Dmitrievna Polenova' in *Russkoe iskusstvo. Ocherki o zhizni i tvorchestve khudozhnikov vtoroi poloviny XIX v.*, ed. A. I. Leonov, volume II, Moscow, 1971:92

2
F. O. Shekhtel, letter to Viktor Vasnetsov, 22 October 1902, State Tretyakov Gallery Archive, no. 66/411,1.2; see also E. A. Borisova, 'Arkhitektura v tvorchestve khudozhnikov Abramtsevskogo kruzha (u istokov neorusskogo stilia)' in *Khudozhestvennye protsessy v russkoi kulture vtoroi poloviny XIX veka*, Moscow, 1984:182

3
N. D. Morgunov and N. D. Morgunova-Rudnitskaya, *op. cit.*:214

4
N. V. Masalina, *op. cit.*:48–53

5
N. V. Polenova, *op. cit.*:39–44

6
Ibid.:48

7
I. V. Plotnikova, 'Abramtsevskaya stoliarnaya masterskaya i kollektsiia narodnogo iskusstva', in *Abramtsevo*:147

8
I. A. Kriukova, 'Narodnoe iskusstvo i zemskie organizatsii' in *Russkaya khudozhestvennaia kultura kontsa XIX-nachala XX veka (1908–1917)*, volume IV, *Izobrazitelnoe iskusstvo, Arkhitektura. Dekorativno-prikladnoe iskusstvo*, Moscow, 1980:447

9
Loc. cit.

10
N. V. Polenova, *op. cit.*

11
Russkoe narodnoe iskusstvo na vserossiiskoi kustarnoi vystavke v Petrograde v 1913, 1914

Vrubel and the Abramtsevo Ceramics Studio

1
V. A. Nevsky, 'Abramtsevskaya keramicheskaya masterskaya. Maiolika M. A. Vrubelia', in *Abramtsevo*:174–5

2
Ibid.:196

3
D. V. Sarabianov, '*Russkaya zhivopis na teatralnoi stsene*' (introductory article to an exhibition catalogue), *Russkoe teatralno-dekoratsionnoe iskusstvo, 1880–1930. Iz kollektsii Nikity i Niny Lobanovykh-Rostovskikh*, Moscow, 1988:6

4
Vrubel, Perepiska, Vospominaniia o khudozhnike, Moscow, 1963:79

Talashkino

1
M. K. Tenisheva, *Vpechatleniia moei zhizni*, Paris, 1933:252

2
Information on Talashkino and Princess Tenisheva's work has been taken from a number of sources including:
I. Belogortsev, *Talashkino*, Smolensk, 1951;
L. S. Zhuraleva, *Teremok*, Smolensk, 1969 and Moscow, 1979; B. Rybchenkov and A. Chaplin, *Talashkino*, Moscow, 1973

3
N. Belikov and V. M. Kniazeva, *op. cit.*:71

4
L. S. Zhuraleva, *op. cit.*:58

Religious Art at the Turn of the Century

1
S. I. Vashkov, *Religioznoe iskusstvo*, Moscow, 1911, unpaginated

2
Ibid.

3
Ibid.

4
Bogoslovsky vestnik, volume I, January 1915:263

5
V. Pashkov, 'Monashestvo na Rusi v zerkale statistiki', *Nauka i religiia*, no. 2, 1990:48

6
I. I. Nikonova, *Nesterov*, Moscow, 1979:123

Cathedrals in the Neo-Russian Style

1
N. S. Semenkin, *Ukaz. soch*:154

Church Interiors: Painting and Applied Arts

1
V. D. Polenov, *Pisma dnevniki vospominaniya*, compiled by E. D. Sakharova, Moscow, 1950:228

2
M. V. Nesterov, *Letters*, Leningrad, 1968:192

3
M. V. Nesterov, *Davnie dni. Vstrechi i vospominaniya*, Moscow, 1959:93

4
M. V. Nesterov, *Letters*:134

5
S. Glagol, *Mikhail Vasilievich Nesterov, zhizn i tvorchestvo*, Moscow, undated:50–51

6
M. V. Nesterov, *Letters*:86

7
V. V. Rozanov, *Sredi khudozhnikov*, St Petersburg, 1914:58

8
I. I. Nikonova, *Nesterov* (from the series *Zhizn v iskusstve*), Moscow, 1979:91–2

9
M. V. Nesterov, *Letters*:185–6

10
I. I. Nikonova, *Ukaz. soch.*:127

11
From the manuscript by Nikolai Roerich, *'Geroicheskii realizm'*, cited in V. P. Knyazeva, *Nikolai Konstantinovich Roerich, 1874–1947*, Moscow, 1963:40

12
N. K. Roerich, *Sobranie sochenenii*, volume I, Moscow, 1914:310–11

Russian Folk and Medieval Themes in Secular, Fine and Graphic Arts

1
B. A. Kapranov (compiler), *Boris Mikhailovich Kustodiev. Pisma, Stati Zametki, Interviu. Vstrechi i besedy. Vospominaniia o khudozhnike*, Leningrad, 1967:104

2
S. V. Golynets, *'I. I. Bilibin i kniga'*, *Iskusstvo*, no. 5, 1987; Golynets, *Ivan Bilibin*, Leningrad, 1988:6

3
S. V. Golynets (ed), *I. I. Bilibin. Stati, Pisma. Vospominaniia o khudozhnike*, Leningrad, 1970:54

4
I. I. Bilibin, *'Narodnoe tvorchestvo russkogo Severa'*, *Mir iskusstva*, no. 1, St Petersburg, 1904:315

The Russian Avant-Garde and Russian Tradition

1
S. P. Bobrov, *'Osnovy novoi russkoi zhivopisi'* in *Trudy Vserossiiskogo sezda khudozhnikov v Petrograde. Dekabr 1911–Ianvar 1912*, volume I, St Petersburg, 1914:43

2
A. V. Shevchenko, *Neoprimitivizm*, Moscow, 1913, unpaginated

3
A. V. Shevchenko, *Printsipy kubizma i drugikh sovremennykh techenii v zhivopisi vsekh vremen i narodov*, Moscow, 1913, unpaginated

4
G. G. Pospelov, *'Karo-Bube'. Aus der Moskauer Malerei zu Beginn des 20-Jahrhunderts*, Dresden, 1985; G. G. Pospelov, *'Obrazy gorodskogo zhivopisnogo folklora v natiurmortakh Larionova, Konchalovskogo, Mashkova'*, in *Veshch v iskusstve. Materialy nauchnoi konferentsii 1984 (XVII)*, Moscow, 1986:197

5
From research in N. Kiemi, *Problemy ispolzovaniia narodnoi traditsii v russkoi zhivopisi kontsa XIX-nachala XX veka*, dissertation, Moscow, 1984

6
C. Gray, *The Russian Experiment in Art, 1863–1922*, London, 1962:100

7
Egenbiuri, *Natalia Goncharova. Mikhail Larionov*, Moscow, 1913:19

8
O. A. Tarasenko, *Puty osvoeniya Drevnerusskogo iskusstva v russkoy zivopisi kontsa XIX–nachala XX veka*, dissertation, Moscow, 1979:161–2

9
C. Gray, *op. cit.*:141

10
K. S. Malevich, *Suprematizm*, UNOVIS, Vitebsk, 1920:1

11
D. V. Sarabianov, *'O Kandinskom'*, in *Vasily Vasilievich Kandinsky, 1866–1944* (exhibition catalogue), Leningrad, 1989:39

12
O. A. Tarasenko, *op. cit.*:113, 116, 126

13
Ibid:122

14
D. V. Sarabianov, *Russkaya zhivopis kontsa 1900-kh nachala 1910-kh godov, Ocherki*, Moscow, 1971:45

15
O. A. Tarasenko, *op. cit.*:133

16
From research in V. N. Konstantinova, *Problema dekorativnosti v russkoi zhivopisi nachala XX veka*, dissertation, Moscow, 1985

17
L. Dmitriev, *'Kupanie krasnogo konia'*, *Apollon*, no. 3, 1915:15; D. V. Sarabianov, *Russkaya zhivopis kontsa 1900-kh–nachala 1910-kh godov. Ocherki*:49

18
D. V. Sarabianov, *'Kupanie krasnogo konia'*, *Tvorchestvo*, no. 7, 1962:16; *Russkaya zhivopis kontsa 1900-kh–nachala 1910-kh godov. Ocherki*:49

ACKNOWLEDGMENTS

We are indebted to many people
for their help on this project. We would like
in particular to thank Carey Schofield,
whose suggestion prompted the idea for the book,
Nina Asharina, Mariana Bubchikova,
Luisa Efimova and Olga Gordeyeva at the
Historical Museum in Moscow,
and Grigory Klimov, Leonid Ogarev and D.A.,
also in Moscow.

The book could never
have been realized without John Stuart,
whose work on the captions and advice
and help on every other aspect of the project
have been invaluable.

PICTURE CREDITS

We are grateful to the following institutions and individuals for allowing
us to reproduce the illustrations numbered:
Frontispiece and plates 76, 192, 193 & 194, the Forbes Magazine Collection, New York.
Plates 15 & 16, Vadim Gippenreiter, Moscow.
Plates 33, 35, 36, 127, 128, 188, 191, 249, 282, 283, 284, 288 & 293, Sotheby's, London.
Plates 58, 63, 64 & 65, Cary Wolinsky. Plate 72, Olga Suslova and Lilia Ukhtomskaya.
Plates 115, 117, 119 & 120, Alexander von Solodkoff, London.
Plate 116, Gewerbemuseum, Nuremburg.
Plates 143, 286, 287, 294 & 295, collection of Mr and Mrs Nikita Lobanov-Rostovsky, London.
Plate 164, private collection, Paris. Plate 199, Christie's, London.
Plate 285, Christie's, Geneva.
Plate 297, Stadtische Galerie im Lenbachhaus, Munich.

INDEX

(figures in *italics* refer to captions)